Sketching from the Imagination:

MAGIC & MYTH

3dtotalPublishing

3dtotalPublishing

Correspondence: publishing@3dtotal.com
Website: www.3dtotal.com

Every effort has been made to ensure the credits and contact
information listed are present and correct. In the case of
any errors that have occurred, the publisher respectfully
directs readers to the www.3dtotalpublishing.com
website for any updated information and/or corrections.

First published in the United Kingdom,
2022, by 3dtotal Publishing.

Address: 3dtotal.com Ltd, 29 Foregate Street,
Worcester, WR1 1DS, United Kingdom.

Soft cover ISBN: 978-1-912843-52-7
Printing & binding: Gutenberg Press Ltd (Malta)
www.gutenberg.com.mt

Visit www.3dtotalpublishing.com for a
complete list of available book titles.

Managing Director: Tom Greenway
Studio Manager: Simon Morse
Lead Designer: Joseph Cartwright
Lead Editor: Samantha Rigby
Editor: Marisa Lewis

Cover images
© Individual artists as listed
throughout the book

FSC
MIX
Paper from
responsible sources
www.fsc.org FSC® C022612

ONE TREE PLANTED FOR EVERY BOOK SOLD

We at 3dtotal Publishing donate 50% of our
profits to charity. For every book sold, we give
to reforesting charities to plant new trees.
This is just one part of our annual donation to
a large number of the most effective charities,
covering causes such as humanitarian
work, animal welfare, and the protection
of existing rainforests. We also aim to be a
carbon-neutral publisher with carbon-neutral
products, which means that by buying from
3dtotal Publishing, you are helping to balance
the environmental damage caused by the
publishing, shipping, and retail industries, as
well as supporting many other causes. See
3dtotal.com/charity for full details.

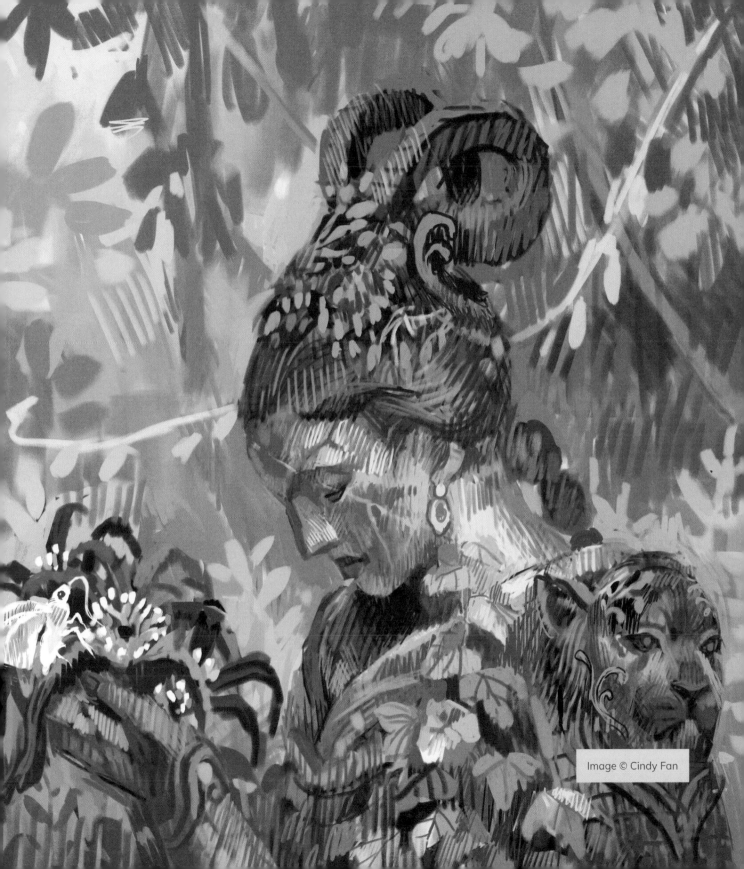

Image © Cindy Fan

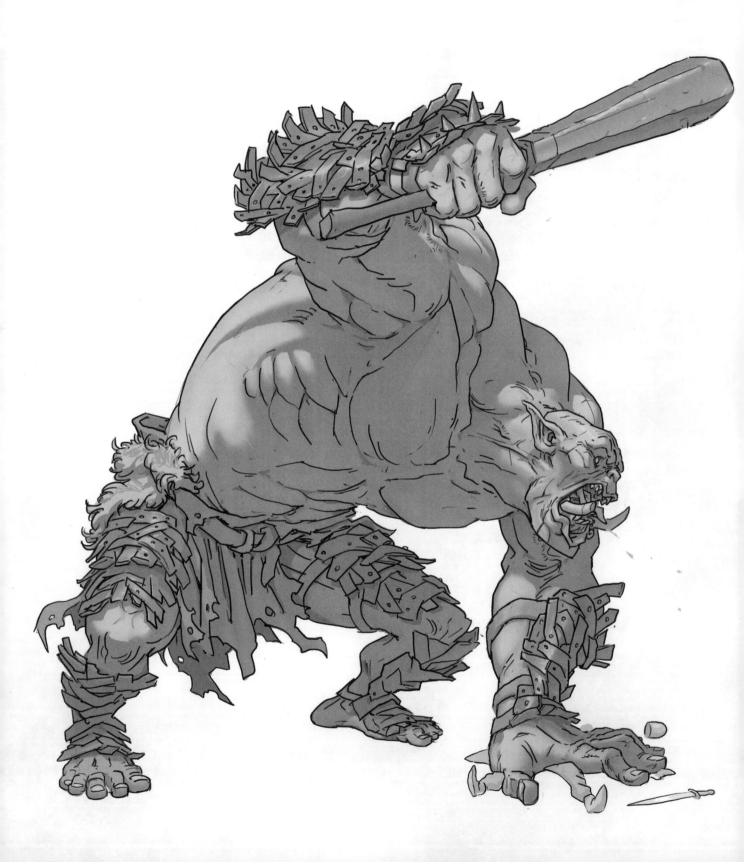

CONTENTS

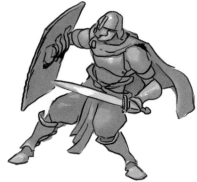

Image © Leroy Steinmann

INTRODUCTION

From the surreal whimsy of *Alice's Adventures in Wonderland* to the dark grandeur of *Elden Ring*, the fantasy genre never loses its power to enthrall us. This fascination reaches from the present day back to the folk tales and epic sagas of old – the very human compulsion to imagine, invent, examine reality through another lens, and simply tell stories that enchant others and will be remembered.

In this volume of *Sketching from the Imagination* we'll be delving into the archives of fifty talented artists from around the world, whose passion for fantasy, folklore, magic, and mythology has been a defining aspect of their lives and work. Within these pages, you'll find monsters, knights, gods, adventurers, castles, and landscapes; artists reinventing fairy tales and legends, or creating their own, putting their dreams and imaginings onto paper.

Each artist will share their own personal relationship with fantasy and drawing, their insights learned through years of industry experience, and, of course, a look at the sketchbooks and in-progress files that show their raw creativity at work. We hope you enjoy your journey through this book and that it inspires you to pick up a pencil, pen, or stylus and make some magic of your own.

Editor

Marisa Lewis

Image © Entei Ryu

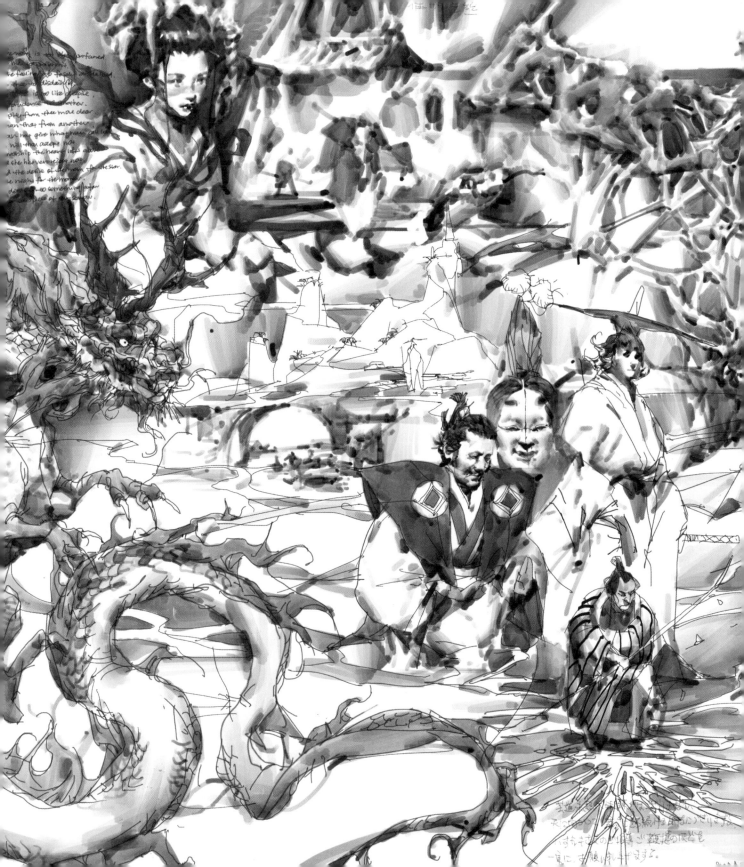

Adams, Shafi

shafiadams.com
Images © Shafi Adams except where noted.

I am an illustrator and concept artist from Singapore. I started drawing when I was young and my family fueled my imagination with healthy doses of comic books, video games, and action figures. It took a lot of convincing (from myself, especially) for me to make art professionally. I always wondered if it would be a good idea, but eventually I realized that there was nothing else I'd rather do.

My work was always influenced by fantasy and horror media, but college helped me cultivate an active interest in folklore. It felt similar to the genres I enjoyed, but came with a rich cultural and historic background based on real traditions. I love reading tales about Japanese spirits, Arthurian legends, Southeast Asian fables and so on. They are often ambiguous, leaving space for the imagination and new interpretations. A friend once said that my efforts to adapt and borrow elements from such tales felt like a continuation of those storytelling traditions. That resonated with me!

On a more primal level, I enjoy the scratch of a pen or pencil on a piece of paper, or the way paint sometimes falls in unanticipated ways, creating moments you would never have been able to achieve purposefully.

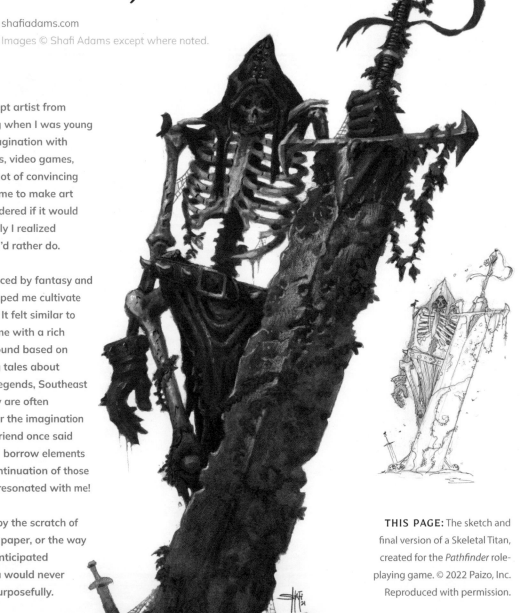

THIS PAGE: The sketch and final version of a Skeletal Titan, created for the *Pathfinder* role-playing game. © 2022 Paizo, Inc. Reproduced with permission.

INSPIRATION AND IDEAS

While I'm interested in stories from all around the world, I try to look toward my Southeast Asian heritage when I can. There are many hidden stories and myths to uncover, and discovering them is part of the fun. I learn a lot about my family background and community in the process. Combined with my affinity for storytelling through the fantasy and horror genres, this can create unique ideas that feel personal while being a natural expression of what I enjoy. I am also deeply inspired by film, music, and video games.

MATERIALS

I sketch with pencils and ballpoint pens. For final work, I paint over my drawings with acrylic inks, but when I have time, I like to use a combination of wax crayons (because they feel like giant ballpoint pens) and oil paints.

Using digital painting and sculpting software is a part of my process. It helps me work out compositions and color studies in a more effective manner. I also work digitally for concept-art assignments, when quick iterations and non-destructive methods of working are often more valuable than polish.

TECHNIQUES

My initial sketches and thumbnails are very loose. I try to keep things fresh and open up the possibility for new, accidental ideas. I follow one idea to the next while asking myself questions like, "What if this was another material?" or "What if this was twice as big?" After figuring out proportions and compositions, I work on a final drawing. Only then do I worry about color. With enough preparation and reference, the final painting process is made easier. It can often be nerve-racking, so I also employ breathing exercises and practice mindfulness throughout.

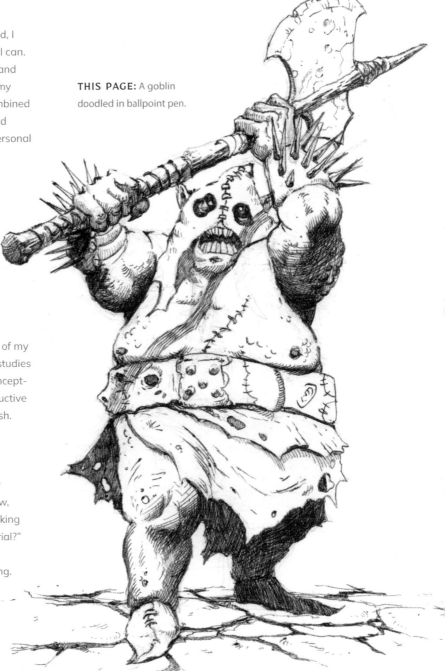

THIS PAGE: A goblin doodled in ballpoint pen.

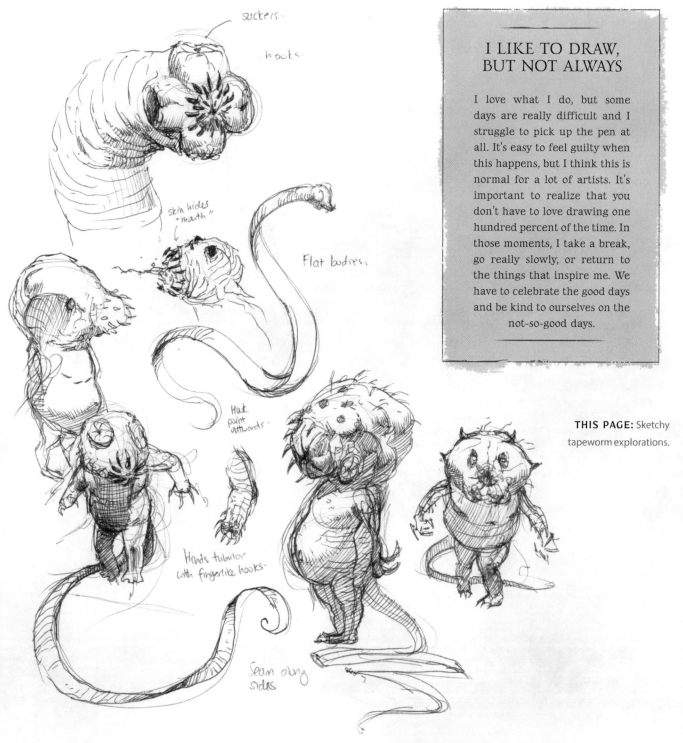

suckers.

hooks.

skin hides "mouth"

Flat bodies.

Hook point outwards.

Hands tubular with fingerlike hooks.

Seam along sides

I LIKE TO DRAW, BUT NOT ALWAYS

I love what I do, but some days are really difficult and I struggle to pick up the pen at all. It's easy to feel guilty when this happens, but I think this is normal for a lot of artists. It's important to realize that you don't have to love drawing one hundred percent of the time. In those moments, I take a break, go really slowly, or return to the things that inspire me. We have to celebrate the good days and be kind to ourselves on the not-so-good days.

THIS PAGE: Sketchy tapeworm explorations.

10

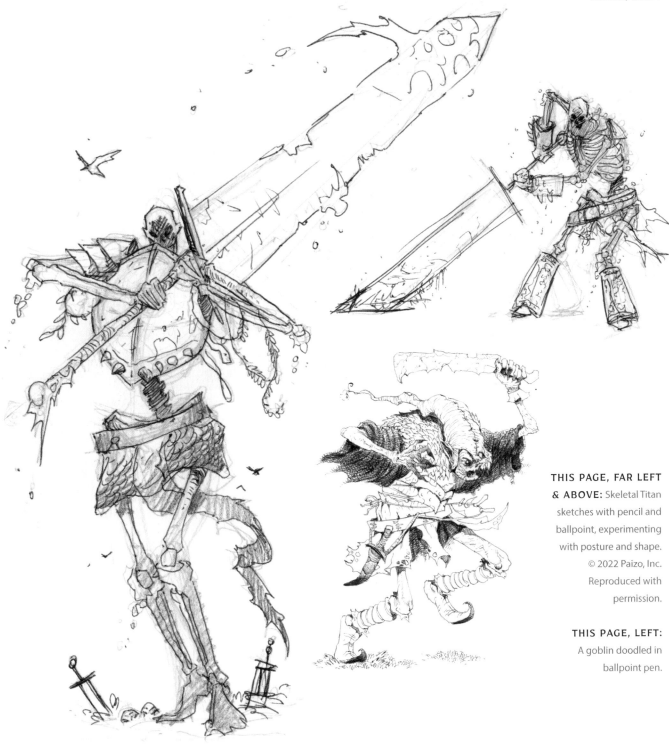

THIS PAGE, FAR LEFT & ABOVE: Skeletal Titan sketches with pencil and ballpoint, experimenting with posture and shape. © 2022 Paizo, Inc. Reproduced with permission.

THIS PAGE, LEFT: A goblin doodled in ballpoint pen.

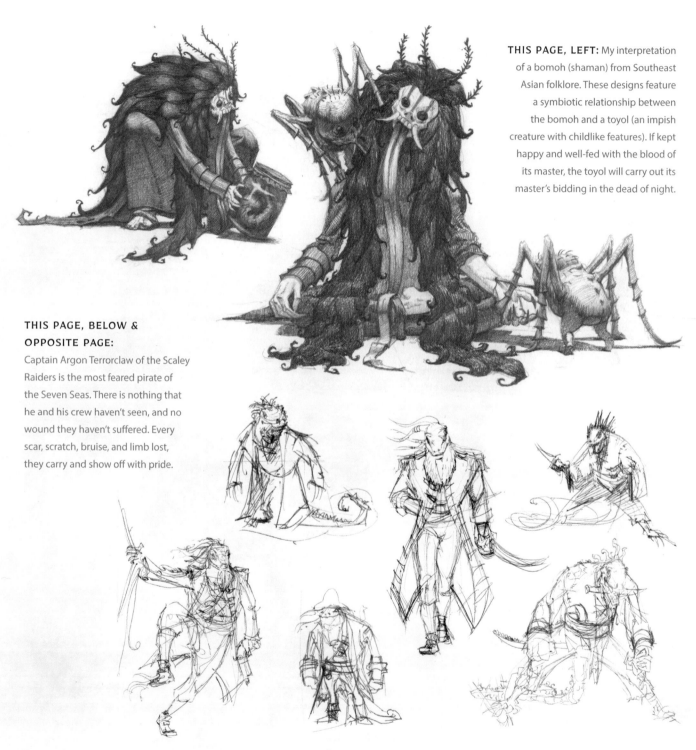

THIS PAGE, LEFT: My interpretation of a bomoh (shaman) from Southeast Asian folklore. These designs feature a symbiotic relationship between the bomoh and a toyol (an impish creature with childlike features). If kept happy and well-fed with the blood of its master, the toyol will carry out its master's bidding in the dead of night.

THIS PAGE, BELOW & OPPOSITE PAGE:

Captain Argon Terrorclaw of the Scaley Raiders is the most feared pirate of the Seven Seas. There is nothing that he and his crew haven't seen, and no wound they haven't suffered. Every scar, scratch, bruise, and limb lost, they carry and show off with pride.

"I enjoy the scratch of a pen or pencil on a piece of paper, or the way paint sometimes falls in unanticipated ways"

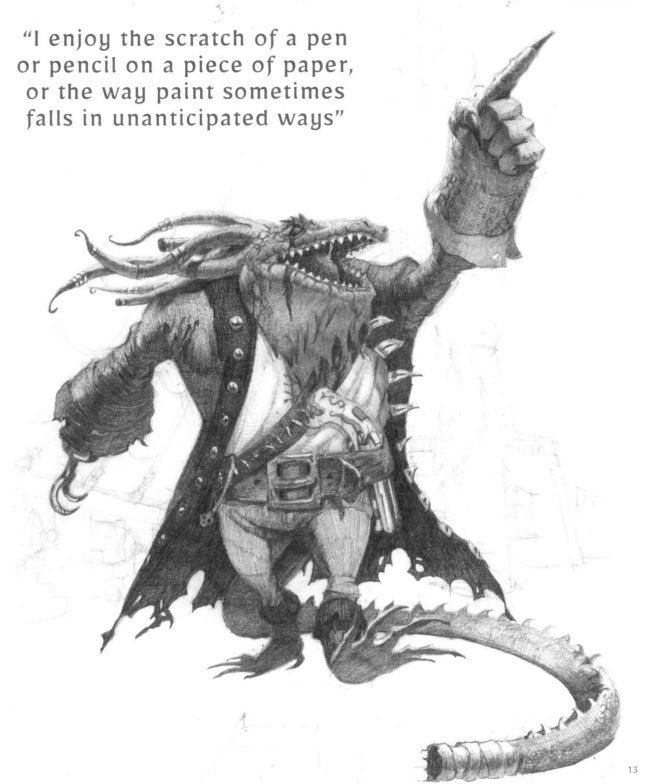

Afshar, Reza

instagram.com/rezaa_afsharr

All images © Reza Afshar

I am an Iranian concept artist and illustrator, and I have been working professionally on book covers, album artwork, video games, movies, and animations since 2012.

INSPIRATION AND IDEAS
◇◇◇◇

For me, it all started with reading fantasy novels and playing video games such as *Prince of Persia* when I was a teenager. Fantasy movies like *The Lord of the Rings* also influenced me a lot in my early years as a concept artist and painter. Nowadays, I am inspired by many artists, including contemporary concept artists, comic book artists, and traditional painters. It would be hard to single out just a couple as I love so many, and my list is always changing as I discover new sources. Still, if I had to, I would say that my main influences – the ones I always come back to when I'm confused or need to push myself further – are Paul Lehr, Mœbius, Arnold Böcklin, and Zdzisław Beksiński.

MATERIALS
◇◇◇◇

For professional commissions I usually work digitally, using either Adobe Photoshop or Procreate. I like Procreate as it can be used to create an effect that is much more painterly than Photoshop.
I enjoy working in Photoshop too, but in quite a different way, often without my graphics tablet and stylus. I often use Photoshop to create simple shapes and play with geometry and space. It makes quite a different result: neater and more efficient, but less painterly.
In my spare time, when I'm not in a hurry, I love using traditional paint and inks.

TECHNIQUES

◇◇◇◇

Whatever technique I am using, I always sketch
a lot during the day. It helps me clear my mind
and is very restful to me. I don't think about what
I want to draw, I just let my hand wander until
something comes out. Then, I push the values of
my sketches, or put them in color using digital
tools, or leave them as they were in the first
place, just black lines and hatching on paper.
This is actually the main way that I create: I don't
usually have a final image in mind for my personal
works. The idea just evolves through the process
of drawing until a painting starts to appear.

Of course, it's a bit different when it comes to
commissions! I then have to follow the briefs
and desires of the people I'm working for.
It can be trickier, but I am lucky enough to
keep a certain freedom in the compositions
or styles I want to use. From time to time,
I use visual references to try and stay close
to what is asked of me. I find inspiration in
photos or paintings that I like, and am usually
able to come up with a new piece that is
a mix of everything I have been using.

OPPOSITE PAGE: The Photoshop sketch was
inspired by my hometown of Hamedan, where you
can find an old brick kiln that I love. The character
and his cow refer to ancient cave paintings you
can also find there. I love this piece for its simple
shapes and the memories it brings back.

THIS PAGE: I started this steampunk city with a
quick pencil sketch – I love the feeling of pencils
on paper! I then scanned it and refined it in
Photoshop. I love crowded cities on huge rocks,
and flying boats are always so cool to draw.

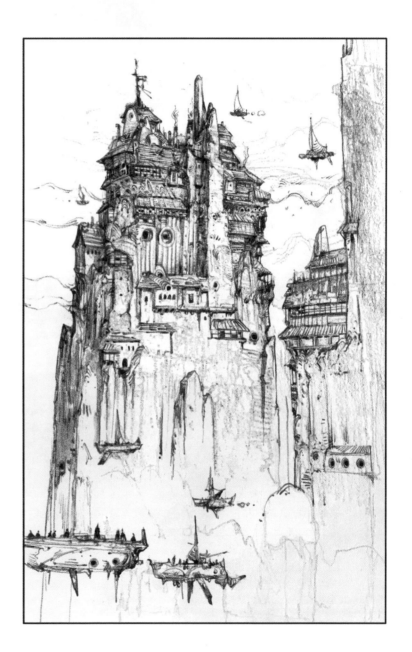

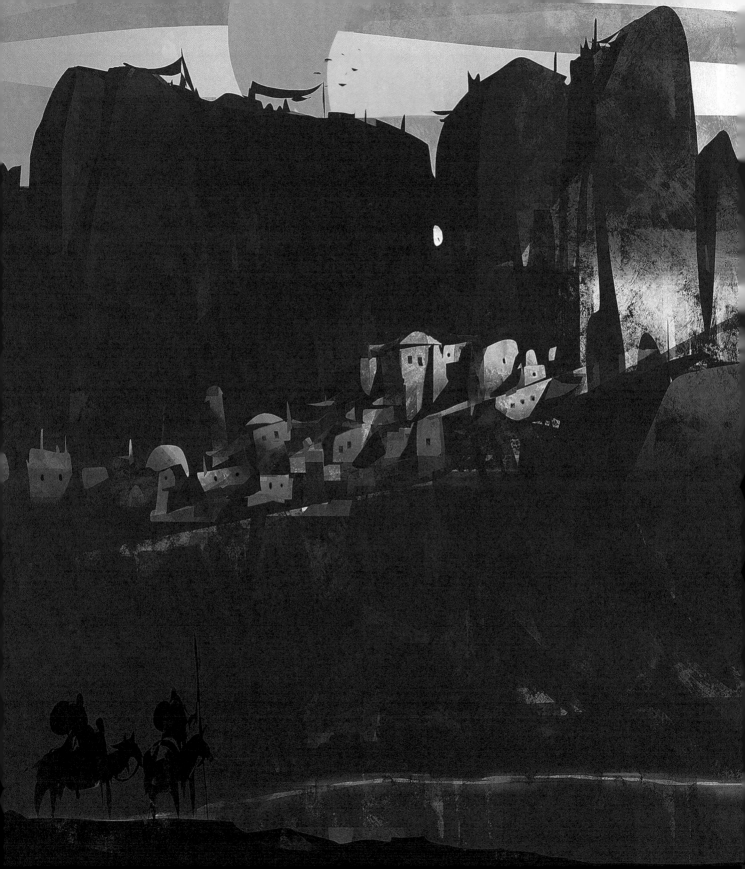

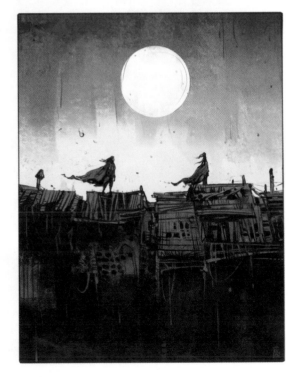

OPPOSITE PAGE: The simple geometric shapes were made with Photoshop's Lasso tool. The horse riders in the foreground are looking up at the village. Maybe they are just travelers looking for a place to spend the night, or perhaps they are soldiers trying to reach the settlement.

THIS PAGE, TOP LEFT: This Procreate sketch was made in a couple of hours, using random ink and drawing brushes: A magical being in search of dark powers to control others. But, as always with dark forces and black magic, nothing comes without a price!

THIS PAGE, TOP RIGHT: *Quest of Revenge.* "All he wanted was to go home, where he could walk through the door and see their smiles once again. But his journey had just begun, for there was no home to go back to."

THIS PAGE, LEFT: This Photoshop sketch reminds me of an impossible love story, such as one from classical literature: The last meeting of two lovers who cannot be together, with the moon as their only witness.

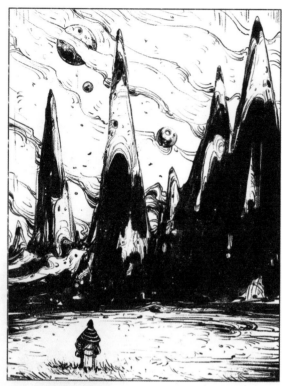

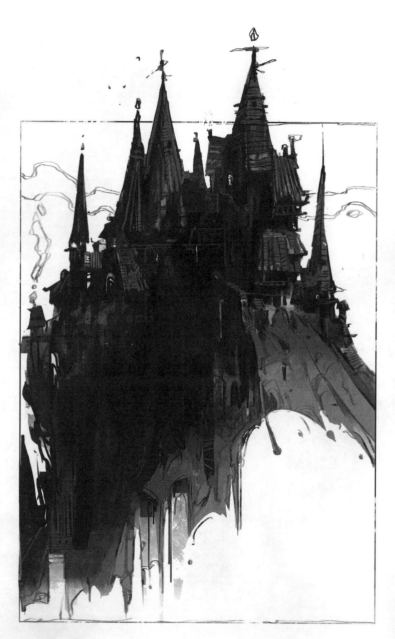

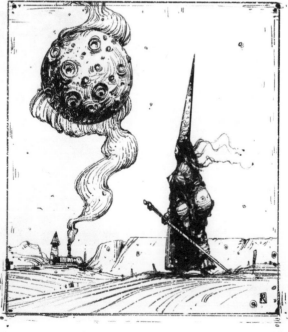

OPPOSITE PAGE, LEFT: This sketch was made using Photoshop. I have always wanted to draw a medieval castle. I am fascinated by ancient European architecture – the intricate details in the rooftops, stone walls, doors, and bridges! This one might look unfinished, but it's actually my favorite personal grayscale artwork.

OPPOSITE PAGE, TOP RIGHT: This Procreate sketch is of a girl wandering in an unknown landscape, just looking at her surroundings and discovering dreamy, beautiful places. Like Alice in Wonderland, who knows what she will find?

OPPOSITE PAGE, BOTTOM RIGHT: This one, I particularly love. It came to me after reading many amazing magical and dark stories about Persian wizards and witches. I love the ancient legends from my country – they are so inspiring! I tried to dress this witch in traditional clothing.

THIS PAGE: In this Photoshop sketch, I went for high contrasts, from white to deep black. I like parts of the landscape to "appear" without actually being drawn. This wanderer seems lost, but is not lonely or suffering. He is calm and resigned to following his path – a recurrent feeling in my paintings that I sometimes share with my characters.

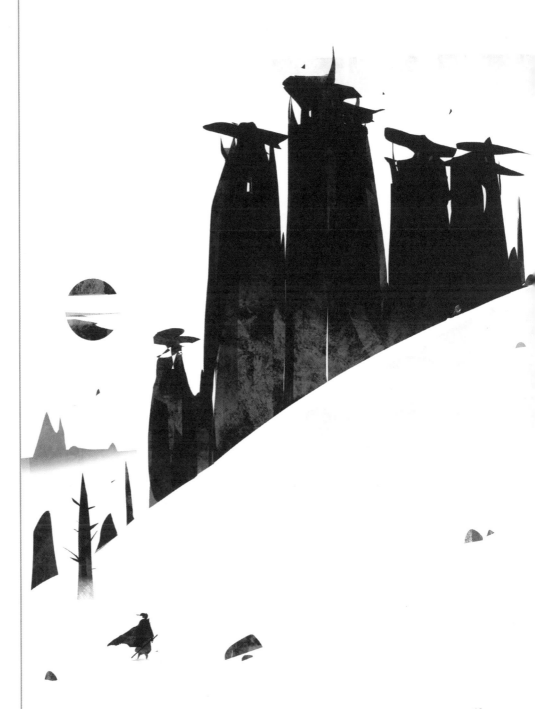

Amaral, Carlos

artofamra.com

All images © Carlos Amaral

Drawing is something I've done as far back as I can recollect – perhaps since I was able to hold a pencil or pen. There was never a dull moment as long as I had those and some paper. Unfortunately, like most other children, my love for drawing started fading with time, as it wasn't and isn't something that the majority of people encourage or see a future in. But thankfully, in my late teens, my love for art rekindled with a newfound purpose: to make a living from it. This started my self-taught journey. Around that time, my passion for fantasy art surfaced; I discovered the work of my now-favorite artists and was properly introduced the masterful works of J.R.R. Tolkien and Robert E. Howard, as well as the incredible big-screen adaptations of their works: *The Lord of the Rings* and *Conan the Barbarian*. Since then, fantasy creatures and heroic characters have been my favorite subjects to put to paper, or to pixels!

INSPIRATION AND IDEAS
◇◇◇◇

Being raised in a small countryside village in Portugal allowed for constant contact with nature. Nature so closely relates to the love of art and is without a doubt a predominant source of inspiration for any artist. Such a perk compensated for the other inspiring things I lacked access to growing up.

Nature remains one of my biggest wells of inspiration, alongside art in any form, be it my favorite films, books, games, music, sculptures, or simply my favorite concept-art and illustration peers and masters from the present and past. My most significant artist inspirations are Adrian Smith, Paul Bonner, Alan Lee, Frank Frazetta, and my good friend Daniel Zrom, among too many others to name here.

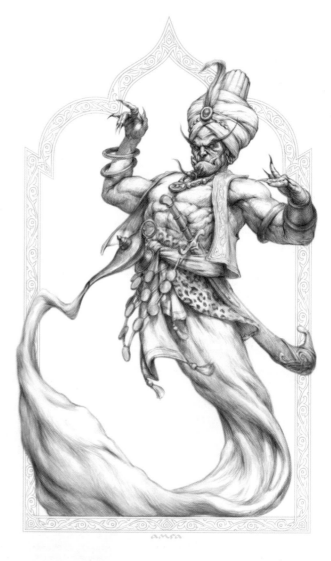

THIS PAGE: "You have two wishes left." This drawing was done with the intention of making it a 3D model. I wish it had happened!

MATERIALS
◇◇◇◇

Up until recently, my work has been mostly created with Adobe Photoshop. Now my current "weapon" of choice to create board-game miniature concepts is the good old graphite pencil. More specifically, I use a 0.5 mm mechanical pencil with 2B graphite lead. But I do like to draw and experiment with many different mediums and art forms, digital or traditional, from ballpoint pens to watercolors to sculpting, though I have yet to dive deeper into exploring other traditional painting mediums besides watercolors.

TECHNIQUES
◇◇◇◇

I draw differently depending on the mood and task. Sometimes I sketch freely without any specific idea in mind and see where my hand takes me; other times I give a little more thought before I start. Most often I do a mix of both and create rough thumbnails or a base that I then take to a higher level of finish. I enjoy rendering my drawings with small lines around and across the forms; it takes time but it's one of the steps I enjoy the most, along with detailing and thumbnailing.

THIS PAGE: Almost every time I draw a character, a story comes up in my head. In this case, it was a little poem, starting with "If you hear his squeak, you ought to run quick…"

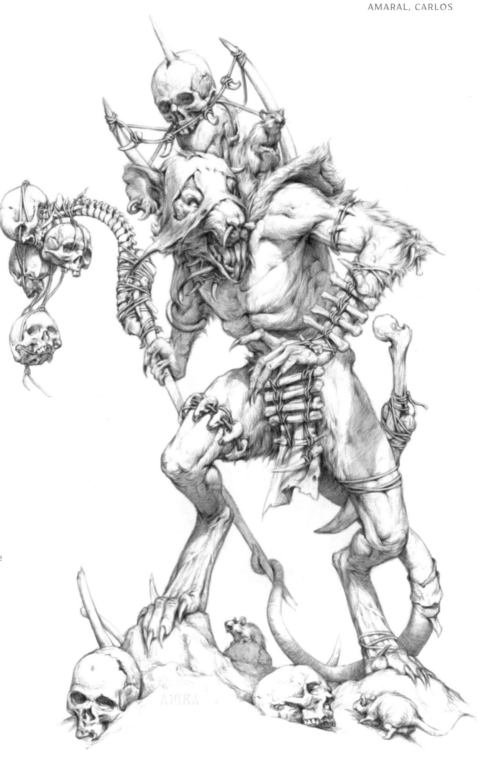

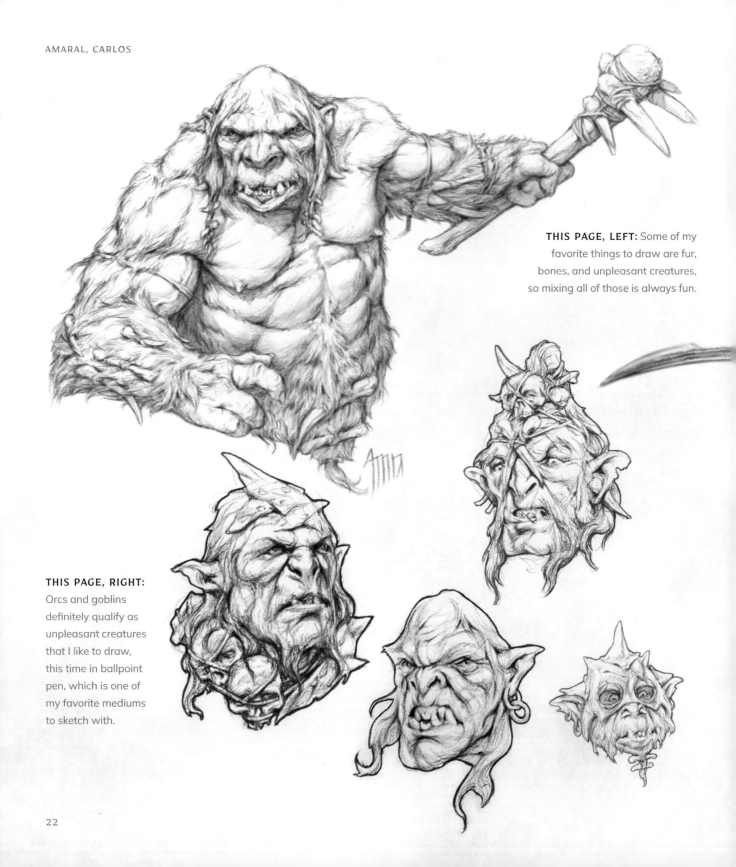

THIS PAGE, LEFT: Some of my favorite things to draw are fur, bones, and unpleasant creatures, so mixing all of those is always fun.

THIS PAGE, RIGHT: Orcs and goblins definitely qualify as unpleasant creatures that I like to draw, this time in ballpoint pen, which is one of my favorite mediums to sketch with.

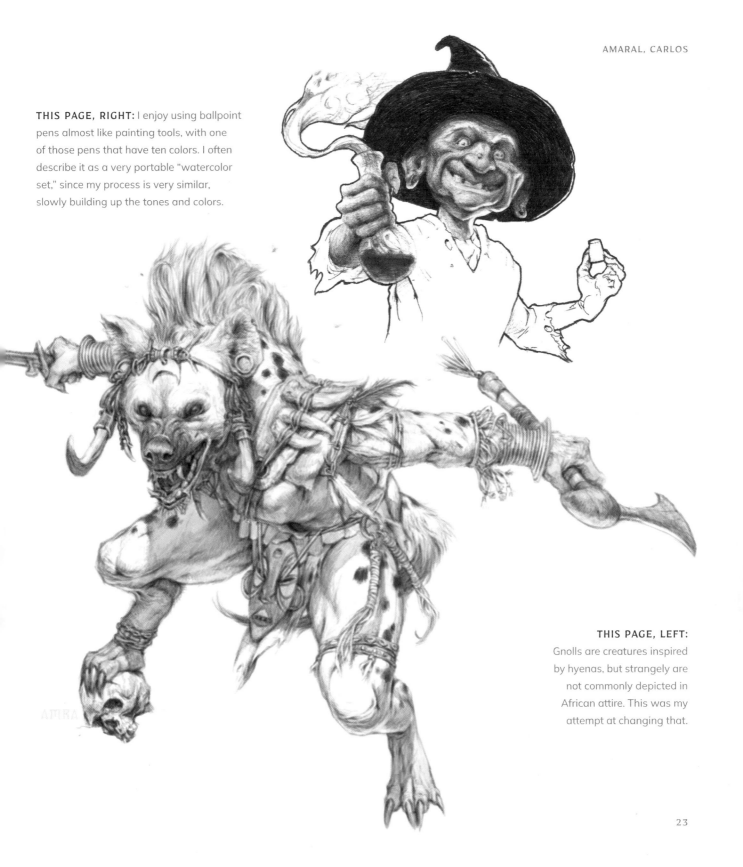

THIS PAGE, RIGHT: I enjoy using ballpoint pens almost like painting tools, with one of those pens that have ten colors. I often describe it as a very portable "watercolor set," since my process is very similar, slowly building up the tones and colors.

THIS PAGE, LEFT: Gnolls are creatures inspired by hyenas, but strangely are not commonly depicted in African attire. This was my attempt at changing that.

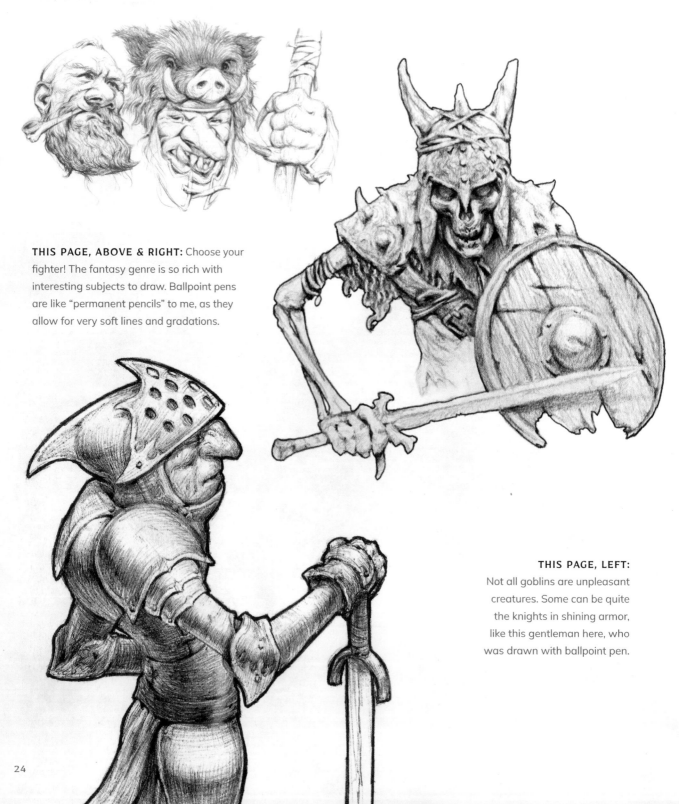

THIS PAGE, ABOVE & RIGHT: Choose your fighter! The fantasy genre is so rich with interesting subjects to draw. Ballpoint pens are like "permanent pencils" to me, as they allow for very soft lines and gradations.

THIS PAGE, LEFT:
Not all goblins are unpleasant creatures. Some can be quite the knights in shining armor, like this gentleman here, who was drawn with ballpoint pen.

THIS PAGE, BELOW: Even though all mediums can be fun in their own way, the pencil is probably still my favorite. As they say, "There's no love like the first."

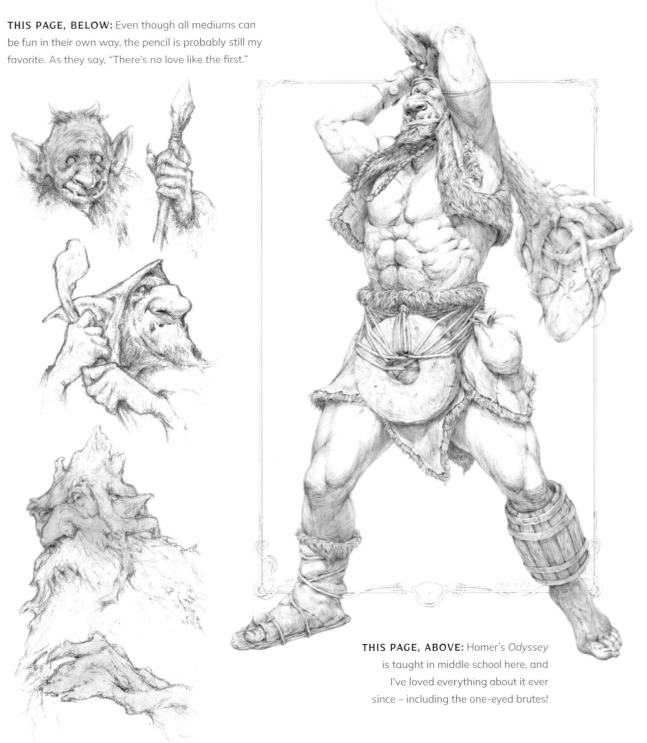

THIS PAGE, ABOVE: Homer's *Odyssey* is taught in middle school here, and I've loved everything about it ever since – including the one-eyed brutes!

Avelino, Cindy

cindyworks.com

All images © Cindy Avelino

I have had a passion for drawing creatures and monsters since I was a child, maybe because I was inspired by the cartoons and games of that time. I remember drawing a different monster almost every day! Nowadays I have the opportunity to work creating more characters and letting my imagination run wild.

INSPIRATION AND IDEAS

Games like *The Legend of Zelda*, *Tibia*, *World of Warcraft*, and *Pokémon* inspire me, as well as movies such as *Kung Fu Panda*. I also enjoy reading history books and imagining what those periods of time were like. My inspirations aren't too deep – just doing stuff I love and enjoying life!

MATERIALS

I use a lot of colored pencils and a black pen (a Uni Pin fineliner) to practice anatomy, perspective, and design in my sketchbook. For work, I use a Wacom Cintiq 22 and Adobe Photoshop 2022, but I would like to get back into using colored pencils for finished illustrations again. It's hard but very fun, and I love using them!

TECHNIQUES

I like to sketch and hatch a lot. I also love making a simple painting over a sketch and adding colored hatching to it. I want to develop more interesting ways of using lines to fill the drawing space.

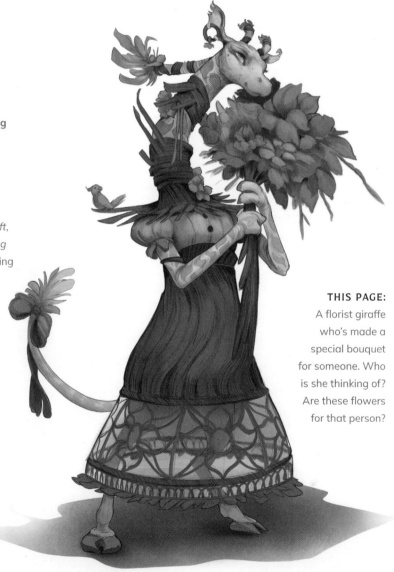

THIS PAGE:
A florist giraffe who's made a special bouquet for someone. Who is she thinking of? Are these flowers for that person?

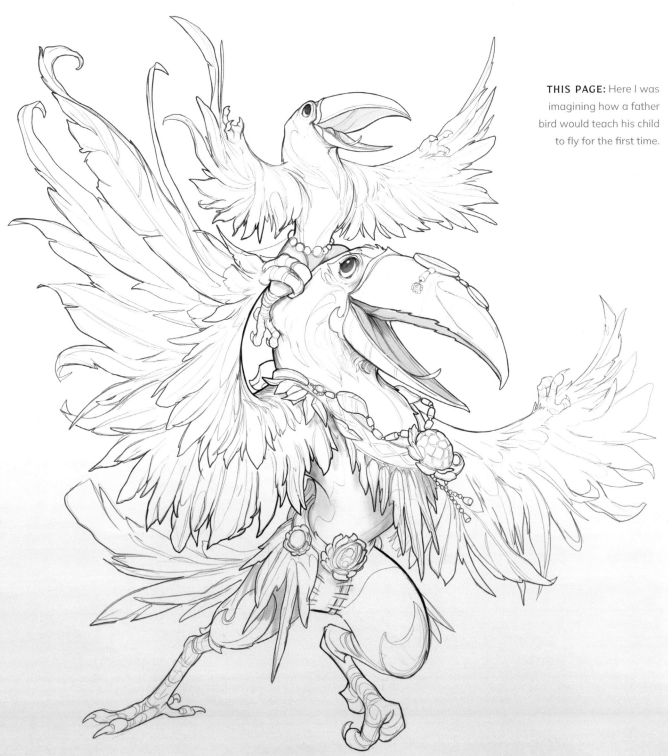

THIS PAGE: Here I was imagining how a father bird would teach his child to fly for the first time.

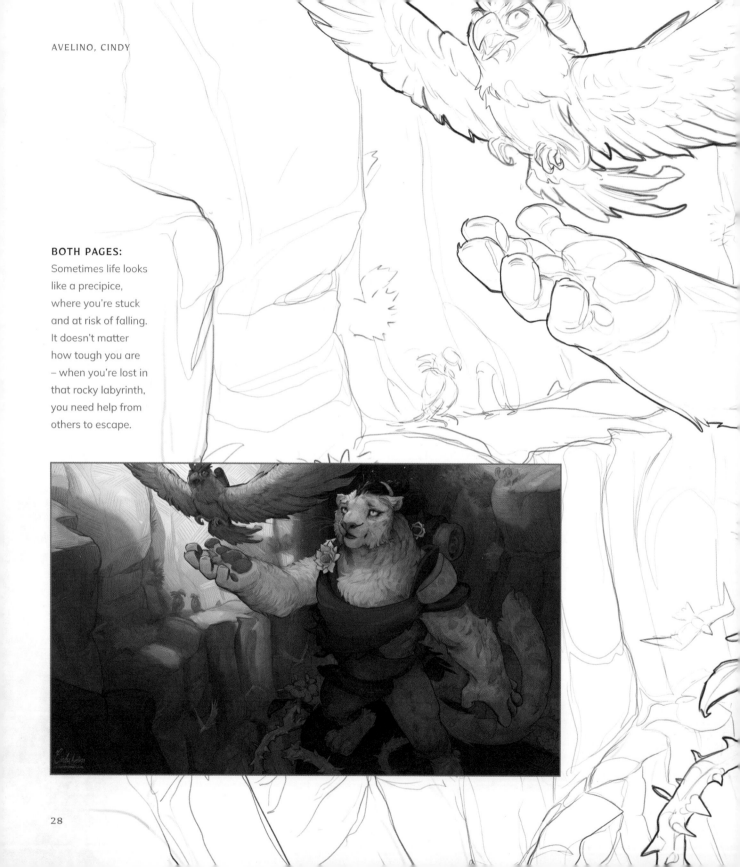

BOTH PAGES:

Sometimes life looks like a precipice, where you're stuck and at risk of falling. It doesn't matter how tough you are – when you're lost in that rocky labyrinth, you need help from others to escape.

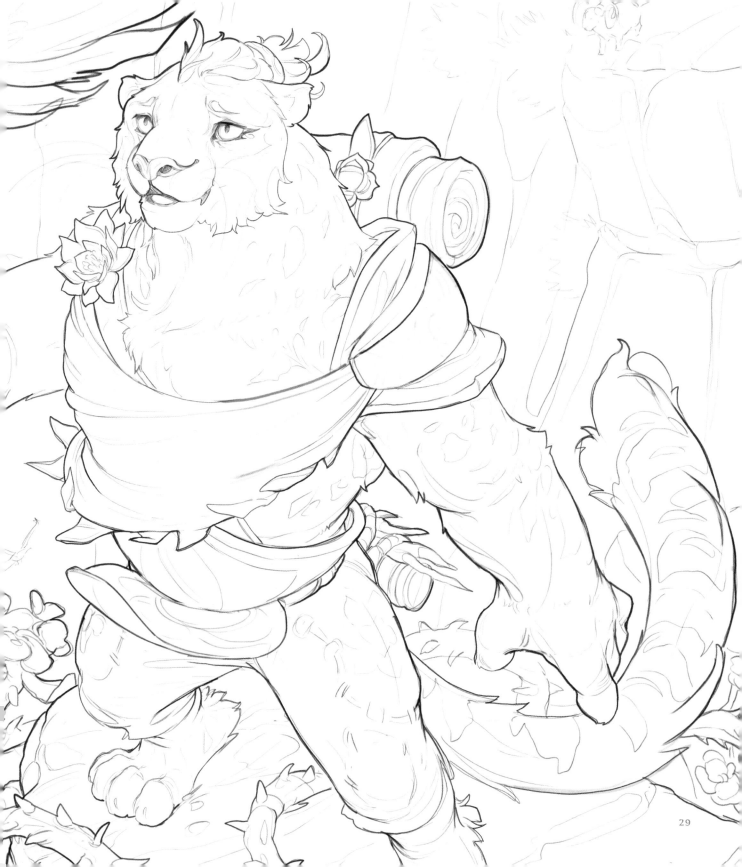

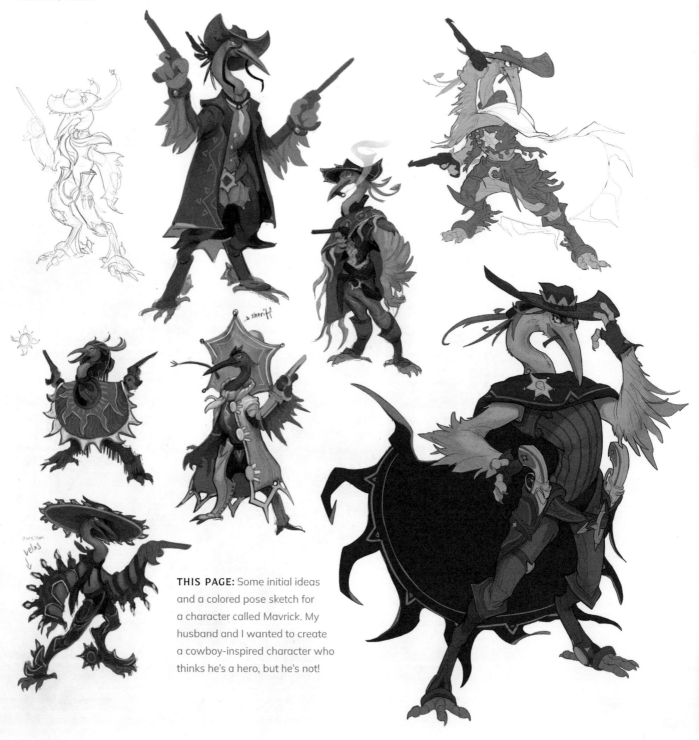

THIS PAGE: Some initial ideas and a colored pose sketch for a character called Mavrick. My husband and I wanted to create a cowboy-inspired character who thinks he's a hero, but he's not!

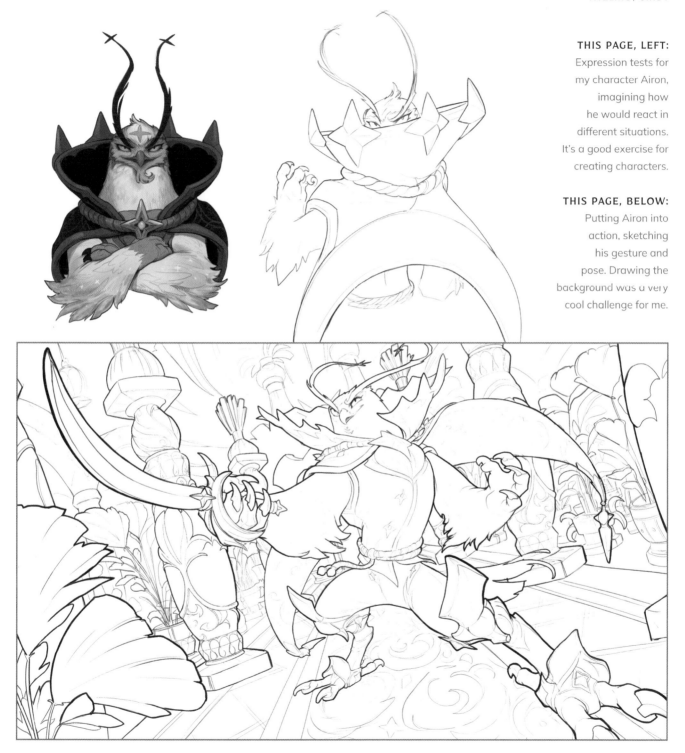

AVELINO, CINDY

THIS PAGE, LEFT:
Expression tests for my character Airon, imagining how he would react in different situations. It's a good exercise for creating characters.

THIS PAGE, BELOW:
Putting Airon into action, sketching his gesture and pose. Drawing the background was a very cool challenge for me.

Azevedo, Carol

carolazevedo.myportfolio.com

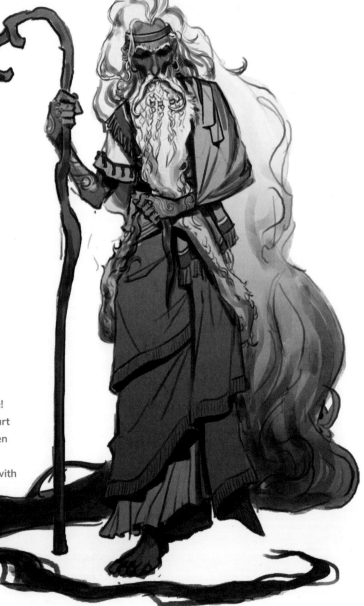

I have always been especially interested in people and their cultures. Ever since I was a child I was surrounded by literature on Ancient Egyptian and Greek mythology. We all start somewhere! Although I adore other times, like the medieval period or the 1920s, discoveries and stories about the ancient world have always particularly caught my attention.

I believe this initial contact is what opened the gates to all my further interests. I think there is something amazing in looking back at human history and finding the source of our superstitions, how we used "magic" to cure ailments, and how we came up with creation myths that so often share similarities with one another. I recommend this exercise if you are ever so inclined to try.

As far as sketching goes, I have always been that kid who has drawn for as long as they can remember. However, it was only later that I thought about marrying my love of mythology and history with art. I am not sure if I can say anything new about sketching that hasn't been said before! It is every artist's first contact with the process of making art and it will be ever present in our lives. It is exhilarating when you see an idea translating well or even transforming into something better by a happy accident. Maybe the novelty with sketching, for me, is that I feel weirdly anxious when sketching idly; I need a clear subject or a purpose, or else nothing comes out.

INSPIRATION AND IDEAS
◇◇◇◇

Inspiration can come from anywhere for me. Sometimes I will look into a single object and an idea will strike fully formed inside my brain. When that doesn't happen, I go off to look at books, photography, films, and art. I try to fill my brain with new knowledge and revisit old favorites in order to spark new ideas.

Recently I have been listening to a lot of history and mythology podcasts. They are an amazing companion during my work hours, with the advantage of fulfilling my nerdy need for the ancient times.

MATERIALS
◇◇◇◇

Ironically, I cannot remember the last time I really picked up my sketchbook. For years I have used my trusty Wacom Cintiq for everything. I always mean to use my sketchbook more, but I am much more comfortable with the quick pace of Photoshop. I like the freedom to edit my sketches as I go.

TECHNIQUES
◇◇◇◇

First and foremost, I will get inspired by something: a piece of artwork, a story, or a moment in time. That inspiration will be my base for the next step: research. I spend a lot of time getting acquainted with my subject before the pen touches the paper. From there I let my brain roam free to use all the knowledge I've gathered: I sketch portraits, scribble notes, and do anything else I need to get the idea across. After this first wave is done, I jump into more straightforward steps: concepts, iterations, colors, and finals.

I tend to focus on one piece of the design that I want to be the focal point and work around it. That helps keep the drawing from feeling overcrowded. Most of the sketches here are for a slow-going project I started in 2022 about the Epic of Gilgamesh. I hope I can finish them soon, but for now I am enjoying the process.

BOTH PAGES: The flood survivor and immortal Utnapishtim. It was important to sketch these with color in mind; I wanted to showcase his long hair, graying from the years lived, and use plenty of blue to associate him with water.

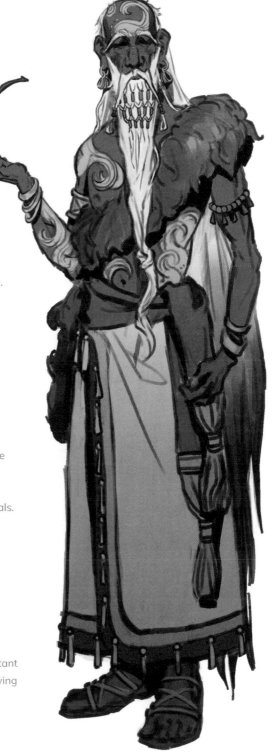

THIS PAGE, TOP:
These designs were a fun exercise. I had just watched an amazing video about the Minoans and felt inspired! I put a lot of effort into matching these heroes with exciting images of Minoans.

MOODBOARDS

Researching and creating a moodboard are probably the most important parts of a project for me. It's the stage when I organize my thoughts and decide which elements fit within the character's role. As you can already tell, I am big on research! You know that "80/20 rule" people talk about? It's 80% research and 20% creation for me.

THIS PAGE, RIGHT:
More designs from my Gilgamesh project. The first on the left is my chosen design for a young Gilgamesh. Still a long way to go for the final!

OPPOSITE PAGE:
A weird little idea I had of Rapunzel as a Minoan witch. She cuts the hair of brave young men to grow her power.

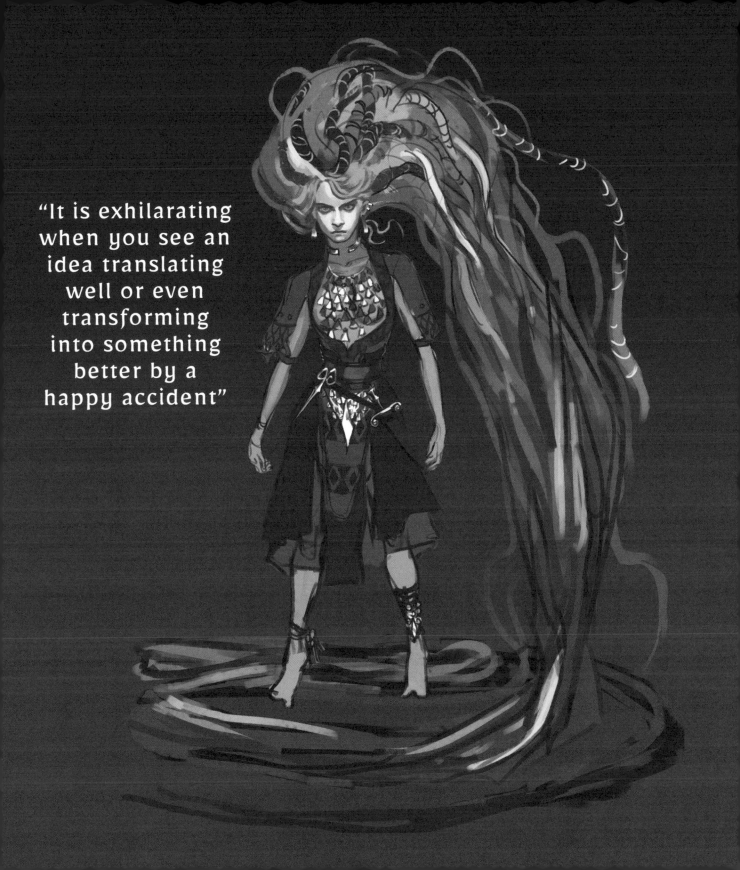

"It is exhilarating when you see an idea translating well or even transforming into something better by a happy accident"

THIS PAGE: Sometimes I cannot fight the urge to pick one design and jump ahead a couple of steps!

OPPOSITE PAGE: This is the very first step of my drawing process. I tend to write a lot of notes to myself here.

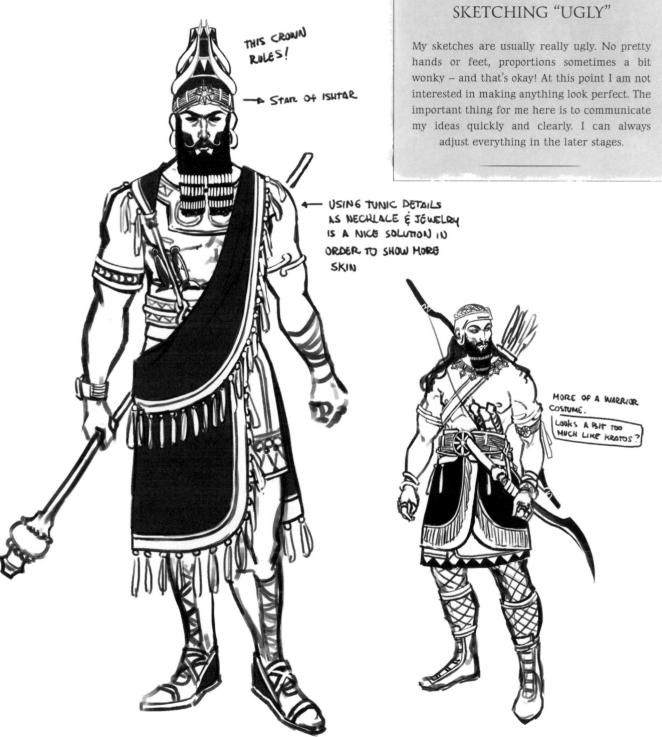

THIS CROWN RULES!

A STAR OF ISHTAR

USING TUNIC DETAILS AS NECKLACE & JEWELRY IS A NICE SOLUTION IN ORDER TO SHOW MORE SKIN

MORE OF A WARRIOR COSTUME.

LOOKS A BIT TOO MUCH LIKE KRATOS?

SKETCHING "UGLY"

My sketches are usually really ugly. No pretty hands or feet, proportions sometimes a bit wonky – and that's okay! At this point I am not interested in making anything look perfect. The important thing for me here is to communicate my ideas quickly and clearly. I can always adjust everything in the later stages.

Beauregard, Francois

deviantart.com/built4ever | facebook.com/Built4ever

All images © Francois Beauregard

As a youngster I spent some of my spare time drawing cars, military stuff, *Star Wars* spacecraft, and more. I was raised on car culture and rock and roll, tempered by a Catholic-school education. It was clear to all my classmates that I had advanced artistic aptitudes. By the age of ten, I thought that a career in architecture might be my life plan. I studied art and art history in both high school and at university.

While holding several sales positions in my twenties, the urge to draw kept reasserting itself, and I started drawing historic homes as a hobby. My skills increased, and eventually I began sketching original designs. Meanwhile I learned some basic construction skills, especially woodworking and carpentry. I settled in Greenville, South Carolina, did construction work on million-dollar homes, and eventually started drawing actual plans for homes in 2007. I found out that it wasn't necessary in my area to have an architecture degree to draw plans. From 2007 to the present, I have designed dozens of custom homes throughout the United States, many of which have been built.

I have also created work as an illustrator and a concept artist, as my architectural drawings became known and reposted across the internet. My clients have included authors, game companies, other architects, and role-playing games, especially *Dungeons & Dragons*. I also taught myself the fine art of 3D modeling. Over time I became a designer of both real and imagined buildings, towns, castles, villages, and cottages, as well as detailed custom home plans – always hand-drawn!

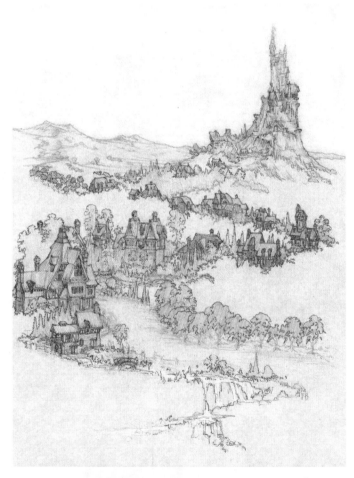

THIS PAGE: *Castle and Village of Cascadium.*

OPPOSITE PAGE: *Clifftop Village.*

INSPIRATION AND IDEAS

The beauty, permanence, form, and detailing of traditional architecture is unsurpassed! From 500-year-old villages, to Gothic cathedrals, to ancient ruins, to nineteenth-century cities, our modern civilization cannot even come close to building what was built in the past. Old buildings have a life and soul that is a delight to the eye and a pleasure to live and work in. I studied eighteenth- to twentieth-century watercolorists, architectural drawing and illustration, and twentieth-century home design. I learned how to draw by sitting on the street and sketching old houses!

MATERIALS

Ninety-nine percent of my drawing is executed using Faber-Castell 9000 series pencils, usually grades 2H, H, and HB; sometimes lighter than 2H. Rarely, I use 2B or softer, which tends to smudge easily. I keep them sharp for fine linework. Later I might add black ink, white watercolor highlights on toned paper, and sometimes full-color watercolor. I tend to start with very light sketching in 2H, and once corrected and satisfied, I darken and add details until the drawing "says what it needs to say; nothing more, nothing less."

TECHNIQUES

I draw on and off in the morning until the evening, taking breaks for snacks and exercise. Sometimes I use a few photos for rough inspiration, sometimes nothing at all. I concentrate on the architectural massing and "roofscape" of castles, villages, city skylines, and individual homes. I box out 3D geometric forms in perspective, from bird's-eye angles or from the ground or street level. Later I add details such as window and door openings, arch styles, dormers, and roof forms, followed by the surrounding landscape, including trees, orchards, gardens, shrubs, boulders, hills, mountains, and water features. Gentle shading gets worked in near the end.

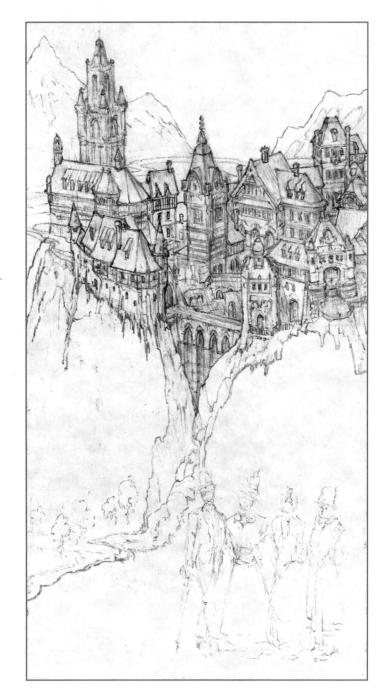

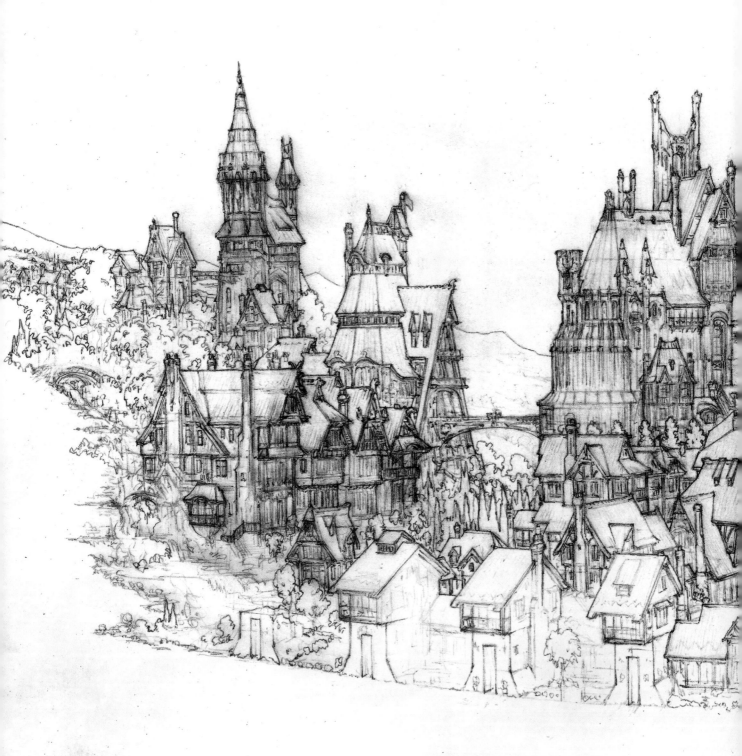

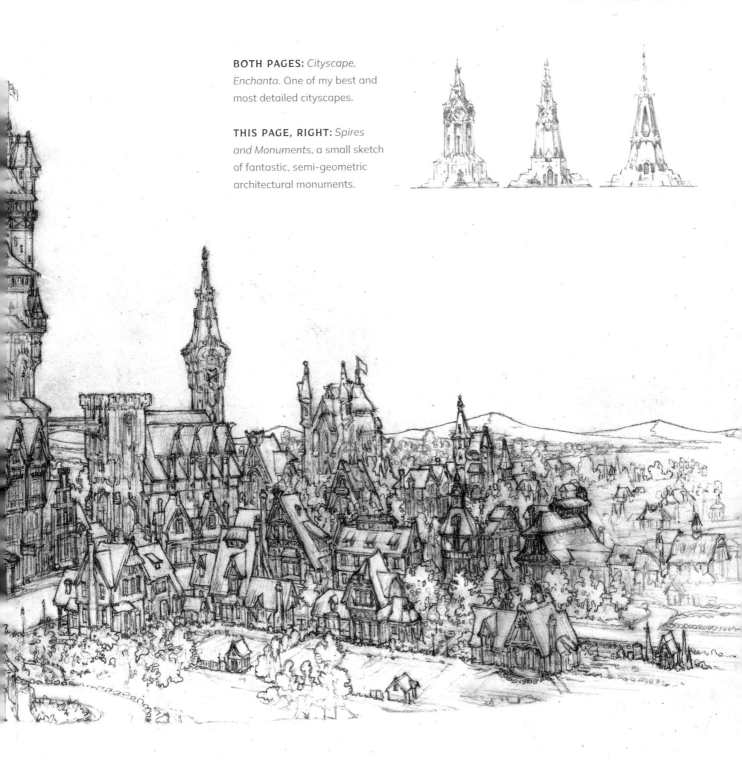

BOTH PAGES: *Cityscape, Enchanta.* One of my best and most detailed cityscapes.

THIS PAGE, RIGHT: *Spires and Monuments*, a small sketch of fantastic, semi-geometric architectural monuments.

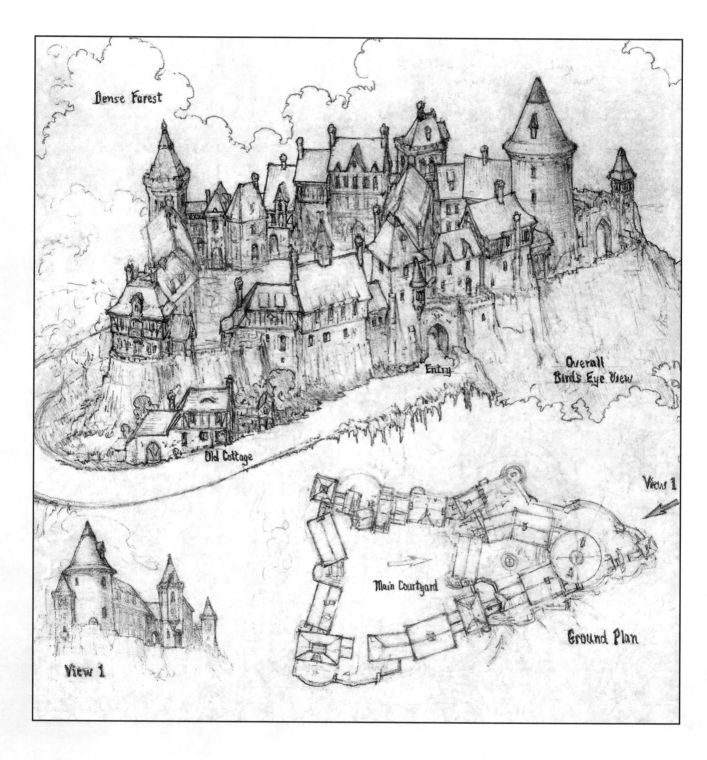

Dense Forest

Overall
Bird's Eye View

Entry

Old Cottage

View 1

View 1

Main Courtyard

Ground Plan

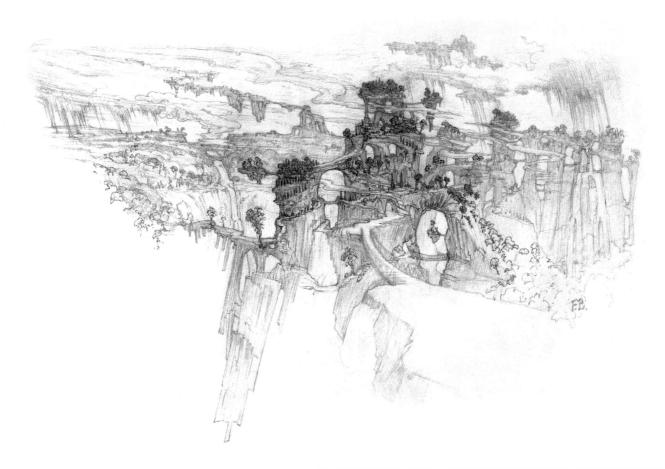

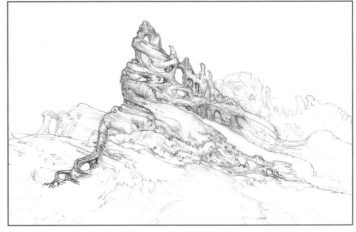

OPPOSITE PAGE: *Sumava Krasna*, a village built on a castle ruin, including a bird's-eye view, ground plan, and a small perspective view.

THIS PAGE, ABOVE: A more fantastical, surreal landscape scene.

THIS PAGE, RIGHT: *Unusual Landscape*, a small, gently shaded pencil sketch of bizarre fantasy rock formations.

Benavides, Christian

voyagerillustration.com

All images © Voyager Illustration

I'm an illustrator from Medellín, Colombia. My biggest creative growth came when I decided to travel and apply my life experiences to my art: from encounters with indigenous and artistic traditions around South America, to working and studying at The Animation Workshop in Denmark, to practicing Tibetan thangka art in the Himalayas. After years of traveling and self-learning, I modified my style and technique to what it is today.

I create images under the name of "Voyager" – a traveler of time and space. The art I create represents this internal and external journey. To me, art works as a tool for the integration of ideas, dreams, and values I want to apply in my life. It's a journey with the intention of learning new ways and perceptions of life, and therefore new ways of representing visual ideas.

INSPIRATION AND IDEAS
◇◇◇◇

I really enjoy mystical, spiritual, and philosophical topics and experiences, so I do a lot of research into those matters. But, to me, the most important thing is experience. When we experience something, it becomes wisdom – wisdom we can apply and put into practice. We don't just know it in our mind, but with our whole being. When something is only theoretical information, it lacks the capacity to manifest, so the mystical and surreal inspirations for my work originate mainly from real experiences I have had. This is the research I'm doing for my own self and spiritual growth, and this is what I integrate into my artwork.

MATERIALS
◇◇◇◇

I enjoy using ink pens and watercolors, but I mainly work digitally in Clip Studio Paint. My style has a strong emphasis on line art, and this software offers plenty of advantages that make the drawing process smoother. Filling the line art with a paint bucket is an easy method that has saved me so much time. Clip Studio Paint also enables me to use vector and pixel layers.

TECHNIQUES
◇◇◇◇

My process can be divided into sketching, creating line art, adding flat colors, and finally adding volume and light/shadow details. I always go for complementary color combinations and I like to saturate them a lot. Depending on the mood of the scene, I give more importance to a color that better resembles the feeling I want to convey. Then I add a complementary color that gives some contrast to the scene and directs attention to the focal point. In my workflow, I apply the base tones of the objects or elements of the scene, then add temperatures of color in the shadows and the light. This makes the artwork pop.

OPPOSITE PAGE: An image published in *Zen'nō*, written by Karen Andrea Reyes, for Ediciones Vestigio (edicionesvestigio.com | instagram.com/edicionesvestigio).

THIS PAGE: The awakened warrior found three poisons inside himself and undertook a fierce battle within to purify them.

 猫鬼仏

"To me, art works as a tool for the integration of ideas, dreams, and values I want to apply in my life"

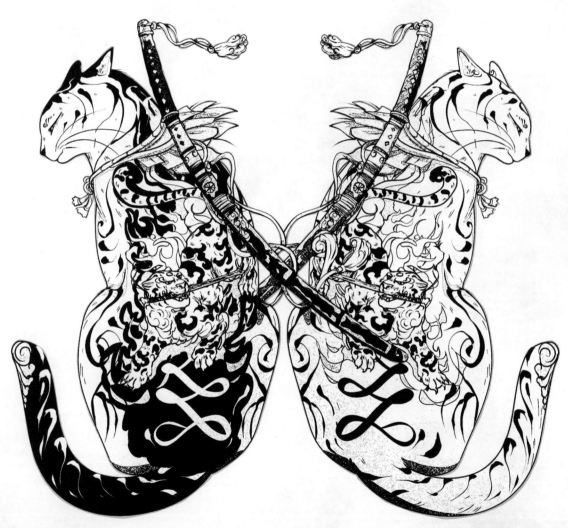

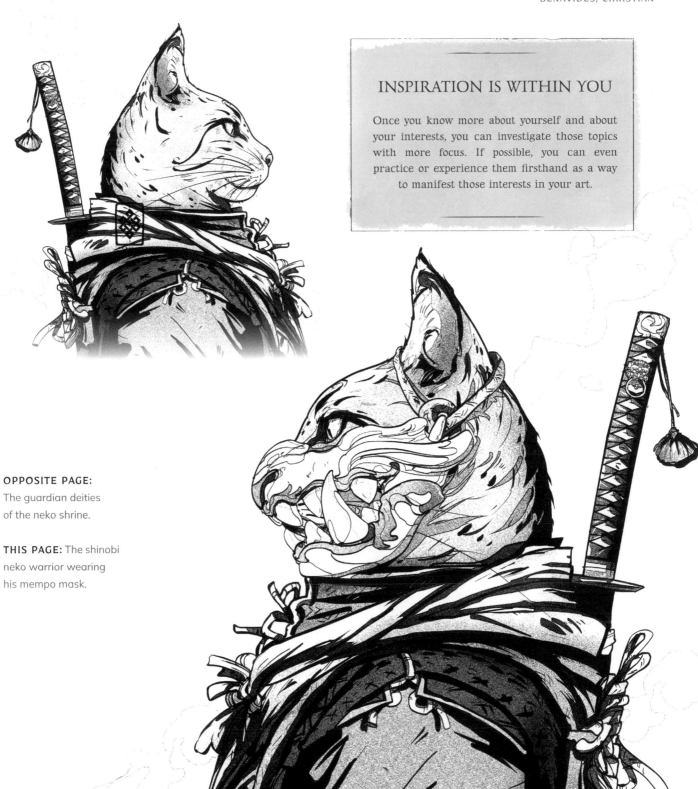

INSPIRATION IS WITHIN YOU

Once you know more about yourself and about your interests, you can investigate those topics with more focus. If possible, you can even practice or experience them firsthand as a way to manifest those interests in your art.

OPPOSITE PAGE:
The guardian deities of the neko shrine.

THIS PAGE: The shinobi neko warrior wearing his mempo mask.

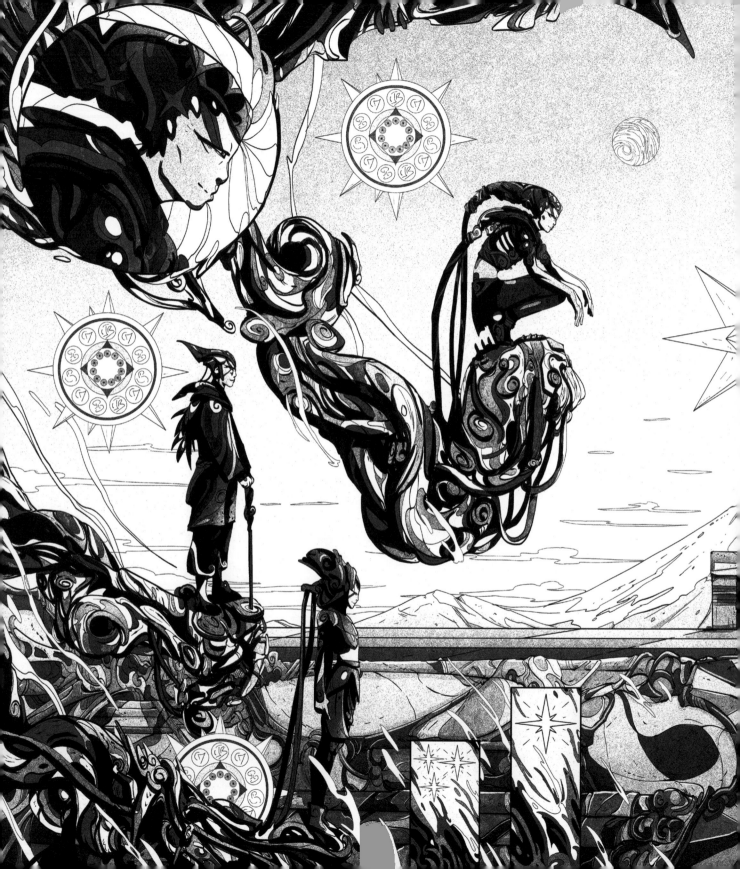

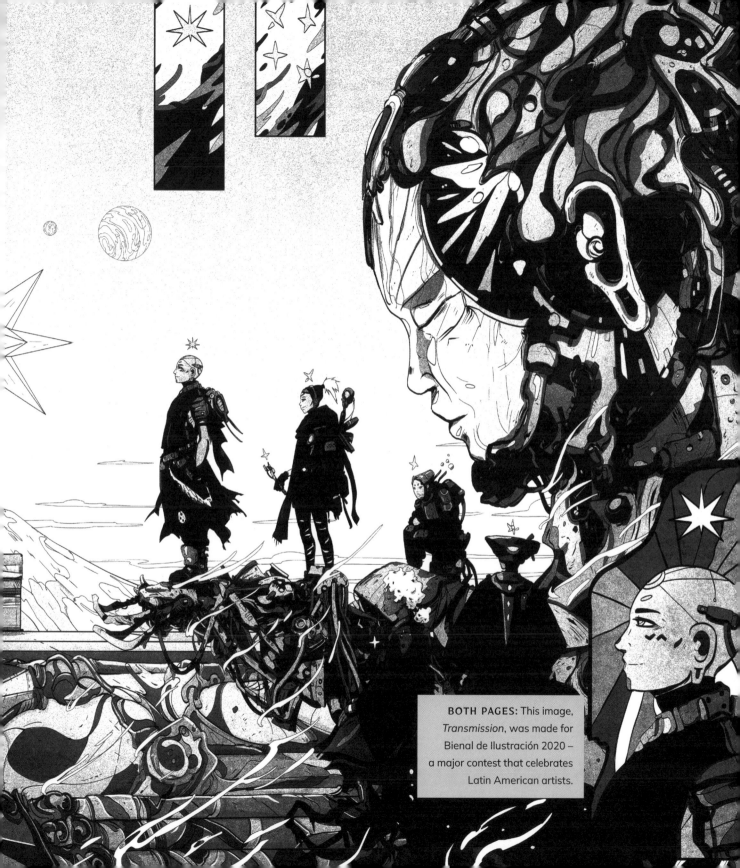

BOTH PAGES: This image, *Transmission*, was made for Bienal de Ilustración 2020 – a major contest that celebrates Latin American artists.

Blight, Davi

artstation.com/daviblight

All images © Davi Blight

I grew up with a love for video games and fantasy movies from a very young age, and that has never left me. The main fuel that got me into making art was designing characters for the worlds of which I was a fan. Over time, I got into the habit of creating my own projects and worlds to explore, such as the examples I'm sharing here! That passion for fantasy design led me to working in video games and related industries for fifteen years.

I currently work at Hi-Rez Studios, which has some amazing properties that are inspired by mythological and fantasy settings. I was recently able to design Morgan Le Fay and Atlas for the *Smite* property. It was a ton of fun being able to pull from my own inspirations as well as diving deep into the lore of what makes those myths great.

INSPIRATION AND IDEAS
◇◇◇◇

I am inspired by many things, but I often think of a setting first and then extrapolate a series of characters to fit in it. An easy method for me is to create a lineup to make sure there's diversity in the designs throughout multiple characters. I look to game design, films, and stories for references of archetypes I may want to fill or character tropes that may be fun to explore. I often take simple objects or concepts, such as "pottery people," and see how far I can go with them – which, truly, is probably forever!

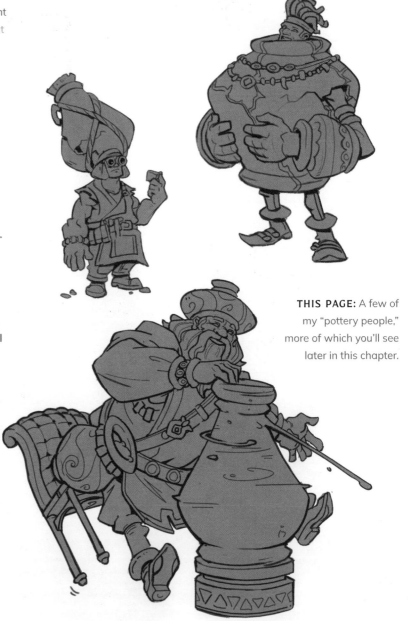

THIS PAGE: A few of my "pottery people," more of which you'll see later in this chapter.

50

MATERIALS

I make most of my art on a Wacom
Cintiq with Adobe Photoshop, but once
a week I will take my iPad and work in
Procreate at my local coffee shop. As a
work-from-home artist, getting out once
in a while to do art is great for my psyche.

TECHNIQUES

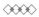

One of my daily habits is to write in
a notebook dedicated to ideas and
mind-mapping. Later, after work, I can
pull from my lists to create new and
original characters. It has helped me
to be consistent in both coming
up with ideas and having
an easy source to pull from
when I want to sketch.

I tend to create lots of very
rough, ugly thumbnails. I do
this primarily by creating
large silhouettes or shapes
with a few values. Once
I find some that I enjoy, I
then draw directly over those
shapes to find the "real" designs.

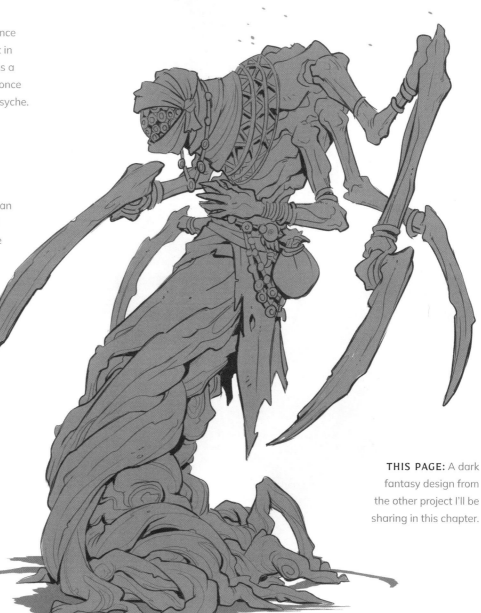

THIS PAGE: A dark
fantasy design from
the other project I'll be
sharing in this chapter.

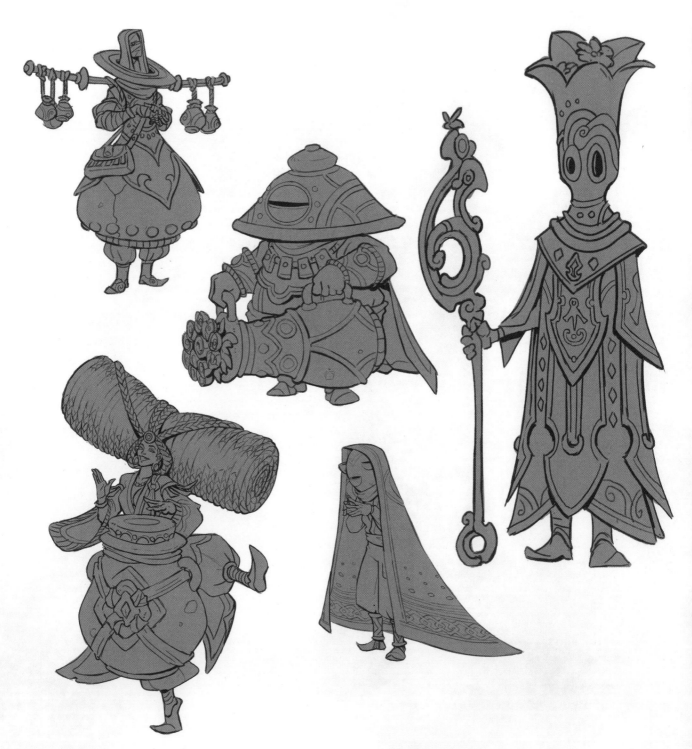

BOTH PAGES: I've spent a lot of my time working on video games with characters who fight each other, so this personal project was aimed at exploring a series of fun characters that are generally less aggressive and have very different quirks.

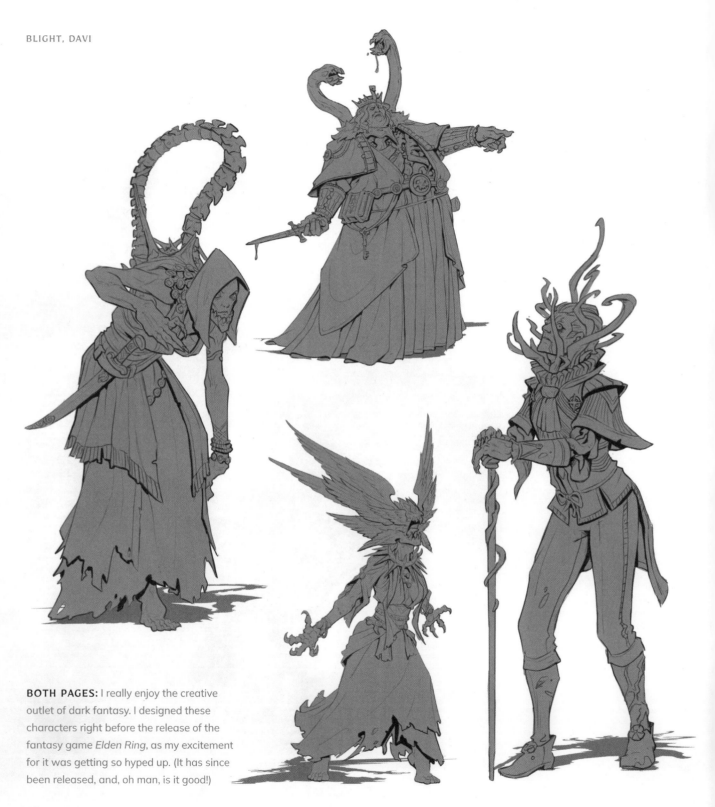

BOTH PAGES: I really enjoy the creative outlet of dark fantasy. I designed these characters right before the release of the fantasy game *Elden Ring*, as my excitement for it was getting so hyped up. (It has since been released, and, oh man, is it good!)

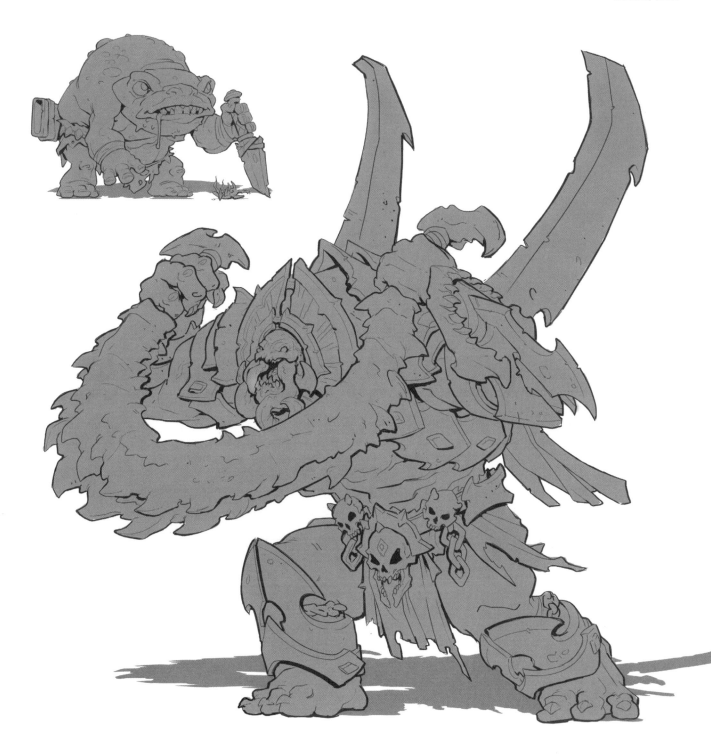

Corsi, Candida

candidacorsi.com

I started drawing when I was very young. I studied fine art in my hometown in southern Italy, but, before finishing my academic studies, I changed my mind and enrolled in the Faculty of Communication Sciences at the University of Urbino, where I studied visual and narrative communication. I became a professional artist and now I combine all of my different study experiences in my work. However, drawing is not just a job for me. Drawing is my connection to the world and to other people – a direct and privileged link that can quickly be accessed through the pencil (or its digital counterpart). I think that sketching is the fastest way to shape ideas that are so volatile and elusive.

My favorite genre is fantasy, which I like to infuse with a bit of surrealism to create magical suggestions that speak to the subconscious of viewers of all ages. In character design, I also like to develop the psychology of the characters, and this makes the connection between the artwork and the viewer even more complex and interesting. Drawing from the imagination, and not just from reality, is an intense mental activity that helps me scrutinize the unknown and represent the nonexistent.

INSPIRATION AND IDEAS
◇◇◇◇

For me, inspiration often comes from dreams. Even when I have to follow the briefing of an art director, I have my own "dream pool" from which I get the visual ideas that I need. Drawing your dreams is a great way to know yourself.

I also take inspiration both from other fantasy artists and from the symbolic representations belonging to thousands of cultures that populate this world. In my head, inspiration already comes as an image, so all I have to do is transfer it to paper or tablet. This is not quite easy, but it is necessary.

THIS PAGE: Fantasy characters take their work very seriously. This tailor's work is everything to him and he always goes around with his tools and a pile of cloth on his back. From my *Entitae* project.

MATERIALS
◇◇◇◇

When it comes to sketching quickly to explore or pin down ideas, the pencil is all I need. It is fast, powerful, portable, and cheap. But when it comes to making finished work, digital is indispensable, because you cannot get the same quantity and quality of work with watercolors or acrylics.

However, I think it is important to use traditional tools such as acrylics, oil pastels, and gouache, to achieve unique, one-off pieces that cannot be reproduced.

TECHNIQUES
◇◇◇◇

My technique is a kind of "dark light," both in traditional and digital drawings. When I want to make a finished full-color illustration for printing, all I do is apply color gradients to the grayscale images with the Clipping Mask tool in Adobe Photoshop.

When I want to make a colored image without it looking too finished, especially for personal work, I make a pencil sketch, scan it with Photoshop, and apply a single color gradient from bottom to top or vice versa, or from the center to the edges. I then highlight the points of light with white, and shadow with a faint black. I can also do the same thing with traditional techniques directly over a pencil drawing using watercolors or gouache.

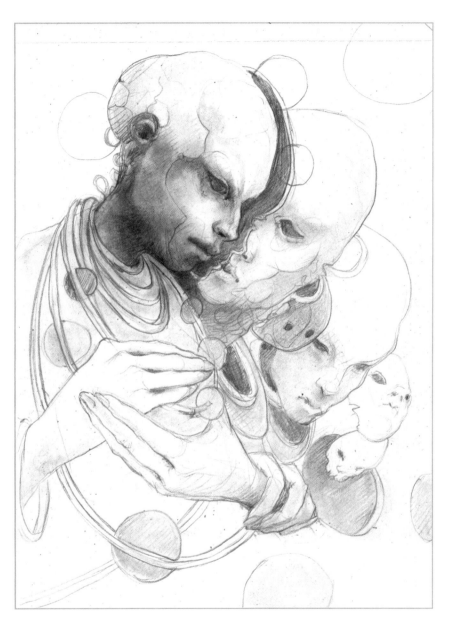

THIS PAGE: A drawing from a dream. I was probably in love that night.

"Drawing your dreams is a great way to know yourself"

THIS PAGE: A special ink for special drawings...

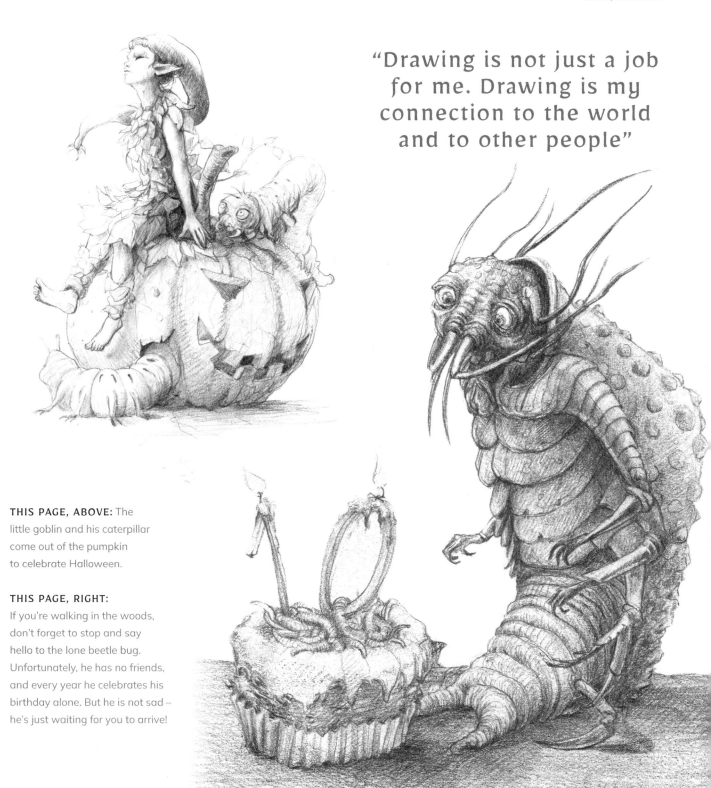

"Drawing is not just a job for me. Drawing is my connection to the world and to other people"

THIS PAGE, ABOVE: The little goblin and his caterpillar come out of the pumpkin to celebrate Halloween.

THIS PAGE, RIGHT:
If you're walking in the woods, don't forget to stop and say hello to the lone beetle bug. Unfortunately, he has no friends, and every year he celebrates his birthday alone. But he is not sad – he's just waiting for you to arrive!

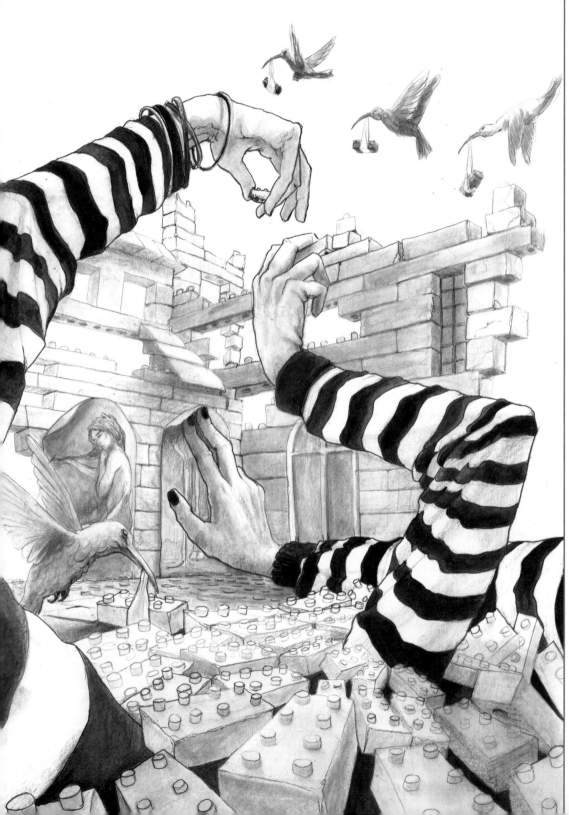

THIS PAGE: Strange alien hands reconstruct the museum of my city (Complesso San Domenico, Forlì), helped by hardworking hummingbirds.

OPPOSITE PAGE, TOP LEFT: What would have happened if Alice had told stories to the caterpillar and the caterpillar had sat on her lap, listening to them in admiration?

OPPOSITE PAGE, TOP RIGHT: A drawing from a dream. In a period of intense work as a concept artist, I dreamed of myself as in this drawing.

OPPOSITE PAGE, BOTTOM: These are very high-ranking priestesses who, by their spiritual value, almost completely lose their earthly consistency. From my *Entitae* project.

ADD LIFE TO YOUR LINE ART

Simple line art is the fastest tool for processing ideas, especially in the entertainment industry, but communicating well with lines is not so simple. Transferring an idea from your mind to a drawing can often simplify and flatten it too much, like the solid outlines in a coloring book.

To avoid this, think about the effect of the line on the environment, and vice versa. If you are drawing a "flat" surface, think about the textures that might modify its silhouette: dust, wind, wear, and so on. That boring, continuous line should disappear and give way to something more interesting.

With this approach, much of the work is mental, and you can draw a complex design in a couple of hours. The real challenge is how fast you can think!

Cruz, Raúl

artstation.com/raulcruz
All images © Raúl Cruz

I'm an illustrator and fine artist who is passionate about fantasy and science fiction. I was just another child who drew, played, and imagined like any other. I was in a constant search to give identity to my drawings. One day, unexpectedly, I drew the Aztec god Quetzalcoatl in the form of a spaceship. That day, the concept of my personal work was born, and since then it has become my greatest passion.

In my youth, I dreamed of being a science-fiction artist and participating in large projects. I didn't know that there was no market for sci-fi in my country. Despite always having a lot of work as a commercial illustrator, my clients never asked me for fantasy or sci-fi art, so I made countless illustrations of very varied subjects for commercial and advertising work.

However, the impulse to develop my own ideas was so great and powerful that I continued to create fantasy scenes even when no one was commissioning them. I have developed a considerable amount of work within the genre known as "fantastic art," with different techniques and tools, from the traditional to the most recent digital ones, always combining fantasy and science fiction with the beautiful art of ancient Mayan, Aztec, and other cultures. I have a massive number of sketches ready to be turned into works of art, paintings, sculptures, costumes, and more.

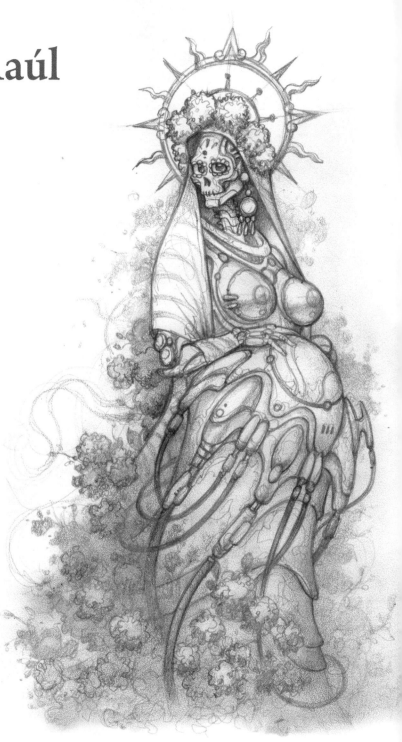

INSPIRATION AND IDEAS

I have many sources of inspiration, from the beautifully random forms of nature, the art of ancient cultures, and the great masters of visual art in human history, to current science and technology, and the creators of fantasy and sci-fi today.

All of this has inspired me to imagine scenes mixing two or more of my favorite themes, a combination that has been the fertile ground where I sow and harvest the ideas that have given my work identity. This is how I dared to be happy doing what I love.

MATERIALS

My main inseparable companions are sketchbooks and a sharpened pencil. I really like to sketch on textured paper with pencil, charcoal, or watercolors. Most of the sketches you see here are made simply with pencil on textured paper. I do my final works mostly with acrylics on canvas, or sometimes with oil paints. I have recently been discovering and experimenting with different pigments, resins, and surfaces.

Currently I work on wood, metal, recycled paper, and my favorite amate paper. It is a surface with a beautiful texture and color, made from tree bark using ancestral techniques of the Mesoamerican peoples.

TECHNIQUES

I try to catch ideas in their wild state, anytime, anywhere, using my sketchbooks and a pencil. The physical and mental freedom allowed by the quick stroke of a sketch lets the concepts flow.

I prefer my final works to be in large formats. Mostly I use acrylic paint diluted with resins to give it a more transparent finish, almost like watercolor, resulting in a beautifully artistic, random texture on the amate paper. I use any type of powder mixed with resins, such as coffee, rust, burned bread, and dried herbs and flowers.

OPPOSITE PAGE: A Day of the Dead-inspired cybernetic entity that represents death in a state of pregnancy – the paradox of the circle of life.

THIS PAGE: A robot lizard seeking warmth for its system, perched on a floating Olmec head.

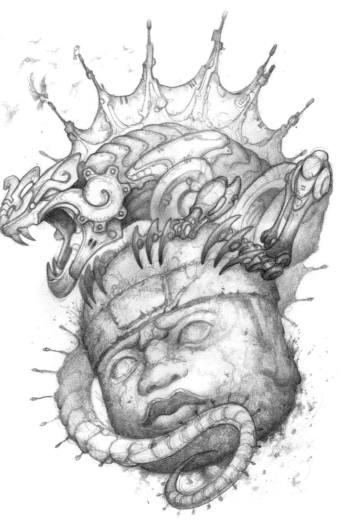

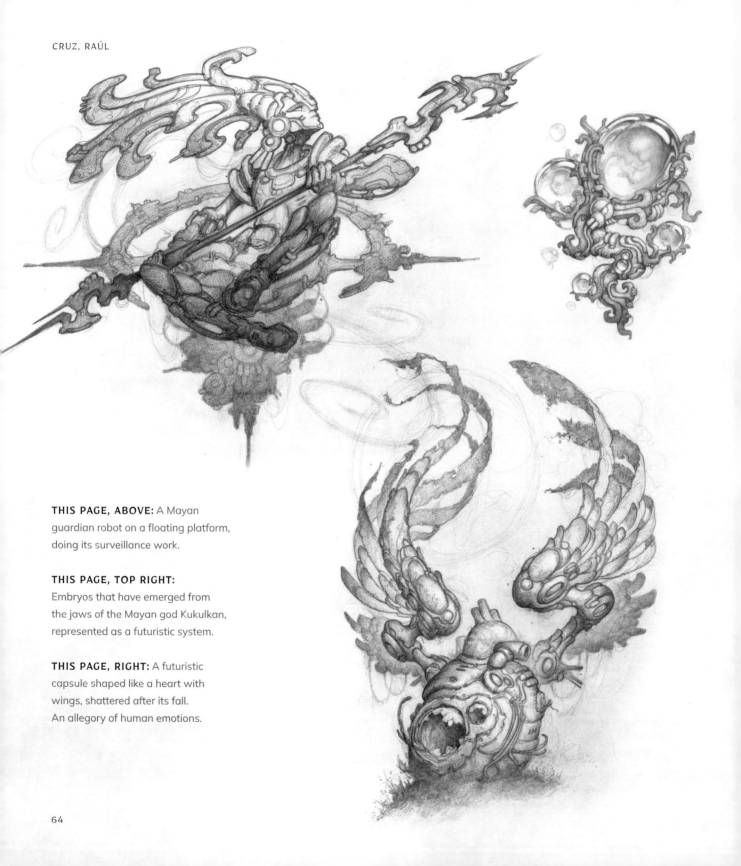

THIS PAGE, ABOVE: A Mayan guardian robot on a floating platform, doing its surveillance work.

THIS PAGE, TOP RIGHT: Embryos that have emerged from the jaws of the Mayan god Kukulkan, represented as a futuristic system.

THIS PAGE, RIGHT: A futuristic capsule shaped like a heart with wings, shattered after its fall. An allegory of human emotions.

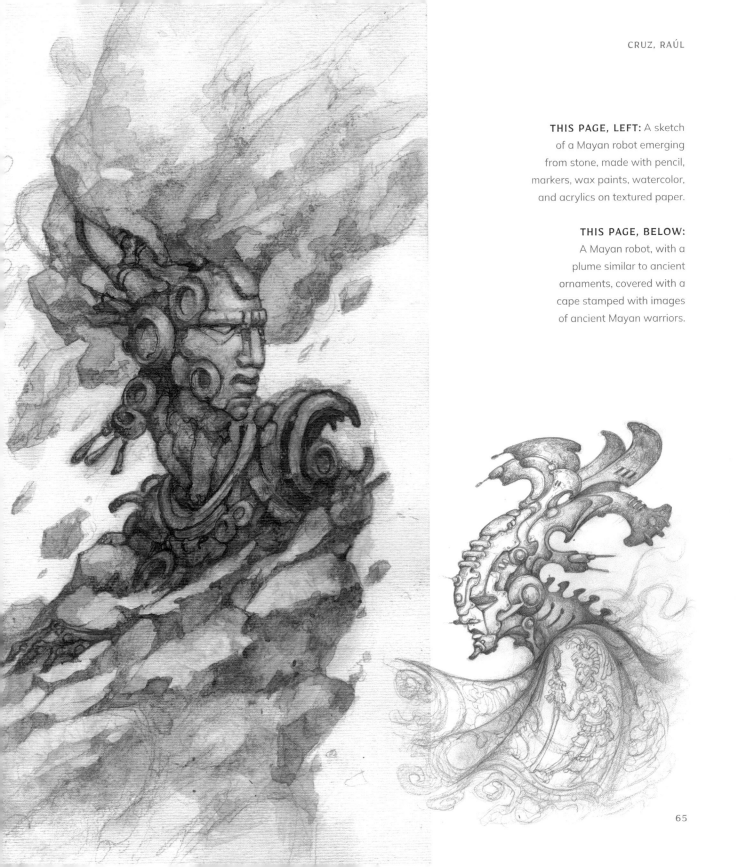

THIS PAGE, LEFT: A sketch of a Mayan robot emerging from stone, made with pencil, markers, wax paints, watercolor, and acrylics on textured paper.

THIS PAGE, BELOW: A Mayan robot, with a plume similar to ancient ornaments, covered with a cape stamped with images of ancient Mayan warriors.

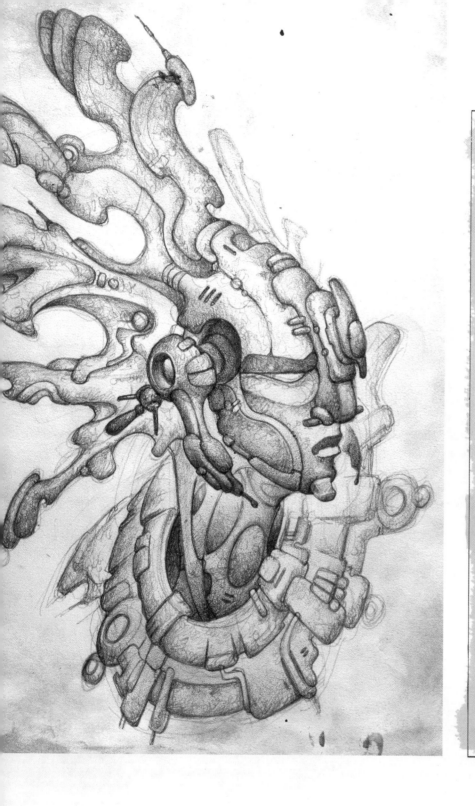

CONCEPT AND TECHNIQUE

A good work of art is made up of two main parts: concept and technique. Concept is the message you want to convey with your work. It is the way in which you show the thoughts and ideas that inhabit your head: your individuality as a person and artist, your loves and fears, your convictions and philosophy. It is what gives you value and makes your work unique. Let your ideas flow and catch them in their wild state in a sketchbook. The happiness you will experience in doing so will be incomparable.

Techniques are the many different methods with which you use your tools and materials. Experiment with as many as possible. If you can, invent new ones. Once you feel comfortable with one or several techniques, practice them day and night throughout your life. Without realizing it, you will become an expert. A technique used with mastery is the perfect complement to a great concept. Good technique is useless if you don't have anything interesting to say, and vice versa.

OPPOSITE PAGE:
A cybernetic Mayan warrior
ready to go into action.

THIS PAGE, LEFT: A cyborg in
an astronaut suit with features
and details inspired by the Day
of the Dead and Frida Kahlo.

THIS PAGE, BELOW:
A cybernetic Aztec warrior
executing a triumphal war
rite, using a drum, next to
the heads of his enemies.

"I try to catch ideas
in their wild state,
anytime, anywhere,
using my sketchbooks
and a pencil"

De Dominicis, Andrea

artstation.com/huidao

All images © Andrea De Dominicis

I am a concept artist working for internationally acclaimed studios and publishers, and am one of the three co-founders of IDEA Academy, an international visual arts school located in Rome. I have a very versatile approach to art, changing themes and styles often. Like many other concept artists, I have always loved fantasy settings and artists. Growing up looking at Gerald Brom's work on *Dark Sun* and Frank Frazetta's amazing art has left me with an everlasting love for dark fantasy, which is what my own work tends toward.

Sketching fantasy characters and creatures gives a unique freedom to explore shapes, stories, and costumes compared to other settings, and it is something that I enjoy a lot. I really love delving into the storytelling of the characters and trying to nail down some of those bits early on with messy lines and happy accidents while sketching.

THIS PAGE: A quick color sketch of my interpretation of Lady Macbeth.

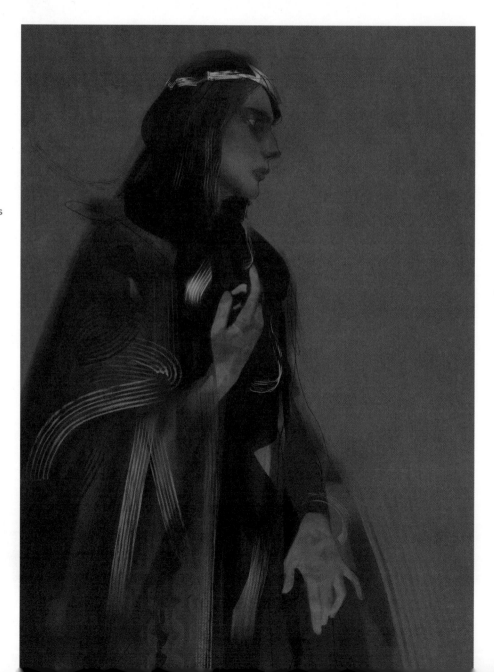

INSPIRATION AND IDEAS
◇◇◇◇

My biggest inspirations are both "The Golden Age of Illustration" and more modern artists. I constantly refer to them for color, style, or story, while striving to achieve my own unique vision. Reading books outside the regular fantasy tropes is also a great way to think more laterally when you design characters and develop ideas that are not too derivative. To put it simply, be interested in many topics and read about them as much as you can.

MATERIALS
◇◇◇◇

Using a sketchbook with a pencil or marker is a great way to sketch, for its simplicity. I also often use an iPad and Procreate, as they allow me to move and still have a wide range of tools to mess around with while drawing or painting.

TECHNIQUES
◇◇◇◇

More often than not, I start with a basic idea of my goal and a lot of reference research to really give grounding to the costume, posing, and other details. Sketching is sometimes tough, but it's also nice to just scribble or paint shapes and get inspired by the randomness of the process.

I don't have one single technique, as I try to approach the work with the method that I think will get me to my desired result fastest. Sometimes I scribble, other times I do emergent paintings (starting from a dark canvas and slowly pulling out shapes and values from it). It really depends on my aims and time available.

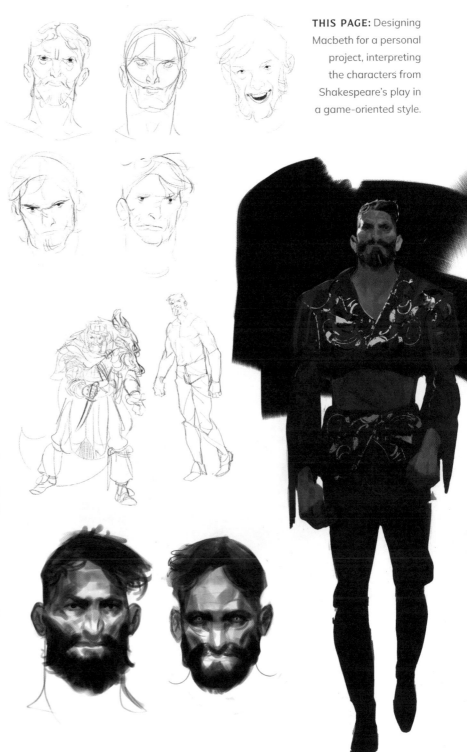

THIS PAGE: Designing Macbeth for a personal project, interpreting the characters from Shakespeare's play in a game-oriented style.

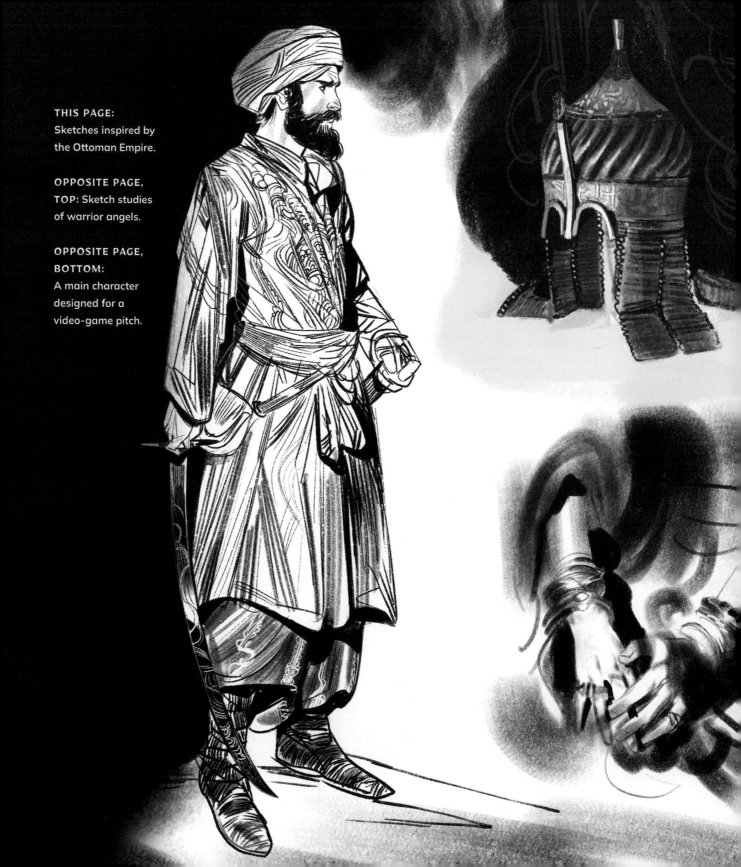

THIS PAGE:
Sketches inspired by
the Ottoman Empire.

OPPOSITE PAGE,
TOP: Sketch studies
of warrior angels.

OPPOSITE PAGE,
BOTTOM:
A main character
designed for a
video-game pitch.

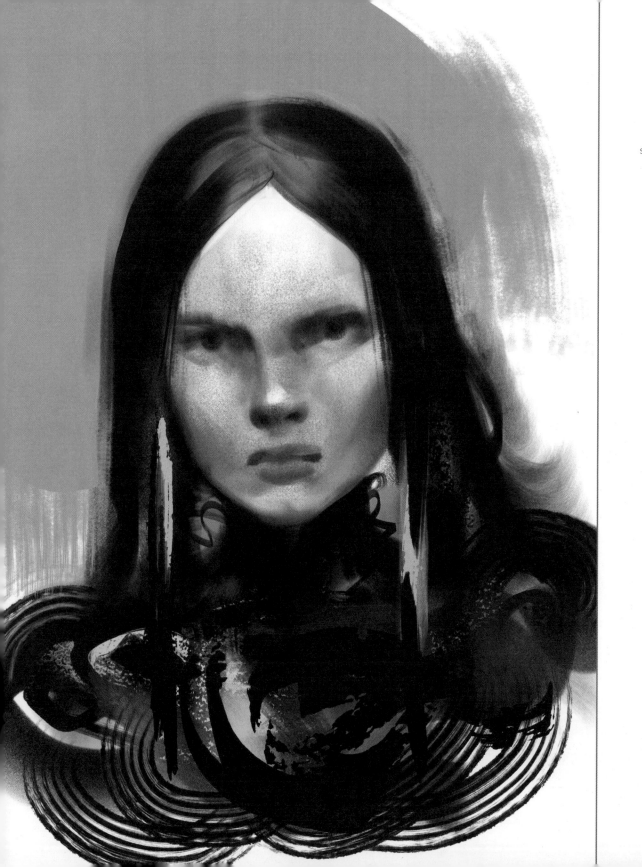

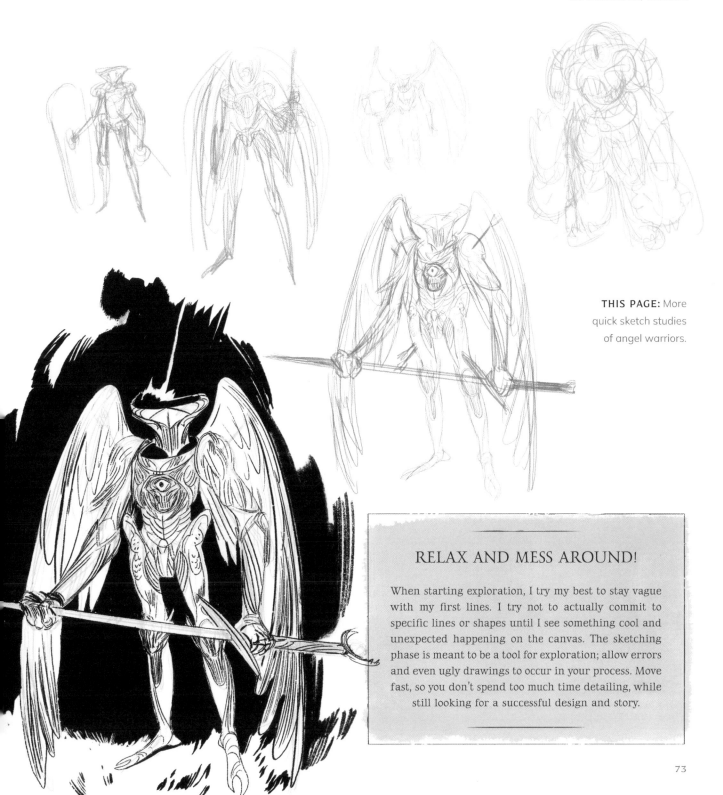

THIS PAGE: More quick sketch studies of angel warriors.

RELAX AND MESS AROUND!

When starting exploration, I try my best to stay vague with my first lines. I try not to actually commit to specific lines or shapes until I see something cool and unexpected happening on the canvas. The sketching phase is meant to be a tool for exploration; allow errors and even ugly drawings to occur in your process. Move fast, so you don't spend too much time detailing, while still looking for a successful design and story.

Eidenschink, Luke

instagram.com/luke.ink | youtube.com/c/LukeInk

Since I was young I have drawn in some form or another. My earliest subjects were dinosaurs rendered in crayon, pencil, or ballpoint pen. Now I specialize in creating scenes of fantasy and mythology, still mostly drawing things that I see with my mind rather than my eyes. So you could say that imagination has always played an important part in my work.

INSPIRATION AND IDEAS
◇◇◇◇

My creativity is inspired by many things. So many artists throughout my life, both current and from times past, have given me tremendous enthusiasm for drawing. Reading inspires me; stories of fantasy, mythology, sword-and-sorcery, and science fiction are all big influences that really fire up my imagination. Reading about history, researching cultures, and studying the natural world also provide me with a curiosity and sense of wonder that I feel is important for an artist to have.

THIS PAGE: A character design inspired by my research into real-world cultures.

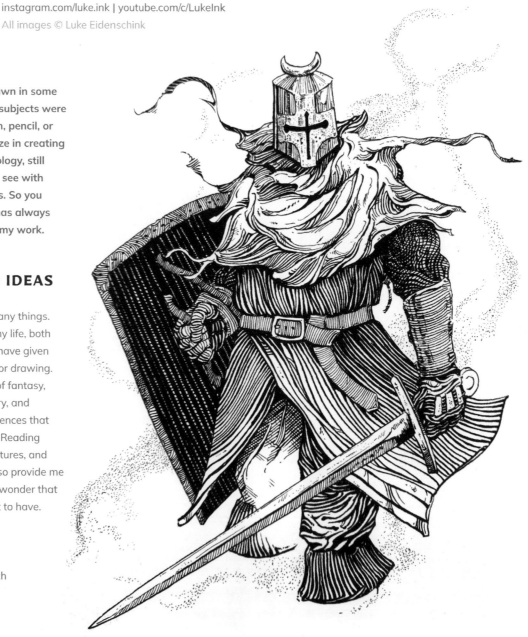

MATERIALS
⟨⟨⟨⟨⟩

My drawings are made with traditional ink on paper, using both pen and brush. I have used a variety of ink pens, but my preference is the dip pen. It's the same basic tool used by calligraphers, consisting of a handle with a metal nib that is repeatedly dipped into an ink reservoir. Dip pens and brushes allow for a wonderful degree of expression and individuality that is difficult to reproduce using other methods. For paper, I like to use a smooth-finish watercolor paper with a weight of at least 100lb or 300g. This allows for heavy application of ink, if needed, without too much warping. It also allows me to add watercolor or ink washes, which I am beginning to experiment with.

TECHNIQUES
⟨⟨⟨⟨⟩

My drawing process begins with a pencil. If I have an idea of what I want to draw, I play with different compositions on the paper until I have an outline that I feel is good enough to begin inking. If I have no idea, I might just doodle for a bit and see what comes out! Sometimes these doodling sessions produce my best work. Once I am happy with the pencil layout, I begin the inking process. When inking, I work from the foreground to the background (if there is one). Basic shapes and outlines are inked first, followed by increasingly finer details. After the ink has dried completely, I erase all pencil marks still visible.

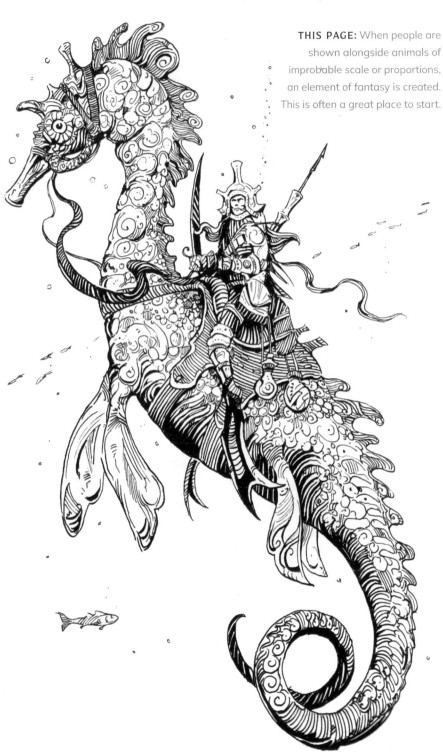

THIS PAGE: When people are shown alongside animals of improbable scale or proportions, an element of fantasy is created. This is often a great place to start.

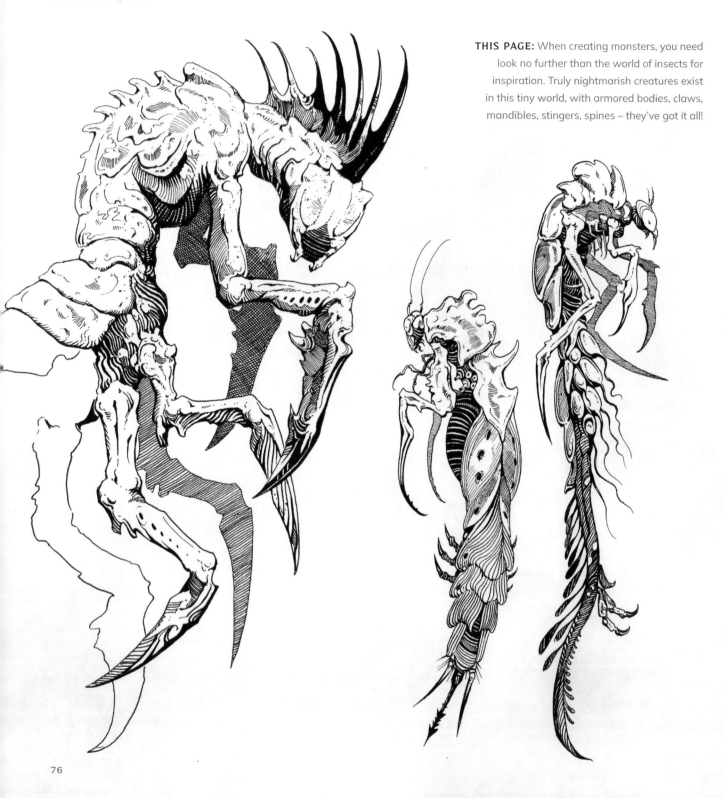

THIS PAGE: When creating monsters, you need look no further than the world of insects for inspiration. Truly nightmarish creatures exist in this tiny world, with armored bodies, claws, mandibles, stingers, spines – they've got it all!

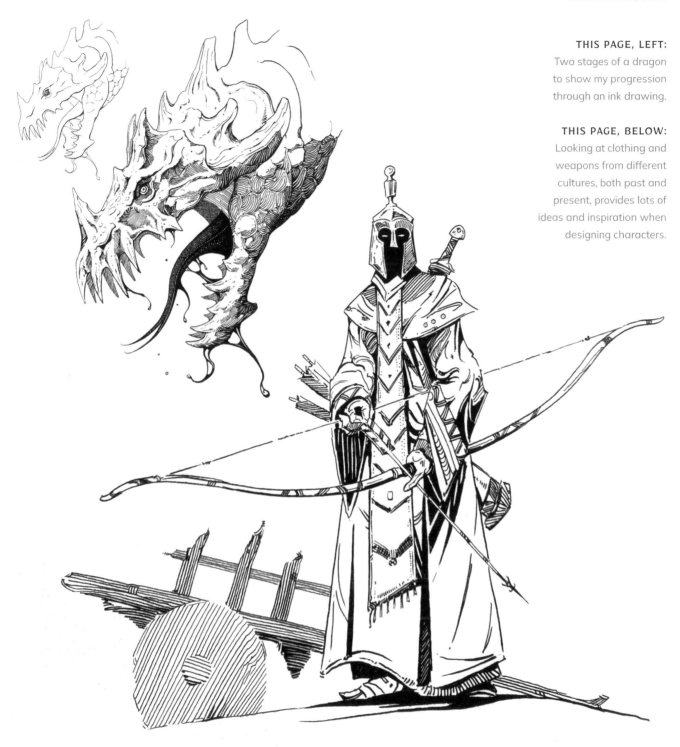

THIS PAGE, LEFT:
Two stages of a dragon to show my progression through an ink drawing.

THIS PAGE, BELOW:
Looking at clothing and weapons from different cultures, both past and present, provides lots of ideas and inspiration when designing characters.

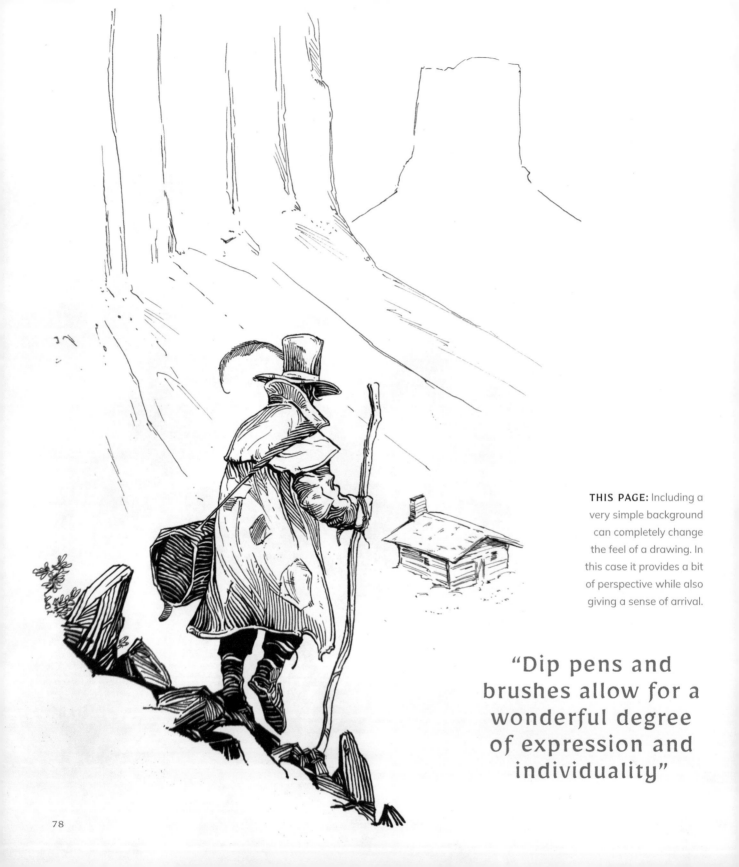

THIS PAGE: Including a very simple background can completely change the feel of a drawing. In this case it provides a bit of perspective while also giving a sense of arrival.

"Dip pens and brushes allow for a wonderful degree of expression and individuality"

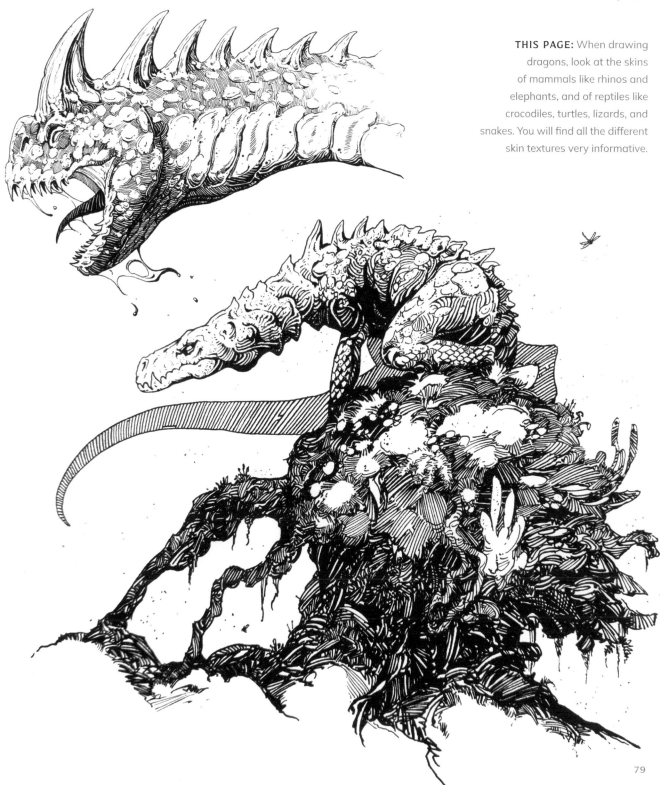

THIS PAGE: When drawing dragons, look at the skins of mammals like rhinos and elephants, and of reptiles like crocodiles, turtles, lizards, and snakes. You will find all the different skin textures very informative.

Eidintaite, Monika

artstation.com/monikaeidintaite

All images © Monika Eidintaite

I have had a passion for drawing ever since I was a toddler. My interest in fantasy started when I was old enough to play *Heroes of Might and Magic III* – I was so fascinated by its mythical world, I would design and draw my own towns and armies on paper. The game is still among my favorite things, as well as Paul Romero's wonderful soundtrack.

Artistically, I come from a traditional background – I studied fine arts in Lithuania, my homeland, and specialized in oil painting. These studies helped shape many of my artistic habits and beliefs, such as the importance of research and references, the fundamentals of perspective and anatomy, and the importance of life drawing. I spent many years carrying a sketchbook around and drawing from life every day. I eventually understood I wanted to pursue a career in creating art and concepts for games and animation, and transitioned fully to a digital line of work.

I am always busy working on several projects at once, but I try to find time to sketch every day. Sketching is my favorite part of any work project or illustration piece – it is the phase during which I am able to capture the most personality and energy of my subject. Sketching is also where I feel safest to experiment, try new things, and learn.

THIS PAGE: A sketch of a living tree for the Character Design Challenge.

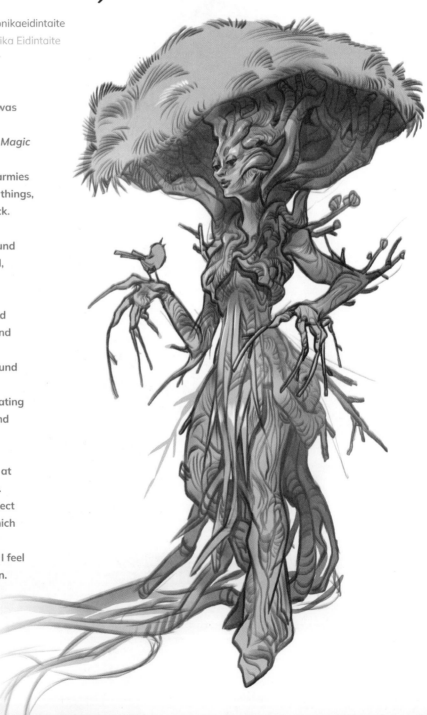

INSPIRATION AND IDEAS

Films, books, video games, and the artwork of other artists are
strong sources of inspiration to me. Reading about other cultures
and their folklore and myths helps with ideas and narratives
for fantasy pieces. I also enjoy participating in community
challenges as they push me to work outside my comfort zone.
I used to do so much daily life-sketching that it became a custom
rather than something born out of inspiration, so in my personal
experience, discipline really is key; I don't always feel inspired
to draw or have a clear idea in my mind, but once I commit
and begin drawing, the sketches sort of build themselves.

MATERIALS

Typically, I'll work digitally at home, and sketch traditionally whenever
I am traveling. For traditional drawing, I prefer materials I can build
up, such as pencils and fine ballpoint pens, so that I can control the
intensity of my linework. Lately, I have preferred sketching digitally,
as it's so much easier to flip the canvas, color, and edit the
image. I'll often scan my traditional sketches and color
and shade them digitally, as I can freely experiment
and play with different values and colors that way.

TECHNIQUES

I almost always start out by creating a loose
underdrawing with really thin, circular brushstrokes.
I find that if I go into thicker and more deliberate
line art too soon, I can get lost in detailing
the piece and lose the silhouette's clarity.
Creating an initial rough pass helps
me experiment and push the shape
design. Then, once I have a clearer idea
of the subject, I will build stronger, more
intentional lines on top. I sometimes clean
up the underdrawing after I've finished a piece,
but most often I leave those lines alone and
they are still visible throughout my sketches.

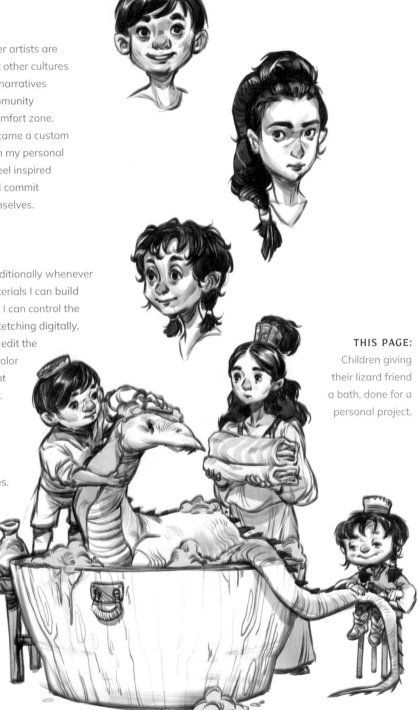

THIS PAGE:
Children giving
their lizard friend
a bath, done for a
personal project.

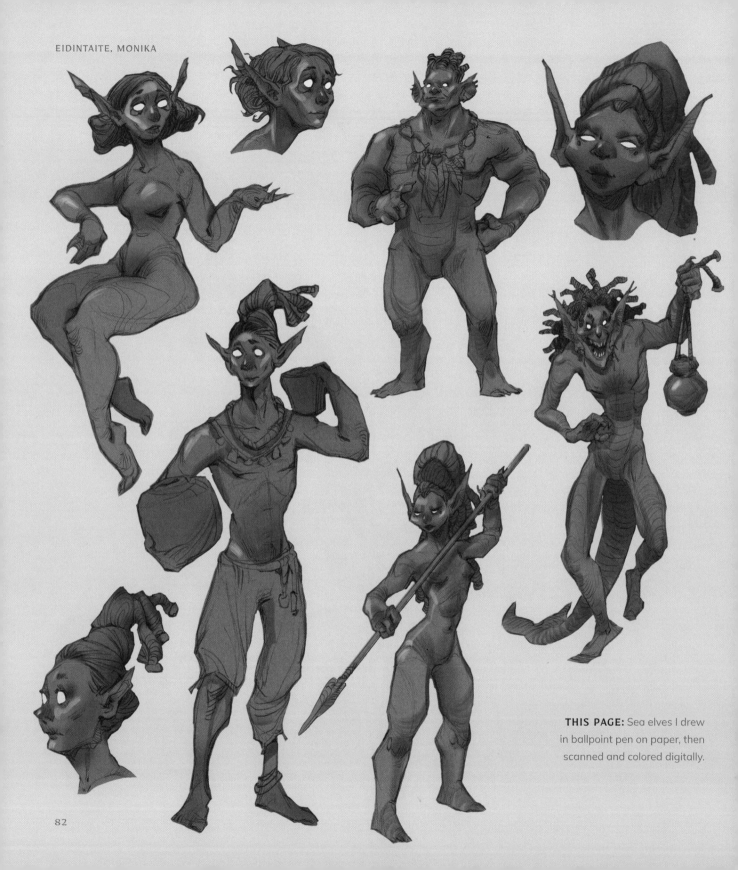

THIS PAGE: Sea elves I drew in ballpoint pen on paper, then scanned and colored digitally.

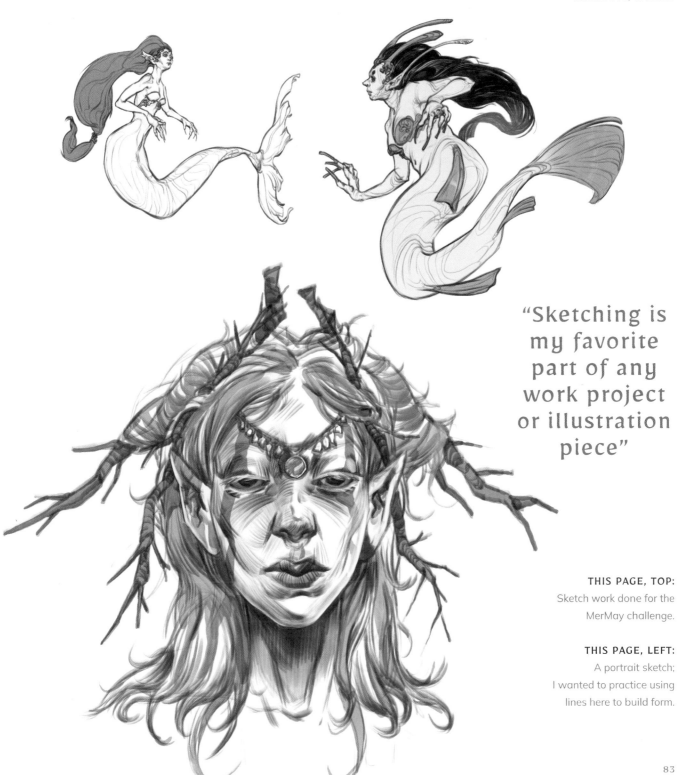

"Sketching is my favorite part of any work project or illustration piece"

THIS PAGE, TOP:
Sketch work done for the MerMay challenge.

THIS PAGE, LEFT:
A portrait sketch; I wanted to practice using lines here to build form.

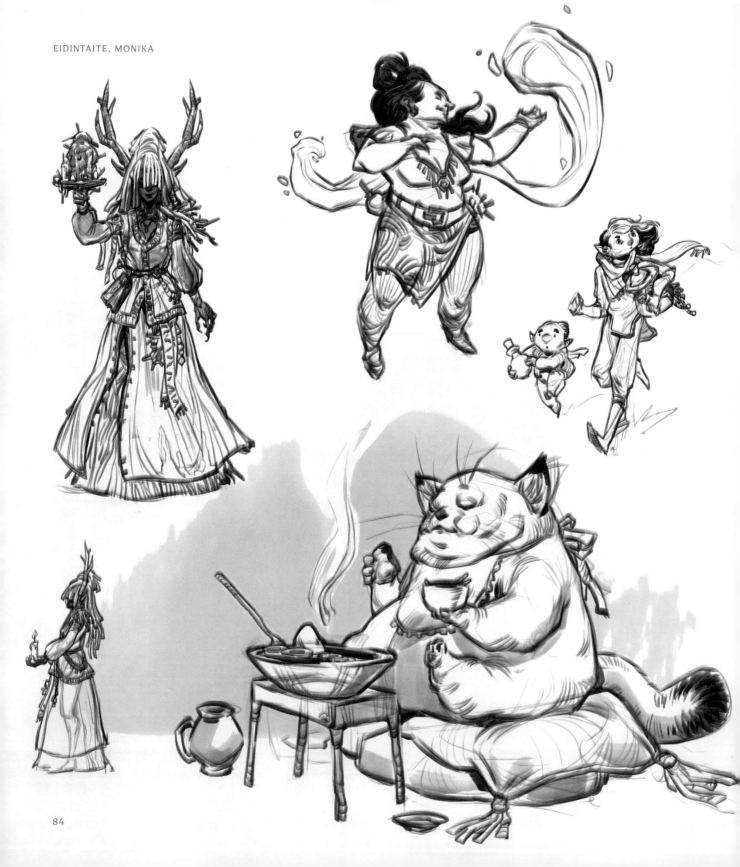

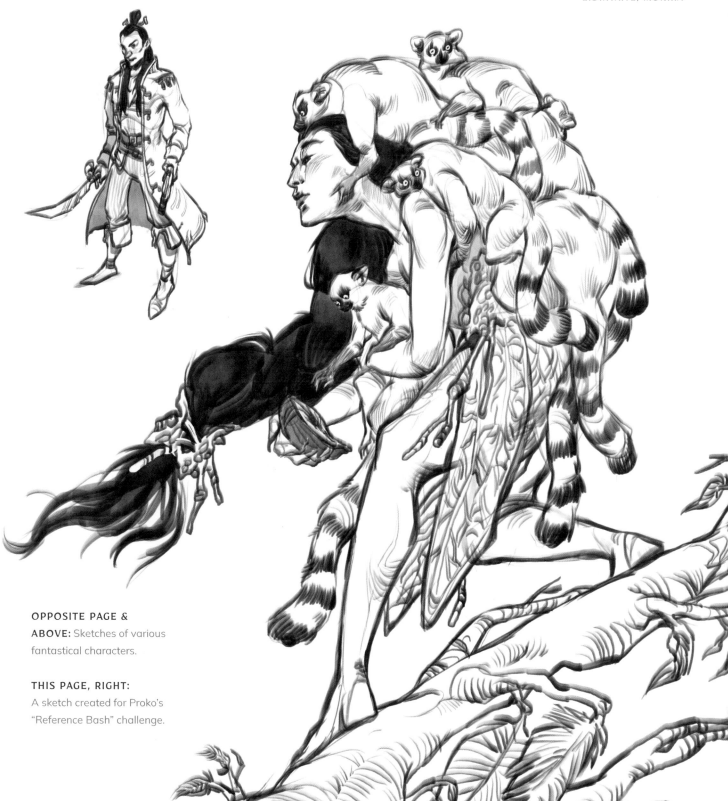

OPPOSITE PAGE &
ABOVE: Sketches of various
fantastical characters.

THIS PAGE, RIGHT:
A sketch created for Proko's
"Reference Bash" challenge.

Fan, Cindy

cind.ca

All images © Cindy Fan

THIS PAGE: A rejected rough for a client that I personally really like and still may work on for myself.

OPPOSITE PAGE: In-progress work for a personal commission, titled *Reminders of Home*.

I was born in Sichuan, China, and emigrated with my family to Canada at a young age. I spent most of my life in and around Toronto and am now living in Texas. I always loved drawing as a child, and began seriously pursuing illustration during my high school years. I attended the OCAD University in Toronto, where I majored in illustration and received my Bachelor of Design. I currently work freelance and specialize in creating dreamy visuals that interpret fantasy and speculative stories for print and digital media. I use a mixture of loose linework, hatching, and painterly strokes to create flow and help direct the viewer's eye. I really enjoy putting small, thoughtful details into my art to create intricate scenes, reinforce narrative elements, and hopefully give the viewer something new to catch upon repeated viewing.

I think my interest in fantasy stems from immersing myself in fables and fairy tales as a child, and loving the strange creatures and locations. I would constantly be daydreaming and thinking about "what if" scenarios, especially ones that bordered on absurdity. I think a lot of that seeped into my artwork over time. I also moved around frequently and so the journeying aspect of fantasy – visiting different lands and worlds – appealed to me a lot. Currently, I am especially interested in using fantasy to explore subjects such as diaspora, isolation, migration, decolonization, and climate justice.

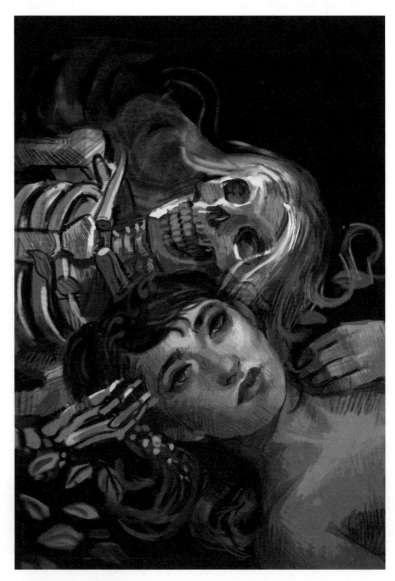

INSPIRATION AND IDEAS

My artistic inspirations are illustrators who I went to school with, such as Wenting Li, Kima Lenaghan, and Jenn Woodall. I love seeing their work develop over the years and find a lot of inspiration in what they do. Other inspirations include lush hikes with overgrown plants, antique stores, and online open-source collections available from the Smithsonian, Metropolitan Museum of Art, Art Gallery of Ontario, and so on. I especially love weird statues, pottery, and lamps. I often find myself combining elements from different eras to create an anachronistic sense of timelessness within my artwork.

MATERIALS

I draw digitally in Adobe Photoshop with a Wacom tablet. This is my preferred method because I find layers to be helpful for testing out many possible ideas with little hassle. That said, I would love to go back to doing more traditional painting with watercolor and gouache when I have the time.

When working digitally, I really recommend spending time experimenting with and picking out a set of brushes you feel confident and comfortable with. I personally love textured brushes, but it depends on your style. Also, just as you may find when working traditionally, not all brushes will work for every piece.

TECHNIQUES

My artistic process depends on the deadline of what I am working on. For personal pieces, I allow myself to explore and start painting without a solid sketch, and let my inspirations take me in different directions as I progress. If I have a deadline, I spend a lot longer planning out composition, colors, and lighting. I also tend to work with a few key colors early on in my process to help develop focal points. I always work from large to small, filling up the canvas and figuring out light sources before doing detail work.

REST AND REFRESH

It is really helpful when working on large, detailed pieces to take breaks, even when you may not want to – at least once or twice per hour of working. Breaks refresh your point of view, help you draw better, and also help you avoid physical injury. Don't try to push yourself if you find you are having an off day. We all have days when we draw better or worse, and resting will help you have more good drawing days.

BOTH PAGES: An in-progress excerpt from a short sequential piece I'm working on, titled *Wilted*.

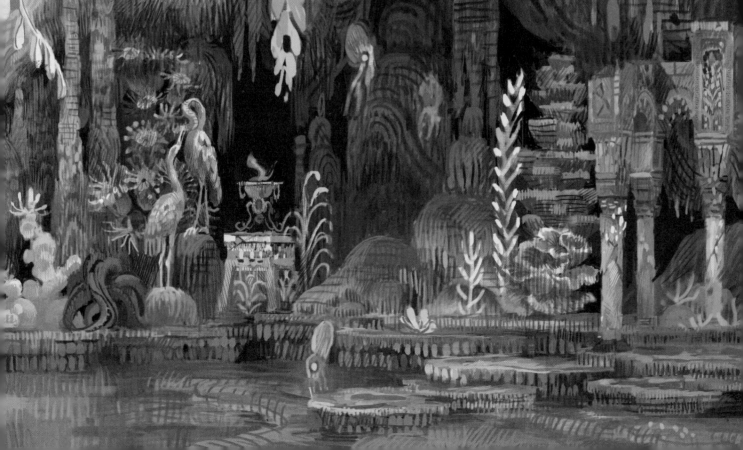

OPPOSITE PAGE, TOP: An early rough for an untitled personal piece featuring a lake.

OPPOSITE PAGE, BOTTOM: Early progress for a piece featuring a cave. I am still working on the colors, lighting, and foliage.

THIS PAGE: In-progress work for a personal piece featuring an old statue.

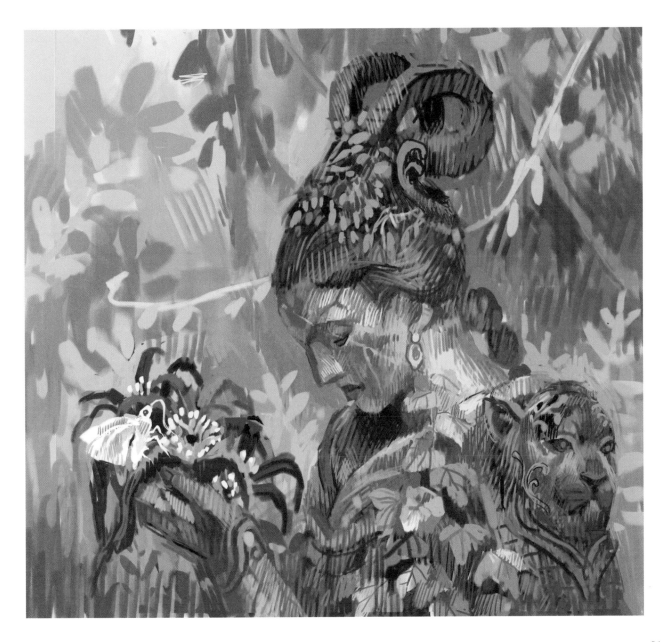

Fdez, Fran

franfdez.art

Images © Fran Fdez except where noted.

I can't remember a time in my whole life when I haven't been drawing. I'm pretty sure I've wanted to make a living from it since I was a child. At a certain point, I wanted to be a paleontologist – I was born in the eighties and grew up with the influence of *Jurassic Park*, so what else could I do?

Later on, I got into the world of role-playing games, sci-fi, and fantasy literature: J.R.R. Tolkien, the *Dragonlance* series, *Warhammer 40,000*, and all the Games Workshop stuff. I was really fascinated with all the covers, illustrations, sketches on the margins of the different army rulebooks... I copied them for years and nowadays I can say with pride that the majority of my work is developing concepts for miniatures.

When I develop the first sketches for a concept or an illustration, I always take time to think about the context of the character, creature, or scene. Of all the different stages of a project, the one I enjoy the most is sketching. Fast ideas, wild gestures, rough and messy strokes – I always leave some parts of this initial stage in the final work, whether it's a polished illustration or a looser concept. I like to search for and find those strokes in my and others artists' work.

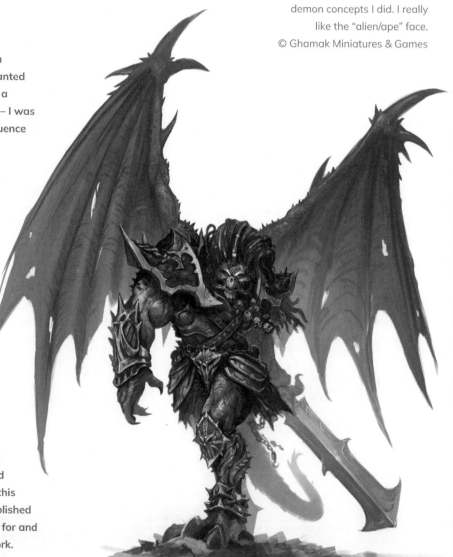

INSPIRATION AND IDEAS

Everything I see and feel inspires me. I love reading novels (J.R.R. Tolkien, Terry Pratchett, Isaac Asimov, and more) and watching sci-fi and fantasy films. I also find it inspiring to research ancient cultures, history, and mythology. However, if I had to analyze where my style comes from, one thing undoubtedly comes to mind: Games Workshop. Many artists that have worked for this company became instant inspirations for me: Karl Kopinski, Adrian Smith, and John Blanche, to name a few. I still look for inspiration in their work at times. And Pinterest, of course!

MATERIALS

My main tool is the well-known combo of Wacom tablet and Adobe Photoshop. In my case, I work with a Wacom Cintiq. I like to work with more traditional methods such as pencils, markers, inks, and watercolors, but I eventually end up using digital media as it is faster and more comfortable. Another important tool for me, although it may sound a little bit obvious, is the keypad. I have tried to use other kinds of tools for the keypad shortcuts, but I always end up returning to the standard keypad! When working traditionally, the combination of Copic markers with a pencil and ink feels super comfortable to work with in my sketchbooks.

TECHNIQUES

I don't have a technique, as such – I am very chaotic in all stages of my work! I could say that I usually use very basic brushes and the Smudge brush tool in my initial sketches. I work on several different layers while defining the idea, then merge them when I'm satisfied with the result.

I like to spot reminiscences from the very first lines. It is like I am looking for shapes in the clouds. When it is not clear what I am looking for I just start drawing abstract strokes. Eventually, the main idea becomes clear to me, and the first shapes begin to form and make sense as a whole.

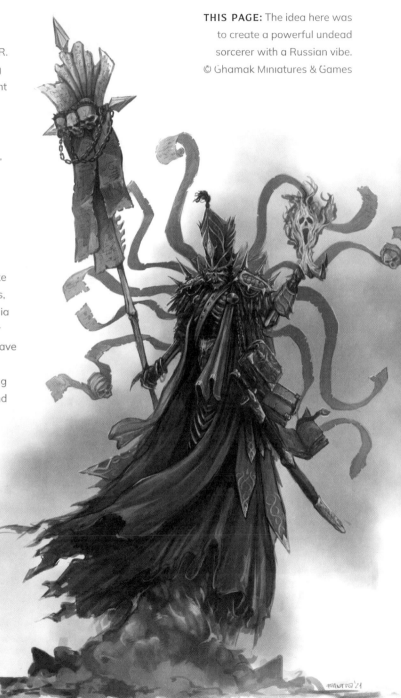

THIS PAGE: The idea here was to create a powerful undead sorcerer with a Russian vibe. © Ghamak Miniatures & Games

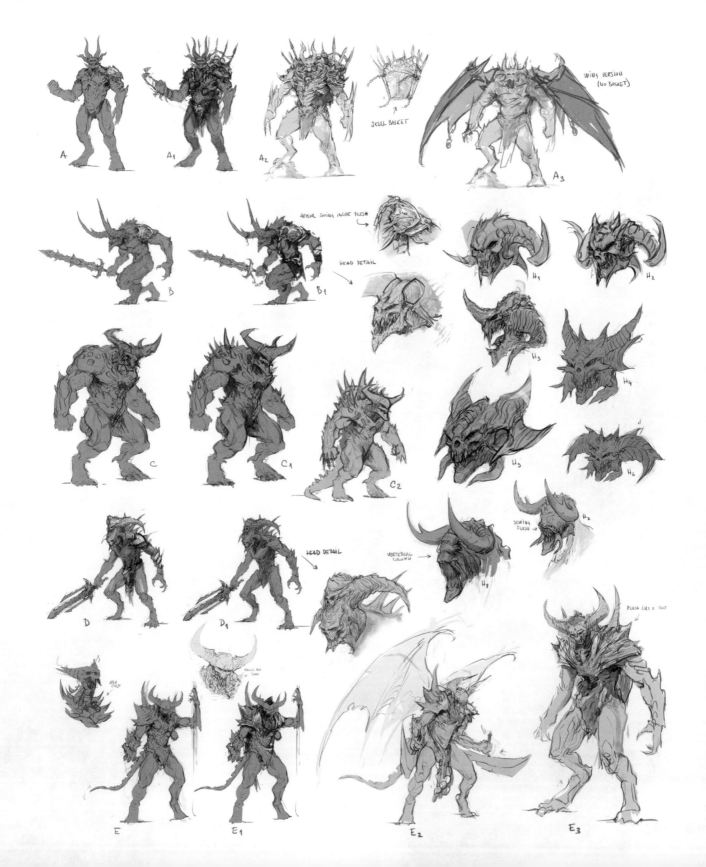

A

A₁

A₂

SKULL BASKET

WING VERSION
(NO BASKET)

A₃

ARMOR GOING INSIDE FLESH

HEAD DETAIL

B

B₁

H₁

H₂

H₃

H₄

C

C₁

C₂

H₅

H₆

D

D₁

HEAD DETAIL

VERTEBRAL
COLUMN

SEWING
FLESH

H₇

H₈

FLESH LIKE A COAT

E

E₁

E₂

E₃

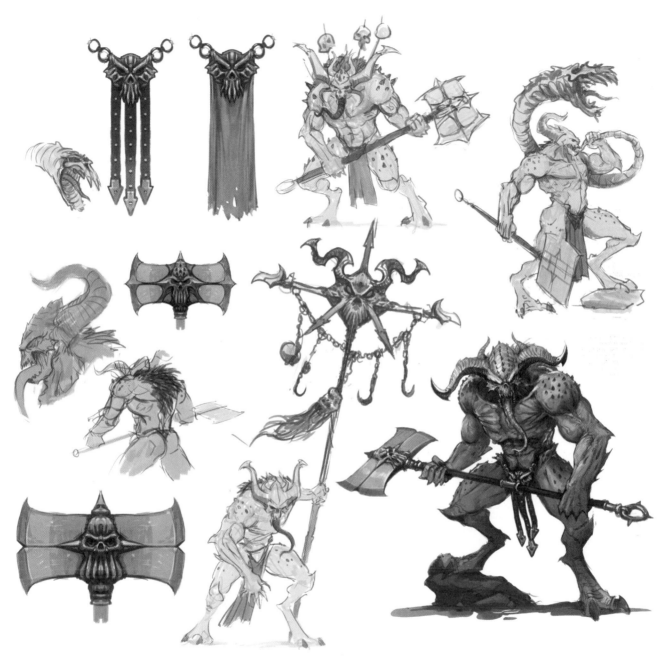

OPPOSITE PAGE: Some explorations
and quick ideas for a new demon faction.
© Onepagerules

THIS PAGE: This demon was a concept
for the basic troops in a demon army.
© Ghamak Miniatures & Games

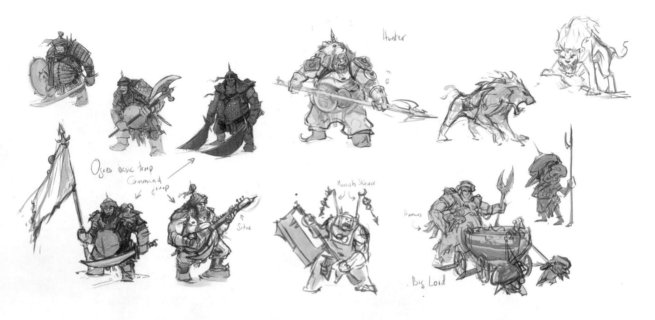

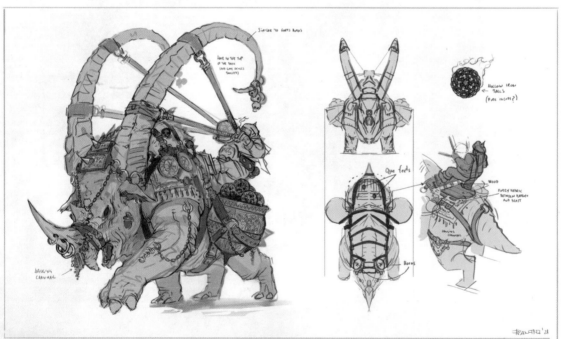

THIS PAGE: Sketches for an ogre
army in a Persian-inspired style.
© Ghamak Miniatures & Games

TAKE CARE OF YOURSELF!

Work out, take care of your posture, rest every thirty minutes, and do stretches and exercises. Invest in your equipment so you can work comfortably. Changing your studio setup from a sitting to a standing desk is a good way to invest your money. The only way to work in art long-term is to get stronger. Believe me, I think this is the best advice I can give to you!

THIS PAGE: A lich orthodox priest mounted on a bone dragon... I love my work. © Ghamak Miniatures & Games

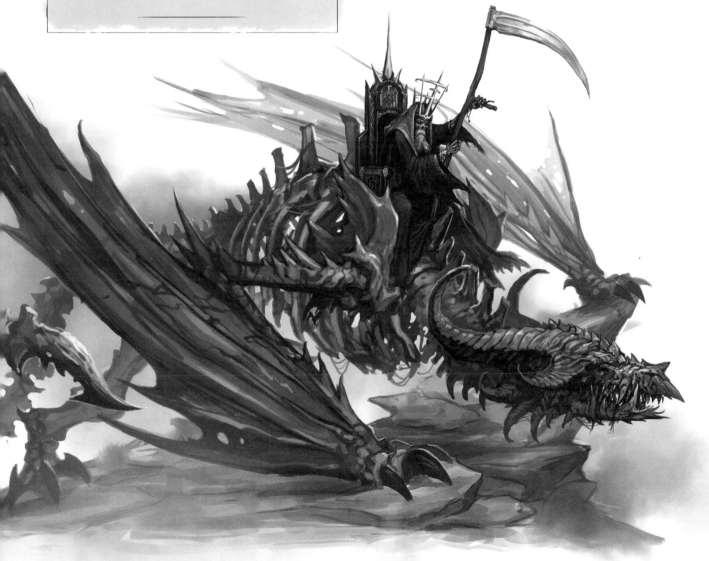

Frederick, Grady

artstation.com/gradyart

All images © Grady Frederick

I am a freelance concept artist and illustrator from Ottawa, Ontario. I feel extremely fortunate to have found a love for drawing and painting early on, since many people spend much of their lives searching for their passion. Mine came from my dad, who is a fantastic draftsman, caricaturist, and watercolor painter. Seeing him work was my first source of inspiration and I very quickly knew that I wanted to make my life all about art. He and I would draw together, challenging each other to draw trolls, robots, and goofy, misshapen characters. Our shared love of art has made us very close.

My mom instilled in me a profound love of nature, history, music, and language; all of which are channeled through my personal art. I love to draw and paint but beneath it all is a passion for creating stories. Imagining the sounds and smells of an ancient forest, the stinging, blowing snow in a tundra, or the crackling fire and gentle strumming of a lute in a small tavern in the mountains; thinking about these things while I draw brings me a great amount of fulfillment while working on a project. It reminds me not to get caught up in outside expectations and to cherish the process. I frequently get discouraged, as many artists do, but having such loving support from those close to me always gives me the strength to carry on.

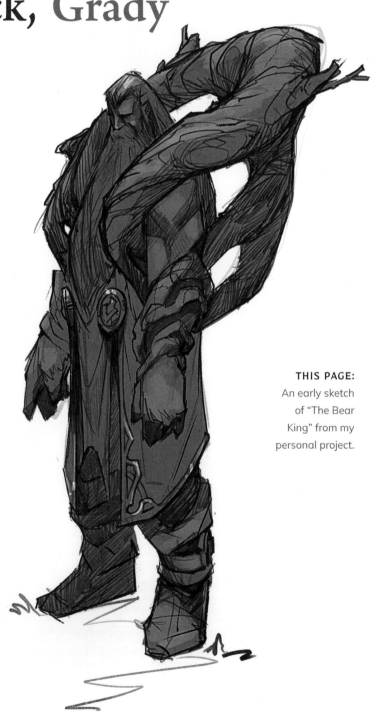

THIS PAGE:
An early sketch of "The Bear King" from my personal project.

INSPIRATION AND IDEAS

I love to sketch and explore ideas for my own personal project, which I have been working on for a couple of years now. It is heavily inspired by ancient Nordic and Celtic mythology, and is set in harsh and beautiful northern landscapes similar to those of Scotland, Norway, and Iceland. I often explore architectural details, the unique topography of a given area, and the strange creatures and characters that dwell there. Loose sketching is a great way to quickly explore multiple ideas without worrying about a beautiful finished drawing.

MATERIALS

I like to loosely sketch on Moleskine paper with a broad HB pencil, and then refine the drawing with a 2B mechanical pencil. I will sometimes sketch directly with a Copic Multiliner pen, which forces me to be more deliberate with my marks and usually means less fiddling around with details. Most frequently, though, I sketch digitally on a Cintiq. Creating landscape compositions and iterating ideas can be extremely fast with all the tools at one's disposal in Adobe Photoshop. Things can also be easily changed and corrected, which helps with progressing to the final stages.

TECHNIQUES

It takes a tremendous amount of repetition to find a sustainable method that works for you. With my particular temperament, I like to see a drawing or painting come together very quickly, rather than a slow buildup with multiple steps. For this reason, I tend to be very loose and messy in the beginning, so that my ideas can freely spill onto the page. Throughout the day, our brains burn out, so it is important for me to use those early hours to materialize as many ideas as possible. Working on cleaning up the drawing is the easy part and can be done later.

THIS PAGE: An early sketch of a snowy tomb high up in the mountains.

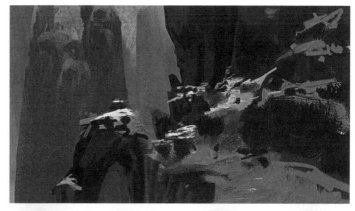

FEED YOUR SOUL

With social media being the main place to share and consume art nowadays, I find it important not to let a collection of "likes" and "followers" dictate the art I produce. Every artist has a unique perspective and experiences to draw from, and when you find out what you truly love to create, you should make that your main focus. The fulfillment you feel when working on something you care about is far greater than the momentary and shallow stimulation of seeing that a stranger has liked your drawing because it was "trending."

THIS PAGE, RIGHT:
Facial explorations for the
protagonist of my project.

THIS PAGE, BELOW: Sketching one
of my favorite subjects: a cozy cottage.

OPPOSITE PAGE, LEFT:
Loose pen sketching, exploring
goofy house ideas.

OPPOSITE PAGE, RIGHT: A quick
sketch idea of old Viking seer.

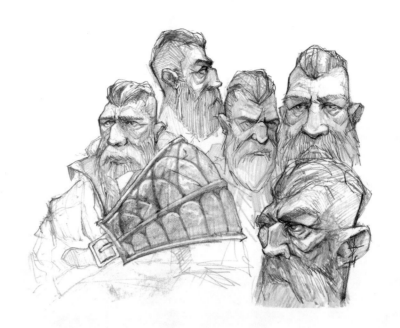

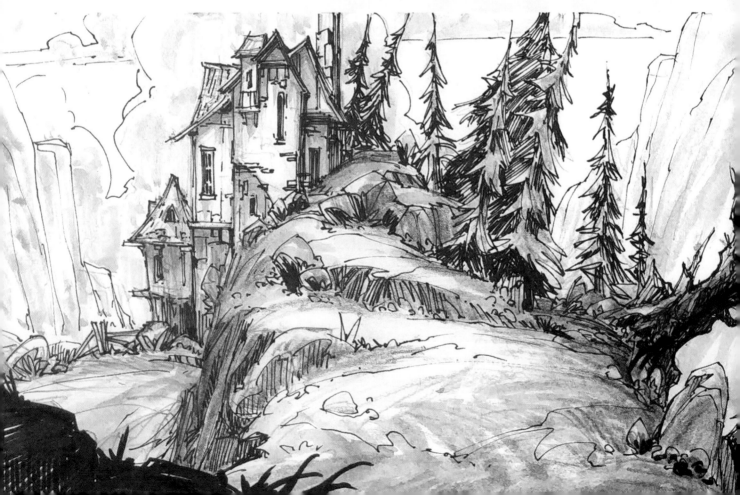

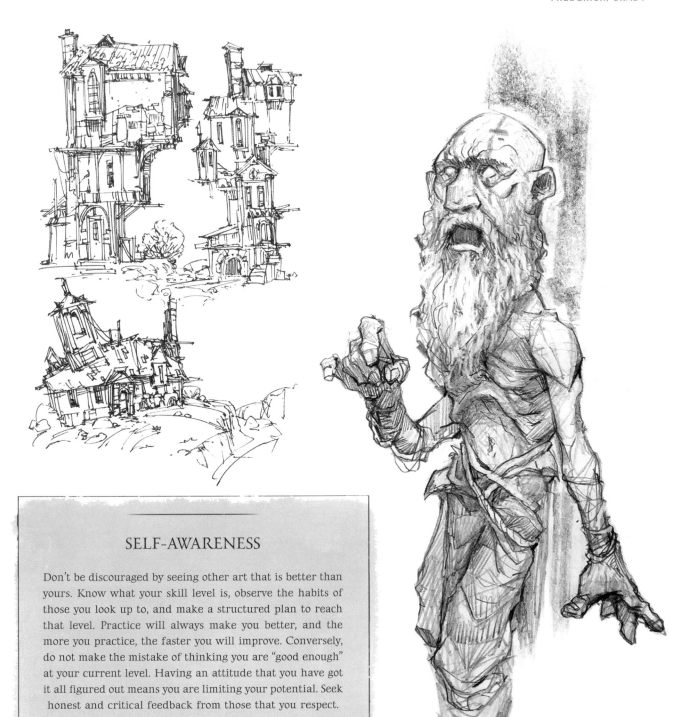

SELF-AWARENESS

Don't be discouraged by seeing other art that is better than yours. Know what your skill level is, observe the habits of those you look up to, and make a structured plan to reach that level. Practice will always make you better, and the more you practice, the faster you will improve. Conversely, do not make the mistake of thinking you are "good enough" at your current level. Having an attitude that you have got it all figured out means you are limiting your potential. Seek honest and critical feedback from those that you respect.

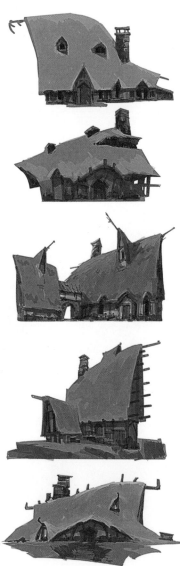

THIS PAGE, LEFT: A very quick graphic composition to warm up with in the morning.

THIS PAGE, ABOVE: Architectural explorations of a tavern from my personal project.

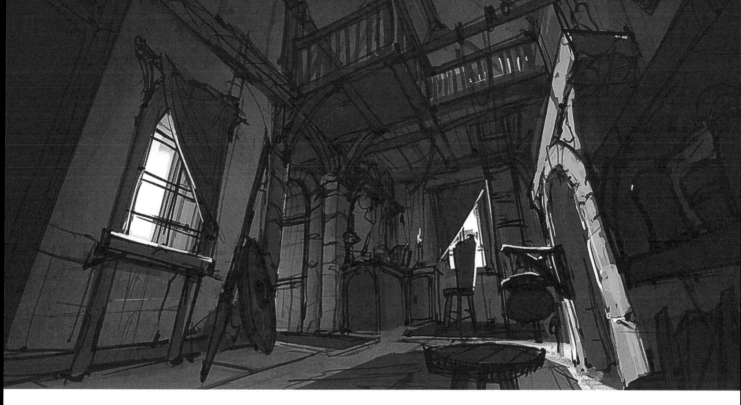

THIS PAGE, ABOVE: Working on the interior of the
main character's house for my personal project.

THIS PAGE, RIGHT: Weapon sketches.
I was trying to find an appealing design for
my main character's sword and axe.

THIS PAGE, BELOW: A rough painting, testing
some new brushes and techniques in Photoshop.

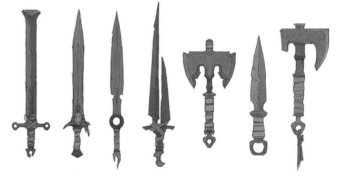

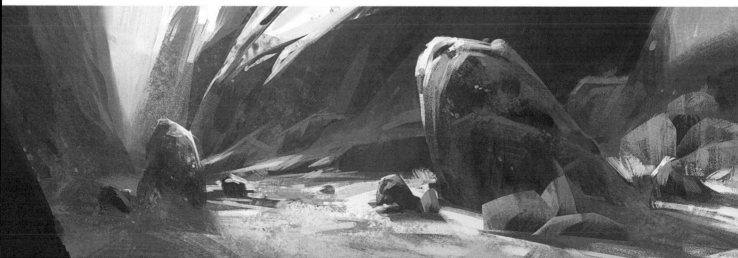

Gatto, Roberto

robertogattoart.com
All images © Roberto Gatto

I started my artistic journey quite late, despite having always been interested in video games and animation. My learning path has been pretty chaotic, starting with 3D modeling early on, and then being mostly self-taught with the aid of a few online classes. Ultimately, I had the chance to step into the game industry with a lead artist role at Spiderling Games, and later transitioned into the animation industry with Axis Studios and Sun Creature Studio.

I have been interested in magic and fantasy since a young age. I was introduced to *The Lord of the Rings* trilogy, the *Harry Potter* series, and role-playing games early on. This translated in later years into art as I began creating my own worlds.

The allure of magic and fantasy to me is in the fact that there are so many different shades of them, allowing the artist to explore fantastical locales inhabited by creatures of all kinds. This works especially well with pen-and-paper role-playing games, a format that has allowed me to write and sketch out my own worlds and adventures for people to enjoy at the gaming table!

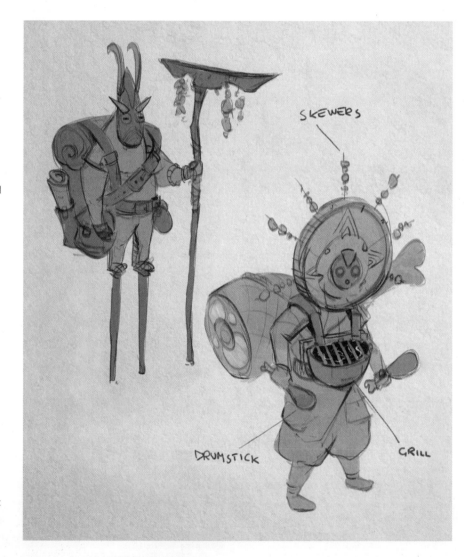

INSPIRATION AND IDEAS

My main sources of inspiration come from the games I play, the books I read, and the shows that I watch. Another great inspiration, again, is pen-and-paper role-playing games, since they rely a lot on imagination and the story that you tell together with your friends. These games are always surprising, offering unique takes on the most diverse of subjects. Another big inspiration is nature. Trying to find the fantastical in the everyday is a lot of fun!

MATERIALS

My preferred medium is definitely digital, as it's the one that I trained with. However, I have recently started to experiment a lot more with drawing from life, using traditional media such as graphite pencils, charcoals, and markers. The feeling you get with pencil on paper is something that is hard to emulate digitally. It creates a special absorption of the subject and the moment, which is why drawings are a lot more powerful than photographs when on vacation.

TECHNIQUES

I don't have an entirely consistent process for sketching. Sometimes I like to start by lightly blocking in the silhouettes using a marker, then defining the interior shapes with a pencil. Other times, I start the sketch directly in pencil. I always end up trying to use my pencil as a paintbrush, defining volumes and trying to sculpt the form, rather than relying on line art alone. This is most likely because I'm more of a painter than a draftsman!

BOTH PAGES: I usually don't draw characters, but here I wanted to try something different. These designs show different types of merchants.

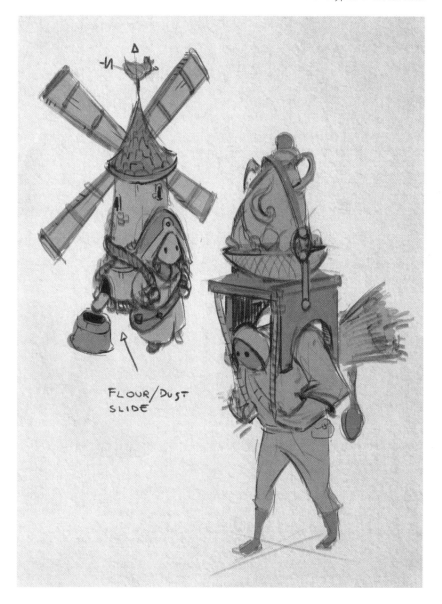

FLOUR/DUST SLIDE

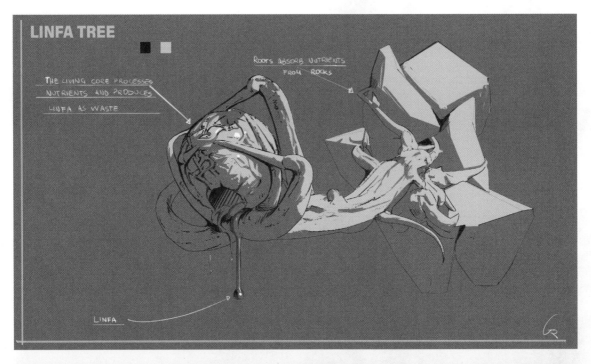

LINFA TREE

THE LIVING CORE PROCESSES
NUTRIENTS AND PRODUCES
LINFA AS WASTE

ROOTS ABSORB NUTRIENTS
FROM ROCKS

LINFA

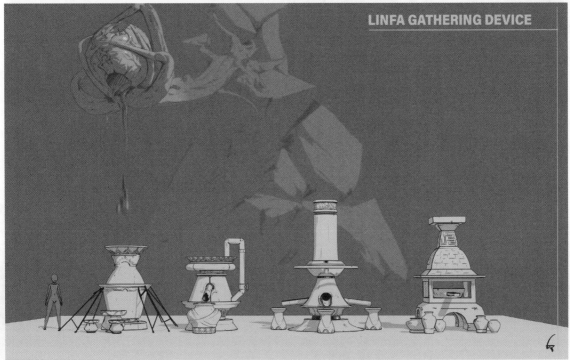

LINFA GATHERING DEVICE

OPPOSITE PAGE, TOP: This "Linfa Tree" design was part of my Candletown setting. People gather its special sap to make their candles.

OPPOSITE PAGE, BOTTOM:
After figuring out the Linfa Tree, I needed to design a device that people could use to gather the sap.

THIS PAGE, RIGHT: Design sketch for the alchemist hut for my project, *Children of the Depths*. This sketch served as a base for a painting.

THIS PAGE, BELOW:
Artwork created for a concept challenge. I had a lot of fun with the idea of a turtle gondola.

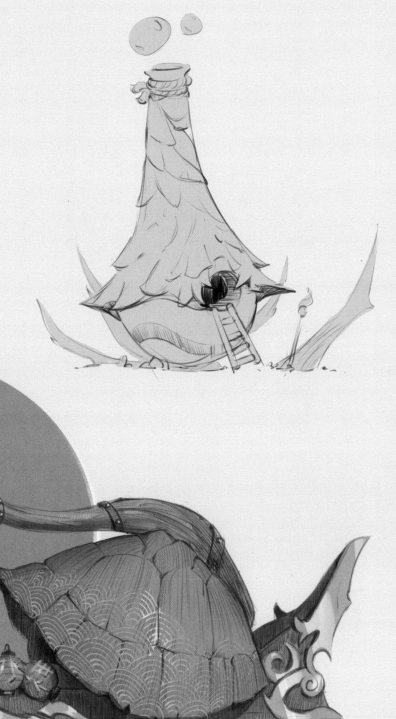

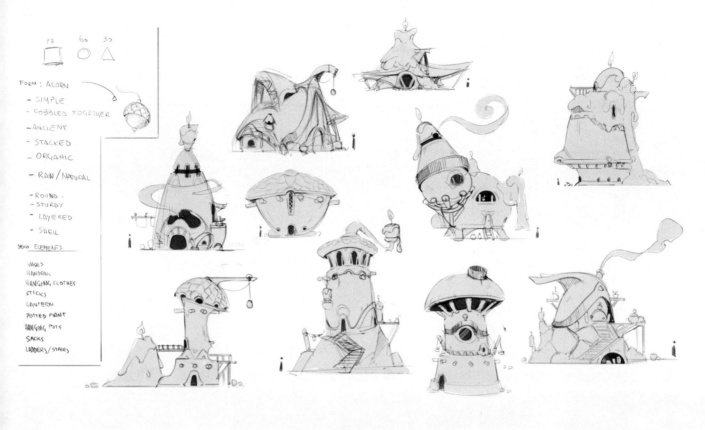

FORM : ACORN
- SIMPLE
- COBBLED TOGETHER
- ANCIENT
- STACKED
- ORGANIC

- RAW / NATURAL

- ROUND
- STURDY
- LAYERED
- SHELL

DECO ELEMENTS

VASES
HANDRAIL
HANGING CLOTHES
STICKS
LANTERN
POTTED PLANT
HANGING POTS
SACKS
LADDERS / STAIRS

CANDLETOWN'S BEACON

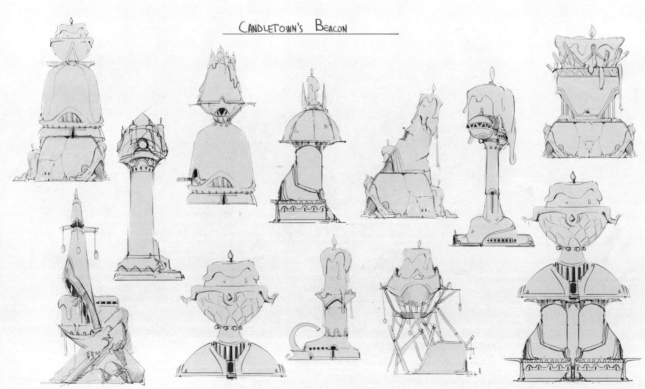

"Trying to find the fantastical in the everyday is a lot of fun"

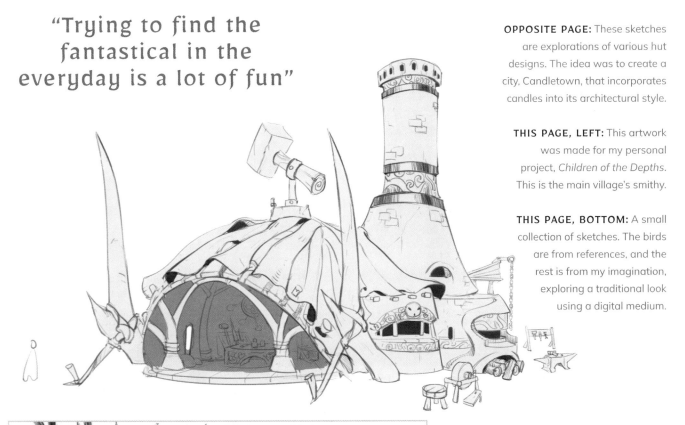

OPPOSITE PAGE: These sketches are explorations of various hut designs. The idea was to create a city, Candletown, that incorporates candles into its architectural style.

THIS PAGE, LEFT: This artwork was made for my personal project, *Children of the Depths*. This is the main village's smithy.

THIS PAGE, BOTTOM: A small collection of sketches. The birds are from references, and the rest is from my imagination, exploring a traditional look using a digital medium.

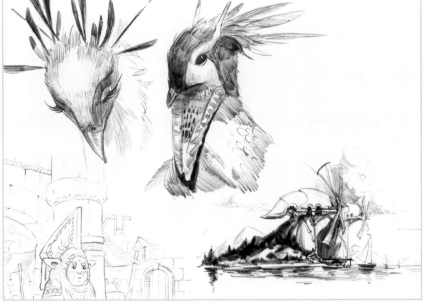

SKETCH FROM LIFE

I will never get tired of telling young artists to get out there and sketch. Draw from life and observation as much as possible. Carry around a small sketchpad that you can fill with drawings whenever you find yourself waiting around during a commute, or in line at a doctor's appointment. Sketching is a skill that has been lost in recent years – even I didn't really do enough of it when I first started out!

Gjorgievski, Damjan

damjangjorgievski.com
All images © Damjan Gjorgievski

I was born in 1995 in a small mountain town in Macedonia. Leaving my parents and brother out of any introduction would be unfair as they have been my biggest supporters for as long as I can remember. My parents introduced me to sci-fi and fantasy movies, books, and video games from a very young age due to their own inclinations toward fantastical themes. However, since my homeland as an environment had a very limited amount of that to offer, I began to feel deficient of stories, heroes, myths, and legends. That was probably my biggest drive to start creating my own worlds. For most of my childhood, I drew my characters and crafted their stories on any kind of paper, using any kinds of pens or pencils.

The main reason I enjoyed (and still enjoy) doing this is probably the fact that I can share my inner worlds with someone else. I have always wanted to create heroes for people to aspire to, complex villains for people to despise, and to deconstruct philosophies and religions in order to better understand and rebuild my own. Ultimately, I do all of this so that I may better understand the world around me. And seeing someone discover and enjoy my work just makes me happy. In addition, there is nothing like the sound and feeling of graphite on paper.

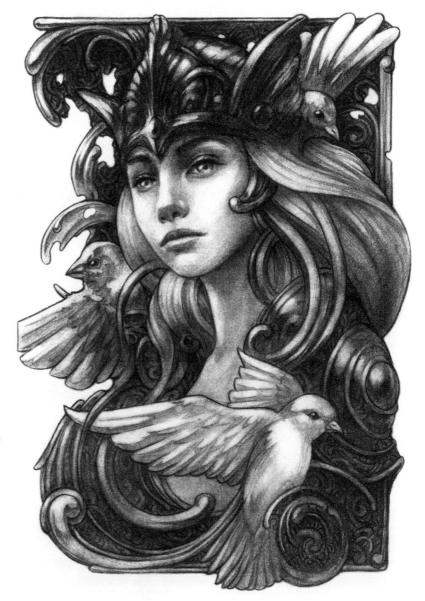

INSPIRATION AND IDEAS

My three biggest sources of inspiration are nature, mythology, and video games. The majority of my free time is spent working on a few worlds that I have created so far. Each moment drawing something is like taking a walk in the fantasy world and sketching what's there. I think of how the subject will fit into the local and more global setting, what its purpose would be, and if it would naturally be there, as I like my worlds to feel real.

MATERIALS

For my personal projects I use mostly graphite pencils. That way I can be away from the screen and immerse myself in what I am doing without any distractions. Sometimes, taking that further, I go to draw in nature in peace. I pick up charcoal from time to time; however, as my space is very limited, it turns into a mess very quickly, which deters me from doing it more frequently. One big part of my drawing process is using the eraser, as I do enjoy playing around with a more "painterly" look using graphite. I enjoy paints and brushes as well.

TECHNIQUES

Most of the time I prefer to experiment with my approach. I do not have a specific process that I follow, because I want to explore and keep projects fresh and exciting. One of my favorite techniques is to simply go in and build up on my errors; I rarely use the eraser to "fix" mistakes, but rather to implement them into my work, using the eraser as a drawing tool in the same way that I would use chalk. Besides that, I use a large variety of pencils, from hard to soft, as I really like the meditative process of gradually building up the shadows and making smooth transitions.

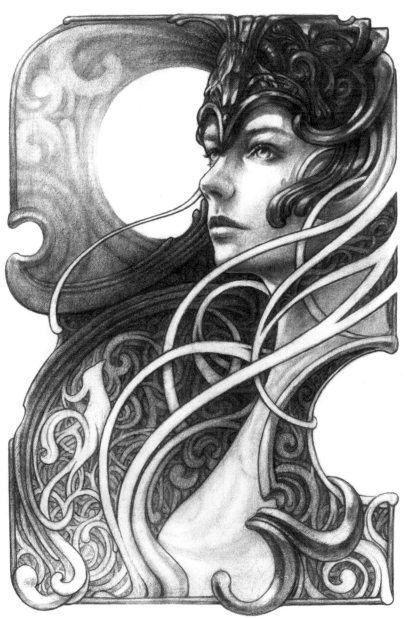

OPPOSITE PAGE: *Freedom*, a drawing inspired by the arrival of spring.

THIS PAGE: *Aspiration*, one of several Art Nouveau-inspired pencil portraits I have made.

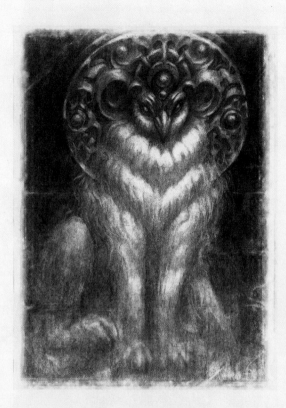

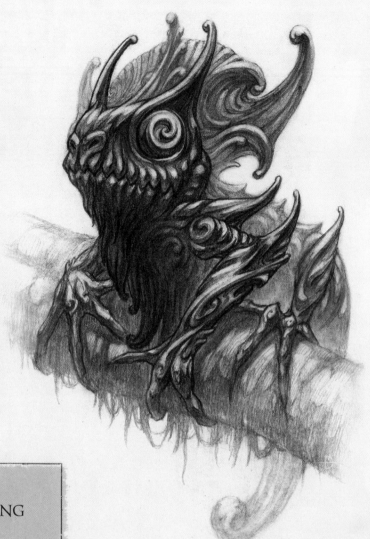

DRAW FOR THE JOY OF DRAWING

One of the pieces of advice I give to people most frequently is to do what they love. Learn to enjoy the process itself without worrying too much about the end result. On many occasions, I see people getting stuck with social media, trends, mimicking someone else's work, and listening to what society tells them to be to the degree that they lose the joy of creating. Sit down and take some time for yourself and your sketchbook. Remember the feeling that got you into this craft in the first place. Indulge in it.

BOTH PAGES: Exploring my *Alariel* project as part of the Creatuanary monthly challenge.

"There is nothing like the sound and feeling of graphite on paper"

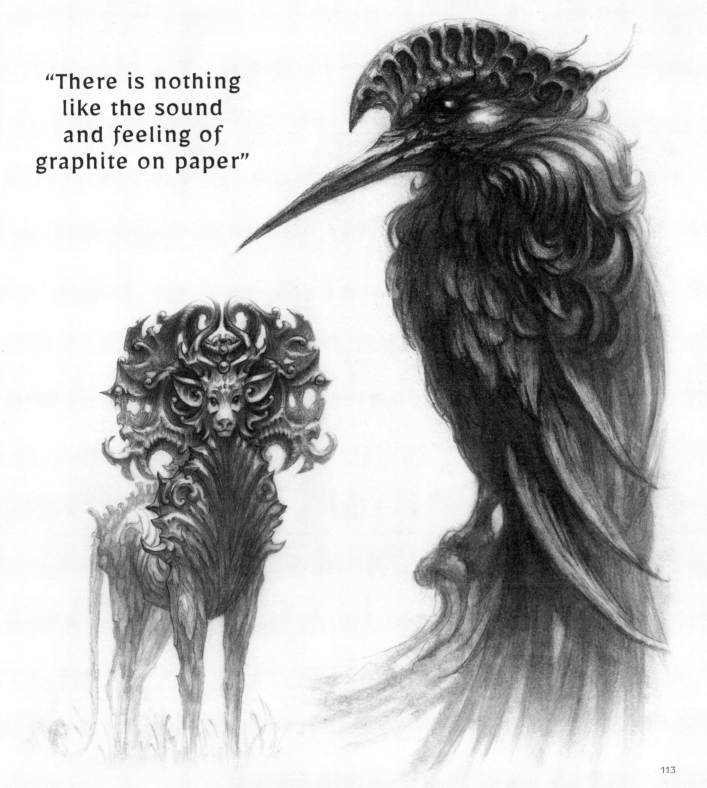

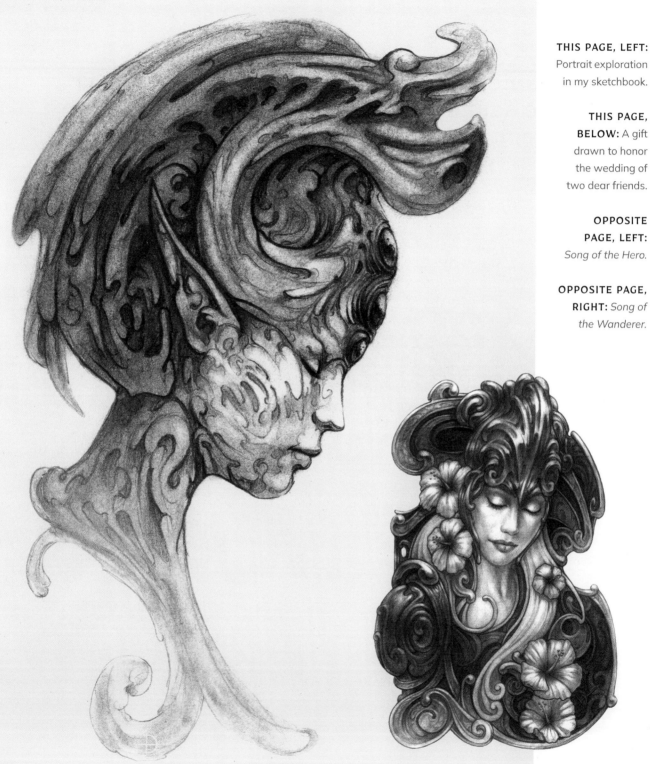

THIS PAGE, LEFT: Portrait exploration in my sketchbook.

THIS PAGE, BELOW: A gift drawn to honor the wedding of two dear friends.

OPPOSITE PAGE, LEFT: *Song of the Hero.*

OPPOSITE PAGE, RIGHT: *Song of the Wanderer.*

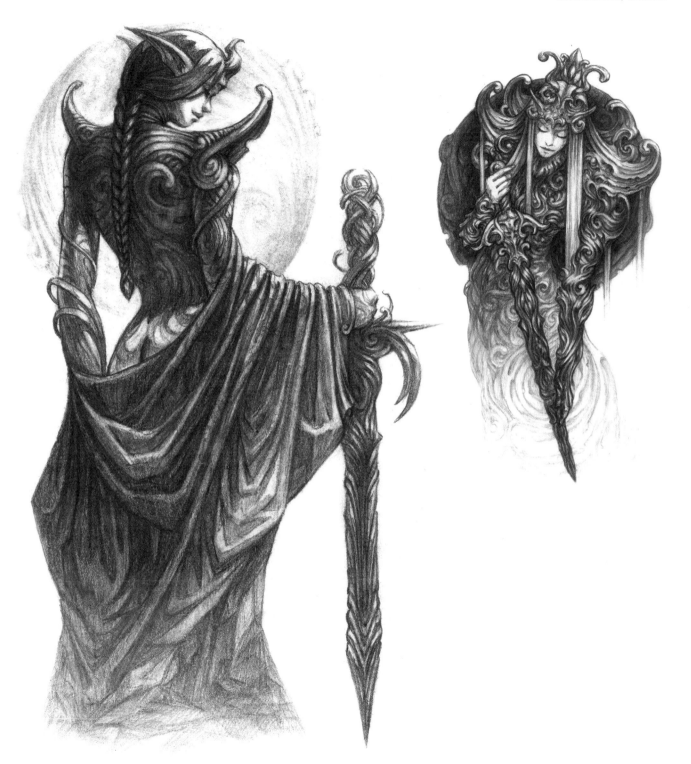

Grintsova, Anastasia

instagram.com/ana_griin_art | artstation.com/anastasiagrintsova

All images © Anastasia Grintsova

I am a freelance artist who usually works as a concept artist. I'm just a human who started drawing once and hasn't stopped since! I love to draw and create character designs for different worlds, and I'm especially drawn to the genre of fantasy.

INSPIRATION AND IDEAS
◇◇◇◇

I am inspired by many things. All of life and any environment is an inspiration for my work. People, nature, animals – the whole world is beautiful and full of vivid images. Sometimes you just need to leave your house and observe what surrounds you. For example, look at the sunset or the dawn, and try to catch those transitions of color and light and keep them in your memory. The same goes for interesting silhouettes and people. You can find inspiration everywhere – you just need to look closely!

As for inspiring artists, I love the paintings of the Old Masters. I love the work of Valentin Serov, Jan Matejko, Anders Zorn, John William Waterhouse, Ilya Repin, and Richard Schmid. These and many other masters inspire me every day. I also adore sculpture.

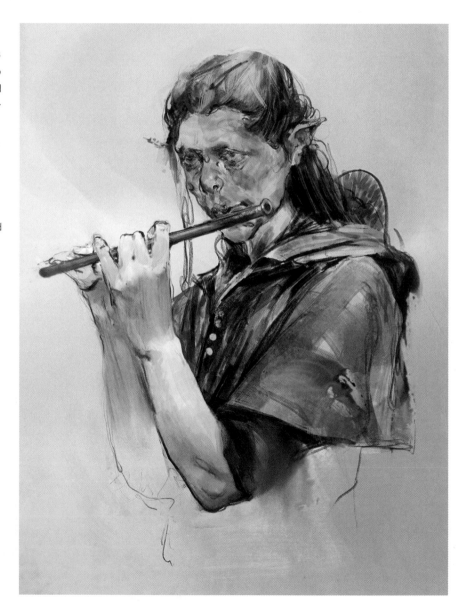

MATERIALS

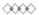

I usually draw in Adobe Photoshop
as my work requires it. I often use
photobashing in my work, and many
other methods that help me speed up
the process of drawing, to deliver work
on time. I also like drawing with ink
and love to paint with oils on canvas.

TECHNIQUES

I try to combine traditional painting and
digital tools to achieve a more painterly
result in my work. By combining
Photoshop and ink, for example, I can
achieve a unique flow of more organic
strokes. I simply paint on canvas or
paper with oils or watercolor, then
take pictures of these pieces and
use them in Photoshop as a base for
further work. This technique helps my
drawings feel more "alive." I also often
use the Mixer brush in Photoshop.

OPPOSITE PAGE: A sketch
of an elf musician character.

THIS PAGE: A concept
sketch of an old king.

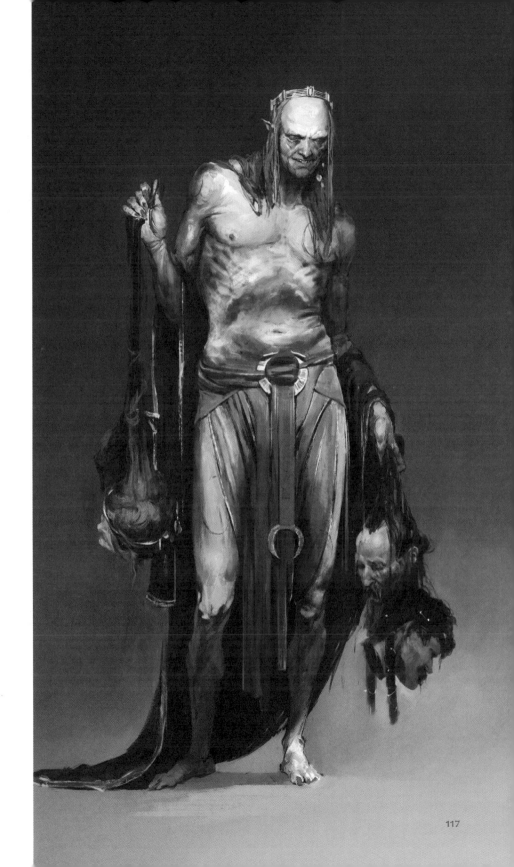

117

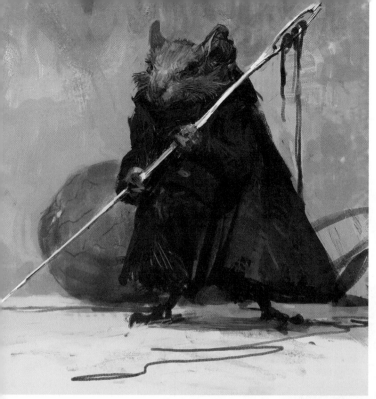

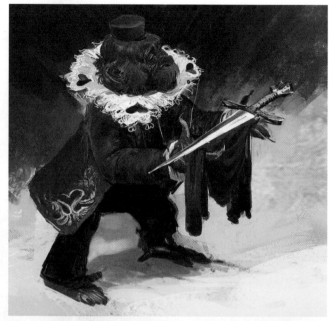

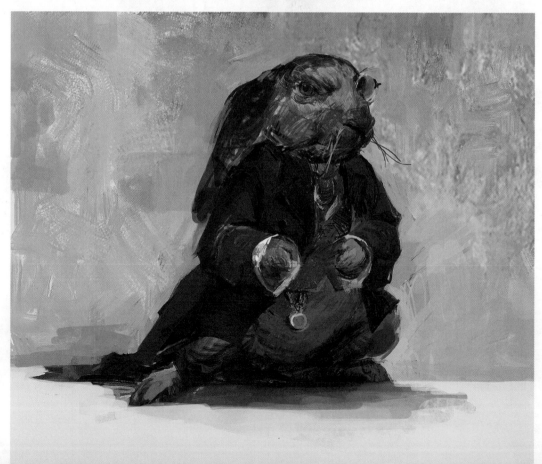

OPPOSITE PAGE: Three animal characters inspired by the world of *Alice's Adventures in Wonderland.*

THIS PAGE, RIGHT: A portrait sketch of a witch character for a personal project.

THIS PAGE, BELOW: A portrait of a girl made with ink and Photoshop.

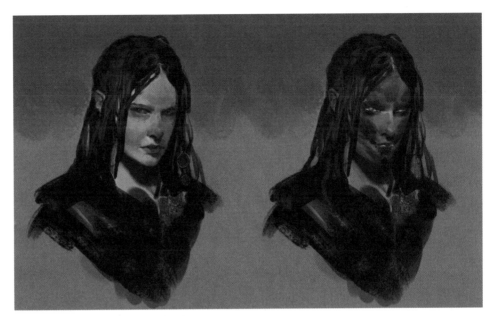

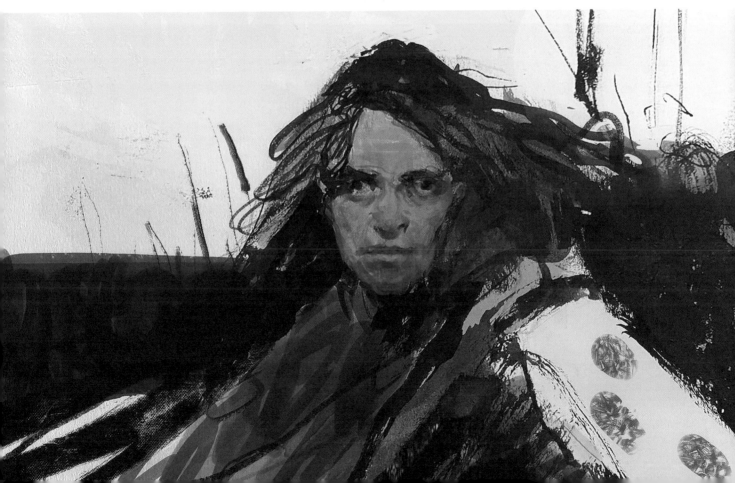

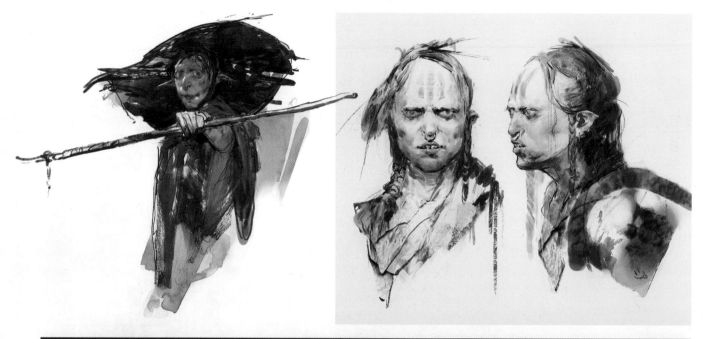

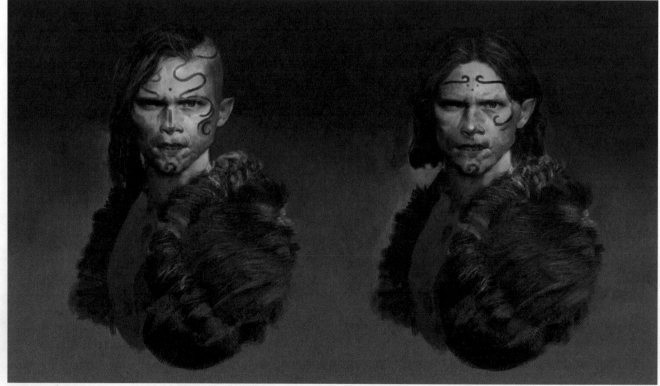

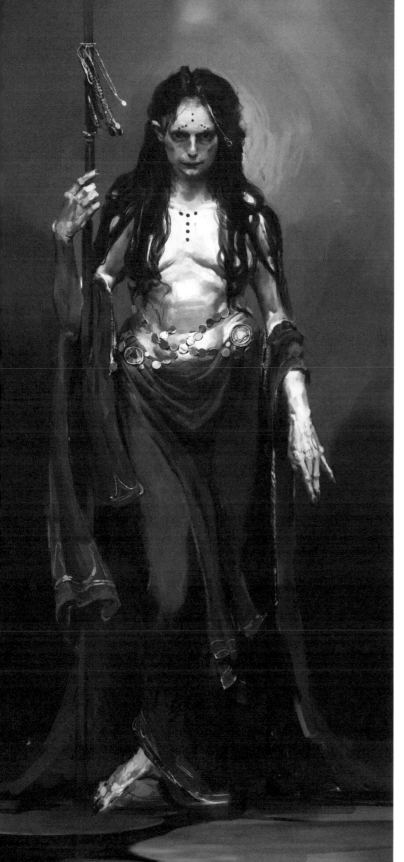

OPPOSITE PAGE, TOP LEFT: A quick sketch of an elf warrior made with ink and Photoshop.

OPPOSITE PAGE, TOP RIGHT: Photoshop portrait sketches of an orc character.

OPPOSITE PAGE, BOTTOM: Personal concept sketches of a young warrior.

THIS PAGE, LEFT: A concept sketch of a witch character.

THIS PAGE, BELOW: Another character sketch made with ink and Photoshop.

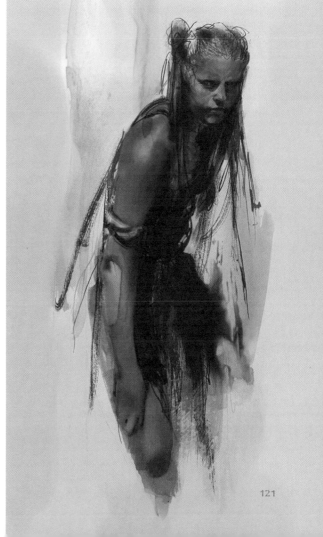

121

Hokama

instagram.com/noiaillustration

All images © Hokama

I've been drawing since I was a child. I have memories of starting to draw when I was four years old. Drawing has always been something close to me: a kind of voice to express myself, which is sometimes good and sometimes not so good. I'm always researching and studying art and illustration. I try to put a little of everything I learn into my drawings, so I don't follow a single concept or theme. I have a predilection for fantasy, mythology, and everything that involves them.

INSPIRATION AND IDEAS

I believe that my greatest inspiration comes from Mother Nature. I am passionate about animals and they are constantly present in my work. I'm also fascinated by movies and sometimes video games, and I always take inspiration from these kinds of media.

MATERIALS

I work mostly with traditional tools and sometimes with digital ones. My favorite tools are a graphite pencil and pen and ink.

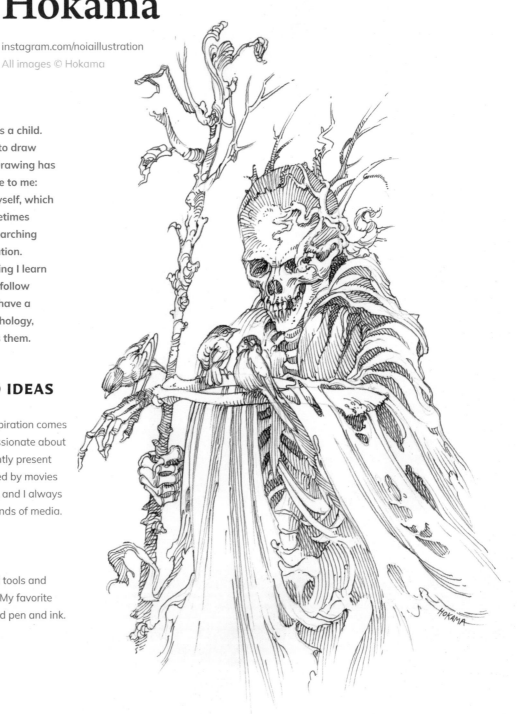

TECHNIQUES

I always start my projects with a pencil thumbnail sketch of what I intend to do. In it I define the main elements, composition, and light and shadow, so I don't get lost later in the process.

My drawings have a lot of detail, so I like to use techniques appropriate to this style. When using graphite, I use several layers to build up different shades. When I use pen and ink, I use cross-hatched lines. I like to get lost in this technique – I've drawn several hatched pieces inspired by metal and wood engravings. I'm always practicing and exploring different ways of doing cross-hatching.

OPPOSITE PAGE:

A guardian skeleton, protector of forests.

THIS PAGE: A barn owl lurking hidden among the trees.

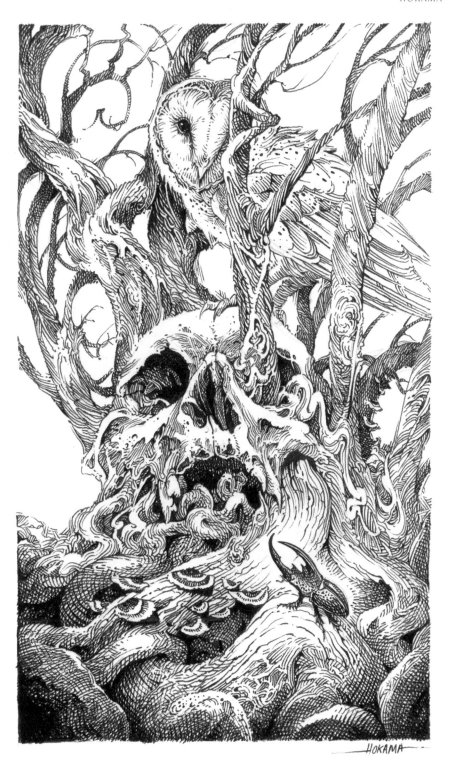

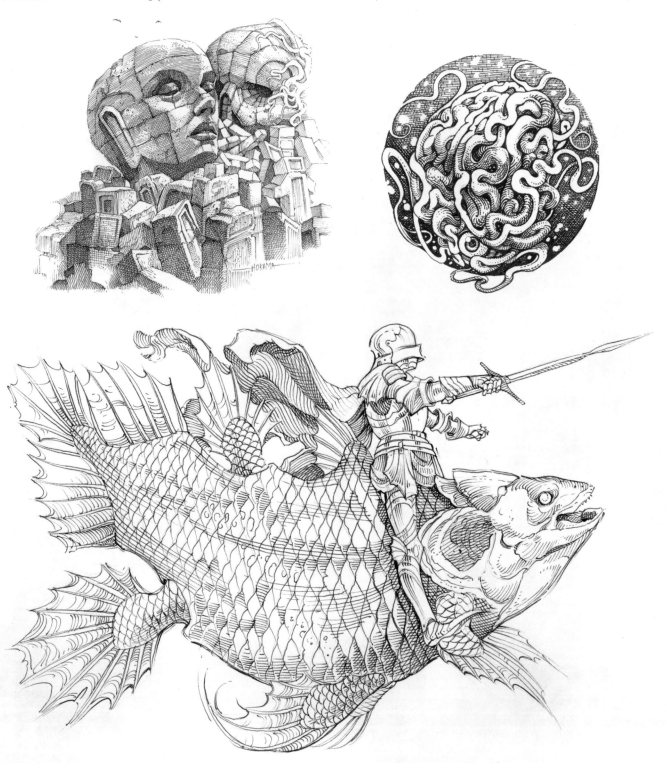

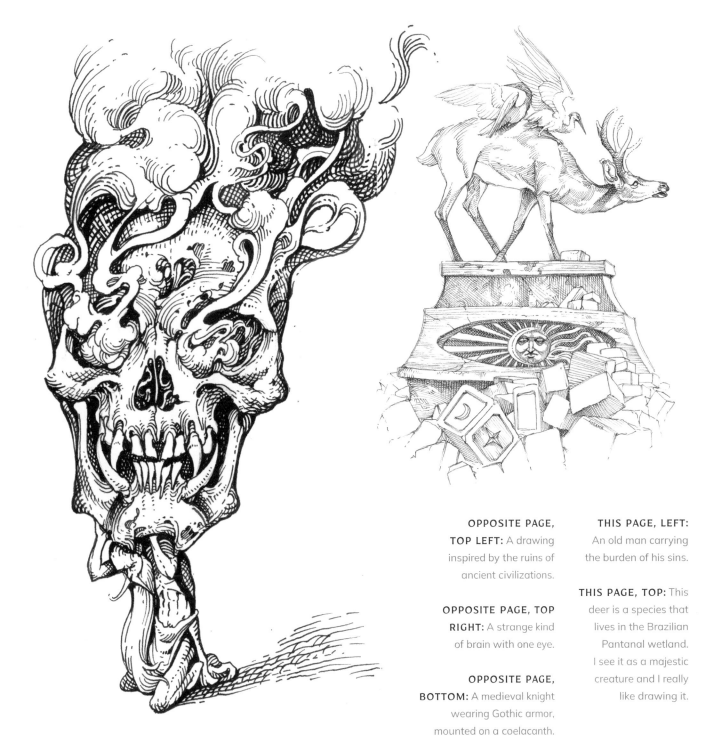

OPPOSITE PAGE, TOP LEFT: A drawing inspired by the ruins of ancient civilizations.

OPPOSITE PAGE, TOP RIGHT: A strange kind of brain with one eye.

OPPOSITE PAGE, BOTTOM: A medieval knight wearing Gothic armor, mounted on a coelacanth.

THIS PAGE, LEFT: An old man carrying the burden of his sins.

THIS PAGE, TOP: This deer is a species that lives in the Brazilian Pantanal wetland. I see it as a majestic creature and I really like drawing it.

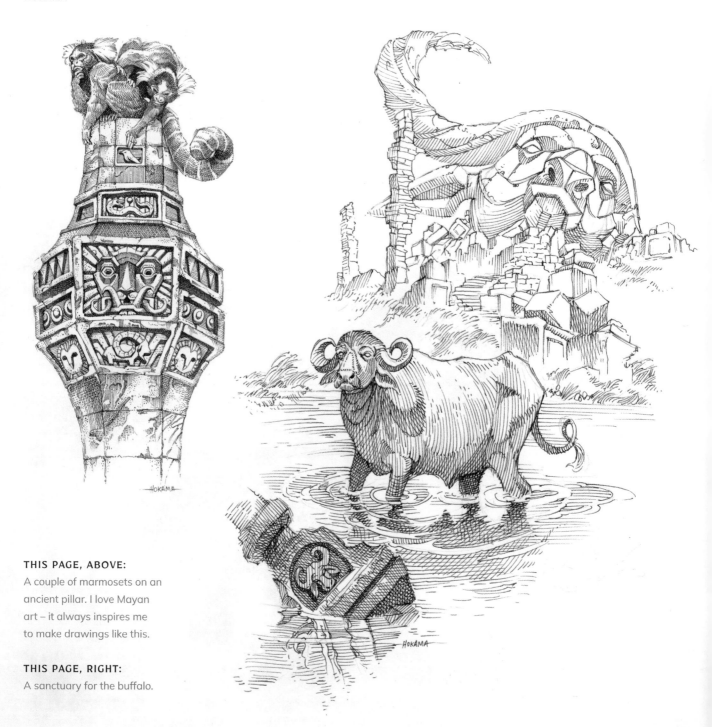

THIS PAGE, ABOVE:

A couple of marmosets on an
ancient pillar. I love Mayan
art – it always inspires me
to make drawings like this.

THIS PAGE, RIGHT:

A sanctuary for the buffalo.

THIS PAGE, RIGHT:
A plein air drawing with some tentacles coming from the depths.

THIS PAGE, BELOW:
A dead bird shrouded in mist.

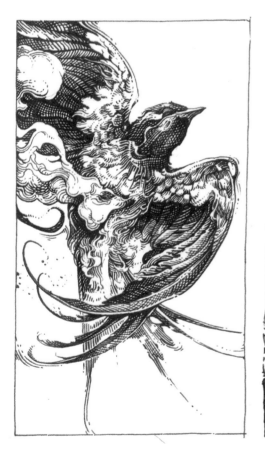

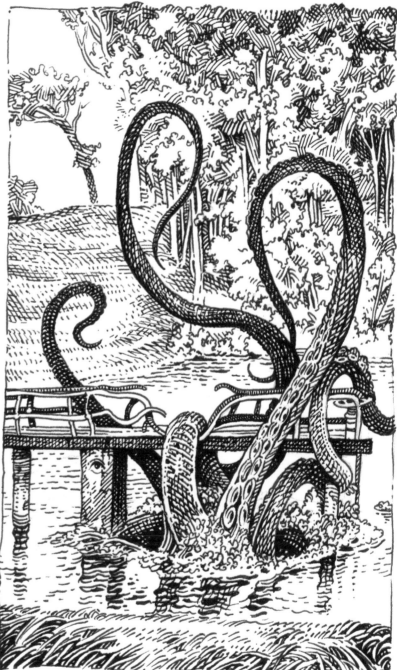

Kazalov, Boyan

artstation.com/bbobyxp
All images © Boyan Kazalov

I've always had a very fascinating obsession with art – it's something that has had a huge influence on my life since childhood. However, it wasn't until I was first exposed to fantasy, in the form of video games and comics, that my interest in art really peaked. My mind was in a constant state of curiosity; every time I picked up a pencil, I felt an overwhelming sensation of all of the infinite things there are to draw. That's something that has always excited me. It's a feeling that I'm very grateful for and that continues to exist after more than two decades of drawing.

I find sketching extremely therapeutic. It allows me to immerse myself in my artwork and express all of my thoughts and ideas on the canvas, constantly striving to create something new that's never been seen before, and hopefully inspiring others along the way.

Fantasy and magical themes are almost always present in my drawings in one way or another. I think it's really exciting to be able to explore and illustrate things that we would never be able to see or do in our everyday lives. Sometimes it's just fun to escape into another world where things are different.

THIS PAGE:
Using enchanted artifacts, Lily the Fishtamer is able to communicate with the fish around her.

INSPIRATION AND IDEAS
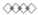

My inspiration used to come mainly from various games and anime, and a lot of it still does. However, I have recently found myself drawing more inspiration from simple day-to-day life. I started paying a lot more attention to what's around me: the clothes that people are wearing, the different types of plants and flowers in nature, and animals interacting with the environment. All of these things provide me with subtle, everyday inspiration that tends to slip into my art.

MATERIALS

For my client work, since most of it is done digitally, I tend to use Procreate for the initial sketches and designs. It gives me the closest feeling to pen and paper and allows me to do my work pretty much anywhere. For my personal art, however, I really enjoy drawing in a sketchbook. I usually use a 0.05 mm ink pen for this, as it allows me to add a lot of small details to my art and really commit when putting down lines. It's also a great alternative if I need to take a break from the screen but want to keep the art momentum going.

TECHNIQUES

A lot of the time, I just go straight into a drawing with a simple idea in my head, gradually adding more elements as I continue working on it. I don't tend to use a lot of underlying sketches or construction lines for my drawings, since I usually find they make my art look somewhat stiff. Instead I just try to focus on the overall silhouette of the figure while also taking gesture, shape, and anatomy into consideration.

"Sometimes it's just fun to escape into another world where things are different"

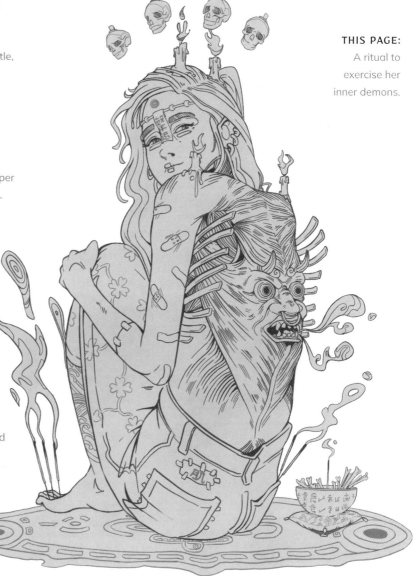

THIS PAGE:
A ritual to exercise her inner demons.

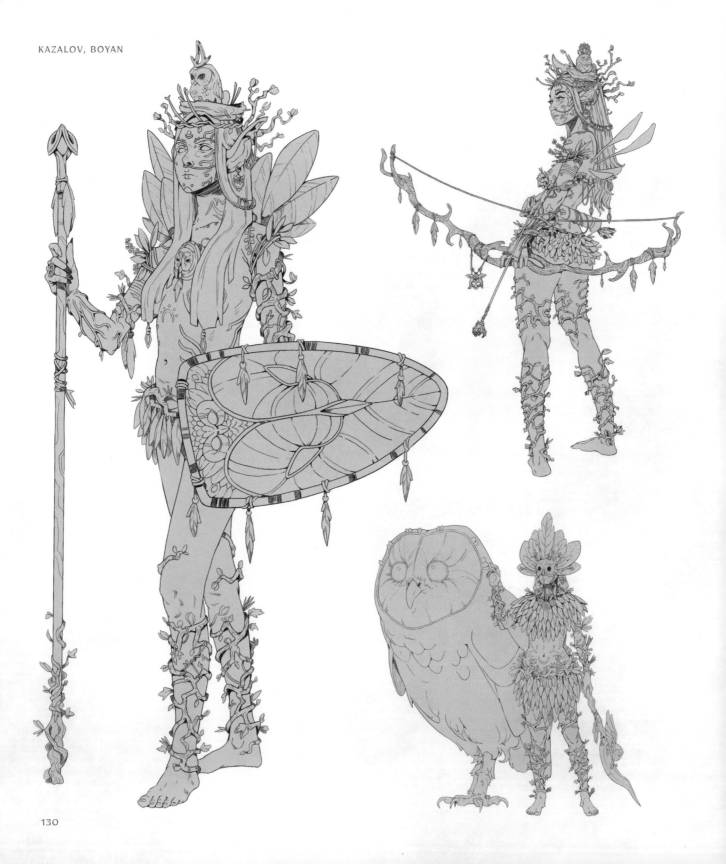

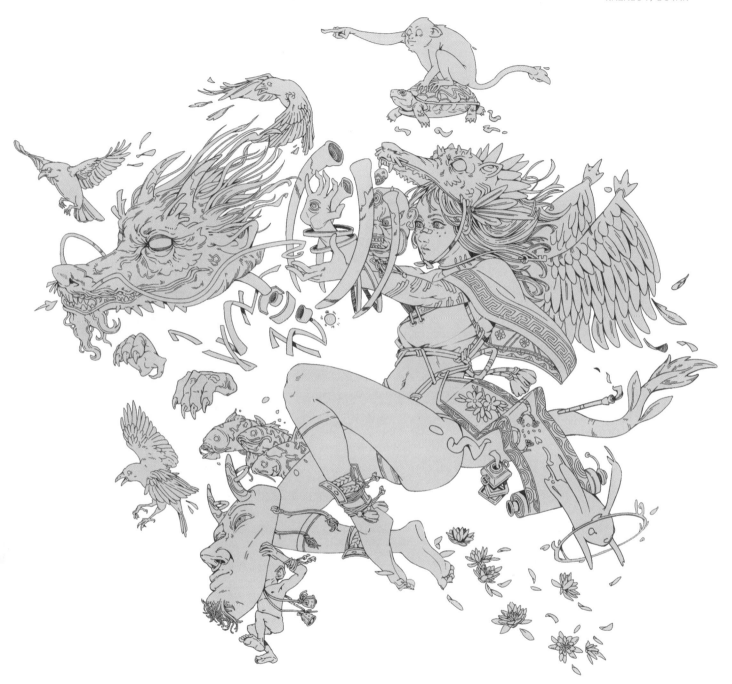

OPPOSITE PAGE: Designs from a personal project about a group of nocturnal elves who worship owls.

THIS PAGE: I wanted to challenge myself and see how many elements I could add to one drawing before things got hectic.

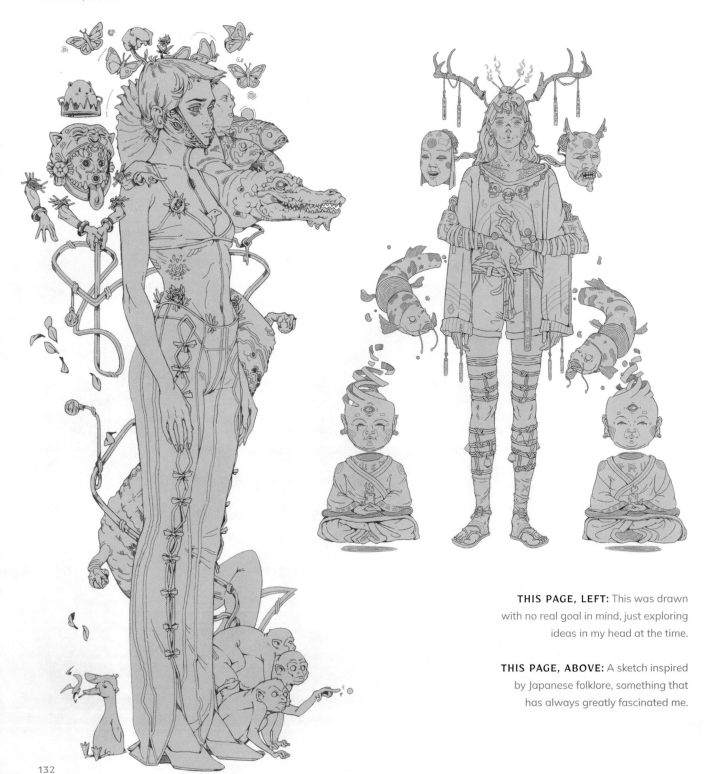

THIS PAGE, LEFT: This was drawn with no real goal in mind, just exploring ideas in my head at the time.

THIS PAGE, ABOVE: A sketch inspired by Japanese folklore, something that has always greatly fascinated me.

TAKING IDEAS FURTHER

When generating ideas and trying to come up with cool and exciting things to draw, something that I've found very useful is to constantly ask myself "What if?" Try to continuously push your ideas and exaggerate your scenarios. This can be done in countless ways: significantly increasing or decreasing an object's size, adding human elements to inanimate objects, or combining elements of past and present. Try to let your imagination loose and see what comes out of it!

THIS PAGE: *Mistress of Light.* Through the darkness, she guides those who have lost their way in the abyss.

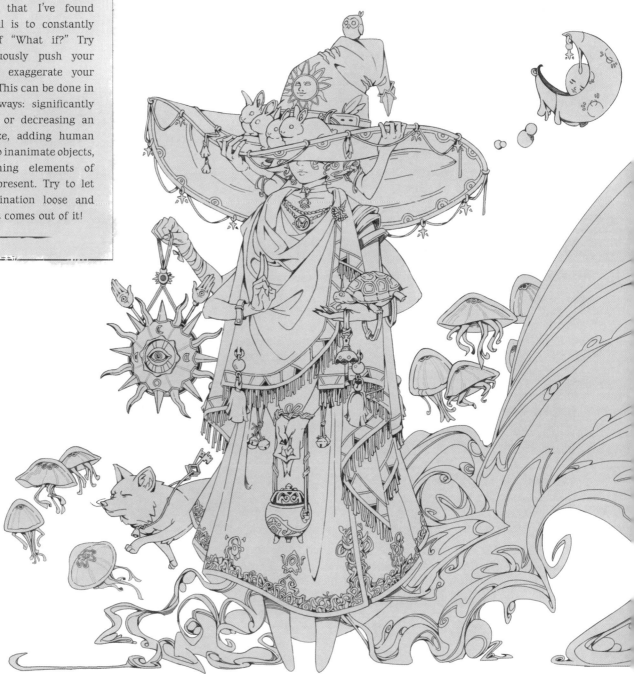

Koniotis, Cos

deviantart.com/coskoniotis
All images © Cos Koniotis

I was born in London, England in 1977, and grew up reading comics by Marvel, DC, Image, and 2000 AD, as well as reading *Fighting Fantasy* and *Way of the Tiger* adventure game books. My favorite characters tended to be the gritty hero type, like Conan, the Punisher, Wolverine, Daredevil, Hulk, Lobo, Batman, and Slaine.

I really credit my older artist brother, Kyri Koniotis, as one of my main inspirations, influences, and reasons for the art I do. We both enjoyed drawing the same subject matter and I remember being heavily impacted at a very young age by things he was drawing completely from his imagination. I always enjoyed drawing and I remember spending hours, at home and in school, drawing comic strips and pinups of my favorite characters, as well as creating my own fantastic characters and worlds.

My first published art was for the collectible cardgame *A Game Of Thrones* by Fantasy Flight Games in 2003. I've since contributed to many projects including *Warhammer Armies* and *40,000*, *Warcry*, *Dungeons & Dragons*, *Magic: The Gathering*, Alexander Royson Jr's hybrid graphic novels *Goliath: The Giant of Gath* and *God's Sword, Giants, and the Demon Wars of Gath*, and more.

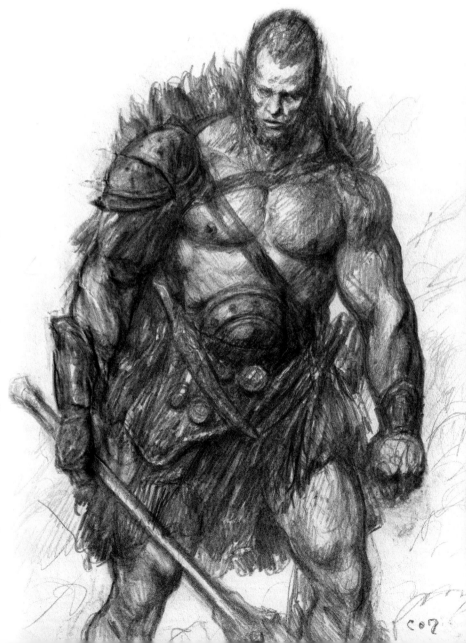

INSPIRATION AND IDEAS

Films are one of my biggest visual influences. I would say I have a cinematic vision and a love for deep shadows, dramatic lighting, mood, feeling, and atmosphere. I love dynamic and powerful action, epic scenes, and art that is quite raw and energetic as well as fully rendered.

Some of my earliest artistic influences were comic books, fantasy art, and films. My early favorite artists, to name a few, were Kyri Koniotis, Simon Bisley, Glenn Fabry, John Byrne, Mike Zeck, John Buscema, Jim Lee, Todd McFarlane, Frank Miller, Bob Harvey, Frank Frazetta, and Jeffrey Catherine Jones. Later influences include fine artists such as John Singer Sargent, Richard Schmid, Howard Terpning, and the Old Masters. Films that also had a big impact on me and my art include *Conan the Barbarian*, *The Lord of the Rings*, and *Troy*, among many more.

MATERIALS

I primarily use Adobe Photoshop, but I also like to get down to the very raw basics and just sketch with a pencil in my sketchbook. I don't feel that the materials are really important, but rather the knowledge and style you acquire over time. You can create something with deep feeling, mood, and atmosphere even with the most basic of equipment. However, when I'm able, I like to try inks, watercolors, and other traditional mediums. I think it's good to experiment with materials and find what you like using and what works for you.

TECHNIQUES

I usually like to start quite loosely with fluid, gestural lines alongside blocking out the shadow constructions and carving out the shapes – thinking about the light and just trying to get a good feel for what's going on. I like to go by feel in the beginning. This is the main thing for me, as it helps me to get the right poses, camera angles, compositions, and so on; deciding what the character is doing, thinking, or feeling, and what is happening in the image. Then I tighten things up later as I go along. If I get too tight right at the start, I feel things can be somewhat stiff and I don't quite capture the moment, or who the character is and what they are doing or feeling quite so well. So starting loose and going by feel is what works for me in capturing what I want to achieve in the image.

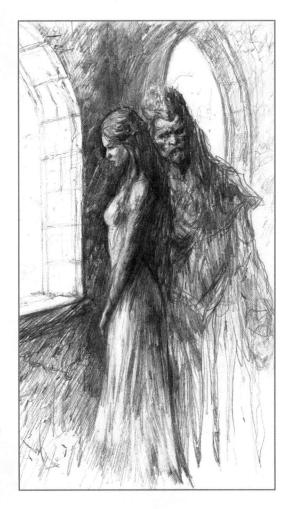

THIS PAGE: The princess awaits her love's arrival. Her father, the king, comforts her as she waits.

OPPOSITE PAGE: A powerful armored warrior gladiator.

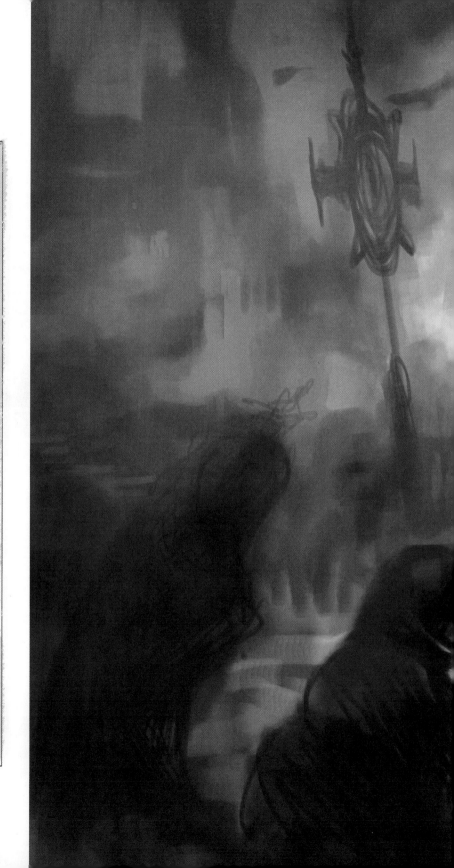

BOTH PAGES: The horseman's journey begins...

IMAGING ANATOMY

I like to work primarily from imagination. It's something that initially came from growing up on comic-book art, where developing a strong base, as well as your style and understanding of human anatomy in various dynamic and powerful poses, was essential. One favorite childhood art book that I fondly remember is *How to Draw Comics the Marvel Way* by Stan Lee and John Buscema. Andrew Loomis' *Figure Drawing for All It's Worth* and George Bridgman's *Constructive Anatomy* and *The Human Machine* also touch on the same subject. I've extensively studied the human body in various poses, angles, and so on, to build my knowledge and ability to create the figure completely from imagination. These studies in repetition eventually lead to your own unique way of understanding and representing anatomy: style. It also gives you the ability to have better control over the art you are making: being able to change poses whenever necessary to heighten feel, mood, drama, and action, and to better capture the moment as the image develops.

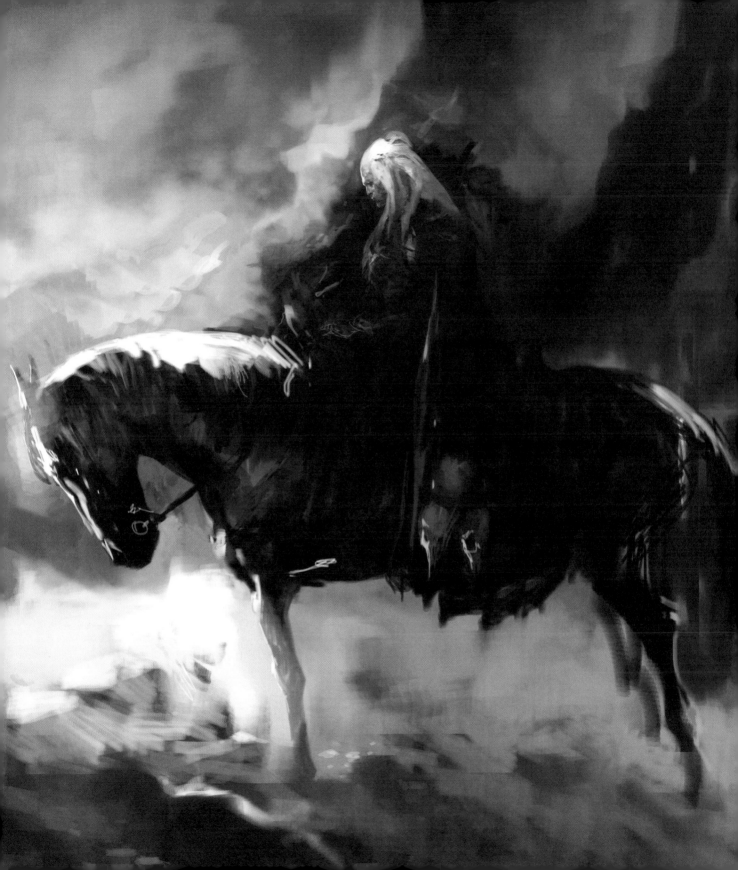

THIS PAGE: *Bloodlines Sketchbook* is a collaborative book by myself and my brother Kyri Koniotis, showcasing both of our art throughout the years. On the left are two pages by Kyri from 1989, when he was aged 17–18, alongside two of mine on the right from around 20 years later. They are all drawn completely from the imagination.

OPPOSITE PAGE, TOP LEFT: Viking-style warriors, ready to raid.

OPPOSITE PAGE, TOP RIGHT: A battle-frenzied barbarian in full charge!

OPPOSITE PAGE, BOTTOM: Paleolithic man claims his kill, engulfed in black smoke and flames.

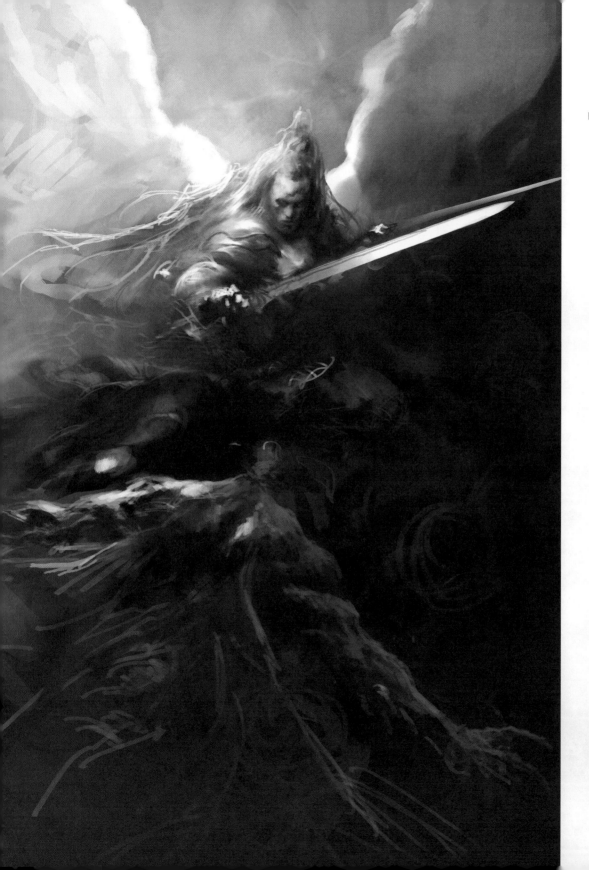

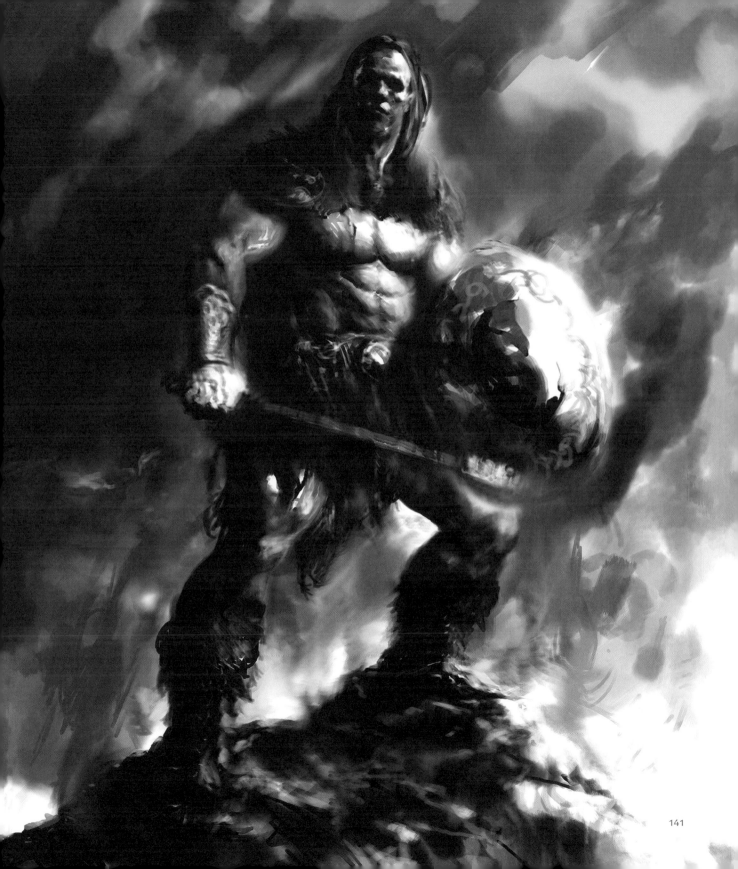

Kornev, Denis

artstation.com/decor88

All images © Denis Kornev

I am an illustrator and designer from Moscow. I mainly create covers and illustrations for e-books by Russian and foreign fantasy authors, in addition to commercial advertising artworks. My passion for drawing began in my early childhood. It was a funny time – I covered tons of paper sheets with my scribbles and sketches! Back then, I was trying to develop knowledge of the world, and paid a lot of attention to portraits and biological drawings. My really serious work as an artist started after my graduation from the Moscow Publishing and Printing College. Now I have been in the industry for around fifteen years.

Sketching is an almost daily activity. It helps me formulate ideas, or think about larger forms and small details. I free my mind and release images onto the paper based on my feelings and experiences. Drawing is a way to transmit emotions – a medium of communication without words. I believe every piece of art carries the soul of the artist. That is the important mission of art and sketching.

INSPIRATION AND IDEAS
◇◇◇

When someone asks me about my source of inspiration, I always answer that it is all around you, in everything you see. While walking or traveling, take notice of small, interesting details in everyday things and objects. Also, the "similarity principle" is a funny thing – you can make out a peculiar face or animal in dirt or paint splashes, or distinguish an exceptional tree form in a small branch. It's a lot of fun!

I have loved sci-fi and fantasy for as long as I can remember, so I translated this love into my everyday employment. I think it is the greatest influence for me. I can be struck by unexpected and breathtaking ideas when I play a video game, watch a beautiful dark fantasy movie, or read a classic sci-fi novel. I also find inspiration in the work of other artists, both contemporary and historical.

THIS PAGE: *Loot Hunter.* Role-playing gamers, do you recognize yourself in this guy?

MATERIALS

I draw sketches only with traditional materials. This gives my images a more tactile sense, more life; they really breathe. I mostly use soft pencils, such as 2B, 5B, and 8B, with thick and thin blending sticks for more delicate results. I also use fineliners in a wide range of thicknesses. I work in Canson sketchbooks with smooth, unbleached paper.

TECHNIQUES

I think that behind every great artwork is narrative. Before starting a new project, I search for and save references for costumes, faces, poses, environments, cultures, and architecture from specific places. All of these things allow me to build believable characters or workable devices and armor.

I sketch with an HB pencil using thin lines, planning the composition and larger forms. I pay attention to the negative space, making an interesting silhouette with the whole composition. Then I fill the darkest places and shadows with 5B and 8B pencils, avoiding "overheating" my drawing and blackening it too much. To create the midtones and a soft, blurry look, I pour graphite powder over my sketch and smudge it, removing the excess powder with a kneaded eraser. For detailing, I use a 2B pencil to add more values and accents to the image.

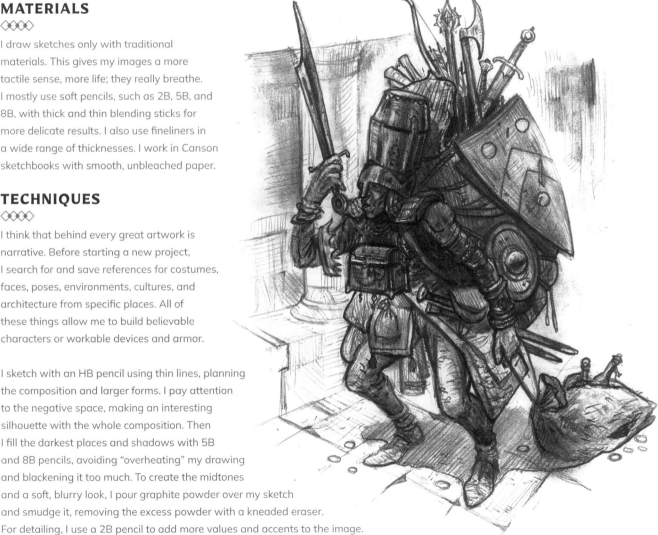

THIS PAGE: *The White Rabbit.* This artwork has been widely spread over the internet. It is my interpretation of the cutest character – Lewis Carroll's White Rabbit.

OPPOSITE PAGE: Some of my sketches from Inktober 2017. Every drawing tells a story in the style of classic high fantasy.

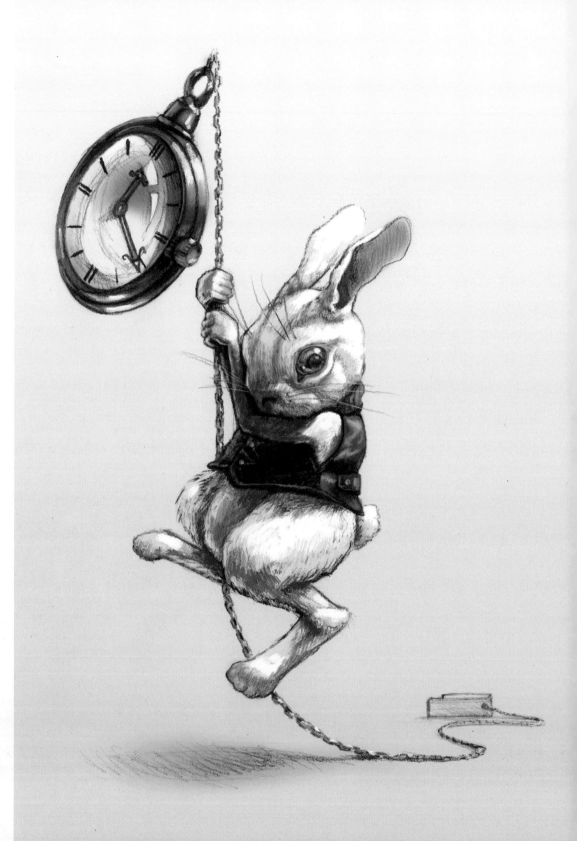

LEARN ANATOMY

Pay attention to the anatomy of humans and animals before you start to draw elves, orcs, or cyborgs. No matter who or what you depict, I advise you to learn how muscles attach to bones, how the body works, and how it changes in motion. These rules are common to almost all creatures and will allow you to portray believable characters.

NARRATIVE ART

I recommend that you give your art narrative. Explore the details, find the composition, and extract your subjects using light. Try to figure out which character placement tells the most story. Set out your idea for the viewer without saying a word.

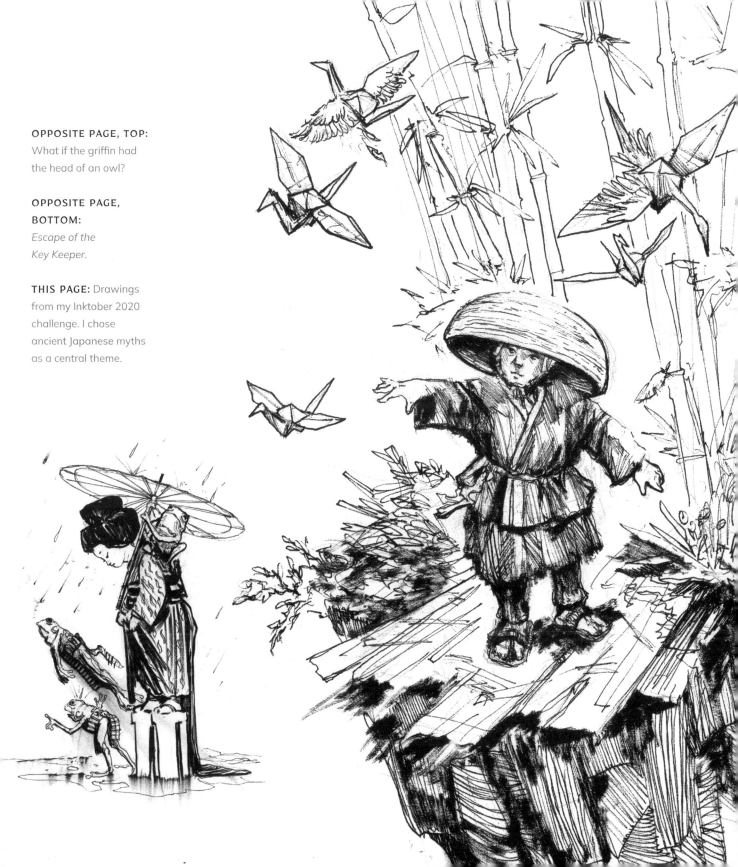

OPPOSITE PAGE, TOP:
What if the griffin had
the head of an owl?

**OPPOSITE PAGE,
BOTTOM:**
*Escape of the
Key Keeper.*

THIS PAGE: Drawings
from my Inktober 2020
challenge. I chose
ancient Japanese myths
as a central theme.

Kwong, Marby

artstation.com/marby

All images © Marby Kwong

I'm an artist from the UK, currently based in California, and I specialize in stylized fantasy artwork. I started drawing from a really young age and began doing digital art in my early teens after I got my first computer. Back then, I would spend most of my time on oekaki image boards, doodling with a mouse, before eventually getting my first graphics tablet when I was fourteen or fifteen years old.

When I was a kid, I was really inspired by Japanese role-playing games on the original PlayStation, so naturally I started drawing a lot of fantasy art. I thought games like *Legend of Mana*, *Final Fantasy*, and *Wild ARMs* looked so cool. Even now, I think they look great and have aged really well. I loved the characters and the worldbuilding, so they have been a huge influence on my work ever since.

THIS PAGE: A jaded mercenary beside the embers of a campfire.

INSPIRATION AND IDEAS

The Lord of the Rings and *Harry Potter* had a huge impact on me when I was growing up and cemented my love for the fantasy genre. The amount of detail and care that went into their worldbuilding was such an inspiration to me. I also grew up watching Studio Ghibli and Disney animations, which probably led me to drawing stylized artwork quite early on. Later, I discovered games like *Ico*, *Shadow of the Colossus*, and the *Dark Souls* series, which have amazing atmospheres. They would leave a huge impact on me and shape my tastes even more.

I also love to look for inspiration in nature. Sometimes, when I'm walking around and I see the light hitting a tree or a stream just right, I take a picture to use as a reference for a drawing later.

MATERIALS

The main software I use these days is Adobe Photoshop. I also use a mix of Blender and 3DCoat to help with more complex compositions that need to be delivered within a shorter timeframe. I don't do much traditional work these days, but I have always loved the feel and simplicity of a ballpoint pen. I also really enjoy using Copic markers.

TECHNIQUES

When painting stylized character portraits, I actually don't use many layers. I try to keep my brushstrokes as concise as possible with an emphasis on laying the marks down with deliberation. I usually paint on one floating layer, and if I am happy with the progress, I will keep merging it down.

For professional or environmental art I will make a sketch (sometimes thumbnailing a few compositions first) and then work out the perspective grid and make sure everything aligns. At this point I will build up the scene in Blender, if it's quite complex or if I am unsure of the lighting or mood and just want to experiment a bit. After that, it's a case of painting and polishing everything up until I am happy with it.

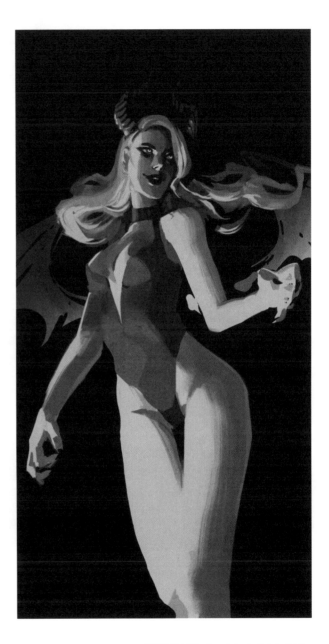

THIS PAGE: A quick sketch I did for fun. I think I just really wanted an excuse to use this neon green color!

KWONG, MARBY

THIS PAGE, RIGHT: I wanted to design a little uniform for the workers of an owlmoth postal service, so this sketch came along.

THIS PAGE, BELOW: These were originally sketches made in preparation for an Inktober challenge.

OPPOSITE PAGE, LEFT: A witch out grabbing ingredients! I love drawing little slice-of-life moments in fantasy settings.

OPPOSITE PAGE, RIGHT: My little witch character, Hildegarde. She's a potion master with a hat based on a pumpkin!

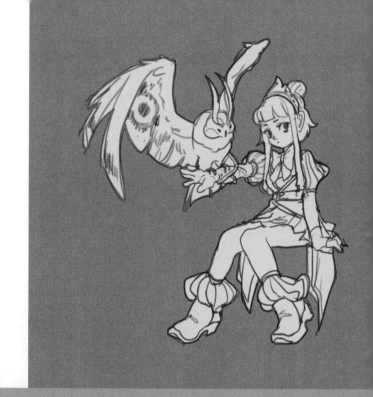

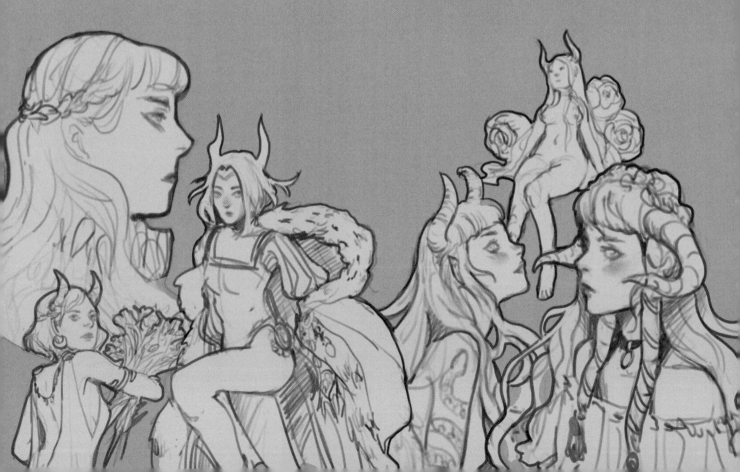

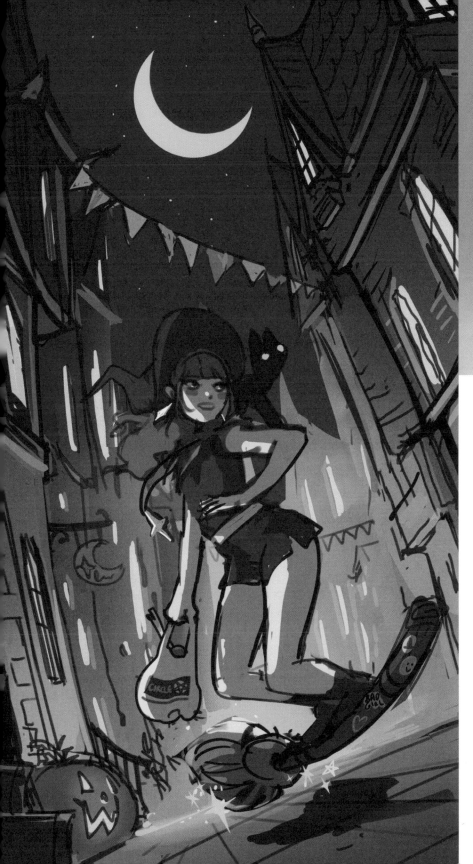

"When I'm walking around and I see the light hitting a tree or a stream just right, I take a picture to use as a reference for a drawing later"

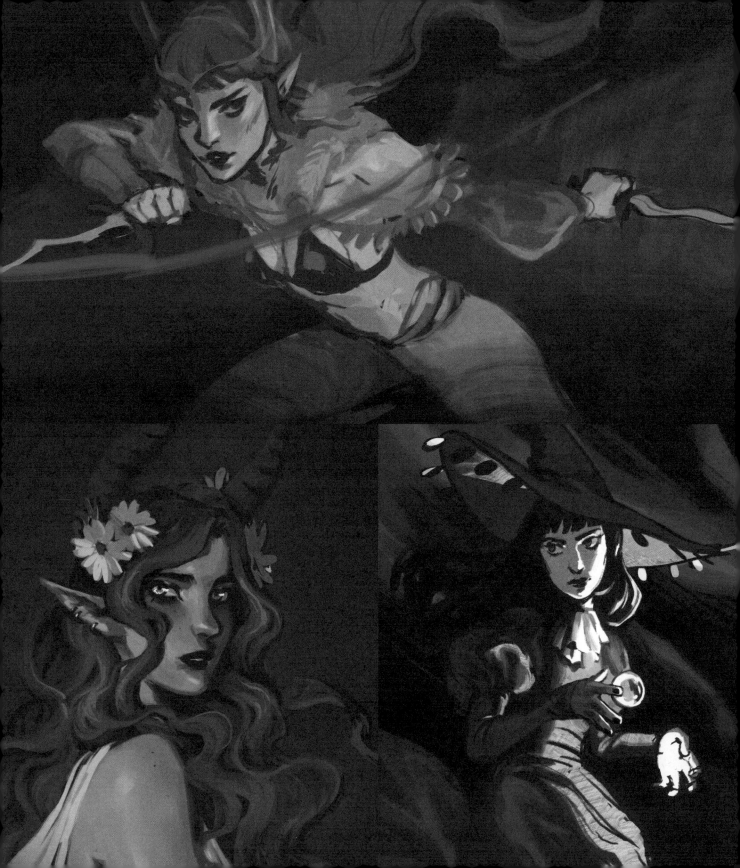

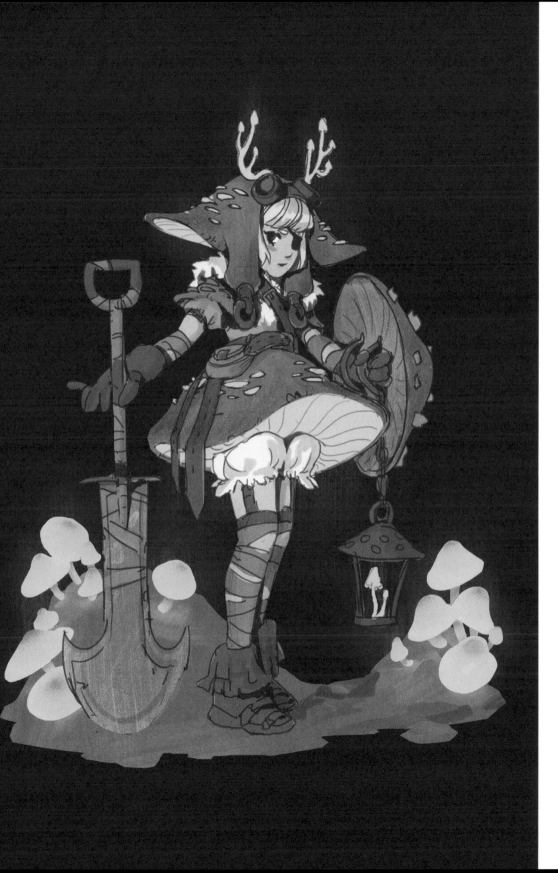

OPPOSITE PAGE, TOP: This was a quick sketch that I never felt like finishing. Sometimes I prefer images at this level of completion.

OPPOSITE PAGE, BOTTOM LEFT: This was a character portrait sketch that I totally forgot about until now!

OPPOSITE PAGE, BOTTOM RIGHT: A witch sketch. Any excuse to use some fun lighting!

THIS PAGE: This was originally a Character Design Challenge with the prompt "Mushroom Knight." She descends the mines in search for Phosphorshrooms.

La Cerva, Francesco

lacerva_art.artstation.com

All images © Francesco La Cerva

THIS PAGE: An axe-wielding female warrior.

I was born in Palermo on the beautiful island of Sicily, where I live to this day. As a child, my parents gave me a pencil and paper to keep me occupied, and I drew, drew, and drew again! As a high school student, I spent a lot of time drawing on desks, in diaries, in notebooks, everywhere. I read a lot of comics and saw many eighties movies. I grew up on bread and the *UFO Robot Grendizer* franchise, known as *Goldrake* in Italy – I loved Japanese robots, they were my passion! I also loved *Conan the Barbarian*. Schwarzenegger? A legend! I remember that as a child I became passionate about Robert E. Howard's fantasy work and drew his stories.

In the meantime, another passion of mine developed: architecture. I remember drawing landscapes and buildings, and inventing castles and cities. I drew everything and I drew continuously. In the end, I chose to pursue architecture, and graduated with full marks. Right from the beginning I started working. I designed houses and gardens, and for many years I dedicated myself to this above all.

Today I support my family, including three children, by working as an established architect. But between my daily commitments designing houses and other buildings, I still feed my soul with a regular diet of books, comics, cartoons, and films. Ever faithful to my first love, I dedicate my free time to illustration, never forgetting the passion that has always inspired me: drawing.

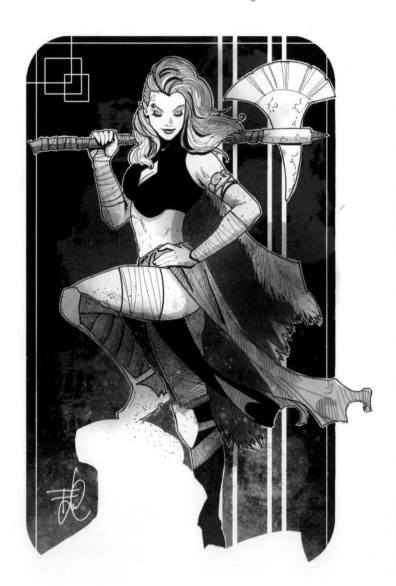

INSPIRATION AND IDEAS
◇◇◇◇

My inspiration and ideas come from comics, video games, role-playing games, manga, superheroes, mythology, fantasy, books, films, and exhibitions. Above all, I'm inspired by the masters of Italian comics, such as Hugo Pratt, Andrea Pazienza, and Dino Battaglia, and international masters such as Mœbius, Frank Miller, Mike Mignola, Jorge Jimenez, and many more.

But if you asked me, "What is your biggest source of inspiration?" I would have no doubts: Sergio Toppi! I love his strokes, and his layout and framing, in which the elements of the composition are connected into a single form where each individual subject is still distinguishable.

MATERIALS
◇◇◇◇

I use pencils, inks, and watercolors – but ink pens most of all. During my university years I learned to master their use. The ink pen is more suitable for experimentation; for creating strong and clear contrasts between black and white, light and shadow, or fullness and emptiness. In my illustrations, the use of color is marginal. I can't explain why, but I just don't use colors often! In recent years, the sheet of paper has given way to the graphics tablet. The advantages that a designer can derive from it are beyond doubt. A new world has opened up to me through digital media.

TECHNIQUES
◇◇◇◇

When I draw, I mainly take care of the layout of my illustration. Just like Toppi and the other Italian masters, I seek a balance between drawn space and white space. White space creates areas of tension that direct the viewer's gaze toward the subject of the drawing. My characters are mostly based in fantasy worlds: fantastic warriors, wizards, heroines, and monsters. Sometimes I draw models from photographs and other times I draw them from life.

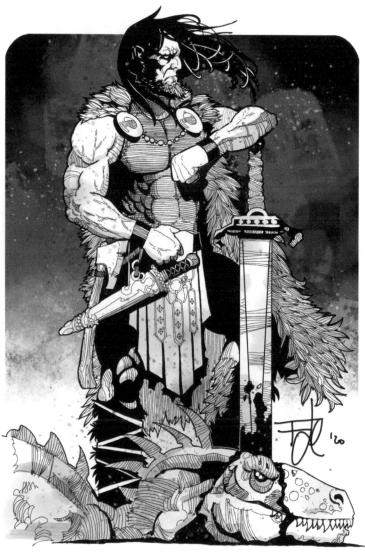

THIS PAGE: A noble warrior defeats his foes on the battlefield.

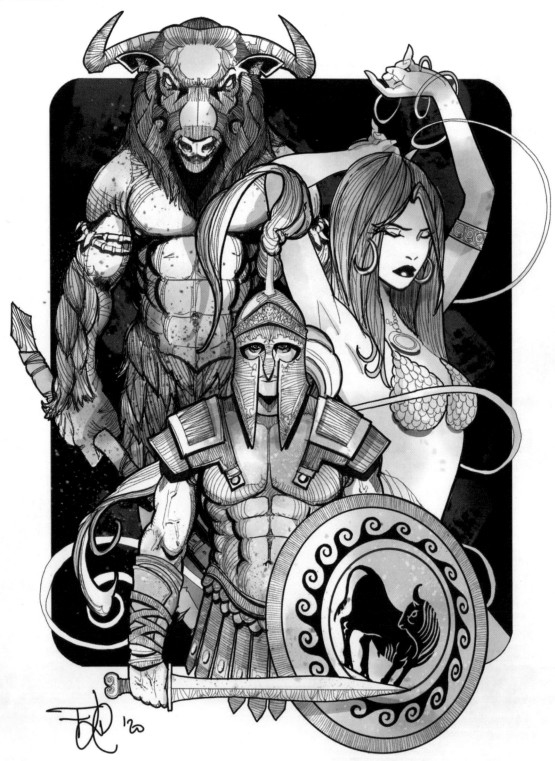

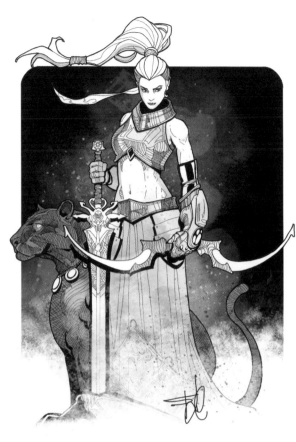

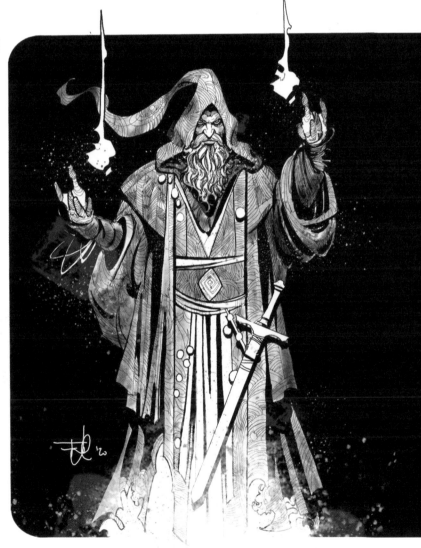

OPPOSITE PAGE:

Theseus, Ariadne, and the Minotaur from Greek myth.

THIS PAGE, ABOVE:

An idea for a female fantasy character accompanied by a panther.

THIS PAGE, RIGHT:

A magic-wielding mystic wizard. Don't get on his bad side!

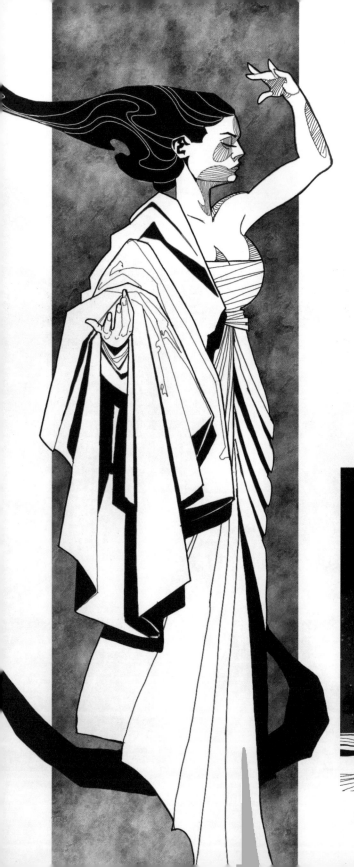

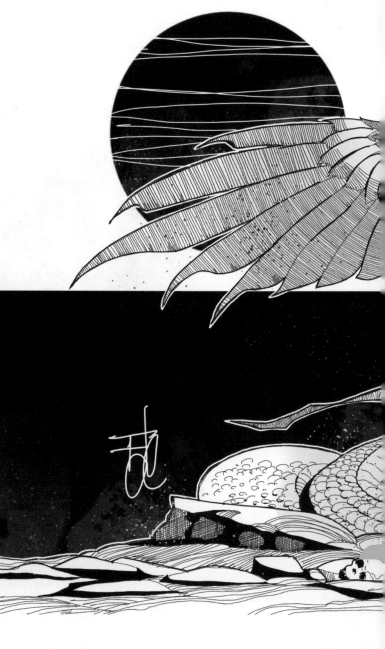

THIS PAGE, LEFT:
Another drawing of a
fantasy character.

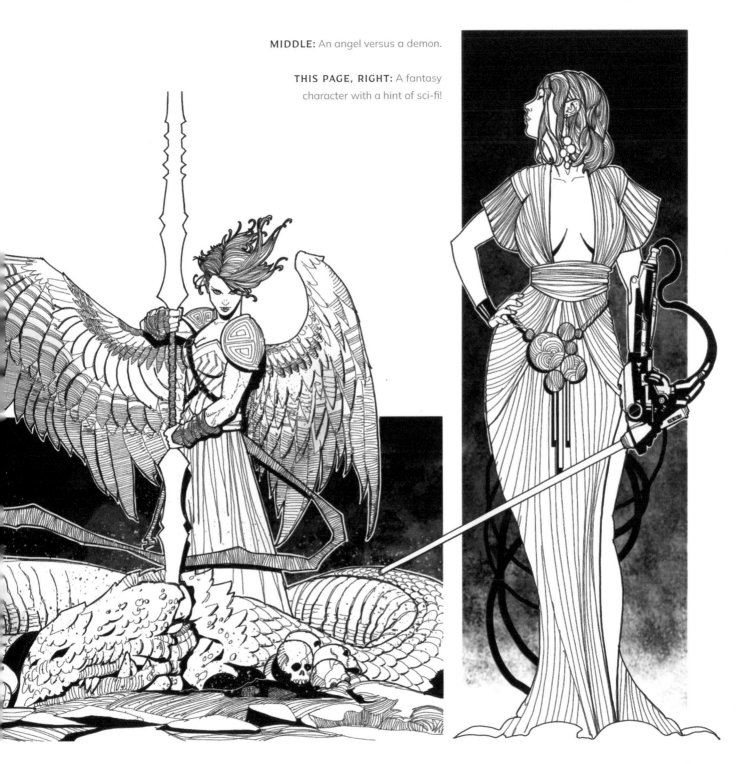

MIDDLE: An angel versus a demon.

THIS PAGE, RIGHT: A fantasy character with a hint of sci-fi!

Lee, Chris Lewis

chrislewislee.com

All images © Chris Lewis Lee

I'm a freelance illustrator and 2D game artist working in the Midlands, UK. I enjoy creating whimsical, cozy, and narrative-focused illustrations centered around my love of fantasy, mythology, folklore, and fairy tales. In fictional worlds, small or potentially mundane choices can have a massive impact on plot and character, whether through magic, the supernatural, or mere luck! Fantasy narratives also enable audiences and creators to explore and express themes, morals, and concepts that mirror our reality, but in a way that has no limitations. They are easy to delve into and enjoy, which I believe is why they are hugely successful.

Alongside this, I just love the absolute freedom I have when sketching fantasy worlds. No rules exist in fantasy, and if they do, I have ownership over them as the illustrator and storyteller. It can be so exciting to have that sort of agency. Whatever I create is valid because I decide what makes sense. The only limitation, I believe, is that good fantasy needs to be grounded, so that we can relate to its world.

INSPIRATION AND IDEAS

My initial spark of inspiration (like many of us) came from video games and film, with the worlds captured in media like *The Lord of the Rings* and *The Legend of Zelda* having a particularly large impact on my childhood self. These mediums have continued to inspire me, although, as I grew older, I also developed an appreciation for nature, history, and morality. I am fond of bringing real-world issues into my work, using it to express how I feel about certain topics without being too serious!

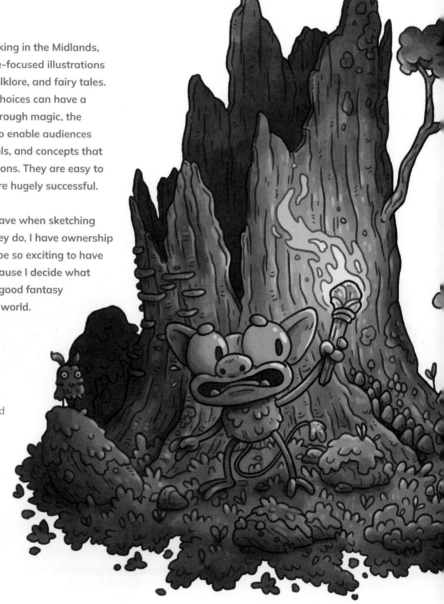

MATERIALS

I mostly work digitally using Clip Studio Paint, although I often use Adobe Photoshop and Procreate too. Whatever the program, I love choosing chunky brushes, as they force me to focus on the shapes and overall design instead of getting lost in the details.

I also enjoy keeping sketchbooks and drawing from life, often sitting with a coffee, hidden in the corner of a café. I use fountain pens for this, focusing on gesture drawing and note-making. As a fantasy artist, I think grounding myself in reality by drawing from life is important and helps with generating ideas.

TECHNIQUES

When starting a new drawing, I begin with a series of thumbnail sketches. These are then developed at a larger scale, retaining the overall simplicity of the image by focusing on the shapes and silhouettes, and eventually progressing into line art. Even then, my first iteration of the line art is sketchy and loose. It isn't until my second (sometimes third) iteration that I will finalize the details.

Recently, on more complex illustrations, I have found using 3D modeling software, such as Blender, to be quite beneficial in the blocking out of shapes and composition.

OPPOSITE PAGE: Naowf the hob, caught out in the middle of the night, lost out and about without his buddy.

THIS PAGE: Knights of the sun and moon. They don't see eye to eye, but fortunately they don't spend much time together!

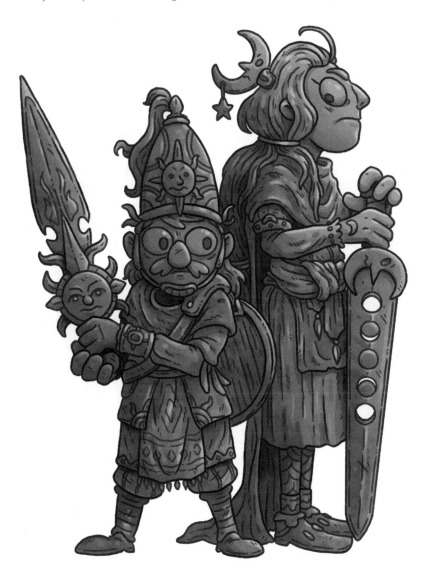

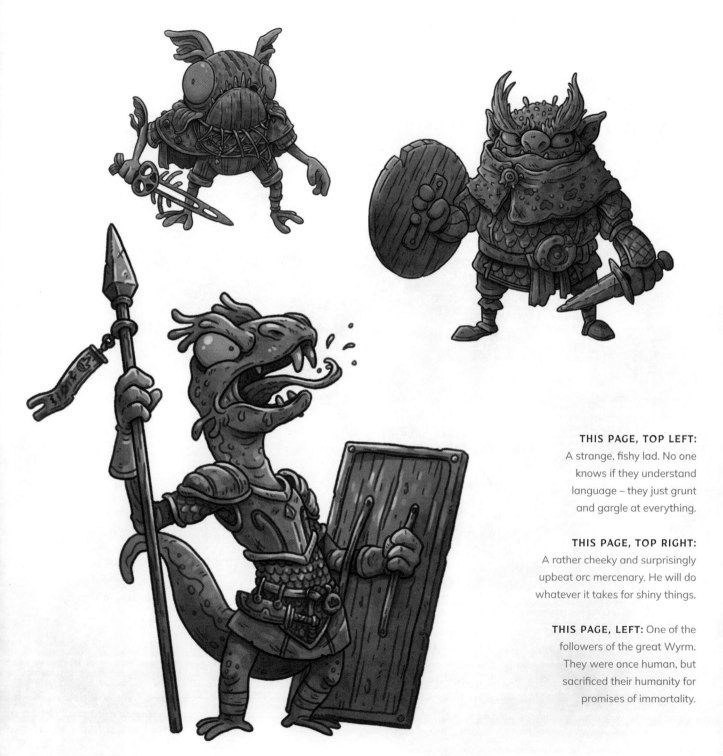

THIS PAGE, TOP LEFT:
A strange, fishy lad. No one knows if they understand language – they just grunt and gargle at everything.

THIS PAGE, TOP RIGHT:
A rather cheeky and surprisingly upbeat orc mercenary. He will do whatever it takes for shiny things.

THIS PAGE, LEFT: One of the followers of the great Wyrm. They were once human, but sacrificed their humanity for promises of immortality.

BUILD YOUR OWN WORLDS

Sketching can be difficult, especially if you're trying to design isolated illustrations and characters. To combat this, I highly recommend creating your own worlds. As an artist, you have complete freedom to build up your own world and its rules, geography, wildlife, cultures, and so on. Worldbuilding will help you to come up with fresh ideas and get you thinking more about a wider narrative.

THIS PAGE: The old man Theok stumbles across a statue of his wife, a hero who died long ago.

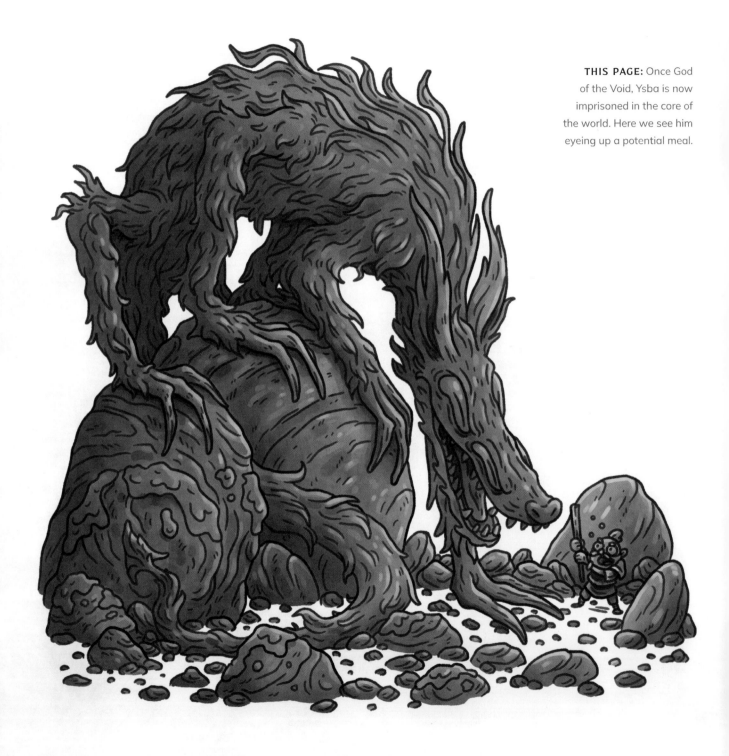

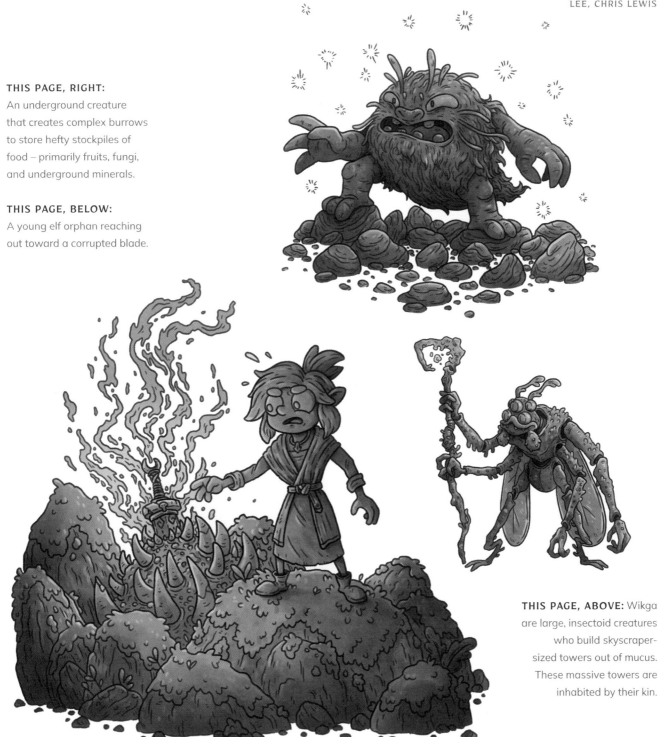

THIS PAGE, RIGHT:
An underground creature that creates complex burrows to store hefty stockpiles of food – primarily fruits, fungi, and underground minerals.

THIS PAGE, BELOW:
A young elf orphan reaching out toward a corrupted blade.

THIS PAGE, ABOVE: Wikga are large, insectoid creatures who build skyscraper-sized towers out of mucus. These massive towers are inhabited by their kin.

Li, Syrena

artstation.com/syrenali

All images © Syrena Li

I have worked in the game industry since I graduated from the Rhode Island School of Design in 2018 with a degree in illustration. I love to draw very much, and have ever since I can remember! I started by copying cartoon books and Japanese animated series, and then moved on to sketching characters from my own imagination. I drew on everything I could find – A4 paper, notebooks, and textbooks – and whenever I wanted, even in class! I still keep the big pile of drawings I did when I was a kid, and the stories I wrote for each of them.

Back then, the internet wasn't as widely accessible as it is now. I taught myself and learned from tutorial books I found in bookstores, as well as comics and illustrated children's books. My mom bought me all kinds of illustrated books when I was little in order to educate me. I immediately fell in love with all the exquisite illustrations. Fairy tales featured heavily among those books. I love stories about magical creatures like dwarves, elves, giants, and dragons. Other than fairy-tale stories, I especially love to read about mythology and the history of ancient civilizations, such as ancient Egypt, China, and Greece.

Later on, I took illustration classes in college, specializing in mythology, magical creatures, and Greco-Roman art history. I also took an Egyptian archaeology class at Brown University, out of interest. Although I can't remember most of the things I learned, these classes left me with a strong impression of these great civilizations and the cryptic mythology born from them, which later influenced my own work.

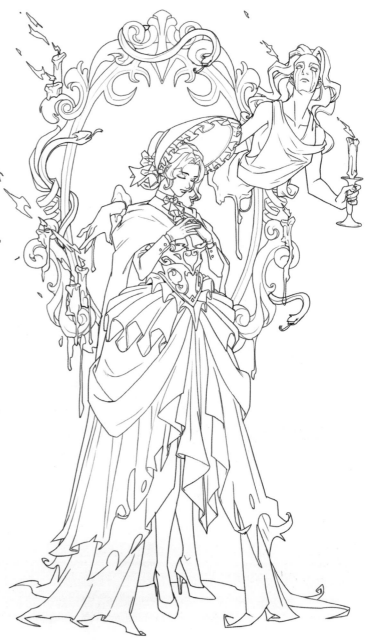

INSPIRATION AND IDEAS

Video games are a crucial part of my life, an inspiration for my work, and the reason why I'm working in the game industry now. The *Monster Hunter*, *Legend of Zelda*, and *Assassin's Creed* games are my favorites. I fell in love with all the epic scenes and powerful magical creatures, and how they all draw inspiration from the real world but alter them into more intriguing fantasy worlds.

Video games, anime, and illustrated books are the three big influences behind all my drawings, but the more direct inspirations would be other artists' work or interesting pictures I find online, on websites such as ArtStation and Pinterest. When I see these images, my brain floods with thoughts and motivation, compelling me to do my own drawings.

MATERIALS

I used to draw with pencil a lot, from my childhood to college, but now I draw mostly with my tablet for work and for personal practice. Pencils and sketchbooks are always great companions for illustrators. The pencil, as a basic drawing material, is easy to control and carry, and is a fast tool for delivering rough ideas.

I learned to use a tablet later on, when I started studying digital painting in my senior year, and it felt very different from a pencil. It's a very powerful drawing tool that can mimic almost all kinds of traditional material (like ink, oil paints, and watercolors). It's very commonly used in the game industry and commercial market. It was hard to master at first, but I use it all the time now.

TECHNIQUES

When I have a basic idea, I often start from a rough sketch and then refine it with clean lines. I always pay attention to the thickness of the lines. The contour lines are often thicker and darker, while the inside lines are lighter. I use this method to reinforce volume. I also use lines to convey light, using darker and thicker lines in areas of shadow and ambient occlusion. After I refine the lines, I add flat color and then lighting using Multiply layers.

OPPOSITE PAGE: Line art for a piece titled *Ghost in the Mansion*.

THIS PAGE: A Roman warrior, ready to pull out his blade.

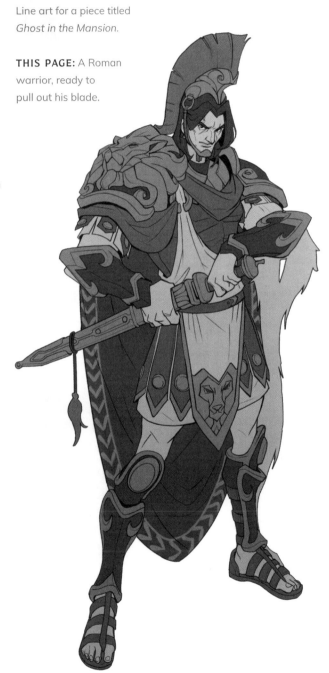

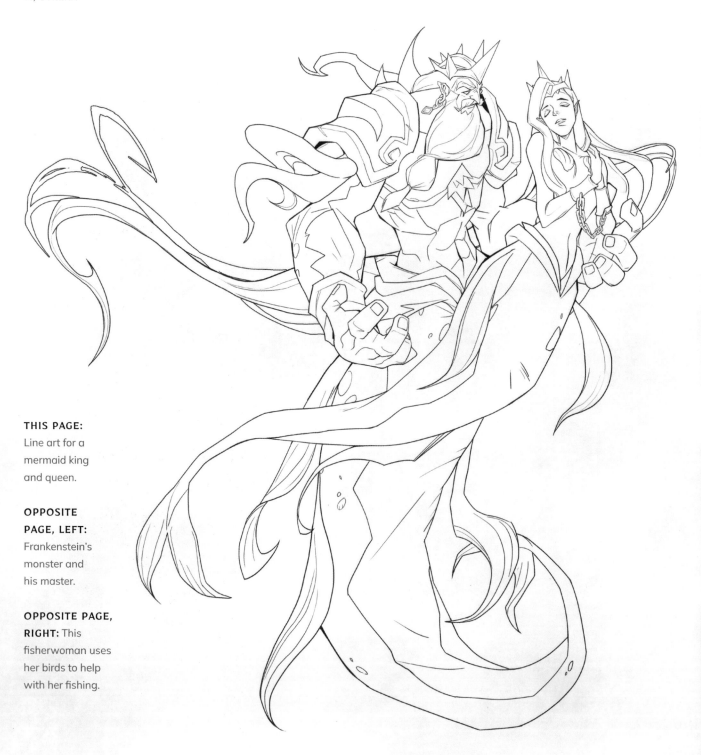

THIS PAGE:
Line art for a
mermaid king
and queen.

**OPPOSITE
PAGE, LEFT:**
Frankenstein's
monster and
his master.

**OPPOSITE PAGE,
RIGHT:** This
fisherwoman uses
her birds to help
with her fishing.

FIND YOUR INTERESTS IN LIFE!

Artists, including me, sometimes spend *too much* time on drawing. We end up sacrificing opportunities to try something new. Enjoy your personal life, find your own interests, and observe the world around you. These things actually help creative thinking, bring more inspiration, make us healthier, and make an artist's career more sustainable.

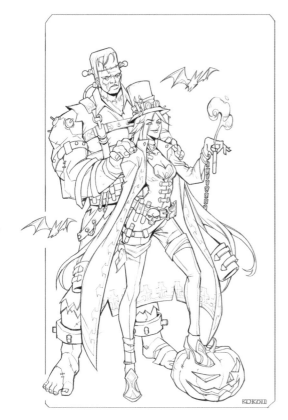

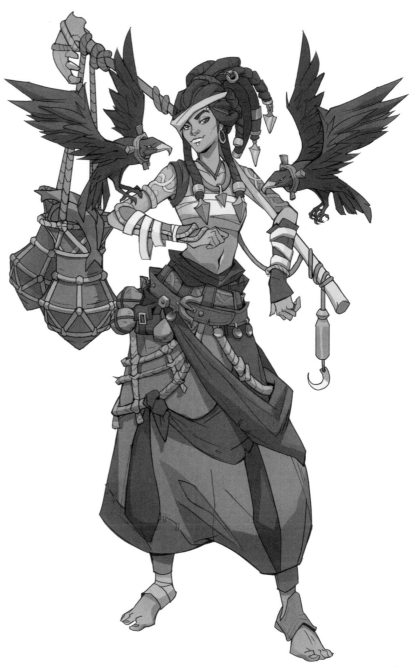

WITH OR WITHOUT REFERENCES

Drawing with and drawing without references can both be good ways to practice. The latter requires artists to have a big visual library in their brains. It's a good way to challenge your speed and memory, but I only recommend this method for more experienced artists. For beginners – and all artists, really – finding references is crucial and nothing to be ashamed of. Good references will improve the quality of your designs, inspire your imagination, and add fidelity to your work. There are always good references behind every masterpiece. I believe good designs are always based on reality, but elevated above it.

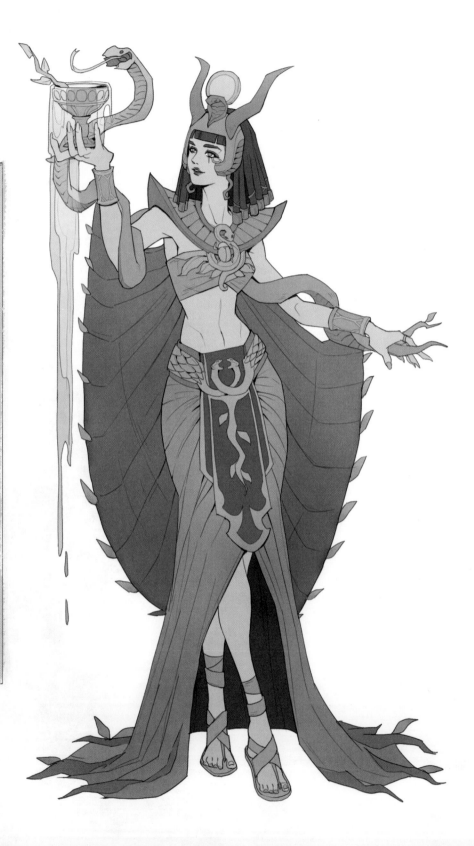

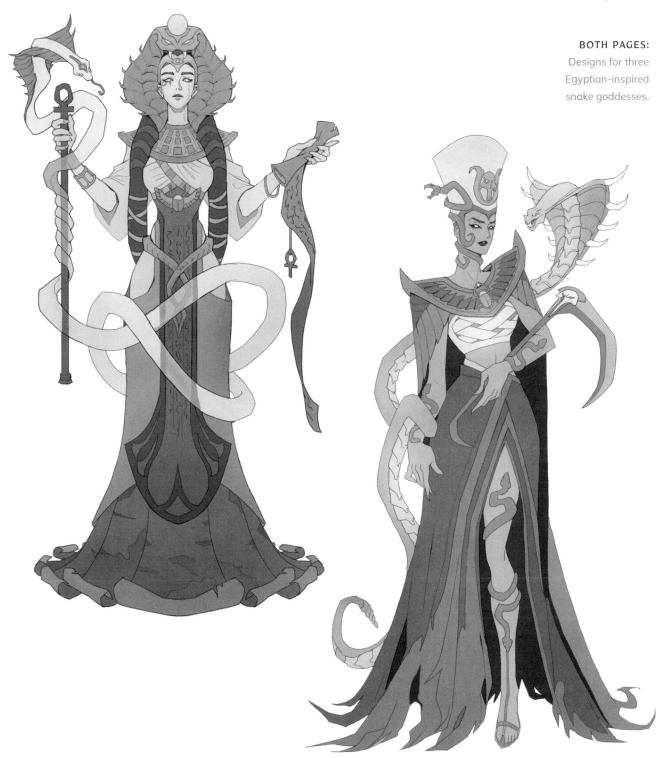

BOTH PAGES:
Designs for three
Egyptian-inspired
snake goddesses.

Litrico, Federica

fedelitrico.com

All images © Federica Litrico

I have drawn for as long as I can remember, but even though I attended art school, I only decided to get serious about making art after my university years. Inspired by the works of various concept artists, I taught myself how to draw digitally and focused my work on character design. I use drawing as a way to relax and let out what's in my mind. My approach to sketching is just improvisation; I start doodling and see where it leads me. Sketching is when ideas can flow freely without the stress of making a perfect drawing.

INSPIRATION AND IDEAS
◇◇◇◇

My inspiration comes from a lot of sources, but the most important ones are movies, games, music, and other artists' work. The works of Sergio Toppi and Mœbius are a huge source of ideas and creativity, and I also like to get inspired by doing studies of the masters, such as William-Adolphe Bouguereau and John Singer Sargent.

MATERIALS
◇◇◇◇

I usually draw digitally with Adobe Photoshop and a Wacom tablet. When I do traditional art, I like to use watercolors with different kinds of paper. I like to try out different materials together, such as ink, oil paints, markers, and copper leaf.

TECHNIQUES
◇◇◇◇

I don't really have a technique. I tend to draw very chaotic shapes and lines at first, and then I start to loosely define what I am trying to create, sketching a rough idea of the pose. I always start by drawing the head, as I love drawing faces, which usually guides me when designing the rest of the character.

OPPOSITE PAGE:
An attempt to combine different animals with a person.

THIS PAGE: A winged lady in watercolor and copper leaf.

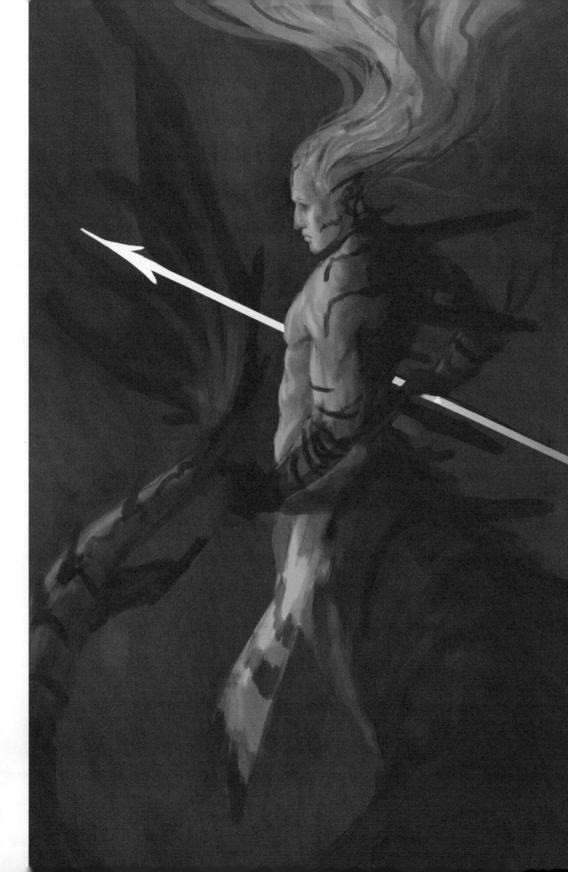

THIS PAGE:
A merman
from the
abyss.

"Sketching is when ideas can flow freely without the stress of making a perfect drawing"

THIS PAGE, RIGHT & BELOW: A little warrior and his partner.

THIS PAGE, FAR RIGHT: I was in the mood for drawing something with a lot of details.

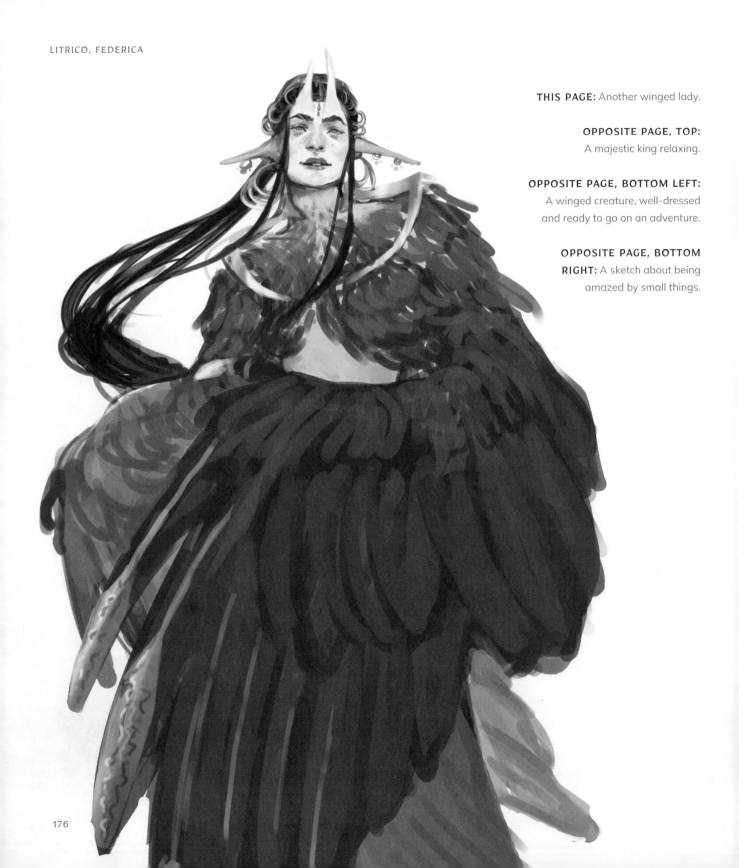

THIS PAGE: Another winged lady.

OPPOSITE PAGE, TOP: A majestic king relaxing.

OPPOSITE PAGE, BOTTOM LEFT: A winged creature, well-dressed and ready to go on an adventure.

OPPOSITE PAGE, BOTTOM RIGHT: A sketch about being amazed by small things.

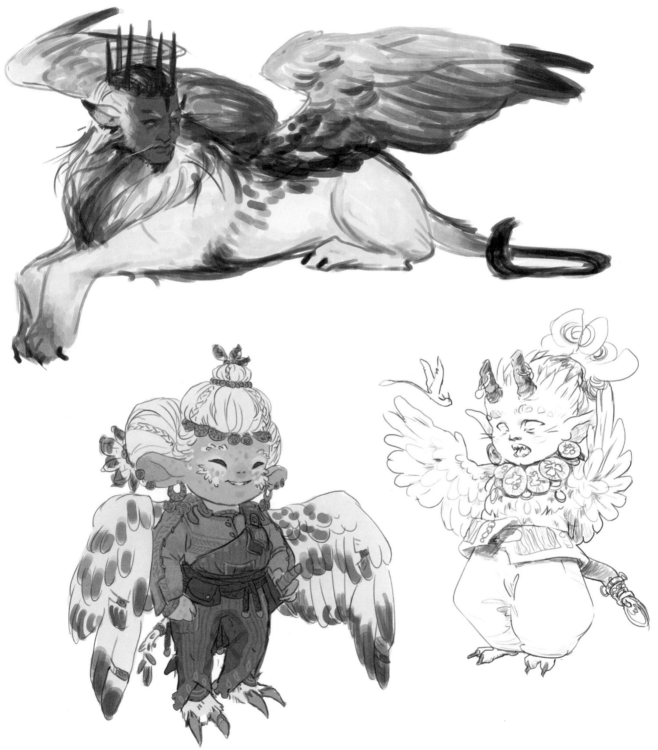

Llorens, Diego Gisbert

artstation.com/diegogisbert
All images © Diego Gisbert

The region of Spain that I grew up in is brimming with history. Ruins of watchtowers punctuate the mountains, caves hide in the forests, and we still celebrate events dating back to the Middle Ages or beyond. All of that has inspired me to dream, but also to question everything I see.

When I sketch nowadays, it's mostly for pleasure, and I like to keep things loose and exploratory, welcoming the inspiration as I work rather than tracing each line intentionally after a clear goal. The effectiveness of the latter is for work, not for fun. Fun and play are where unexpected treasures come to life.

INSPIRATION AND IDEAS
◇◇◇◇

Observing and questioning the world around me could inspire me for a lifetime, but I can also be inspired by the lyrics of a song or the vivid images coming off the pages of a novel or a poem, depending on my mood. It could be something abstract and subtle, or as straightforward as a hero striking an epic pose. Anything goes when it comes to sketching.

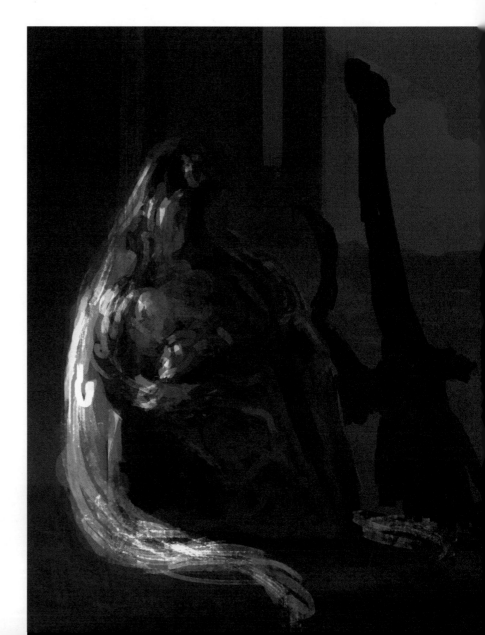

MATERIALS

When not using digital media (Adobe Photoshop or Procreate), I like to use ink brushes or ballpoint pens because of their immediacy and the fact that they can't be erased. Each line and stroke counts, and there's no way back. It is very liberating.

TECHNIQUES

I really believe in keeping things loose for as long as possible. There is a vibrating potential in the first stages of a piece that often gets lost during the process, and thus I prefer to barely hold the pen at first, allowing it to move nimbly over the paper until something really catches my interest and invites me to commit to a stronger, well-defined line.

BOTH PAGES:
King of the Lost, a very rough sketch inspired by J.R.R. Tolkien's *The Silmarillion* and the track "Time Stands Still" by Blind Guardian.

179

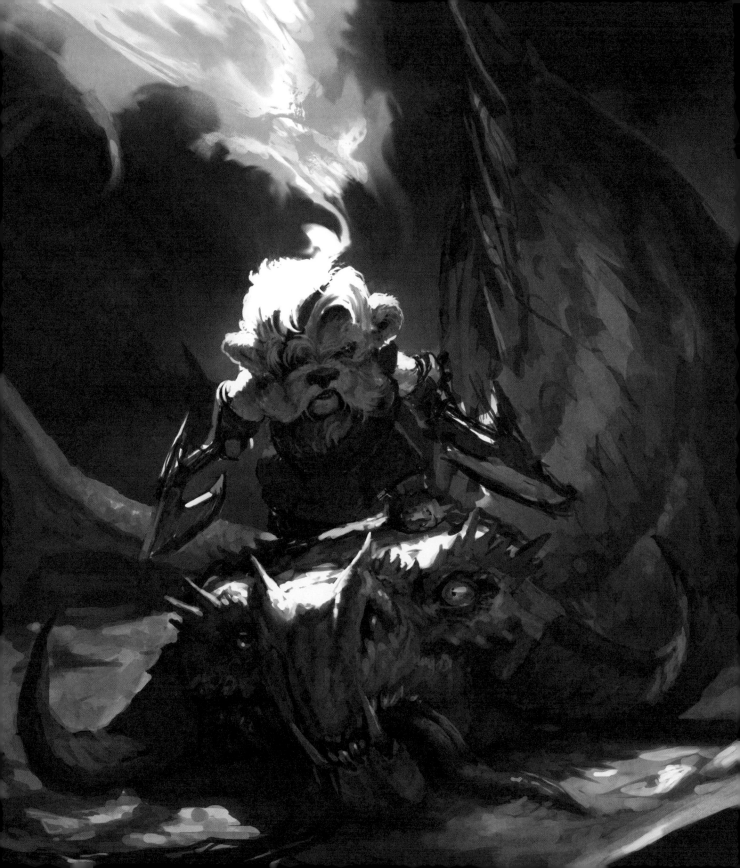

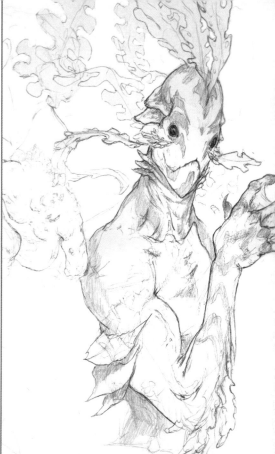

OPPOSITE PAGE:
This is more of an advanced sketch, based on a private joke that developed into an interesting idea for a story.

THIS PAGE, TOP LEFT:
Here I wanted to find a suitable take on this classic creature, one that fitted the tone for a personal fantasy project.

THIS PAGE, TOP RIGHT:
A mer...maid? Merfolk? I made this comfort-zone sketch while hanging out with artist friends. Sometimes it just feels nice to meet and sketch together.

THIS PAGE, BOTTOM RIGHT: Sometimes one idea simply forces its way into existence. This is such a sketch – something that came to me on a random night when I should've been doing client work!

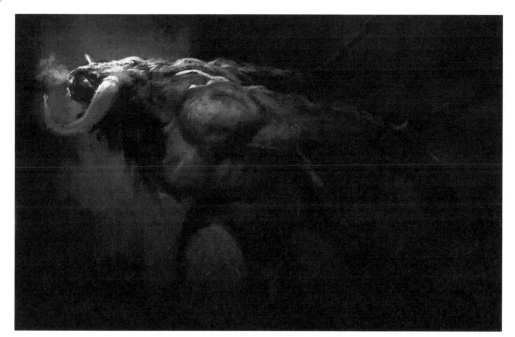

THIS PAGE, LEFT: Part of a class demo, showing how to quickly and loosely approach a painting and create color variations.

THIS PAGE, BELOW: Redesigning the minotaur is trickier than it seems, but playing around with a ballpoint pen and ink is always fun.

OPPOSITE PAGE: The result of some old streaming sessions, exploring locations for a personal project.

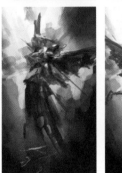 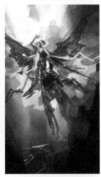

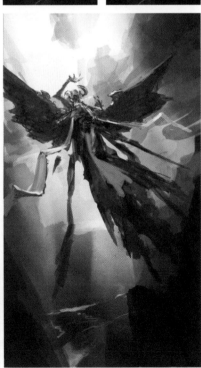

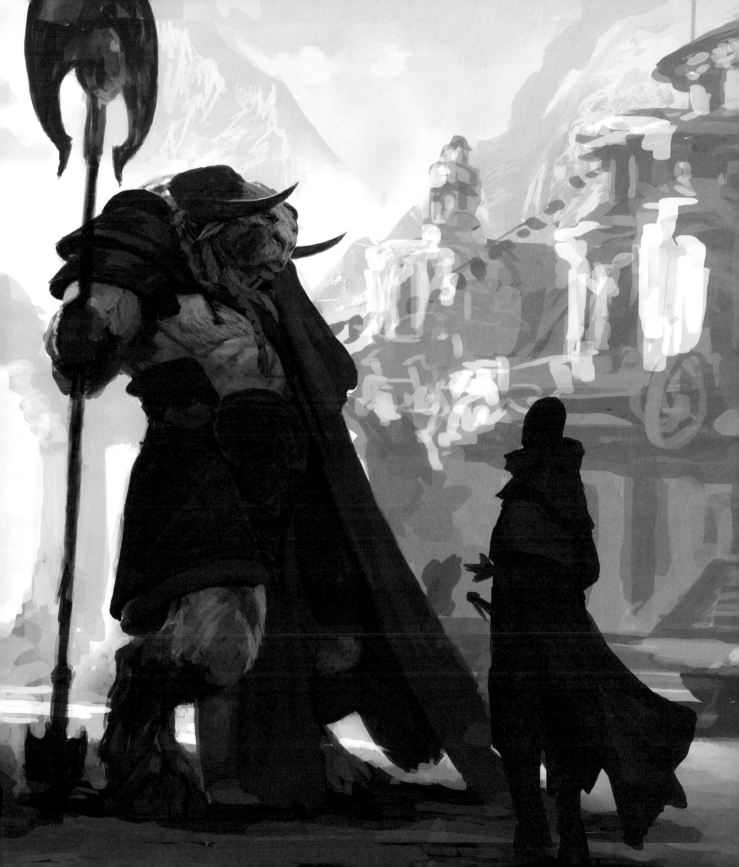

Ly, Erik

eriklyart.com

I am a contemporary digital illustrator residing in sunny California. In between working on projects for clients, I design apparel and accessories for my brand, Orbital Bloom, and also enjoy riding my motorcycle. As a freelancer, I've worked for companies like Amazon, Serif, Digital Extremes, Archie Comics, and Fantasy Flight Games.

When it comes to my personal illustrations, I often find myself returning to the subject matter of medieval and fantasy warriors. My interest began when I was exposed to feudal Japanese history at a very young age through various media, such as *Shogun: Total War*, a strategy game based on the Sengoku period of Japan. For me, this became a gateway that led to learning about other medieval societies. I enjoy the romanticized aspects of these cultures, such as their sense of chivalry and honor, but I also accept the historic truth of their brutality.

There is just something about the aesthetic of the armor, weapons, and style that feels so timeless and appealing to me. When I feel like drawing something therapeutic for myself, I can never go wrong with sketching a warrior wearing a cool set of armor.

THIS PAGE: A wounded knight holds on to the last vestiges of his life.

184

INSPIRATION AND IDEAS

I get creative ideas from anything that makes me feel something: movies, books, history, music, or just real life. It's that raw emotion that inspires me to attempt to convey what is in my head as an illustration. From a more visual perspective, a lot of my inspiration comes from images that inspire me; these can range from sketches of medieval armor to incredible photos of animals captured in nature (for instance, the intensity on the face of an angry tiger). All of these things keep me excited about drawing.

MATERIALS

I started out as a traditional artist, but for around three years now I have been working completely digitally. I still do most of my illustrations on my old but trustworthy 13-inch Wacom Cintiq using Adobe Photoshop, which has been a mainstay for me since college. But when I'm on the go, you will find me sketching on an iPad Pro using either Affinity Photo or Procreate. I love all of these digital tools for their innovation and flexibility.

TECHNIQUES

My drawings start off incredibly messy. I always begin with sketchy lines, and my method is to essentially scribble things into place, hoping that my brain will see something that interests me and looks "cool." At times, I might not even lift my pen while my hand continues to put down more lines. Afterward, I like to spend more time redrawing and refining the linework. Finally, I finish things off with color and do my best to make the piece pop with a vibrant, eye-catching palette.

THIS PAGE: The spoils go to the victor.

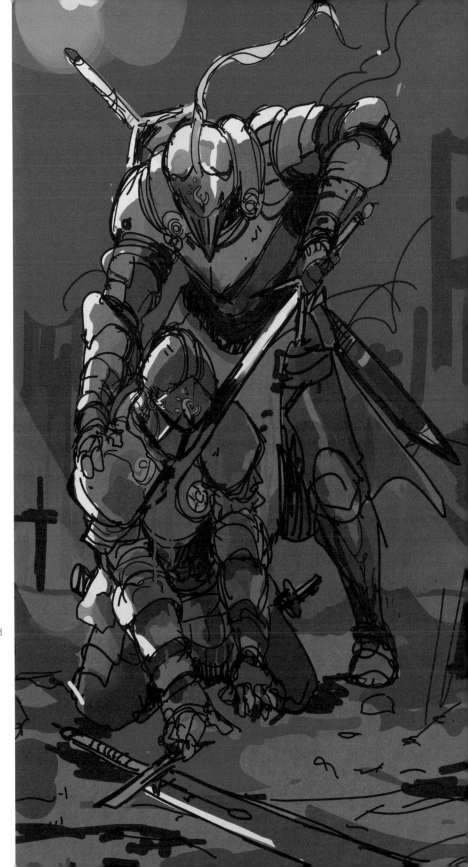

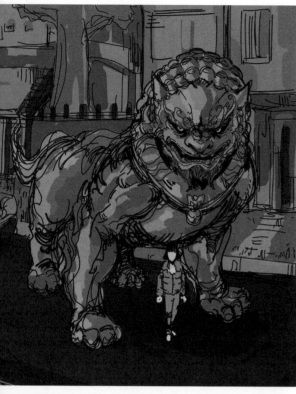

THIS PAGE, TOP LEFT:
The foo dog guardian
watches over its charge.

**THIS PAGE, BOTTOM
LEFT:** An original
character of mine. Hulin is
a product of urban fantasy.

**THIS PAGE, BOTTOM
RIGHT:** A samurai knight
drawn using Affinity Photo.

OPPOSITE PAGE:
A strange giant being, who
is this world's god of war,
watches the battlefield.

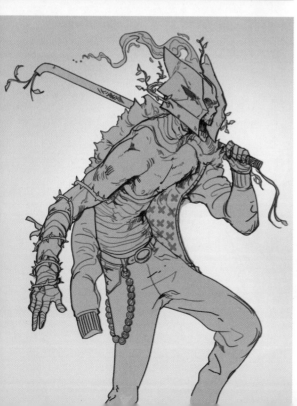

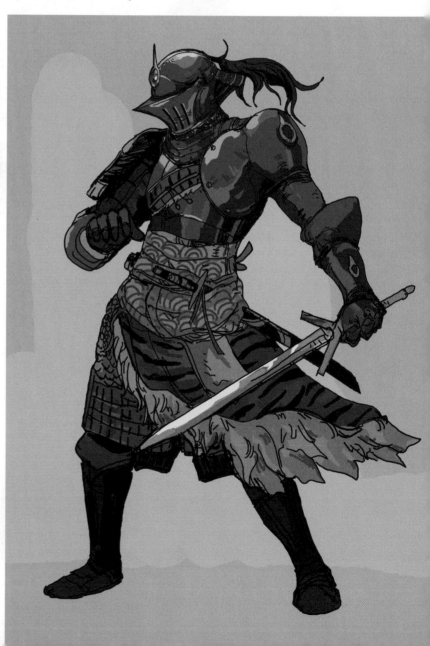

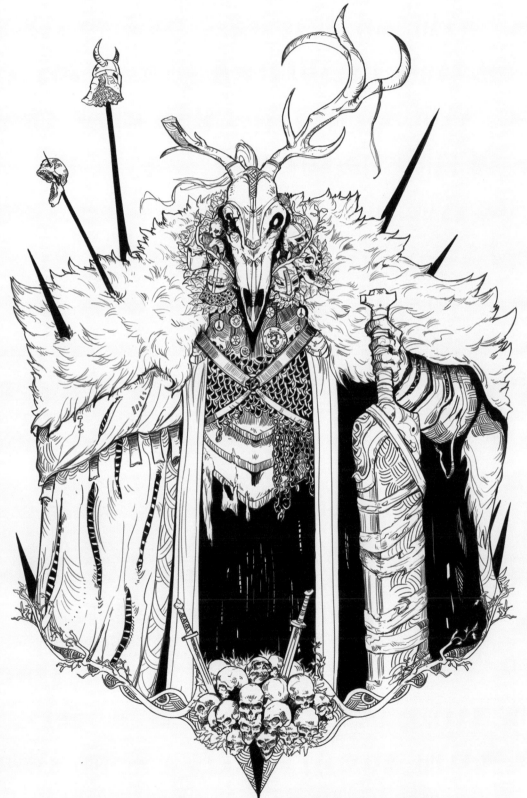

THIS PAGE: A samurai warrior commands the power and spirit of the tiger.

OPPOSITE PAGE: Two samurai warriors engage in a life-and-death struggle.

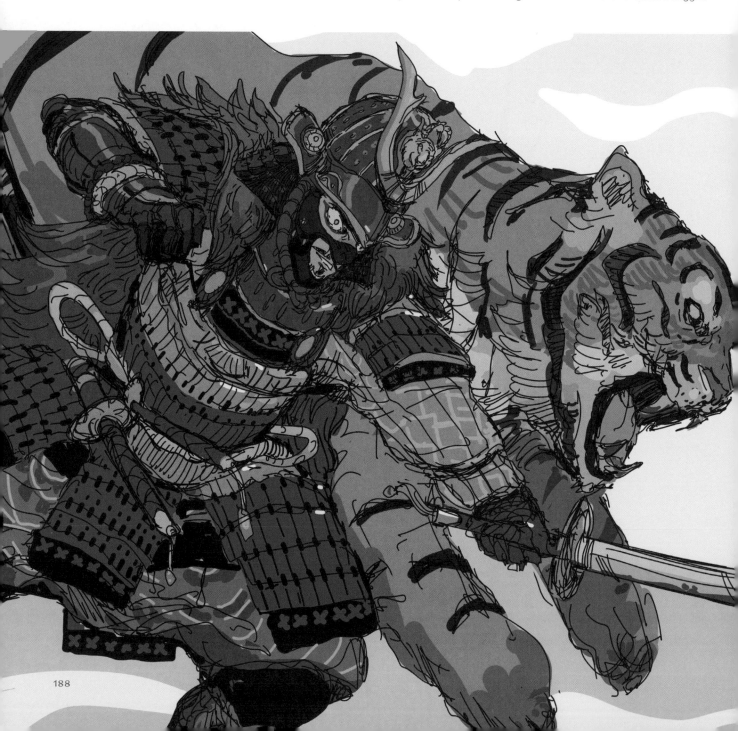

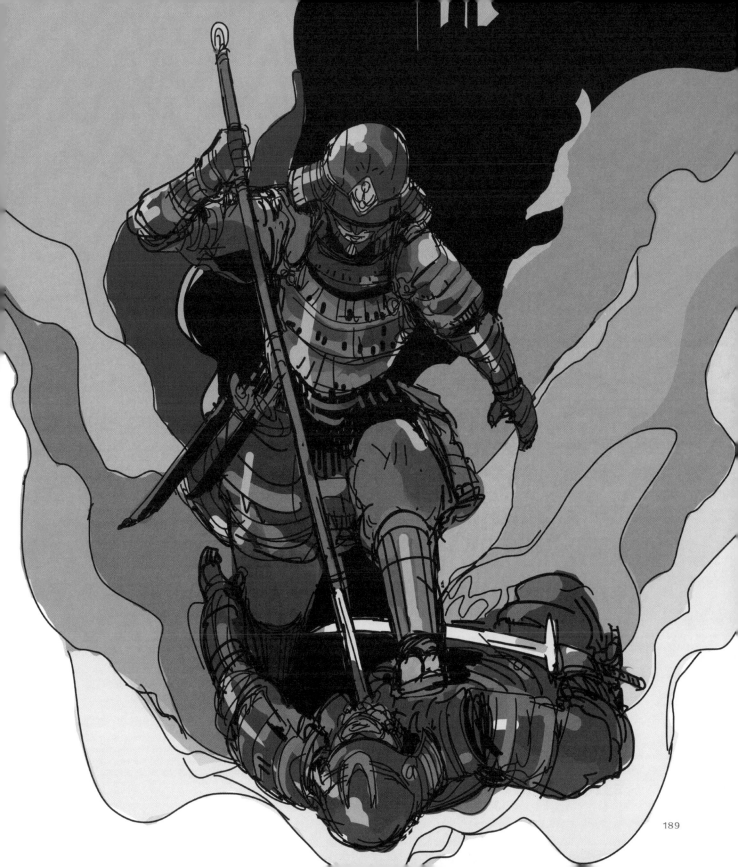

Messinger, Eric

instagram.com/ericmessingerart | facebook.com/TheArtofEricMessinger1

All images © Eric Messinger

I live with my family in the high desert of southeastern Arizona, surrounded by mountains that look like dragon's teeth and hideouts used by both the Native peoples of the area and by Wild West characters looking to escape the law! I have had a long-term love affair with monsters and "things that go bump in the night." What started as childhood pencil-sketching turned into a deep dive with *Dungeons & Dragons*. I was not only the Dungeon Master – I also drew everyone's characters! This focus led me to Image Comics and digital artwork in the 1990s.

After twenty-five years of digital art, I began to long for the feel of paper and pencil again. This transition led me to charcoal and the work I now create. Each piece starts as a charcoal powder abstract. From this amorphous beginning, each creature makes itself known. I then bring it forth to allow it to tell its story. I've come full circle, and the beings who come to visit me enrich my imagination and artwork. My drawings can be found on Instagram and in gallery shows where I sell my work.

INSPIRATION AND IDEAS
◇◇◇◇

Light and the patterns it makes are my most essential inspirations. I look at the way the light plays across an object, how it dances, and how it creates shadows. The interplay between light and dark helps me find the three-dimensionality within my work. Light is such a powerful artistic motivator that I am most drawn to other creative pieces that use light as a medium for communication.

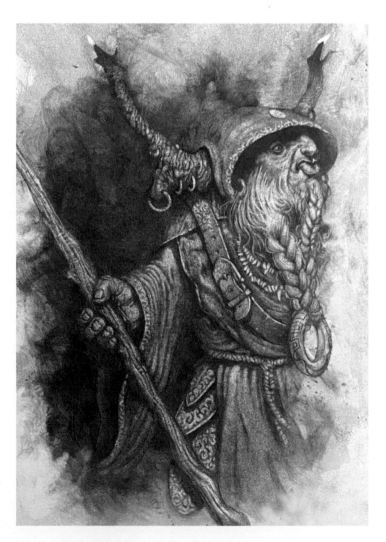

THIS PAGE: *The Bard.*

OPPOSITE PAGE: *There is Magic* process image.

MATERIALS

My usual tools include filbert paintbrushes in #2, #3, #4, and #6; a round #2 brush; a bright #1 brush; a 1.5-inch wash brush; and quarter-inch Royal & Langnickel brush. I also use charcoal powder, a kneaded eraser, a 6B charcoal stick, blending stumps, and charcoal pencils including 2H extra-hard, HB, 2B, 4B, 6B, and white.

TECHNIQUES

My process begins beyond my conscious thought. Dreams, clouds, and shapes all make their way into my unconscious. I start with a fresh piece of cold-press watercolor paper, charcoal powder, and a broad paintbrush to create a new painting. As I swirl the powder, I endeavor to quiet my mind as much as possible to allow the abstract forms to come forward. Once finished, the piece goes on a shelf so I can look at it several times a day until I see my next creature visitor begin to take shape.

At this point, I introduce myself, and our journey together begins. Using kneaded erasers and small paintbrushes, I brush away the dust to find my subject's contours, silhouette, and face. The conversation then begins, and they talk to me and tell me about themselves. Their wrinkles, eyes, clothing, and emotions become structures. Once those pieces are flushed out, it is usually time to let them rest. When they are ready to converse again, the details of who they are and where they live come forward. The types of armor, body piercings, tattoos, jewelry, and the environment in which they live give them their final home.

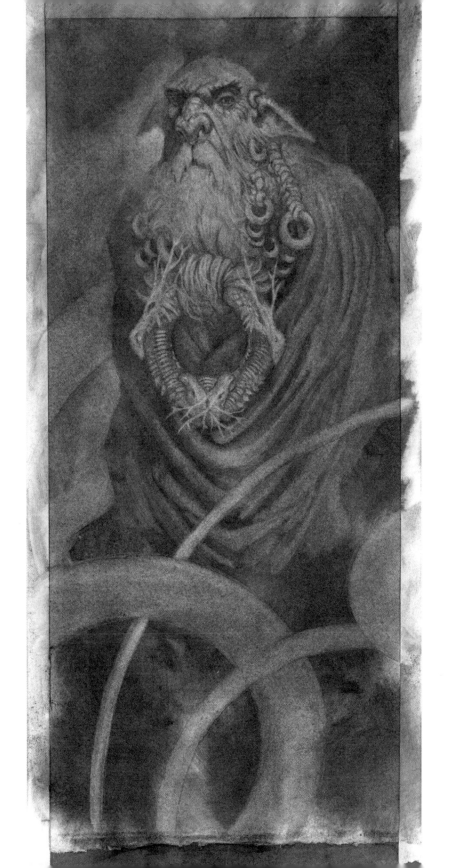

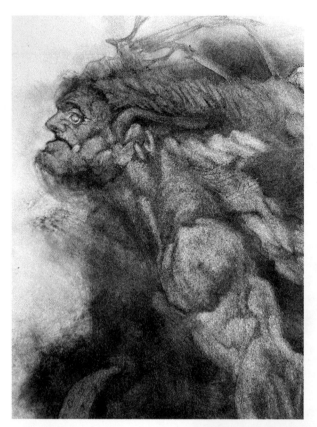

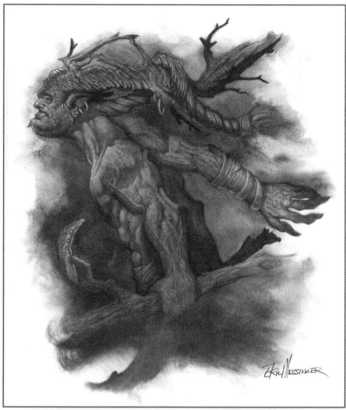

THIS PAGE, ABOVE:
Process and final versions
for *Who Am I.*

THIS PAGE, BOTTOM:
Dragon of the Calm Skies.

OPPOSITE PAGE:
The Ambassador.

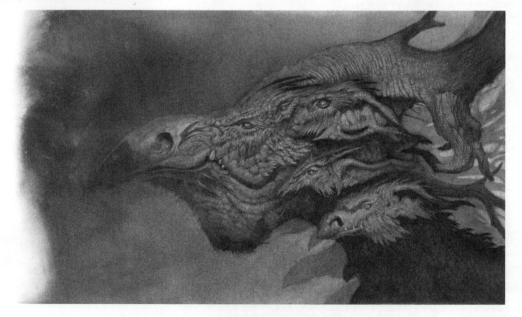

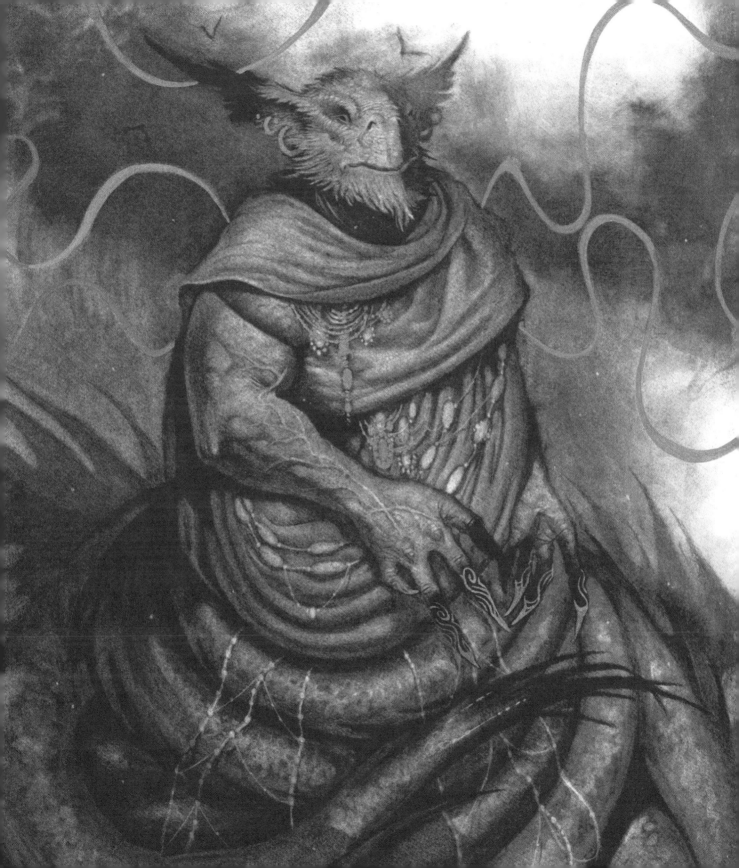

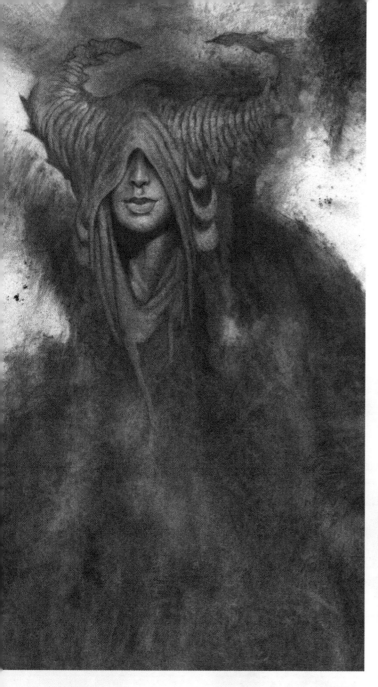

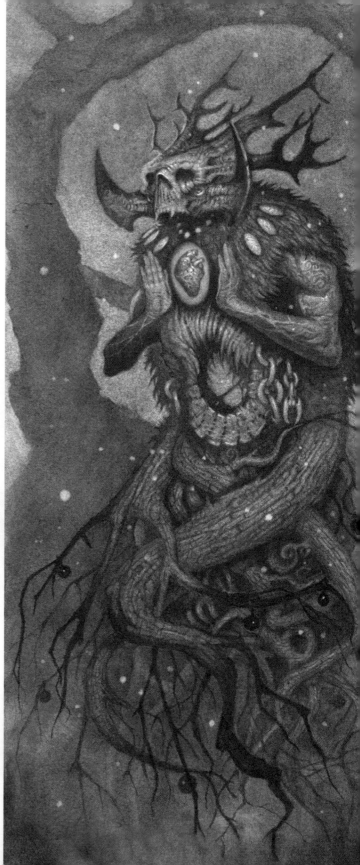

THIS PAGE, ABOVE:

Shroud of Time process image.

THIS PAGE, RIGHT:

The Loss of Christmas.

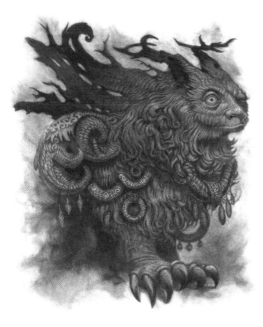

THIS PAGE, LEFT:
Nyoogen.

THIS PAGE, BELOW:
Prince process image.

TIPS FOR CHARCOAL ABSTRACTS

Allow your charcoal abstracts to be playful. String, feathers, and fabric will yield different stroke patterns. Have fun and let your imagination fly!

If you are working with small brushes in your charcoal abstracts, remember to regularly unload your brush. Use your fingers or a tissue to clean the brush between pulls. Keeping your brush clean will give you stronger light values.

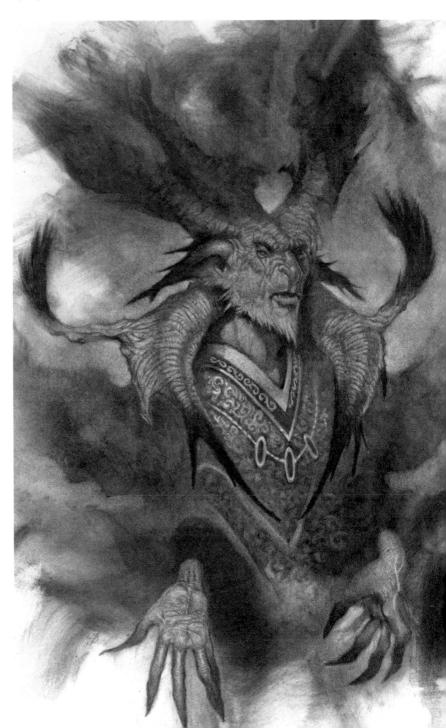

Morais, Maria ("Suni")

instagram.com/__suni_art__
All images © Maria Morais ("Suni")

I am a visual development artist from Portugal. My love for fairies and witches has arisen very quickly in my life since it is very much connected with feminism and the way I express myself.

INSPIRATION AND IDEAS
◇◇◇◇

I think it all started when I really dived into the comic-book series *W.I.T.C.H.* – the way they used magic and how that created a sisterhood was very special. Later came *Harry Potter* and the wizarding world with its creatures and potions! Then, as I became older, I learned more about women's history and how witchcraft and witches seem to be so recurrent throughout history. After that, I began to express myself through my witches and fairies, which became very dear to me as part of my feminism and personal journey of empowerment as a woman. I do like to think of myself as a fairy in the spring and a witch during the fall!

THIS PAGE: *Mystical Sight*. For when you are seeing but not watching.

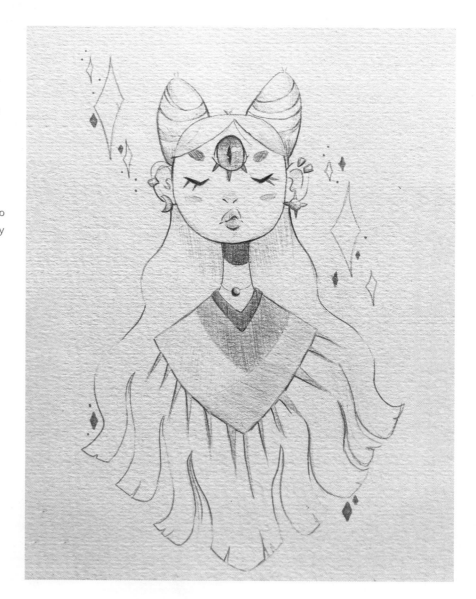

MATERIALS

Just give me some colored pencils and a small sketchbook and I'm happy – bonus points if the pencils are pink or magenta! I mostly draw with pink and blue pencils for the contrast – I just love to see them together. I love the smell of the pencil smudges on the page. My second-favorite thing to draw with is Procreate. For me, there's no better software. It is just like having a big sketchbook in my hands.

TECHNIQUES

My sketchbook is where I explore the most. Inside, you can expect to see sketches in colored pencil, alcohol marker, and even gouache. I recently rediscovered gouache and absolutely fell in love! The way you can block out colors or make a tinted wash with gouache is amazing. It gives you so much space for exploration and just to have fun. These are my absolute favorite techniques and I can't wait to finish a sketchbook just filled with paintings of fairies in gouache.

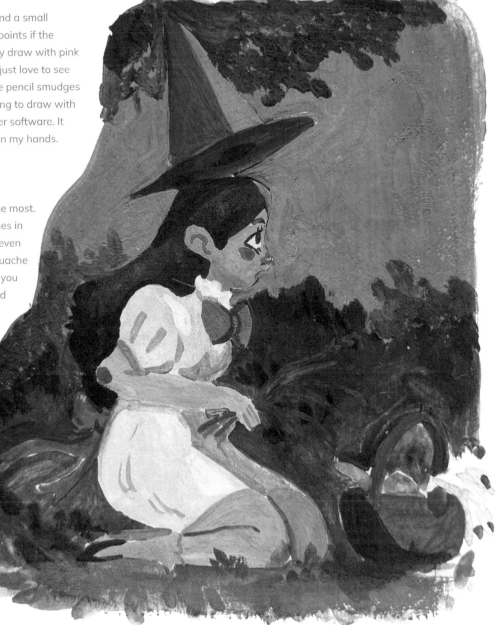

THIS PAGE: Espiga is a Portuguese holiday, very dear to me, where you collect a bunch of country flowers and tie them in a bouquet. You also make a fire on the beach.

OPPOSITE PAGE: *The Woods Coven*. Bodies are beautiful and so are fairies. We all need this kind of support group. You are beautiful.

THIS PAGE, TOP LEFT: *New Moon Circle*. You know, *that* kind of friendship.

THIS PAGE, ABOVE: A sketch of a cute and delicate fairy making her landing.

THIS PAGE, RIGHT: Sometimes I do a random emoji challenge on Instagram. This was what came to be from a teapot, snake, and witch.

"I began to express myself through my witches and fairies, which became very dear to me as part of my feminism"

THIS PAGE, ABOVE: *Bruja.* Beware of her pies – they might contain poison.

THIS PAGE, LEFT: I don't think I will ever get bored of drawing witches in every style and era.

OPPOSITE PAGE: This is still one of my favorite sketches of all time. A cute little grandma witch taking the turnips for a spin around town. She'll never feel lonely.

Murzyn, Kamil

kamilmurzynarts.pl

All images © Kamil Murzyn

I really enjoy crafting fantasy worlds and characters. Coming up with stories about adventures. Drawing was always a way to do it. When it comes to fantasy lands, towns, castles, mountains – words are not enough to convey their mood and magic. When I was a kid, I came up with a story about young rogues who stole an ancient weapon and were unexpectedly sucked into a great adventure. Currently every piece of art I make is a small part of this bigger world.

In childhood, we constantly imagined ourselves as adults. We had no clue! Now, when I'm drawing fantasy stories about little rogues trying to be great adventurers, I always feel a bit like a kid again. What matters is a bursting imagination and an adventurous spirit, and what I love the most is that these drawings are conveying these childhood feelings to others. Fantasy is a universal language for all ages.

INSPIRATION AND IDEAS
◇◇◇◇

Inspiration often comes unexpectedly and out of nowhere, but if I am to give sources where I can be confident of finding it, mountains and forests will come first. A simple walk and being close to nature provides creative fuel for at least a few drawings. The second source would be classical culture – I value Greek mythology and Arthurian legends the most.

I always try to add a broader context to what I draw. I make little "question" drawings that help me imagine the whole story behind a single image. It's almost like planting a seed. Sometimes a single drawing, after a week or two, gives ideas for several new ones.

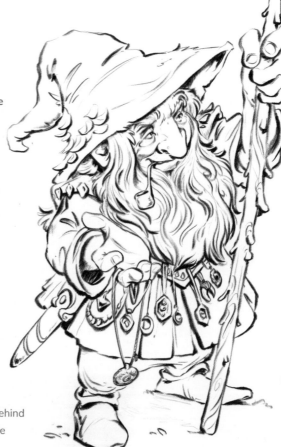

THIS PAGE:
A jewelry dealer from the Kingdom by the Lakes.

MATERIALS
◇◇◇◇

Sometimes I sketch with whatever lies on the desk in front of me, but if I had to choose a medium, I would pick soft pencils. It's hard for me to imagine a more versatile tool – I can be hesitant, spontaneous, or technically accurate, if I want.

I also work a lot with digital media, especially for clients. I find it simpler, with all the layering and transform tools, to manipulate things around and find the best composition. Ideally I would constantly switch between digital and traditional tools to exploit all the little advantages that both worlds offer to artists.

TECHNIQUES
◇◇◇◇

I always start very loosely, almost with stick figures, trying different things, different designs, waiting for the happy accident that will be worth creating the whole picture around. Sometimes I end up with a whole pile of interesting things and I start assembling the composition from it. Then I slowly start being more and more precise, switching from loose sketching to tight drawing. I still like to constantly rearrange elements for better composition – it's always better to make changes early, before committing to the final line art or colors.

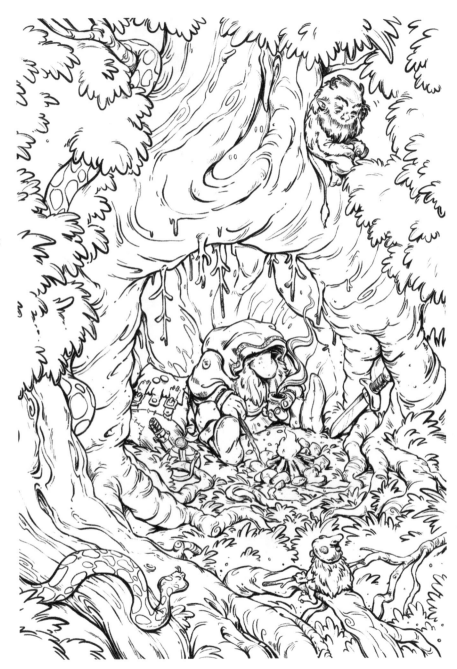

THIS PAGE: Spending a night deep in Brawian Forest.

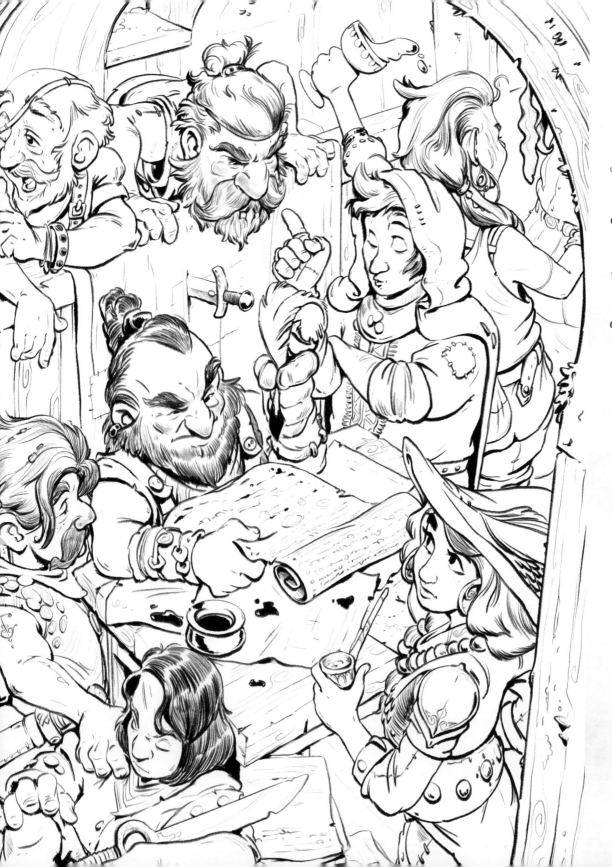

THIS PAGE: Adventurers and pirates gathering together to write down their first set of rules and laws.

OPPOSITE PAGE, TOP: A treeman fighting fiercely against a group of undead warriors.

OPPOSITE PAGE, BOTTOM: Mighty Agun, lord of fire, accompanied by the bravest of dwarves, on a journey through the wastelands.

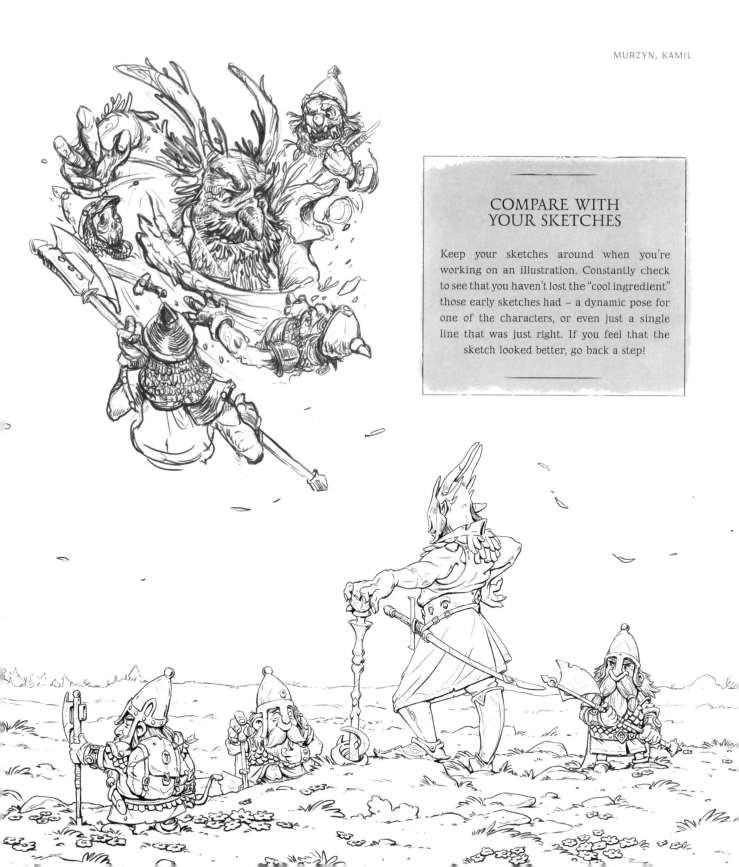

COMPARE WITH YOUR SKETCHES

Keep your sketches around when you're working on an illustration. Constantly check to see that you haven't lost the "cool ingredient" those early sketches had – a dynamic pose for one of the characters, or even just a single line that was just right. If you feel that the sketch looked better, go back a step!

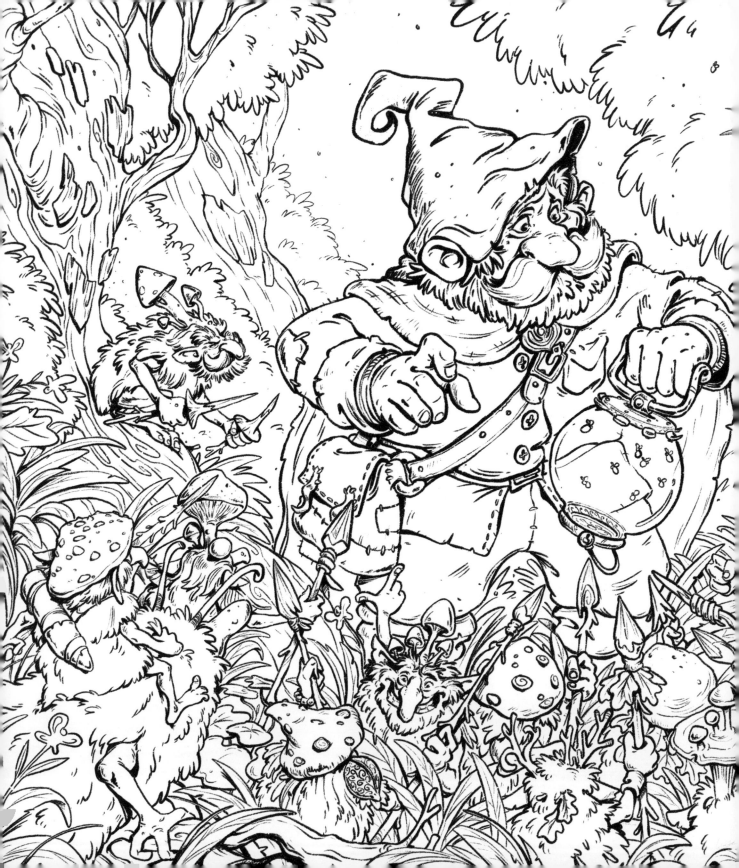

BOTH PAGES:
A brave adventurer encounters an obstacle while wandering through the forests.

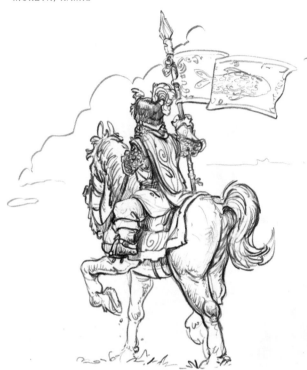

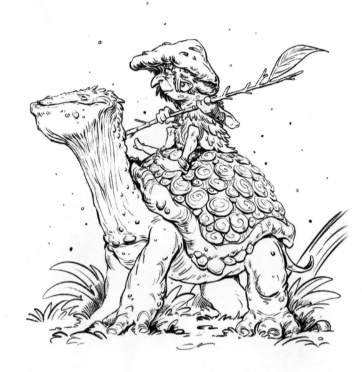

DON'T BE AFRAID OF REDRAWING

We all already draw a lot, right? Let's not be afraid of putting a new layer over a good drawing, or putting it on a light box, and tracing it for an even better result. It's good practice and a common artistic workflow to start small and repeatedly redraw a good composition into something bigger and more detailed.

OPPOSITE PAGE, LEFT: The Knight of the Lake with a trout on his banner.

OPPOSITE PAGE, TOP RIGHT: A woodling, a small inhabitant of Brawian Forest.

OPPOSITE PAGE, BOTTOM RIGHT: A dwarven grand wizard and knight errant meeting at the edge of the woods.

THIS PAGE, BELOW: Tsabo, an inconspicuous-looking master of swords and a legendary warrior.

THIS PAGE, RIGHT: A moment of rest for an old troll wanderer.

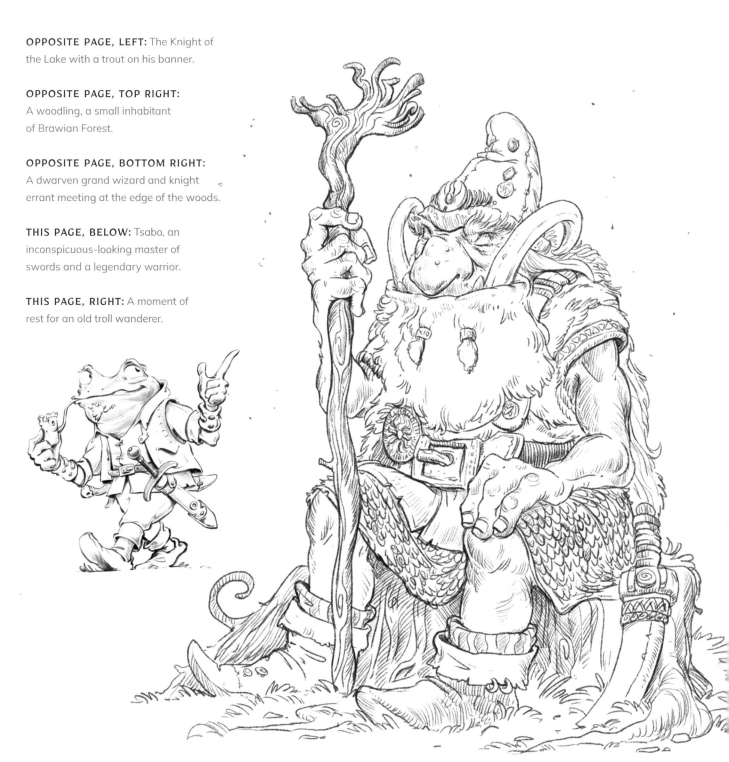

OccultMonk

artstation.com/occultart
All images © OccultArt

THIS PAGE: A sheep monk sketch from 2016.

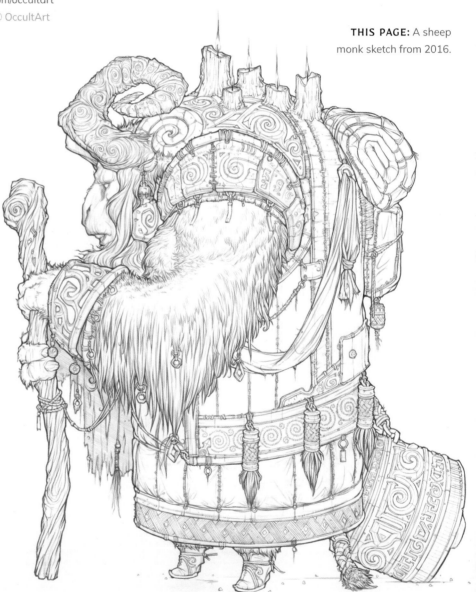

I am mainly a 3D artist with a primary focus on character design, though I also love creating machines such as futuristic vehicles and mechs. Drawing is something I enjoy a lot. I think I still have a lot to learn and hope I can become better at it.

I have wanted to draw and create for as long as I can remember, but when I was young there weren't many prospects for pursuing a vocation in art. Drawing courses that focused on traditional subjects like anatomy and perspective were almost nonexistent. The focus was mainly on abstract art, as classical drawing and painting were out of favor.

Therefore, I chose to get a computer science and programming degree. It was as close to game development as I could get at the time. During most of my schooling I went without any real practice in art and only started drawing again much later. I kept programming and designing user interfaces and websites for a long time, but all I ever really wanted to do was create fantasy and futuristic characters!

INSPIRATION AND IDEAS

I always loved fantasy and sci-fi computer games, movies, and artwork. Later I started reading a lot of books, especially in these genres, but also of classical writers. My focus has always been to try to create things that don't exist yet and make them as different and unique as possible. Studying references is the most important thing you can do. What you create is a recombination of everything you have seen, studied, and experienced in your life. So, learn from references intensively, like you're learning the grammar of a foreign language, to increase the size of that mental library!

MATERIALS

I mainly draw with Adobe Photoshop and a Wacom tablet with a few simple brushes. However, I also frequently draw thumbnails with a pen and use those as a base for my drawings or 3D models. I usually start with a rough block-out sketch for both my 2D and 3D works, and then keep refining from there. I always try to think in 3D shapes when I draw – primary shapes like spheres and cubes, or at least heavily simplified forms. In this regard, I think it helps if you have some experience in 3D modeling.

TECHNIQUES

I start with a block-out sketch, then slowly build up the details. Layer upon layer of refinement adds up in the end. Sometimes I just draw for a few hours from my imagination. When you are in the flow, it's hard to stop, so I often use a timer as a reminder to study reference at regular intervals. I use both gesture and the "visual measuring" rules you can learn from Harold Speed's classic drawing books. Either study or draw, but not at the same time – this forces you to actually learn shapes instead of copying lines.

THIS PAGE: Concept sketches from 2019.

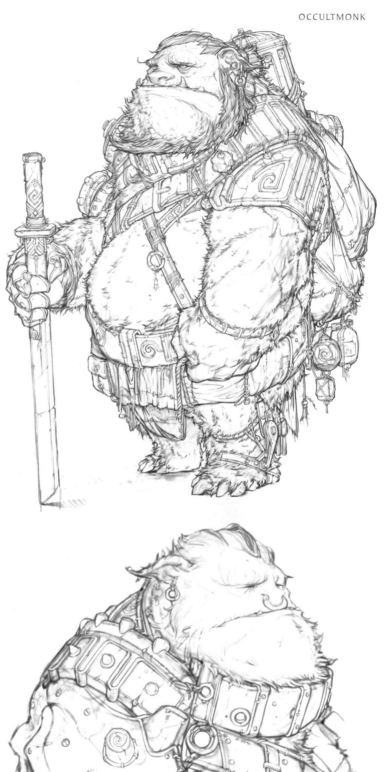

"When I was young there weren't many prospects for pursuing a vocation in art"

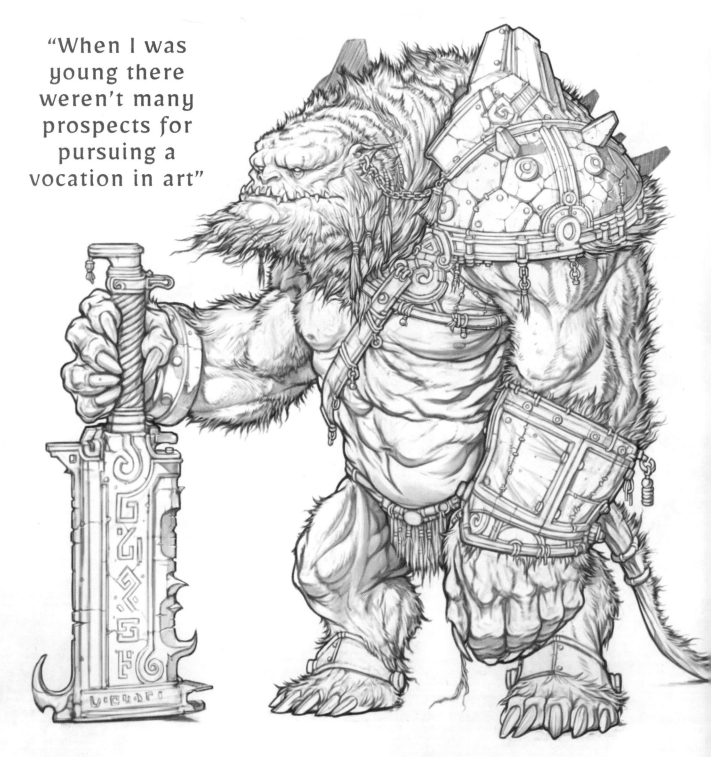

OPPOSITE PAGE: An old fighter I sketched in 2017.

THIS PAGE: *The Sage*, a design I sketched in 2016.

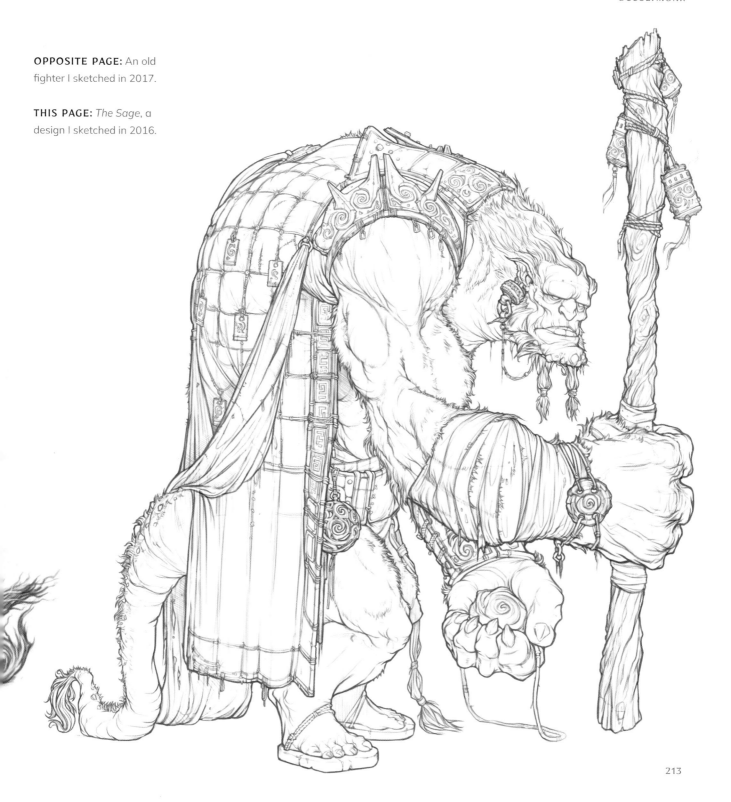

THIS PAGE: A sorcerer sketch from 2016.

OPPOSITE PAGE:
Shadows in the White Forest. A concept sketch for a 3D model.

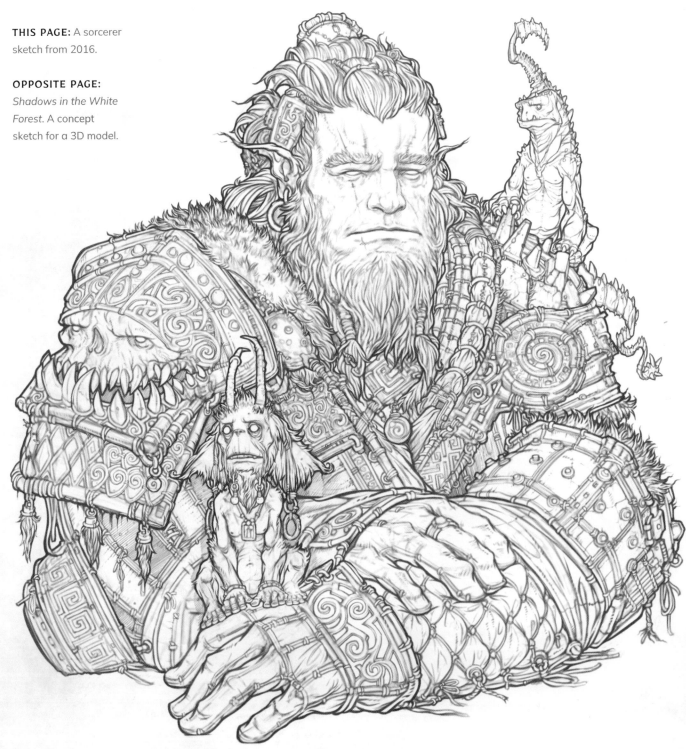

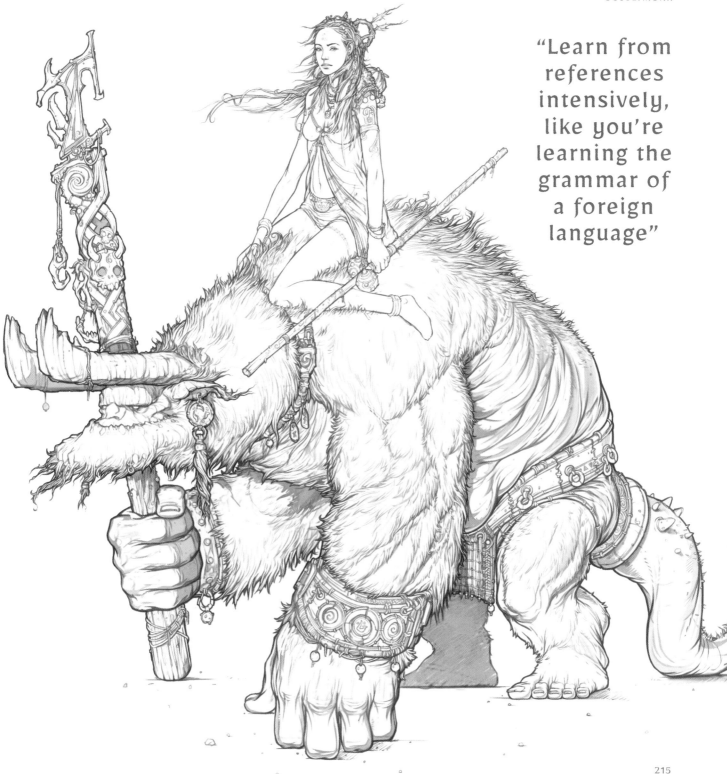

"Learn from references intensively, like you're learning the grammar of a foreign language"

Oh, Jinhwan

artstation.com/jinhwanoh | instagram.com/ozi_art
All images © Jinhwan Oh

After five years of service as a product designer, I changed my career path to become a concept artist, taking on the position of Lead Background/Prop Artist at Studio Mir, a Seoul-based animation studio. During my time with Studio Mir, I worked on several projects including *Voltron: Legendary Defender*, *Mortal Kombat Legends: Scorpion's Revenge*, and *Dota: Dragon's Blood*. I have also been serializing my own web comic, *Kung-Fu Transporter*, on Kakao Webtoon. The magical world of fantasy is full of exciting stories that give fruitful motivation to artists. This is the reason that I am eager to dive into it.

INSPIRATION AND IDEAS
◇◇◇◇

Experiences and appealing stories are where I usually get my inspiration. It's so interesting to try to visualize my feelings, or the certain atmosphere of playing a video game, or my appreciation of movies, and even music.

THIS PAGE: The face-shaped floating fortress of the Demon Region. In fact, it's actually the face of an ancient giant.

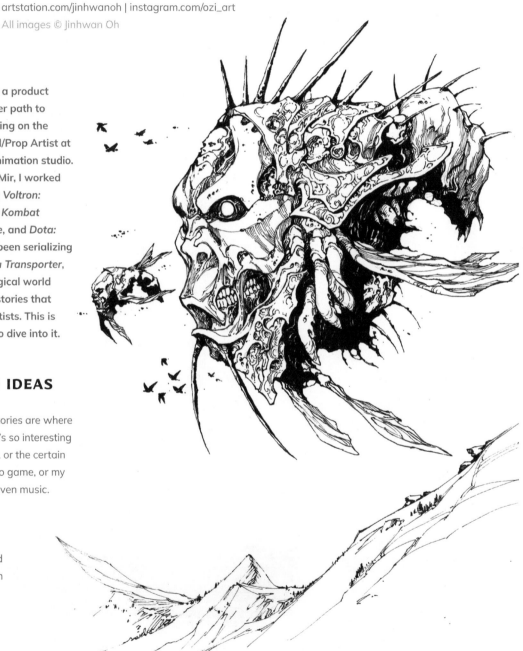

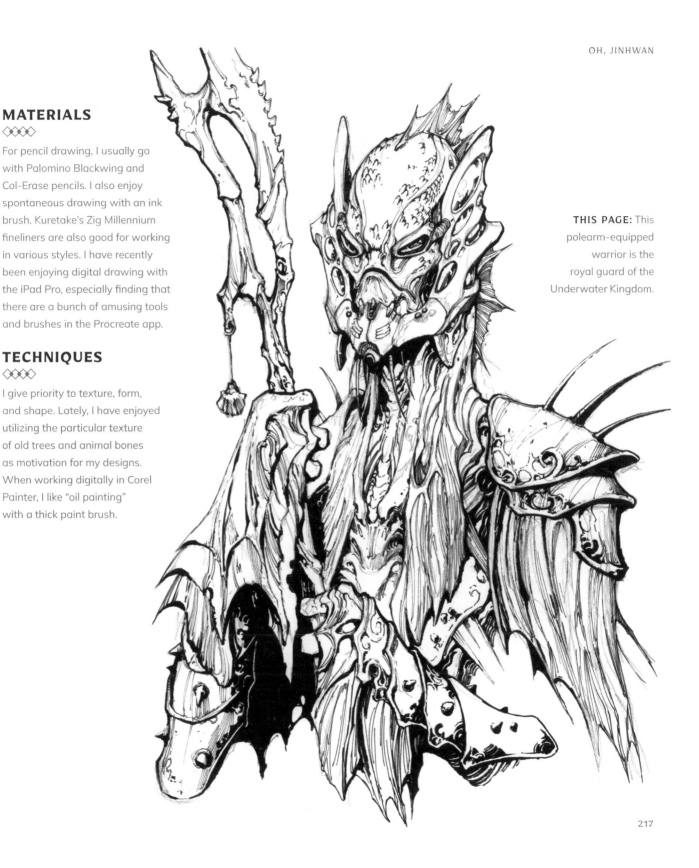

MATERIALS
◇◇◇◇

For pencil drawing, I usually go with Palomino Blackwing and Col-Erase pencils. I also enjoy spontaneous drawing with an ink brush. Kuretake's Zig Millennium fineliners are also good for working in various styles. I have recently been enjoying digital drawing with the iPad Pro, especially finding that there are a bunch of amusing tools and brushes in the Procreate app.

TECHNIQUES
◇◇◇◇

I give priority to texture, form, and shape. Lately, I have enjoyed utilizing the particular texture of old trees and animal bones as motivation for my designs. When working digitally in Corel Painter, I like "oil painting" with a thick paint brush.

THIS PAGE: This polearm-equipped warrior is the royal guard of the Underwater Kingdom.

217

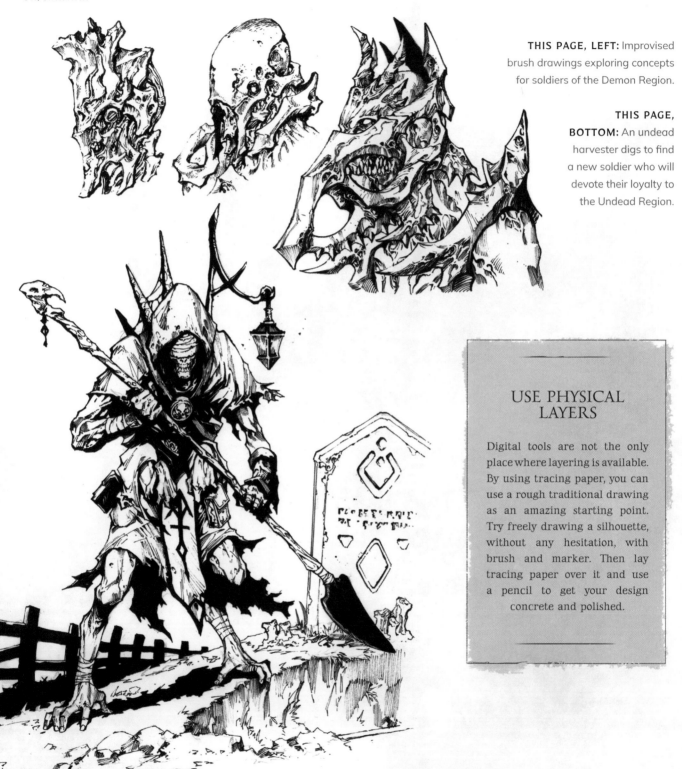

THIS PAGE, LEFT: Improvised brush drawings exploring concepts for soldiers of the Demon Region.

THIS PAGE, BOTTOM: An undead harvester digs to find a new soldier who will devote their loyalty to the Undead Region.

USE PHYSICAL LAYERS

Digital tools are not the only place where layering is available. By using tracing paper, you can use a rough traditional drawing as an amazing starting point. Try freely drawing a silhouette, without any hesitation, with brush and marker. Then lay tracing paper over it and use a pencil to get your design concrete and polished.

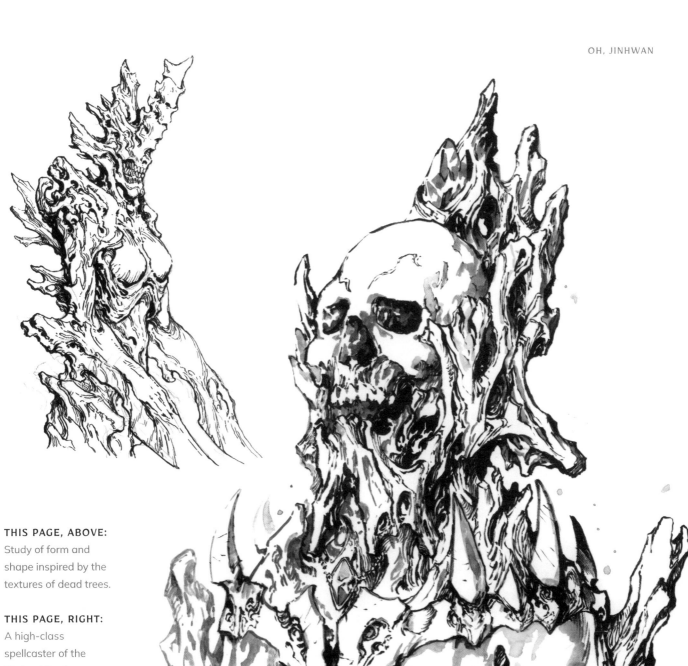

THIS PAGE, ABOVE:
Study of form and shape inspired by the textures of dead trees.

THIS PAGE, RIGHT:
A high-class spellcaster of the Undead Region.

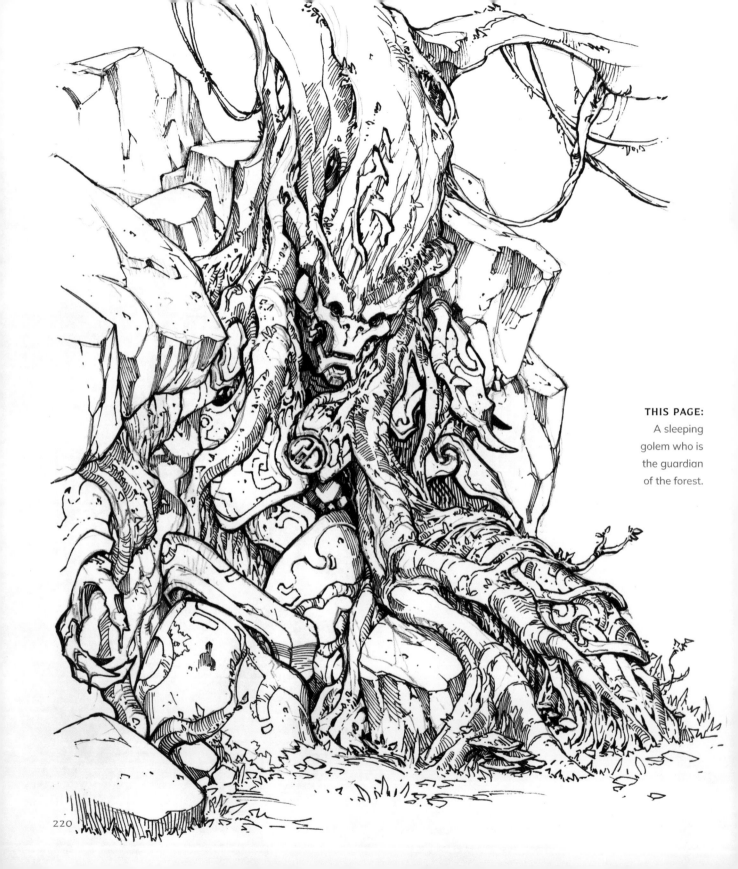

THIS PAGE:
A sleeping golem who is the guardian of the forest.

THIS PAGE, RIGHT:
A dragon knight. These elves defend the sky with their pale dragons.

THIS PAGE, BOTTOM LEFT: A sketch for my *Portraits of the Aspects* pieces: *Jealousy*.

THIS PAGE, BOTTOM RIGHT: Another sketch for my *Portraits of the Aspects* pieces: *Judge*.

BLUR THE LINE BETWEEN STAGES

Sometimes, try not to create a definite division in your mind between the "sketch" phase and the "final" work. Don't worry about drawing the "wrong" lines. Combining spontaneous and bold lines will allow you to discover new, impressive forms that are unfamiliar but good. Try to be bold and manage without that sketch phase.

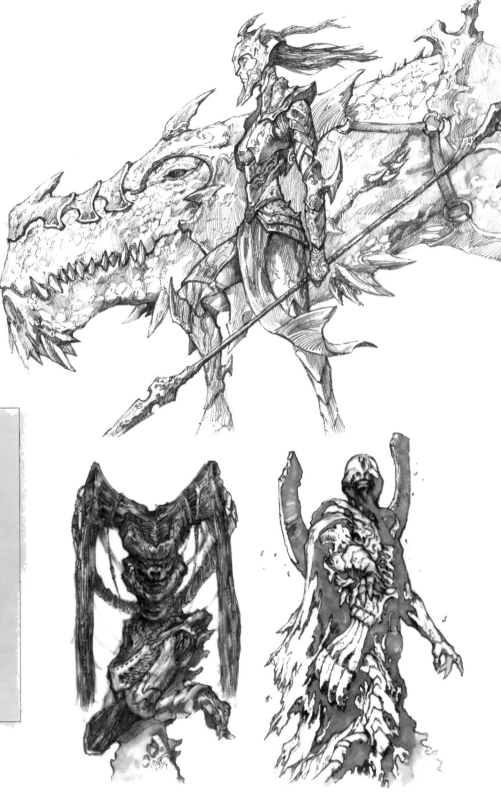

Owen, Matt

instagram.com/mrmattzan
All images © Matt Owen

I am a freelance artist based in Norwich, England. From a young age I have been interested in art, sketching characters and creating fantasy worlds for them to live in, which led me to study art further and pursue it as a job.

My love for fantasy novels, comics, films, and games has encouraged my desire to create my own stories in comics and illustrations. It has inspired me to create relatable characters in fantastical worlds that are grounded in reality, to spark the imagination of my audience in the same way that my favorite stories did for me.

Art has allowed me to put my imagination onto the page. Having grown up with a love for fantasy and magic, I get an enormous amount of satisfaction when I can discover and create my own interpretations of what fantasy means to me. I believe creating identifiable characters and interesting places is a key element for any artist when trying to tackle worldbuilding or coming up with a narrative. Having your audience invested in a character and developing a connection between the art and the viewer is something I strive for and I am constantly learning new ways to achieve this.

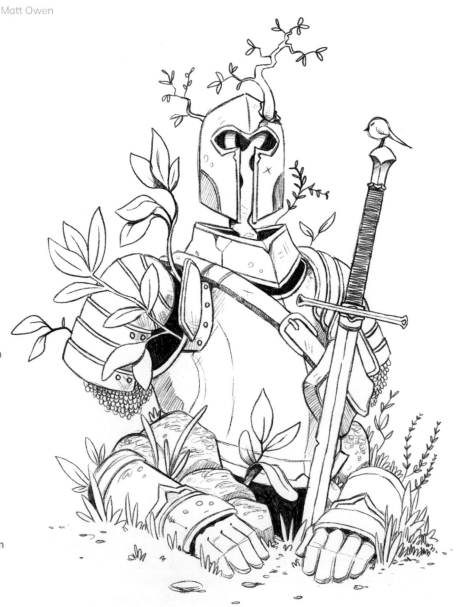

INSPIRATION AND IDEAS

I was always inspired by the North Yorkshire countryside in the north of England. Exploring the valleys and woodlands piqued my imagination and encouraged me to recreate these places the way my imagination interpreted them. Growing up, I was heavily influenced by other artists from comic books, films, and video games, as well as the Old Masters. Seeing the way they could bring epic tales to life blew my mind and motivated me to do the same in my own style.

MATERIALS

Being a digital artist who loves the look of traditional art, I have tried to recreate that same vibe within the programs I draw in. For a long time I would make my illustrations in Adobe Photoshop on a Wacom Cintiq tablet, but in more recent years I have moved to Procreate on the iPad, with a paperlike screen protector to really get that "sketchbook" feeling I was missing with the Cintiq. I also explore thumbnail sketches and rough studies in a normal sketchbook using basic tools such as a ballpoint pen or HB pencil.

TECHNIQUES

I start my drawings with basic shapes and a rough idea of the composition. This can consist of me scribbling down multiple thumbnails with a thick brush, keeping it as loose as I can, letting my imagination do most of the work. Once this is done, I go in and refine the shapes and perspective, keeping in mind the 3D space but concentrating on form and composition. Once the initial sketch is laid out, the linework stage is simple, so cleanup is fast. Then the design is ready for coloring.

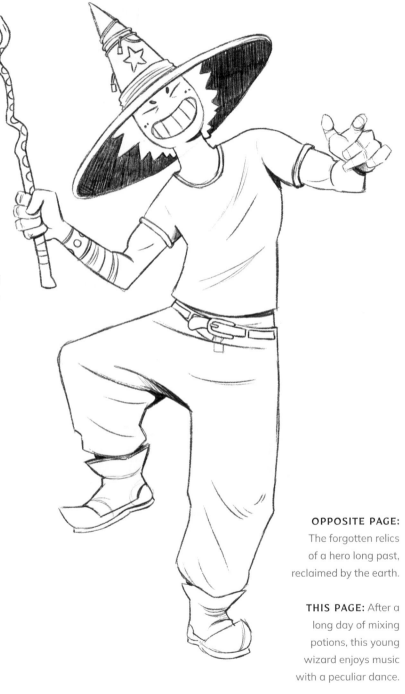

OPPOSITE PAGE: The forgotten relics of a hero long past, reclaimed by the earth.

THIS PAGE: After a long day of mixing potions, this young wizard enjoys music with a peculiar dance.

223

OWEN, MATT

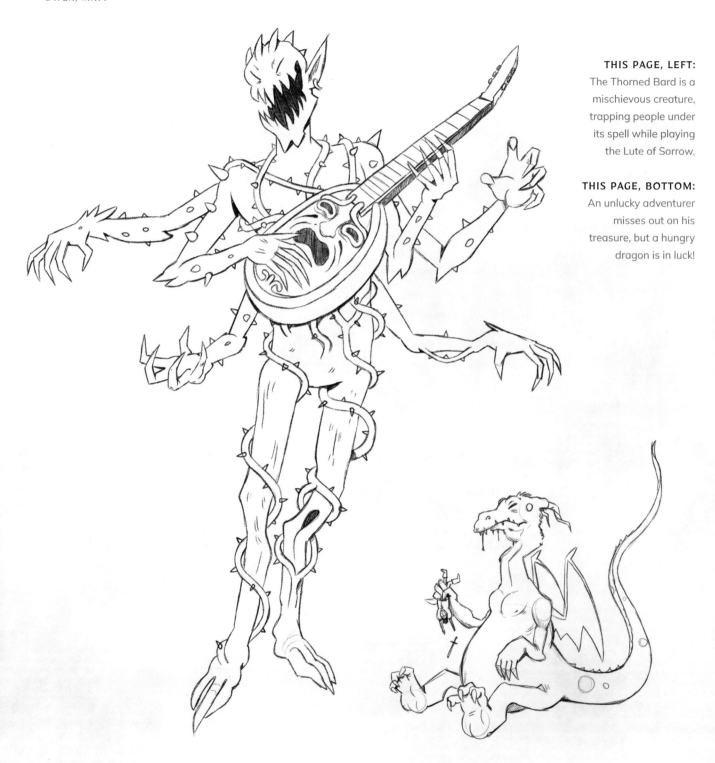

THIS PAGE, LEFT:
The Thorned Bard is a mischievous creature, trapping people under its spell while playing the Lute of Sorrow.

THIS PAGE, BOTTOM:
An unlucky adventurer misses out on his treasure, but a hungry dragon is in luck!

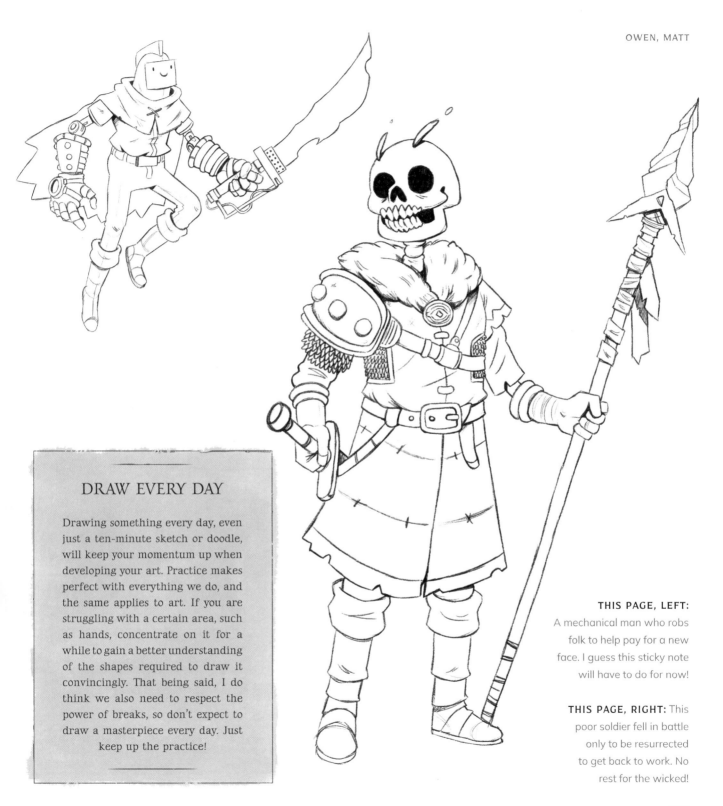

DRAW EVERY DAY

Drawing something every day, even just a ten-minute sketch or doodle, will keep your momentum up when developing your art. Practice makes perfect with everything we do, and the same applies to art. If you are struggling with a certain area, such as hands, concentrate on it for a while to gain a better understanding of the shapes required to draw it convincingly. That being said, I do think we also need to respect the power of breaks, so don't expect to draw a masterpiece every day. Just keep up the practice!

THIS PAGE, LEFT: A mechanical man who robs folk to help pay for a new face. I guess this sticky note will have to do for now!

THIS PAGE, RIGHT: This poor soldier fell in battle only to be resurrected to get back to work. No rest for the wicked!

FINDING A STYLE

When looking for styles in art, I think we must first understand how things work – learn the rules before we can break them, so to speak. Go out and study real life; draw buildings, cars, the countryside, wildlife, and people. Take it all in and start to understand how shapes can fit in everything and why values in color matter so much. Then you can start manipulating the way you draw things with confidence to fit the style you want.

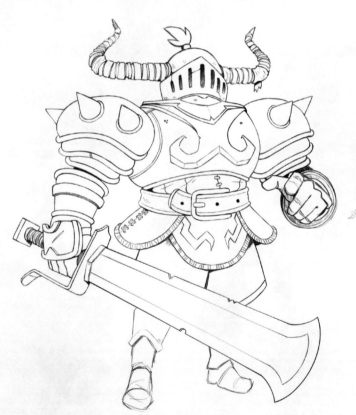

"I get an enormous amount of satisfaction when I can discover and create my own interpretations of what fantasy means to me"

OPPOSITE PAGE, LEFT:
A hulking figure wielding
his impressive greatsword,
ready to charge into battle.

OPPOSITE PAGE, RIGHT:
On the great frontier of the
Magic West, wandslingers
can be found practicing
the art of bullet magic.

THIS PAGE: The titan of Blade
Canyon dragging its colossal
sword through the ground,
wrecking everything in its wake.

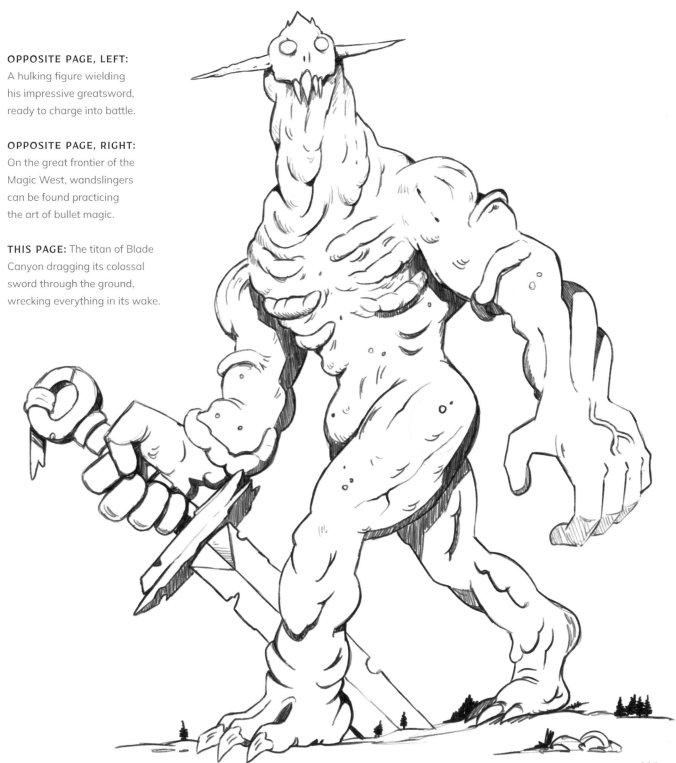

Paul, Rémy

artstation.com/alpyro
All images © Rémy PAUL

I studied 3D realization at Supinfocom (now RUBIKA), and then worked in advertising for a few years as a 3D generalist and motion designer. I was bored by this job, so at the age of thirty I decided to convert into a concept artist. It took me three years to get my first concept-art job at Tokkun Studio.

Sketching, in my point of view, is the best part of creating. It is a fluid moment. You have all your ideas and are planning them on the canvas. You can make mistakes, it doesn't matter. You can go back to zero, it doesn't matter – you don't feel like you worked for nothing or are abandoning forty hours of work. Sketches exist for making mistakes, and erasing a sketch is more like erasing a bad or a poorly constructed idea. By drawing and redrawing, you can and will improve yourself.

I like science fiction and fantasy because they create a space within reality, allowing the unreal to transform and become real. In sci-fi, I enjoy exploring the fusion between humans and machines, and creating new and unusual fashion styles. In fantasy, I tend to work more on the fusion between humans and nature in all her forms, finding something more organic. I enjoy creating characters who are adventurers or solitary warriors, as you'll see here.

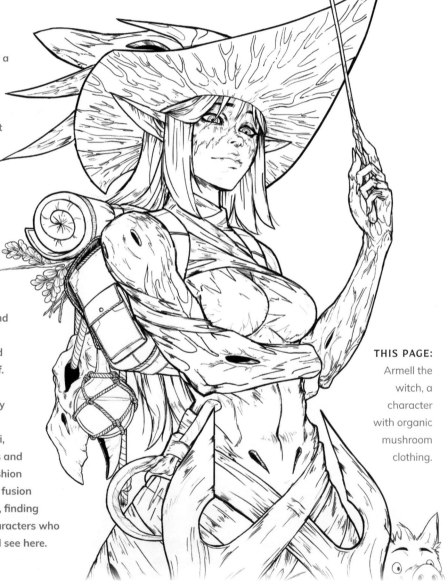

THIS PAGE: Armell the witch, a character with organic mushroom clothing.

INSPIRATION AND IDEAS
◇◇◇◇

Most of my inspiration comes from
Japanese manga and video games. The
one that has inspired me the most overall
is *Gunnm* (also known as *Battle Angel
Alita*), but for fantasy I really like *Berserk*,
Dark Souls, and *Final Fantasy XIV*. I try
to not fall into any particular clichés of
manga, but if I had to create one, it would
be more a seinen than a shōnen. I mix
all of these with some more Western
inspirations, such as Mœbius, *Alien*, *The
Lord of the Rings*, and *Warhammer 40,000*.

MATERIALS
◇◇◇◇

I mainly draw with a Wacom Intuos Pro
graphics tablet on my computer. For
software, I use Adobe Photoshop and
Clip Studio Paint. I also have a small
sketchbook for traveling that I draw in
with a wood pencil or a black ink pen.

TECHNIQUES
◇◇◇◇

I think I have a strange technique. Artists
will usually advise you to start with the big
forms and then go into detail, but, when
I first started to draw, perfecting the face
was my priority, and I learned proportion of
character from there. So, I almost always
start with the eyes, nose, and mouth. Then
I draw the head, neck, and hair (or other
elements, like a helmet). Next, I draw the
full figure to determine the posture I had
in mind. Last, I finalize the design with
clothes, markings, objects, and so on.

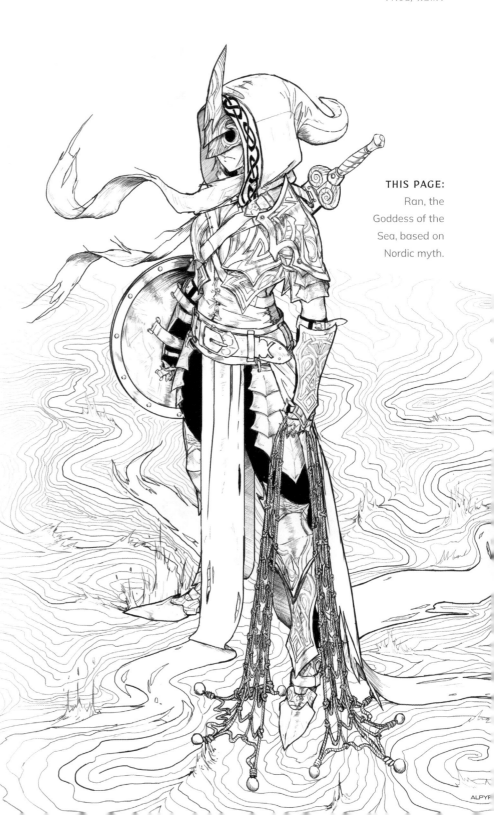

THIS PAGE:
Ran, the
Goddess of the
Sea, based on
Nordic myth.

THIS PAGE: I love witches. I gave this one a cyberpunk theme.

OPPOSITE PAGE, LEFT: An adventurer with a Viking-style helmet.

OPPOSITE PAGE, RIGHT: I just wanted to draw a cute witch!

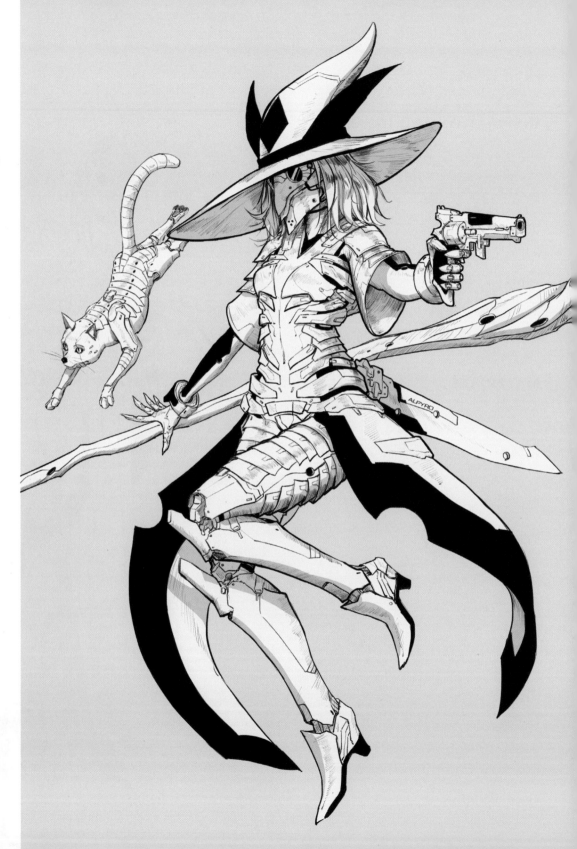

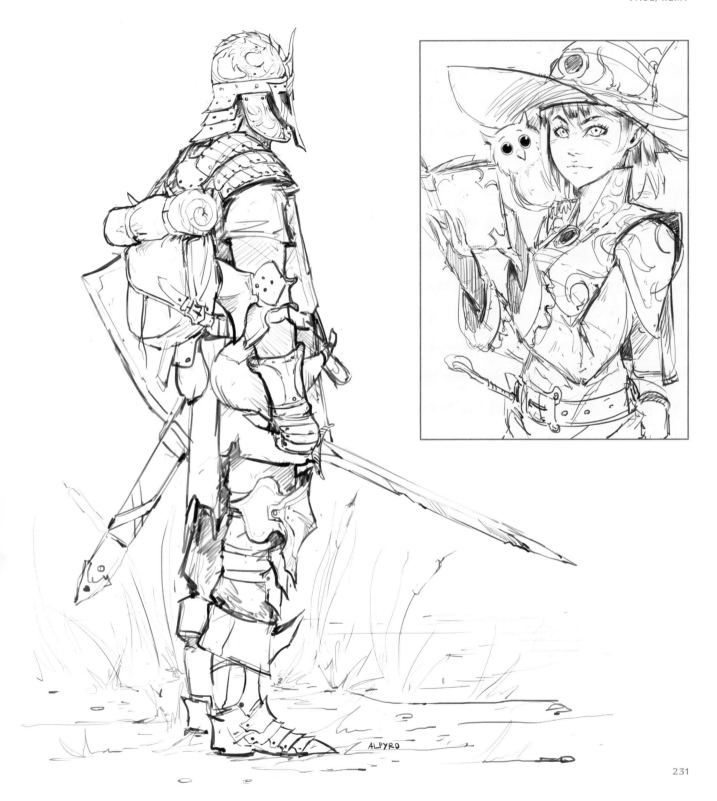

PAUL, RÉMY

THIS PAGE:
A dinosaur rider.

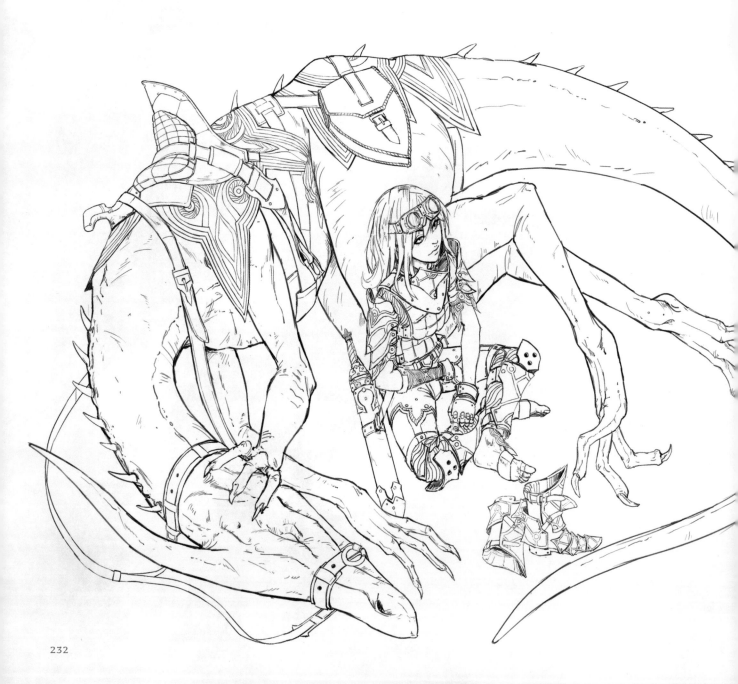

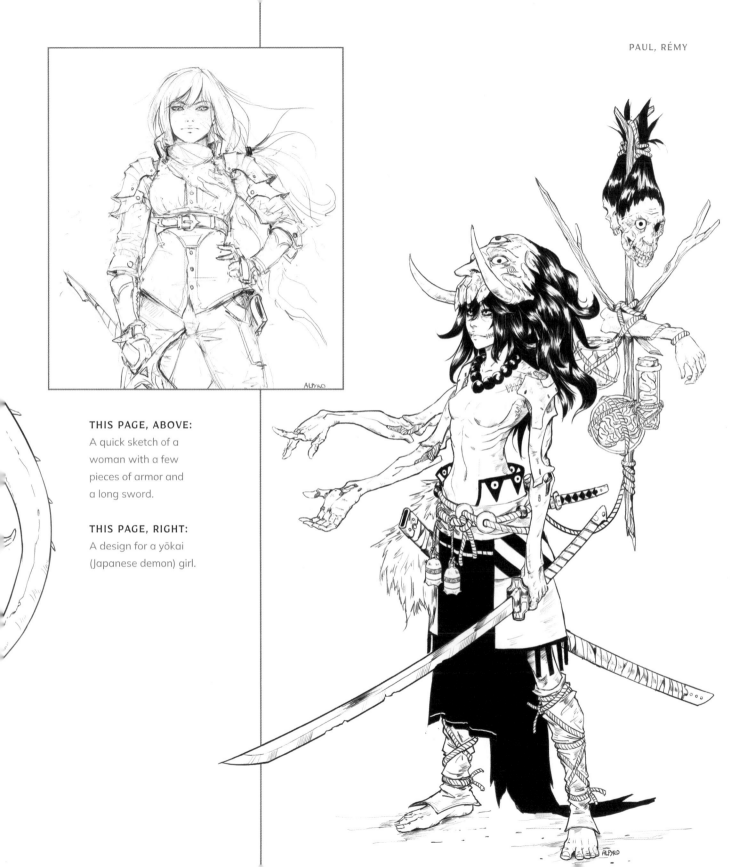

THIS PAGE, ABOVE:
A quick sketch of a
woman with a few
pieces of armor and
a long sword.

THIS PAGE, RIGHT:
A design for a yōkai
(Japanese demon) girl.

Pawlikowska, Elwira

behance.net/ElwiraPawlikowska

All images © Elwira Pawlikowska

I was born in a gray Polish reality. Luckily, I grew up "in the woods," where trees and a brook were my playground. From early childhood I was surrounded by books about classical art and the Old Masters (Leonardo da Vinci, Giovanni Battista Piranesi, Albrecht Dürer). In high school I became interested in fantasy books and role-playing games. These were the main influences that pushed me toward drawing for a living.

After graduating from Warsaw Faculty of Architecture (which looked like a "serious education" to my family), I focused on my career as a freelance illustrator and concept designer. Nevertheless, those studies still have a great impact on my artwork and are a big help in my job.

My niche is architectural subjects, but not just any architectural subjects. What really triggers my creative side is imaginary worlds, especially in the historical fantasy genre. I am fascinated by fairy tales, dark medieval themes, the romantic nostalgia of the Victorian style, and the mysteriousness of folk beliefs.

In my favorite subjects, the real world entwines with a fantasy one or, like in the case of mythological or folk themes, a spiritual one. Sketching gives me an opportunity to capture ephemeral visions of imaginary worlds and make them more real. It helps to get lost in these mysterious realms, so, in a sense, it is a kind of escapism.

THIS PAGE: A castle surrounded by rivers of lava and guarded by a dragon. Maybe there's an imprisoned princess here?

234

INSPIRATION AND IDEAS
◇◇◇◇

I would say that my style is a combination of four main inspirations: classical, technically oriented engravings and sketches; fantasy realms from books and games; heavy, melodic music; and dark, slightly surreal paintings (especially the art of Zdzisław Beksiński). In other words, it is a mix of technical precision, nostalgia, and darkness.

My works are often described as grim and gloomy, but for me there is a feeling of calmness and coziness in them. I rarely consciously search for inspiration. Usually, the artwork just takes shape as I proceed.

MATERIALS
◇◇◇◇

I definitely prefer traditional media over digital techniques. For my initial sketches I use relatively thin and hard mechanical pencils: H or HB, 0.5 mm. Precision is key!

Choosing the right ink pen has a huge impact on the final appearance and character of a drawing, and my choices are, again, precise and thin pens. I use pens with waterproof ink. Sepia ink fits "historical" subjects very well, but black pens are more practical if the final product is meant to be printed in black and white.

Finally, a graphics tablet is an inevitable tool for "cleaning" my illustrations after scanning.

TECHNIQUES
◇◇◇◇

I am a mathematical type of person, technically trained and detail-oriented. It sounds like a very stiff background that doesn't leave much space for artistic freedom, but for me these boundaries are just frames for my work. Even in a fantasy world, buildings should be created in a logical way and constructions must look plausible, though a strong exaggeration is allowed! I rarely draw from nature. To be honest, I just hate plein air drawing! I prefer to construct my sceneries geometrically and purely from imagination, in the comfort of my home.

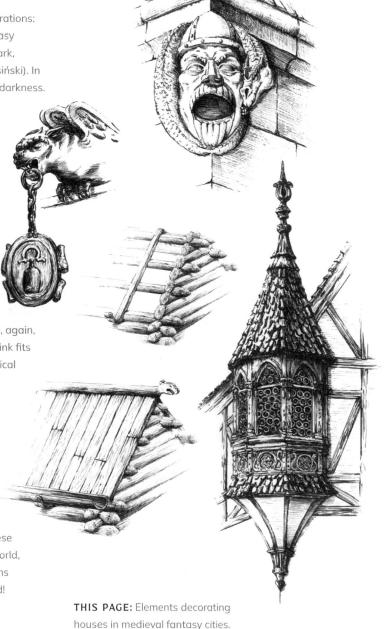

THIS PAGE: Elements decorating houses in medieval fantasy cities. These details are quite sinister.

"EVERYTHING YOU DO PROVES WHO YOU ARE"

These were the words of a professor from my faculty, which really stuck in my memory. It is a very general rule and, at first glance, it may seem obvious, but acting according to it is truly important. The way you interact with other artists, the way you contact people interested in your works, the images you submit to social media – all this shows if you are trustworthy, diligent, and respectful toward others. Don't feel like there's a lot of pressure, though!

THIS PAGE: Details decorating fantasy castles and palaces: an elven portal, a dragon window, and a lion gutter.

OPPOSITE PAGE: No one knows what happened to the soothsayer who lived in this house in a forest in the Far North.

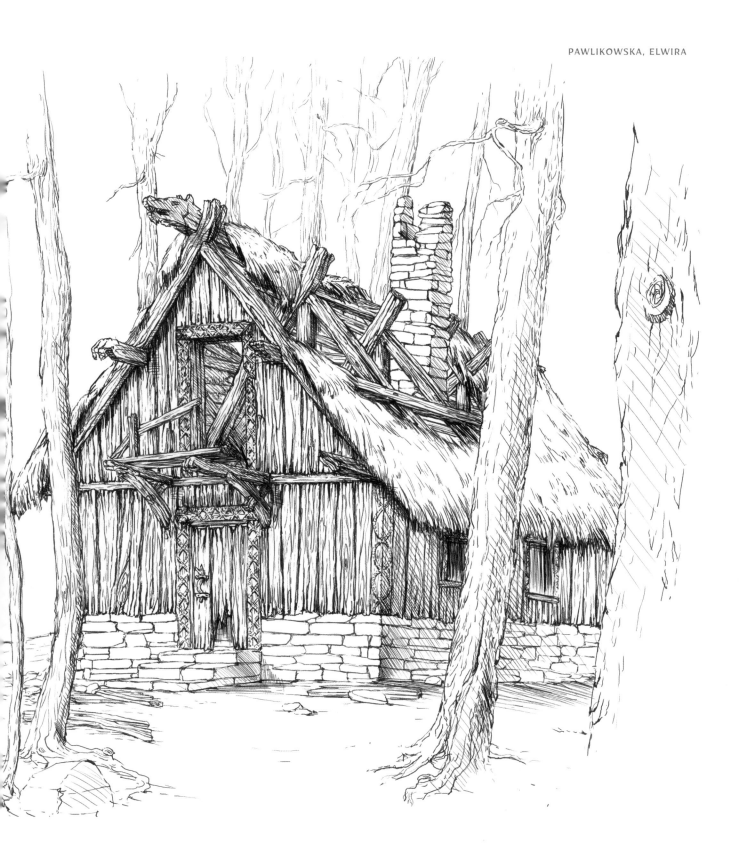

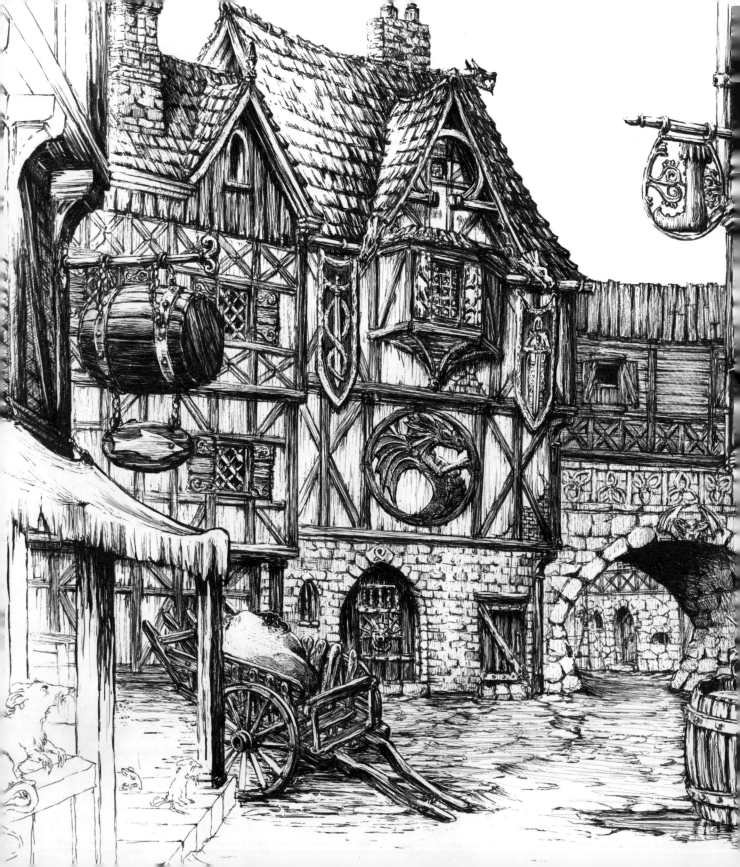

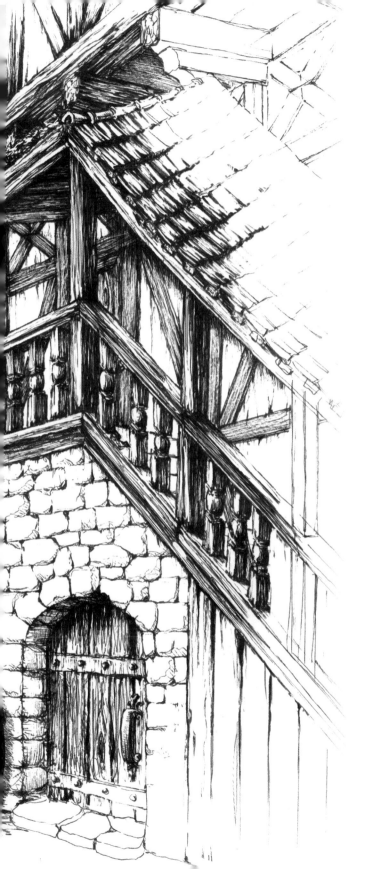

OPPOSITE PAGE: This decaying town used to be wealthy, until an unspecified event relating to the Dragon's Guild occurred.

THIS PAGE: A lonely wanderer roaming through enchanted portals to parallel worlds. Each world is surreal and inhospitable.

EXCESSIVE COMPLACENCY IS THE ENEMY!

Have fun with your artistic activity but, if you want to treat it seriously, you should be a critical reviewer of your works. Being overenthusiastic about your achievements can prevent you from being better. Compare your works with pieces made by your idols and strive to reach their level. It sounds like a perfectionist's motto, but it's good to know your goal and keep moving toward it.

Pham, Ngan ("Zevania")

zevania.artstation.com

All images © Zevania

I was born in Vietnam, where I still live now. I'm so lucky that the place I grew up in was close to nature, so I got to run around and discover many things when I was a kid. When my teenage years came, I was so fascinated by video games, anime, manga, and novels that I picked up the pencil and started doodling. I haven't stopped ever since!

One of the themes that I always come back to is fantasy. In my mind, everything around us always feels so magical. To me, the act of drawing or painting is like speaking a language, except that everybody can understand it. With that in mind, I always strive to tell stories with my drawings, in the hope of conveying an emotion to anyone viewing my artwork.

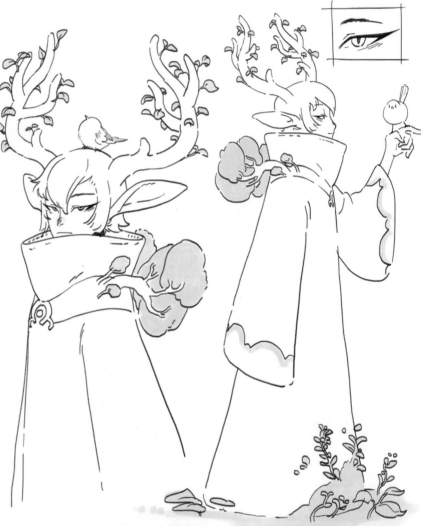

THIS PAGE: When spring comes, this spirit appears and brings life to the forest. He also has the power of healing.

INSPIRATION AND IDEAS

I grew up with so many stories from all over the media that I consumed. They shaped my view of the world and inspired me to make my own contribution. When I took my first step into the art industry, I was completely overwhelmed by the vast number of talented artists, but then they became one of my biggest sources of inspiration. I could list the names of my favorite artists but it would fill this whole book, so I'll hold back on that!

As I grow older, I find that life experience starts to get more inspiring as well. Like many other artists that I know, I'm an introvert and don't go out a lot, but one time I got a chance to go on a vacation and everything just clicked. I realized I'd missed out on a lot because I used my car sickness as an excuse to not explore more.

MATERIALS

I draw and paint mostly with digital tools. The software that I use is Krita, an awesome open-source software. Sometimes I make sketches on paper using colored pencil, which makes me feel closer to my work. I also took part in a big inking challenge once, and it felt great, but it was too time-consuming for me and I haven't returned to it since. Hopefully I can try out more materials in the future.

TECHNIQUES

I usually start with an idea in my head, in words only, just like how you find an idea for a story. Then I move on to the next step, which is "blob sketches." Normally, my first sketches of an idea are only for me, so they are quite messy and appear to have no meaning. I've included some sketches like that here. Don't worry if you can't see the details or what the sketches meant – sometimes I can't, either! That preparation step is super important to my workflow. After the sketching steps are done and well-prepared, I put on music and just flow with the lines and colors.

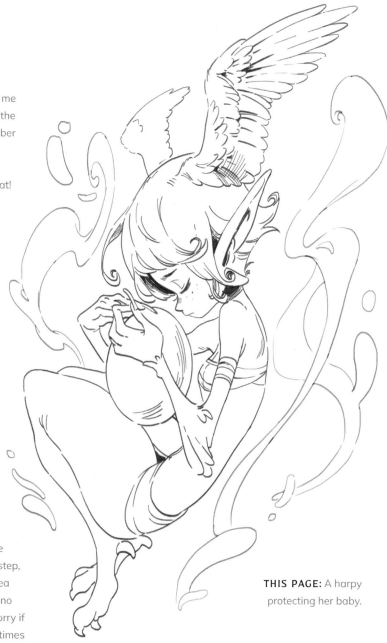

THIS PAGE: A harpy protecting her baby.

241

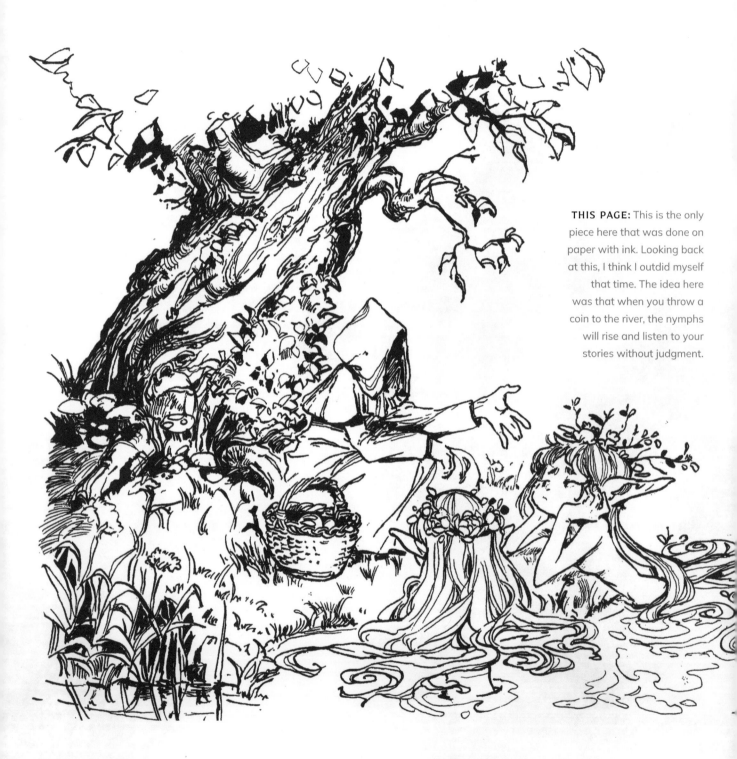

THIS PAGE: This is the only piece here that was done on paper with ink. Looking back at this, I think I outdid myself that time. The idea here was that when you throw a coin to the river, the nymphs will rise and listen to your stories without judgment.

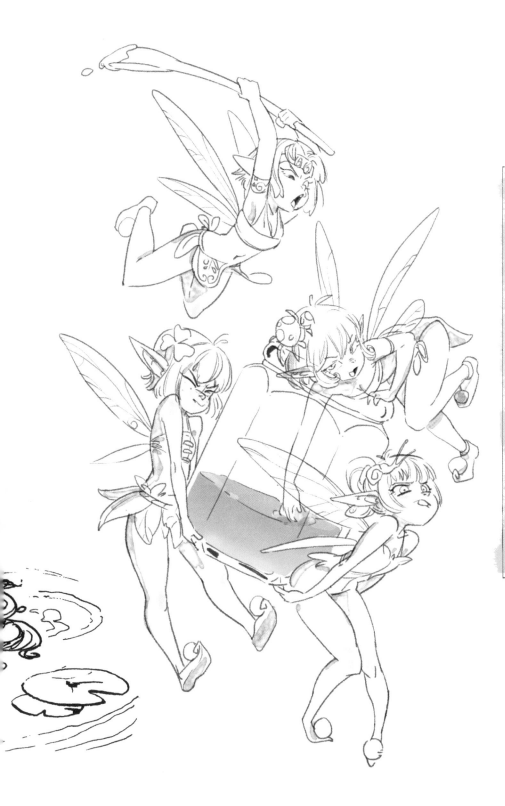

FINDING IDEAS

In my personal experience, reading books, especially fiction ones, really helps me a lot in building my imagination. If you haven't read a book for a while, you could consider picking one up.

Sometimes we can also find ideas from the most mundane things around us. I often catch myself looking at something weird and random, like a stain on the wall or a pile of leaves, and then an idea just sparks up!

THIS PAGE: Keep an eye on your honey jar or these fairies will come for it!

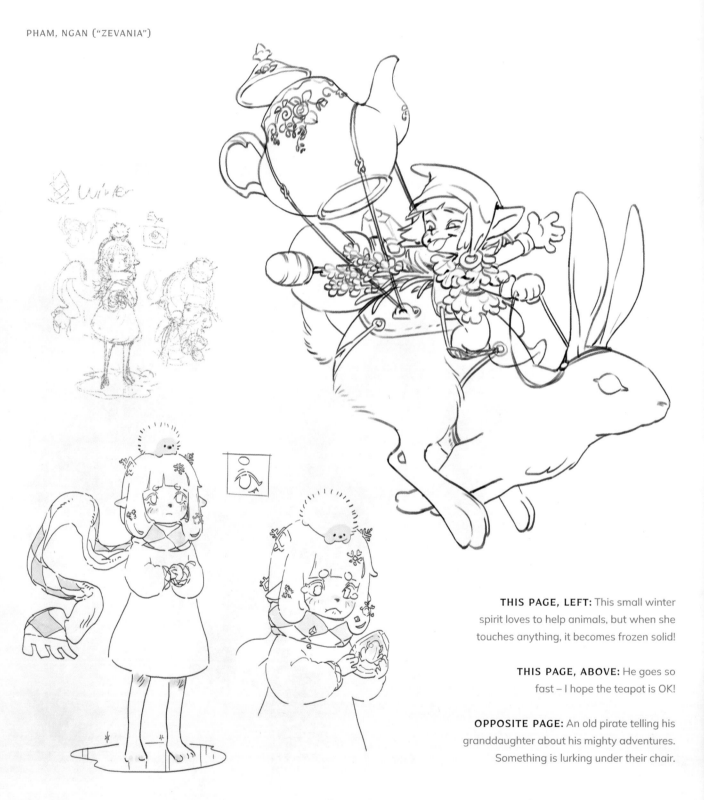

THIS PAGE, LEFT: This small winter spirit loves to help animals, but when she touches anything, it becomes frozen solid!

THIS PAGE, ABOVE: He goes so fast – I hope the teapot is OK!

OPPOSITE PAGE: An old pirate telling his granddaughter about his mighty adventures. Something is lurking under their chair.

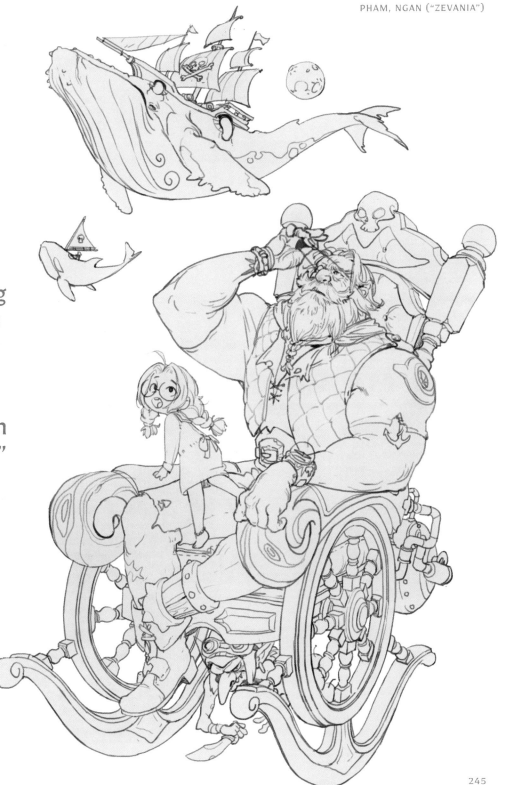

"To me, the act of drawing or painting is like speaking a language, except that everybody can understand it"

Remes, Aleksi

aleksiremes.com
All images © Aleksi Remes

I am a freelance illustrator and artist from Finland, with professional experience in the Finnish indie game and comic scenes. I mostly make art in the fantasy and horror genres. When I'm not working for clients, I'm painting artwork for my graphic novel project and creating other personal pieces.

I gravitate mainly toward fantasy art because of the limitless creative freedom that it grants me in the visual depictions of my characters, worlds, and themes. I especially enjoy creating dreamlike illustrations with hints of surrealism in them. Visual art in general is a way for me to explore myself and communicate my thoughts and ideas to others.

My sketchbooks are a pressure-free space where I study the visual images in my mind. I don't necessarily always have a clear plan of what I'm about to do when I place my pen on paper, but letting my mind roam free while drawing can often bring forth some fantastical imagery with very spontaneous energy. I find this kind of approach not only fun and relaxing, but it also allows me to practice my creativity and test out ideas that can later be refined into more complete pieces of art.

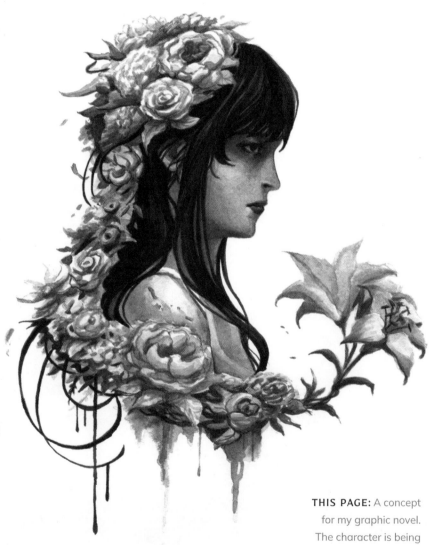

THIS PAGE: A concept for my graphic novel. The character is being consumed by flowers.

INSPIRATION AND IDEAS

Like many artists, I first got into drawing through manga and video games, and illustrations from Japanese fantasy games continue to inspire me to this day. Much of my work also carries little bits of inspiration from my personal experiences. I believe that inspiration found within the self can be a powerful tool to make one's art feel unique, genuine, and heartfelt.

MATERIALS
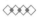

For sketching, I like to use traditional drawing tools such as graphite pencils, ink pens, and India ink. Afterward, I may work my sketches further by coloring and editing them in Adobe Photoshop. Similarly, for my larger and more finished illustrations, I use acrylic and oil paints with digital finishing touches. Unless the work requires me to start digitally from scratch, I rarely skip the initial traditional phase of my creation process, as I enjoy the tactile feeling of drawing and painting on paper too much.

TECHNIQUES

Composition and visual storytelling have always been some of my main areas of interest in illustration. I try to create shapes and contrasts that have strong silhouettes and naturally move the viewer's eye through the different focal points of the image. Even if the piece depicts a stationary figure, I still aim to bring life to it through smaller details such as line direction and object placement. These compositional techniques can also be used to create surprising and unexpected elements, which helps make the artwork more memorable.

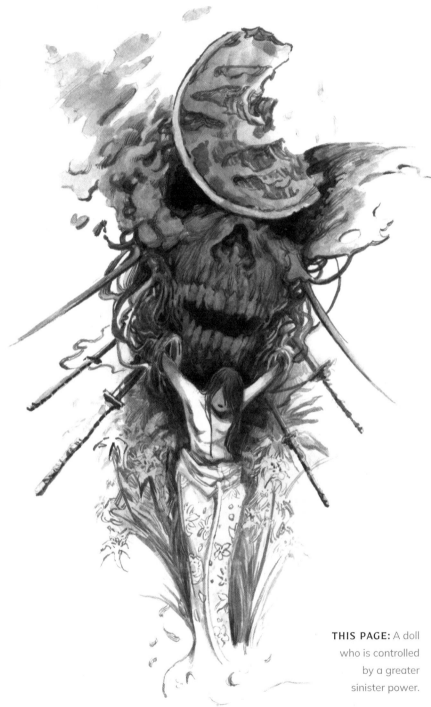

THIS PAGE: A doll who is controlled by a greater sinister power.

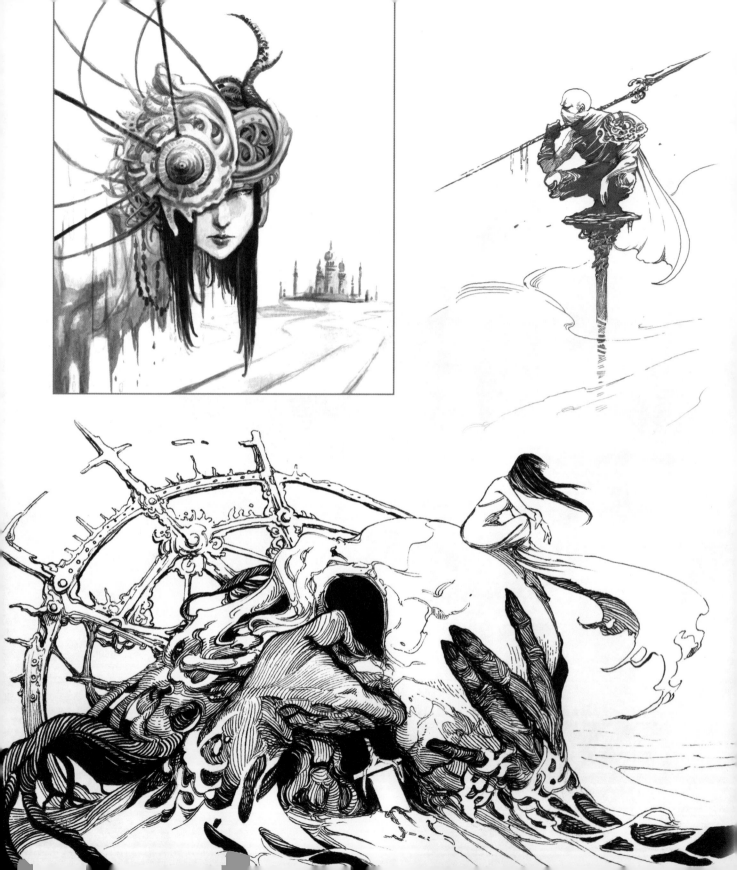

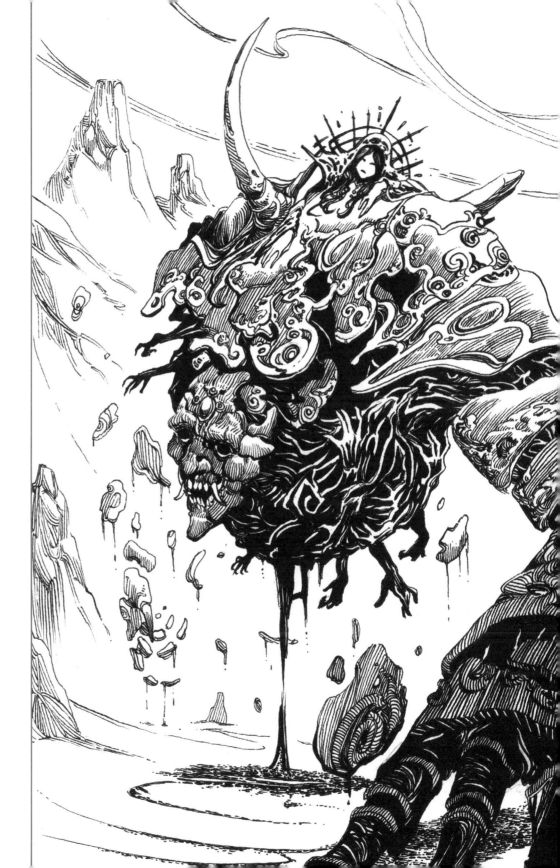

OPPOSITE PAGE, TOP LEFT: A sketch of a woman wearing surreal headwear.

OPPOSITE PAGE, TOP RIGHT: A watchman sits on guard with a spear ready at hand.

OPPOSITE PAGE, BOTTOM: Another concept sketch for my graphic novel. I wanted to convey a feeling of loneliness through this image.

THIS PAGE: A witch summons a fierce golem from shadows and rubble.

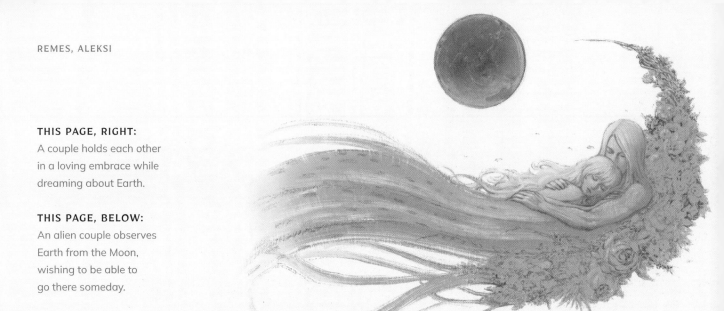

REMES, ALEKSI

THIS PAGE, RIGHT:
A couple holds each other in a loving embrace while dreaming about Earth.

THIS PAGE, BELOW:
An alien couple observes Earth from the Moon, wishing to be able to go there someday.

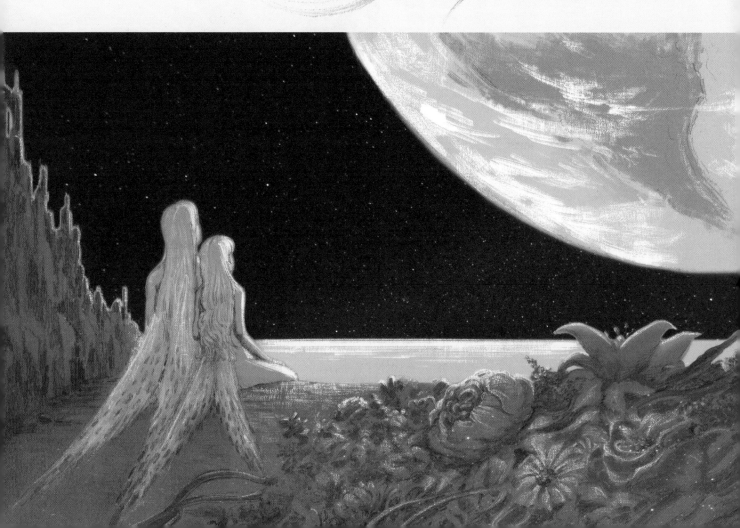

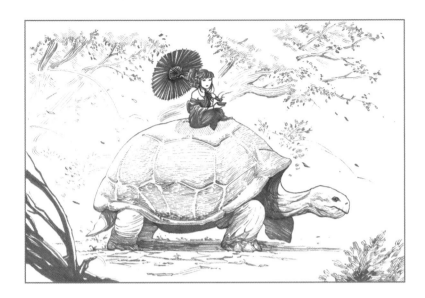

THIS PAGE, LEFT: Two friends on a leisurely walk.

THIS PAGE, BELOW: A demon bride with her two henchmen.

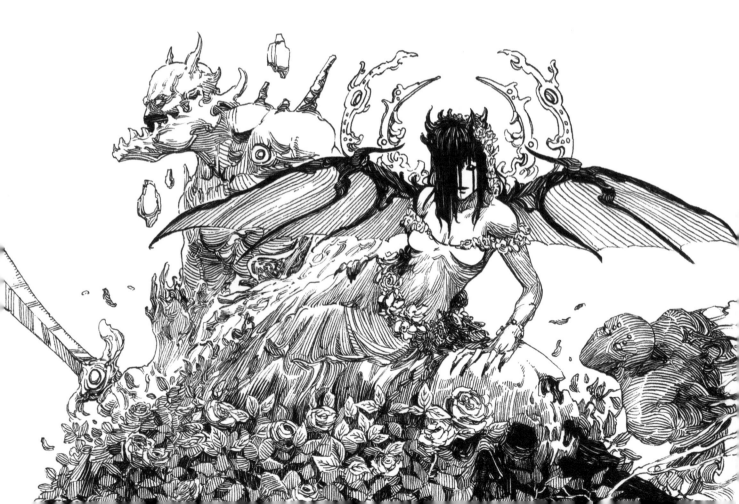

Riekkinen, Riikka Sofia

artstation.com/midorisa
All images © Riikka Sofia Riekkinen

I have always loved art and illustration, and always been fascinated by how artists could build entire worlds out of nothing. Illustrations seemed like windows or doors to those worlds. It's almost a magical feeling to me, as I've loved stories and characters from a very young age. Seeing the work of other artists has been one of the biggest sources of inspiration for me.

My early artistic inspirations came from the media I was interested in, ranging from fantasy books and manga to video games and animation. When I was around six or seven, I got a very strong feeling that I also wanted to be able to draw fantasy characters and become a skillful artist someday. But my artistic path hasn't been straightforward or linear, and it took me some time to get serious about this childhood dream.

For me, sketching is a way to explore and experiment with ideas and to practice my technical drawing skills. I also like how sketching enables me to just have fun while drawing without the pressure to be perfect: sketches in my sketchbooks and digital folders can sometimes be very messy and unfinished, and that's fine.

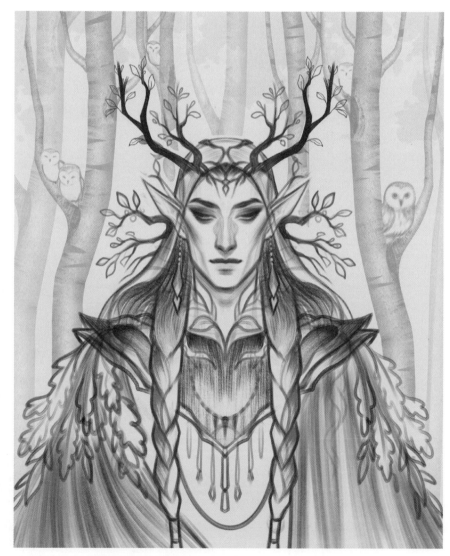

INSPIRATION AND IDEAS
◇◇◇◇

My biggest sources for inspiration are nature, stories, games, and mythology. I'm fascinated by the organic and graphic shapes and rich decorativeness of the Art Nouveau style, and I love botanical illustrations and Japanese ukiyo-e art. I also draw inspiration from my childhood and teen years' artistic influences, such as manga and book covers. Last but not least, I'm a huge fan of music: music and art kind of go hand in hand for me. I almost always listen to music when I draw, as it helps me get into the flow of drawing.

MATERIALS
◇◇◇◇

Traditionally, I like to draw with varying mechanical pencils, especially those that include an eraser as they make sketching smoother. I also like to sketch with ink pens. I use paper suitable for both pencils and inks.

Digitally, I like a feeling that loosely resembles traditional sketching. I've customized my brushes in PaintTool SAI to fit my way of working. I like brushes that have some texture, varying pressure sensitivity and tip softness. I have brushes that resemble the look of ink pens and a brush that feels a bit like my mechanical pencil.

TECHNIQUES
◇◇◇◇

I start my sketching from big shapes and basic form construction. I also pay attention to shape flow and try to avoid using small brushes and zooming-in early on. Instead, I use bigger brushes set to lower opacity to produce a light sketch. After I've got the basic idea down, I start to build more details and smaller shapes on top of it, working from big to small, saving fine details for last. If I need to produce clean line art, I create a new layer on top of the sketch and draw the detailed version on that.

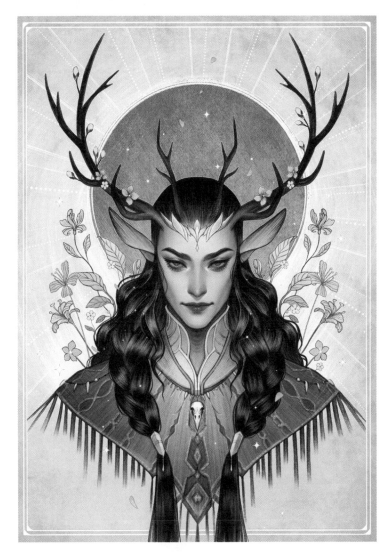

OPPOSITE PAGE: A rough sketch for a future illustration and character, where I want to focus on fantasy and nature themes.

THIS PAGE: A sketch of a character inspired by the springtime and Easter.

THIS PAGE: A sketch for a summer-themed illustration filled with flowers.

"Sketches in my sketchbooks and digital folders can sometimes be very messy and unfinished, and that's fine"

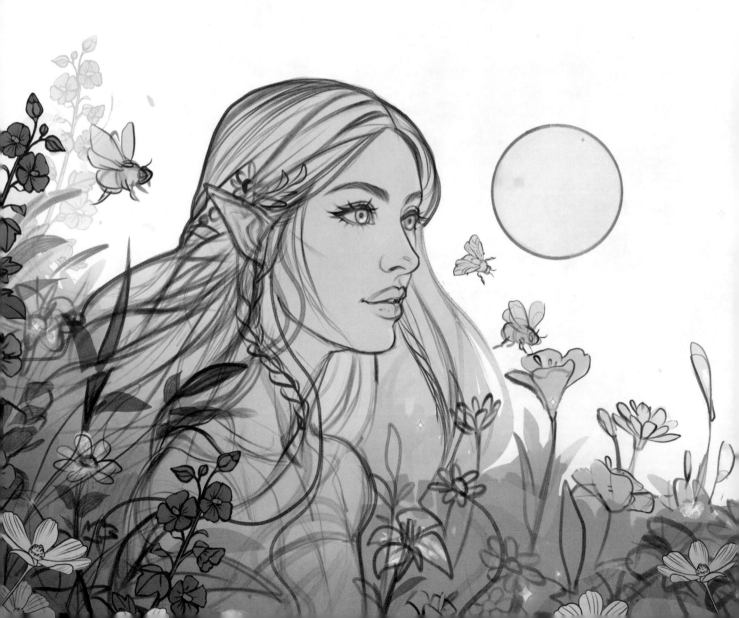

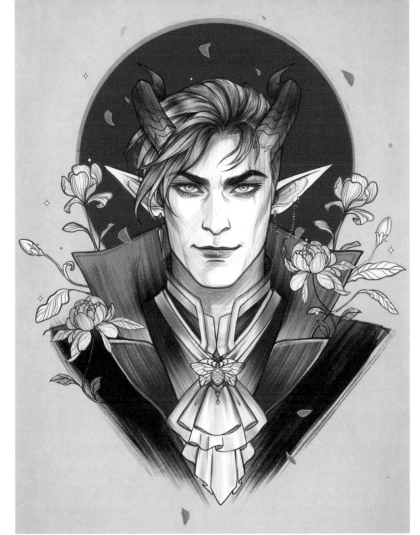

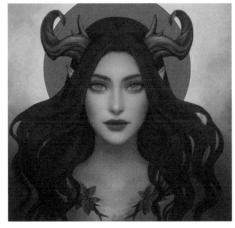

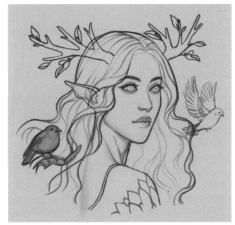

THE BLANK PAPER AND PERFECTIONISM

Sometimes you can feel intimidated by the emptiness of your canvas, building a lot of expectations for yourself. Try not to let fear or perfectionism hold you back from having fun sketching. For me, sketching on a "messy" canvas reduces the pressure of making those first lines of my sketches pretty. I often draw warm-up doodles on the canvas and leave them there for a while, even when I focus on working on the main idea. I also have a private, "ugly" sketchbook. Try to discover the best ways of working for you, which make your sketching process more fun.

THIS PAGE, TOP LEFT: The basic composition for an illustration. I will add decorative frames, details, and colors as I proceed further.

THIS PAGE, TOP RIGHT: An early stage of an image called *Memento Mori*. The basic idea begins in black-and-white values, before I move on to overlaying basic colors and overpainting details.

THIS PAGE, ABOVE: Sketch for an image called *Hope*. This will be painted over with layers of color later, so I leave it rough.

255

THIS PAGE: An idea for a future illustration. I've really wanted to include owls in my work lately!

OPPOSITE PAGE: Some character head sketches and ideas for practice and warming up.

DRAW WHAT YOU LIKE

When you draw what truly interests, excites, and inspires you, you will likely have more fun sketching and feel much more motivated to keep drawing and practicing your skills. If you're feeling art-blocked and stuck, try sketching your favorite subject matter that is in your comfort zone. Don't forget to be kind and gentle toward yourself and remember to rest, recharge your creative batteries, and take breaks as well.

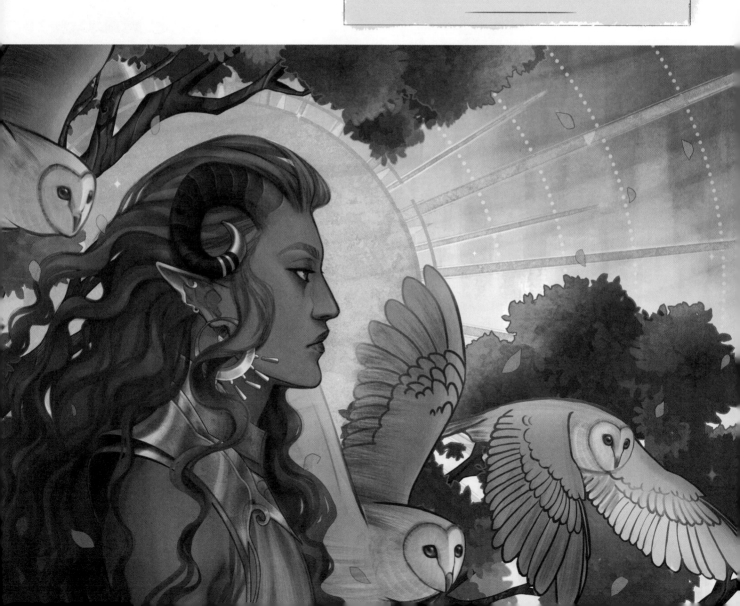

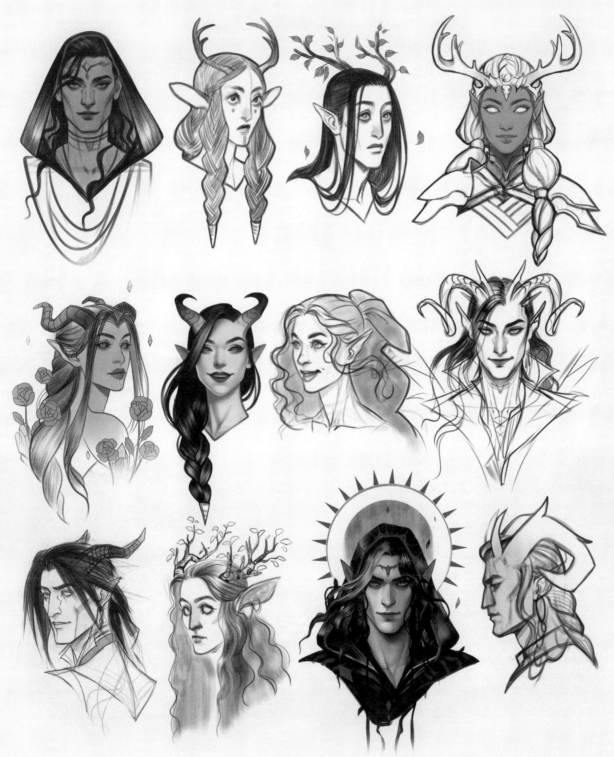

Ryu, Entei

artstation.com/badzr

All images © Entei Ryu

I graduated from the University of Tokyo with a degree in architecture, but now I mainly work on character and creature design for video games and movies. As a freelance artist I also make sculptures and jewelry designs. Sketching has always been my habit to maintain my keen observation and accurate drawing skills. At the same time, it's also a way to try out many different themes in a short time and accumulate a visual library of design ideas.

INSPIRATION AND IDEAS
◇◇◇◇

I've been a fan of fantasy since I was a kid, when I was introduced to my favorite animation, Disney's *Fantasia* (1940). I also love fantasy literature and games. Mythology, magic, and fantasy beasts are always exciting sources of inspiration.

I think what really attracts me to the fantasy genre is the ambiguity between fiction and reality, because fantasy always comes from reality. So, in order to construct a convincing fantasy world, knowledge of reality is very important, and this is what I focus on in my daily drawing practice. Real-life plants and animals are also my inspirations.

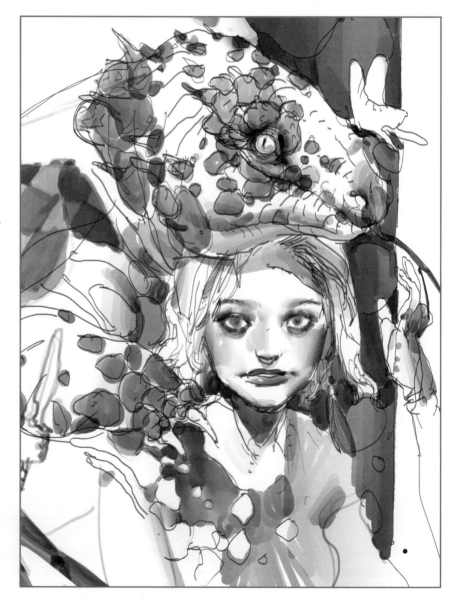

MATERIALS

For traditional tools, I use pencils and ink
brushes. For digital tools, I often use ZBrush,
Adobe Photoshop, and Procreate on my
iPad. I developed my own digital brushes,
most of them in various round shapes.
I don't like my tools and workflow to be
overly complex – keeping tools simple helps
improve my concentration and creativity.

TECHNIQUES

I think it's very important to put enough
thought into your work. For example, if you
are drawing a tree, it would feel completely
different in the cold wind or under the hot
sun. Imagine as many things "outside the
picture" as possible, such as temperature,
gravity, and speed. These associations will
enrich your perceptual system and make
what you draw more convincing. When your
feelings are there in the drawing, the viewer
will naturally be affected by them too.

OPPOSITE PAGE: A white-haired
girl and her "evil dragon" friend. The
pattern of the creature's scales and
the texture of the character's clothes
seem to be linked together.

THIS PAGE: Princess Saturn and her
guards. This sketch used the watercolor-like
rendering I am used to. Instead of detailed
metal parts, I used generalized soft and hard
lines to distinguish the different materials.

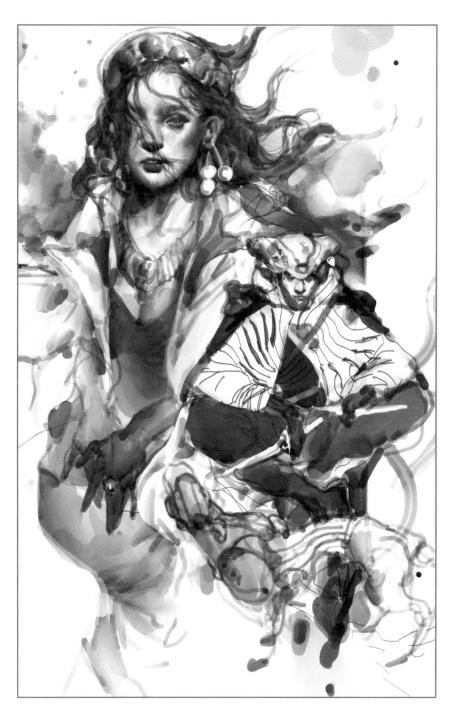

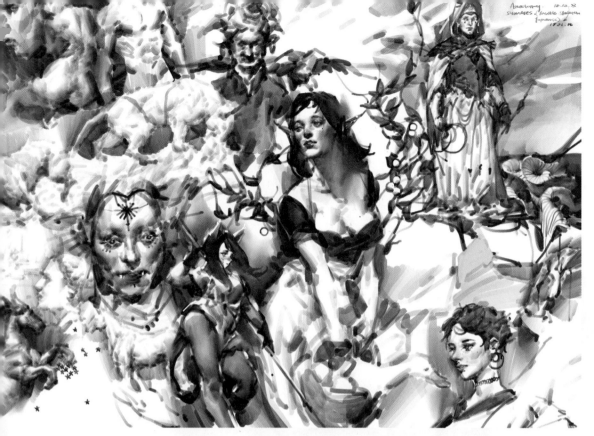

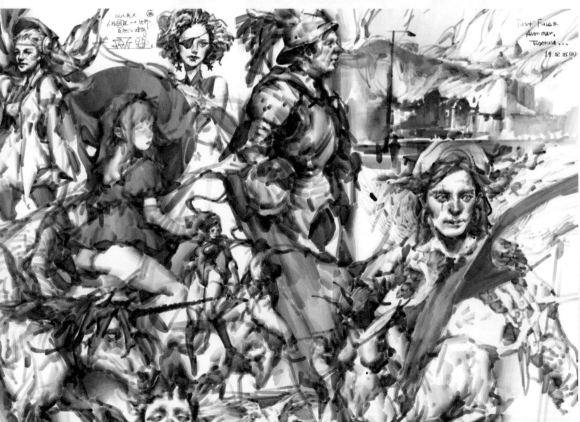

THIS PAGE, TOP:
Magic, knights, fantasy creatures, and little stars – some character sketches made with big strokes, like watercolor.

THIS PAGE, BOTTOM:
This was painted in the same period as the top image. At that time, I cared more about the big outlines and values than the details.

OPPOSITE PAGE:
Several groups of original characters, mainly just drawn with lines. They're a little more anime than my usual style.

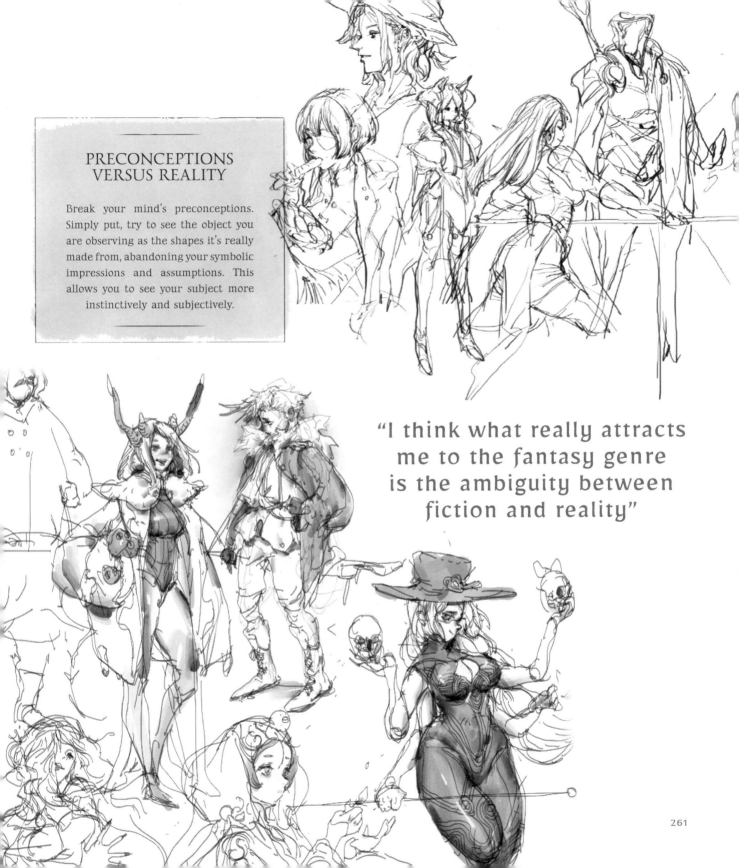

PRECONCEPTIONS VERSUS REALITY

Break your mind's preconceptions. Simply put, try to see the object you are observing as the shapes it's really made from, abandoning your symbolic impressions and assumptions. This allows you to see your subject more instinctively and subjectively.

"I think what really attracts me to the fantasy genre is the ambiguity between fiction and reality"

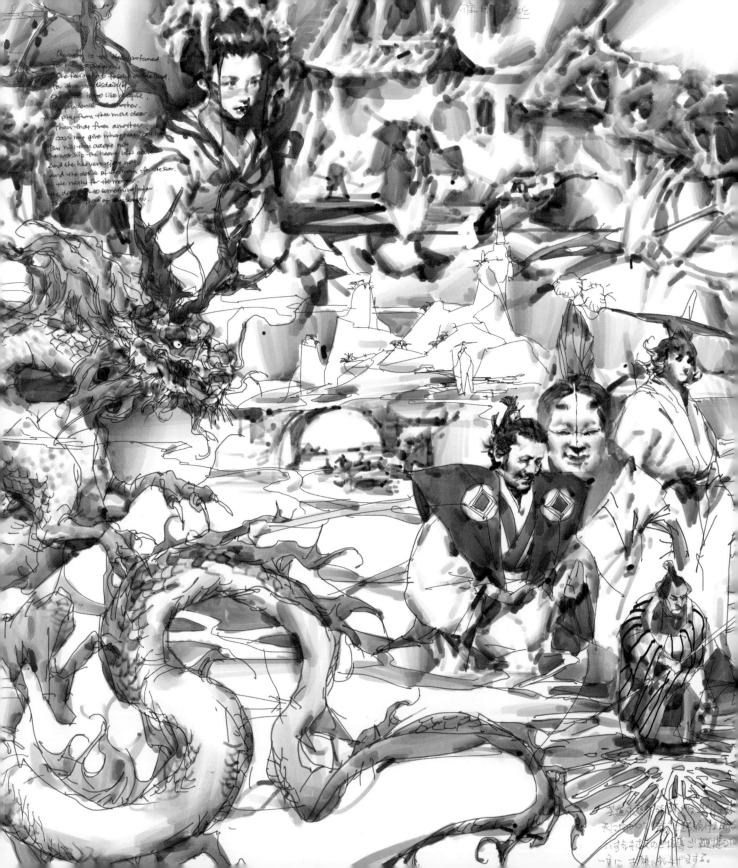

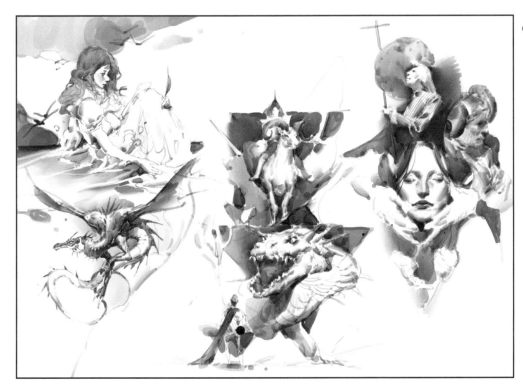

OPPOSITE PAGE: This image, titled *RAN*, is a collection of sketches with a Japanese theme. I actually started from a partial drawing and connected it with decorative lines when I finished.

THIS PAGE, LEFT: These are practices in composition, using fantasy animals and characters to form compositions like movie posters.

THIS PAGE, BELOW: The initial draft of my sculpture *Dragon Mermaid*. The complex, twisted dragon's tail and the upper body of a petite girl form a sharp contrast.

SIMPLE SHAPES ARE POWERFUL

Use more simple, basic geometry in your composition. Spheres, triangles, quadrilaterals – classic geometry never goes out of style, and simple shapes are more likely to attract the viewer's attention. Do more subtraction and simplification in your paintings.

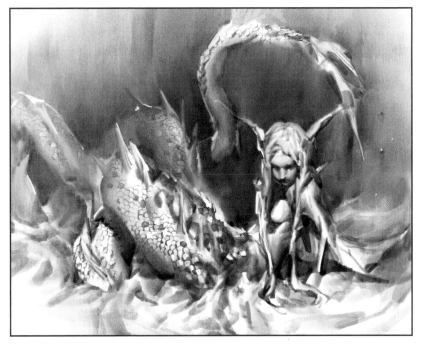

Sporin, Ognjen

artstation.com/ognyendyolic

All images © Ognjen Sporin

I live in Serbia, in a small village near my hometown. I spend most of my time doing art, as I have been doing for several years now. I don't remember being too interested in drawing as a very young child, but as I grew older I got more and more into it. I started to take it very seriously when I was about fifteen, spending whole days studying anatomy and drawing like crazy! There was something deeply enjoyable not only in bringing fantastic things into reality, but also in seeing myself technically improve month by month.

A large period of my formative years was dedicated to studying the fundamentals of art and grinding to get better, all the while being driven by the goal of working at a studio that made my favorite games at the time. I think I've always had an affinity for drawing over painting, being very attracted to art based on highly skilled draftsmanship. I naturally gravitate toward working with lines and construction, and I feel as if that's my default mode of generating ideas and compositions. There's also something so pleasurable in the feeling of graphite on paper. That physical sensation alone makes traditional sketching worthwhile.

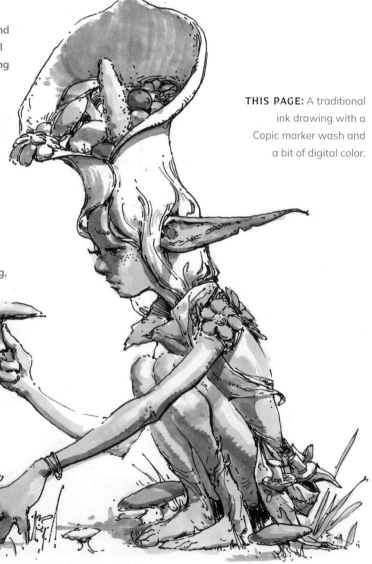

THIS PAGE: A traditional ink drawing with a Copic marker wash and a bit of digital color.

INSPIRATION AND IDEAS

I don't know what exactly pushed me to become obsessive about getting better at art when I was young, but it definitely had a lot to do with the video games I was playing and the books I was reading at the time. I was really into the art style and worldbuilding of *Warcraft* and the quirky mysteriousness of *The Spiderwick Chronicles*. I feel like those two influences are the biggest reasons why I paint the things I paint today. When I create art, I think I'm really just trying to recreate that feeling I had delving into fantasy worlds as a child, both for the viewer and myself.

MATERIALS

When sketching traditionally, almost any pencil works for me, but I prefer using a 2B or 4B. I use a kneaded eraser and sometimes a blending stump when trying to get more transitions in my value rendering. When I work with ink, I mostly use cheap Copic Multiliner pens or a brush pen, sometimes mixed with watercolor washes or Copic marker for quick shadow lay-ins. I've experimented with other painting mediums as well and feel I should definitely pursue and explore those further, but for sketching I like to keep it rudimentary and simple.

TECHNIQUES
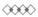

When starting a sketch, I usually have a very rough idea of the design and pose I'm going for, but I never get too fixated on any specifics, and rather try to expand and discover the idea on paper. I don't visualize a lot in my mind, but rather do the visualizing and figuring out physically while drawing. This, mixed with doing multiple sketches and iterations, lets me stumble into happy accidents and unusual solutions. I also use lots of references sourced from different sites to supplement my sketches and make them more believable.

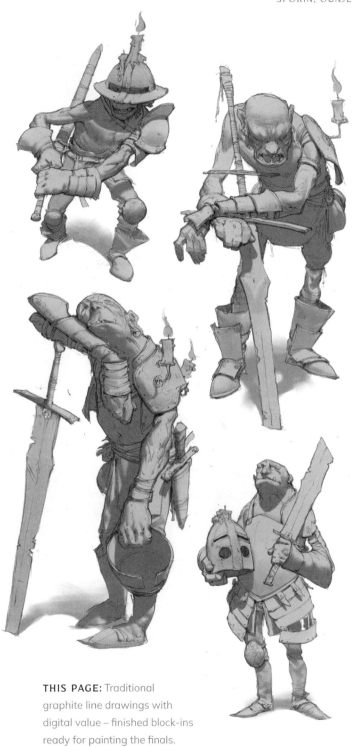

THIS PAGE: Traditional graphite line drawings with digital value – finished block-ins ready for painting the finals.

"I think I'm really just trying to recreate that feeling I had delving into fantasy worlds as a child, both for the viewer and myself"

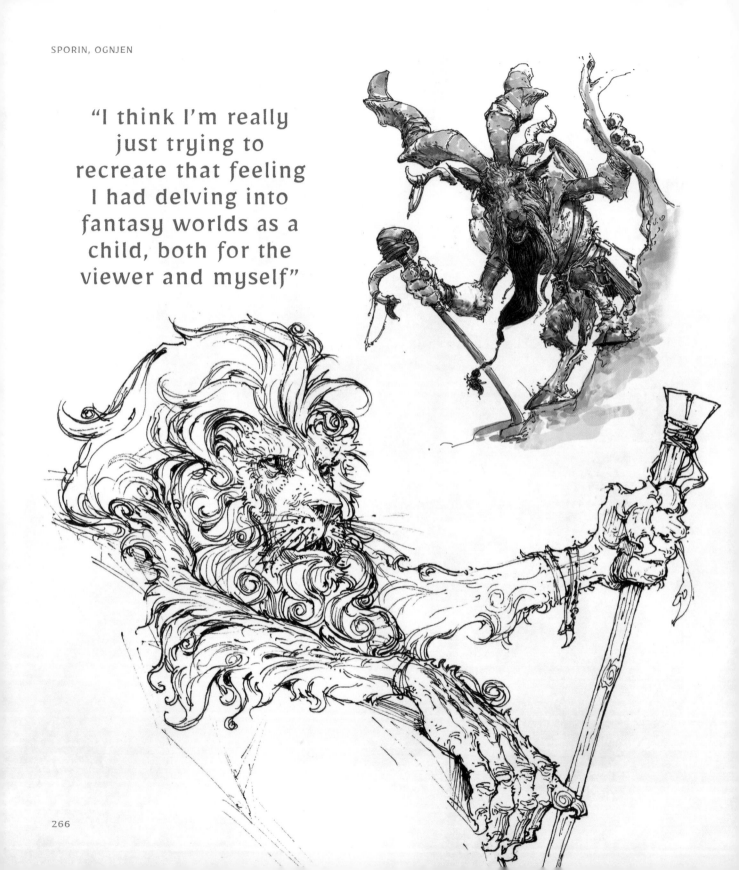

OPPOSITE PAGE, TOP: A traditional ink drawing with a digital wash simulating watercolor.

OPPOSITE PAGE, BOTTOM: A traditional pen sketch of a regal lion.

THIS PAGE, TOP: Preliminary graphite drawings with digital values.

THIS PAGE, BOTTOM RIGHT: An example of a fairly quick drawing that utilizes the blending stump for laying in value quickly, creating transitions and establishing a soft, foggy atmosphere.

THIS PAGE, BOTTOM LEFT: In this orc sketch, short, hatched strokes are used to enhance form and suggest some value.

THIS PAGE, RIGHT:
A traditional pen sketch
of a mammoth warrior.

**THIS PAGE, BOTTOM
RIGHT:** Ink drawing and
a sepia digital wash,
focused more on hatching
for value and texture.

THIS PAGE, BOTTOM LEFT:
The hatching here is very
stylized and used alongside
a watercolor wash to create
a big gradient over the figure,
creating both light and mood.

PRELIMINARY SKETCHES AND THE FINAL

Sketches are obviously a useful tool when preparing for a finished drawing or painting, but you should always keep in mind how the rough sketch relates to your final image. Always keep the big picture in mind when making choices in your sketches. Be decisive and disregard any details or imperfections (as in the proportions, for example). Instead, focus on efficiency and the overall image, so you can create multiple quicker solutions and have several options to mix or choose from.

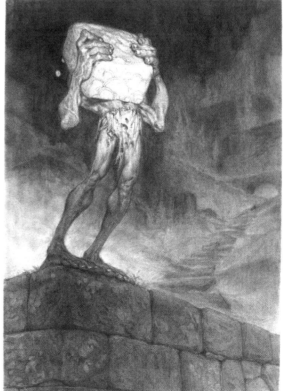

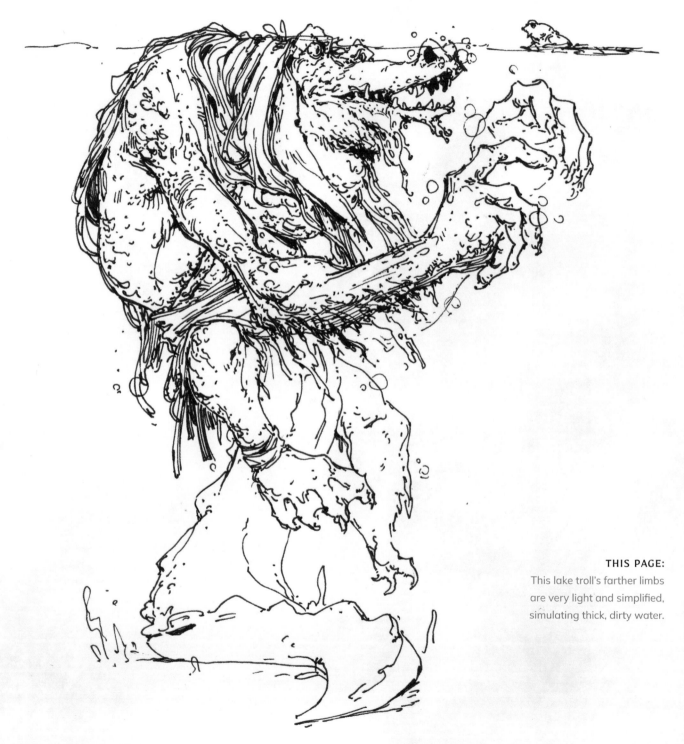

THIS PAGE:
This lake troll's farther limbs
are very light and simplified,
simulating thick, dirty water.

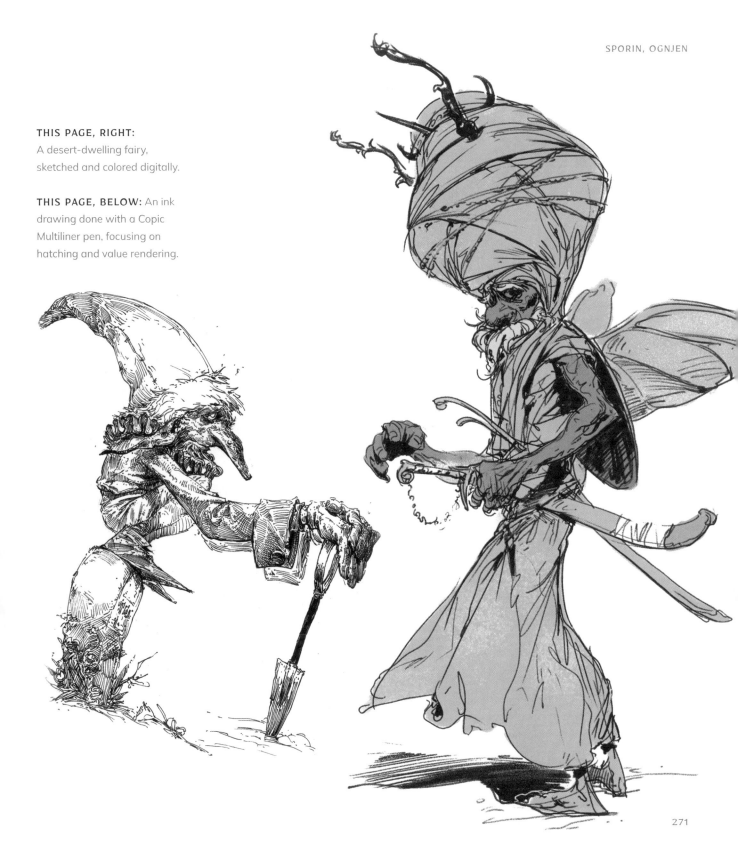

THIS PAGE, RIGHT:
A desert-dwelling fairy,
sketched and colored digitally.

THIS PAGE, BELOW: An ink
drawing done with a Copic
Multiliner pen, focusing on
hatching and value rendering.

Steinmann, Leroy

leroysteinmann.com
All images © Leroy Steinmann

I freelance locally in Switzerland and work with many different companies, including movie studios, advertising and design agencies, universities, music festivals and bands, sport brands, gyms, and construction companies. I have barely done any entertainment work, but I am keen on doing so, and I'm now setting out to find new clients in this field. I am mostly self-taught and love sharpening my craft and studying more and more.

I have drawn ever since I was a little kid and could hold a pen. Making art has always been central in my life, so drawing is very natural to me. Even though work can be stressful, I do enjoy sketching and drawing now more than ever, or at least more than I can ever remember.

Being fit and healthy is essential to me, so I work out seriously and regularly in numerous ways, to balance all the sitting down for drawing and screen time. I really love both the arts and physical movement. There are many areas of art I look forward to, to committing time to. And the best part is there's still so much to learn!

THIS PAGE: The Lion of Turicum.

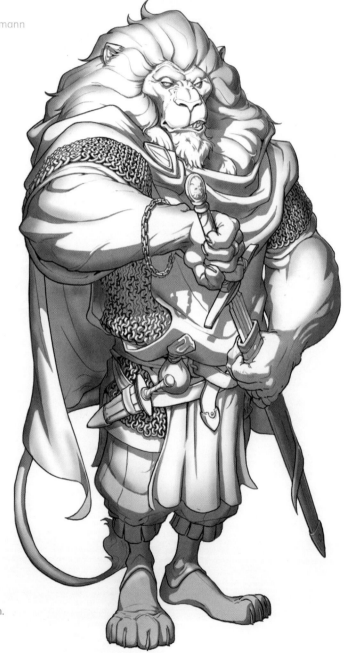

INSPIRATION AND IDEAS

My mind is very visual, so most things I experience inspire me in some way. I think anything can be cool and interesting if you are open to it and engage with it! Other than that, of course there are other artists, books, media, history, science, nature, the planet, the cosmos, life, death, and so on.

I learned to love fantasy art through certain comics, cartoons, movies, game franchises, and books, which are still very dear to me and have informed much of my life. Nowadays I also like to learn more about history and tie that into my artworks. I'm still fresh on the history path but very excited to learn more. Another two big inspirations are the people in my life and the different physical activities I engage in.

MATERIALS

My main weapon of choice for work is the iPad Pro with the fantastic Procreate. On rarer occasions I use a Wacom Intuos Pro with Adobe Photoshop, which I still like a lot. Traditionally I love to draw with ballpoints, pencils, and brush pens. I also use Copic markers sometimes, and enjoy painting with acrylics.

TECHNIQUES

When an idea comes along, I think it's good to engage with it, find something about it that you care about, and express that. Ask and answer a lot of questions about your design. I start with an idea and then do some tiny drawings where I think further about the design. Then the main process is very basic: a rough underdrawing or sketch that I develop into clean lines, throw some shadows onto, and move on to rendering.

THIS PAGE: The Bear of Bern.

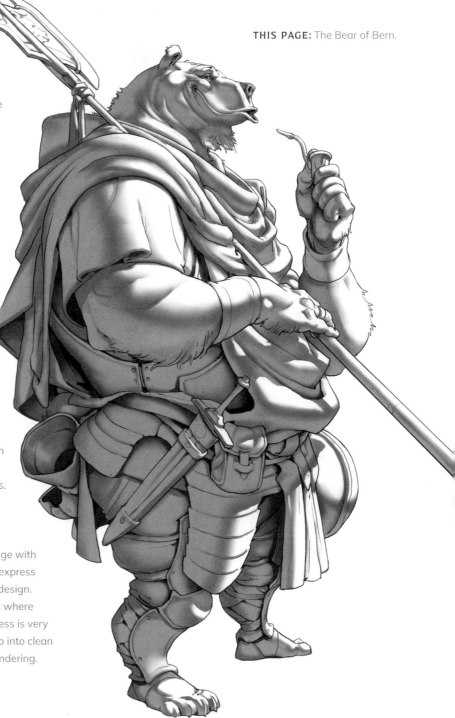

THIS PAGE, LEFT:

A tribal shaman.

THIS PAGE, ABOVE:

A young witch.

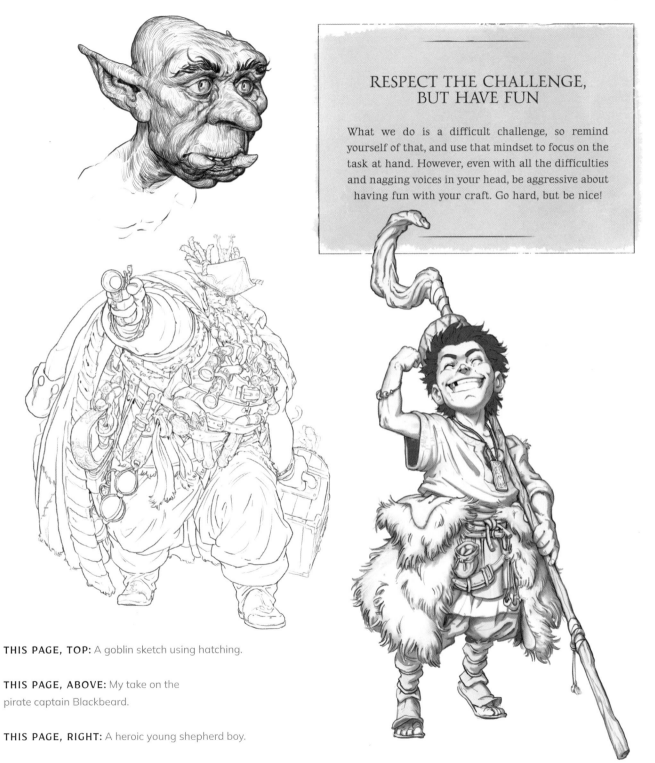

RESPECT THE CHALLENGE, BUT HAVE FUN

What we do is a difficult challenge, so remind yourself of that, and use that mindset to focus on the task at hand. However, even with all the difficulties and nagging voices in your head, be aggressive about having fun with your craft. Go hard, but be nice!

THIS PAGE, TOP: A goblin sketch using hatching.

THIS PAGE, ABOVE: My take on the pirate captain Blackbeard.

THIS PAGE, RIGHT: A heroic young shepherd boy.

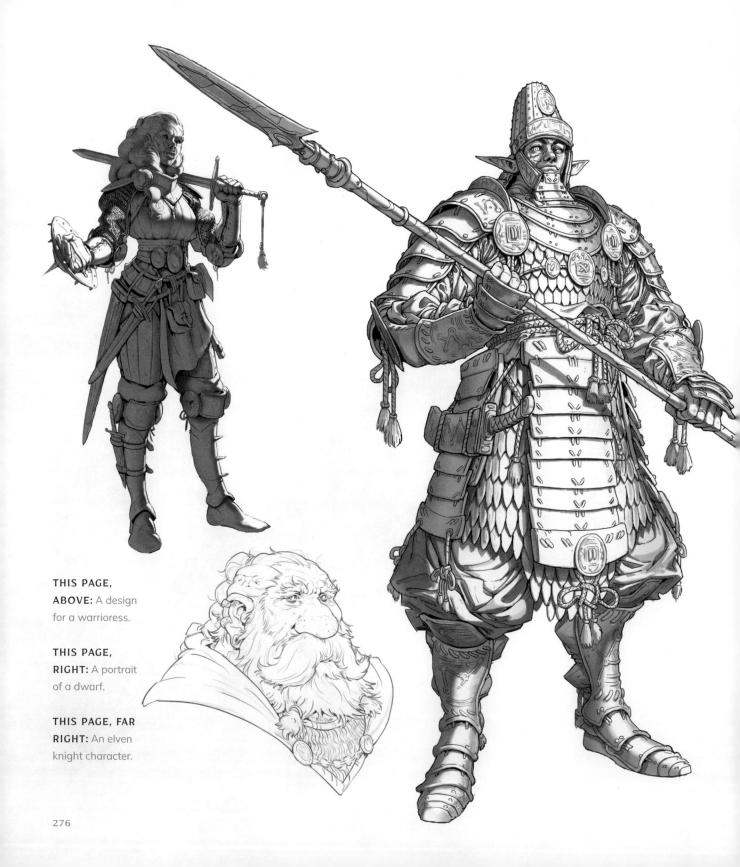

THIS PAGE, ABOVE: A design for a warrioress.

THIS PAGE, RIGHT: A portrait of a dwarf.

THIS PAGE, FAR RIGHT: An elven knight character.

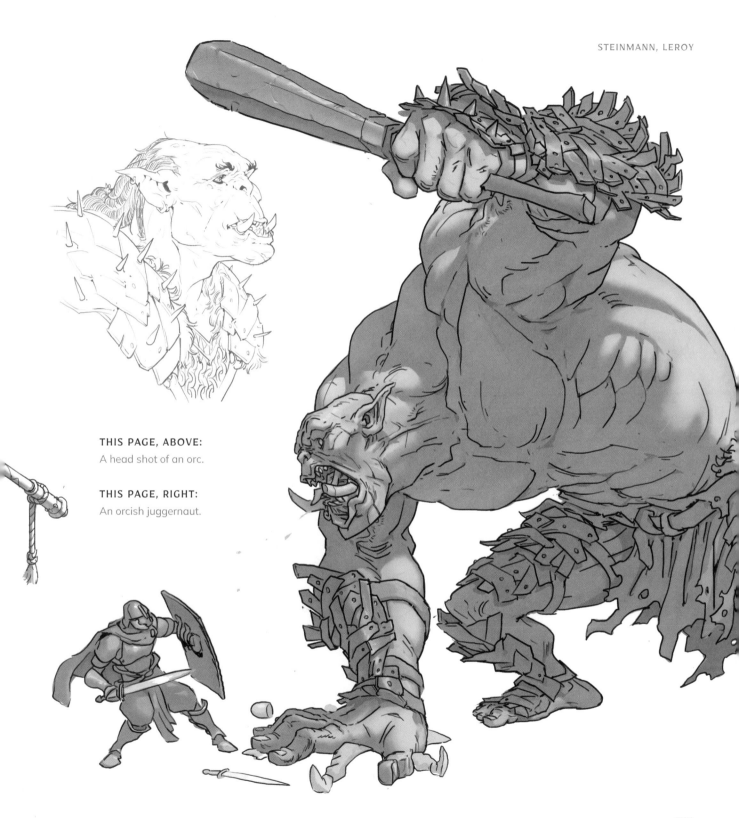

THIS PAGE, ABOVE:
A head shot of an orc.

THIS PAGE, RIGHT:
An orcish juggernaut.

Stepanov, Timofey

artstation.com/timofeystepanov

I am a fantasy artist from Russia, mostly making character concepts and illustrations for books, video games, and board games.

My art journey was a bit strange. As a kid, I hated drawing and saw it as a pointless endeavor, but today I draw to make a living. The irony! I picked up drawing in high school just so I could stand out in some way from the other kids, and the most obvious inspirations at the time were video games and Japanese animation. My love for those things eventually led me to fall in love with making art.

Many years later, in another attempt to stand out, I looked to history, mythology, fairy tales, and old, obscure artists for narrative and stylistic inspiration. Looking into the past transformed my approach to art, as our world is full of wild stories and fascinating designs.

Nowadays, I prefer to collaborate with other people and do client work. I find it much more interesting to work with other people. I believe it helps me learn and allows me to create something bigger and better than I could ever do on my own. Using my skills to visualize other people's ideas gives me a sense of purpose.

THIS PAGE: I made *Ravenseer* for *King's Saga*, a post-Ragnarok game that I worked on with my friend Nikolay Popov, who did the game design and worldbuilding. The images in this chapter are all from that project.

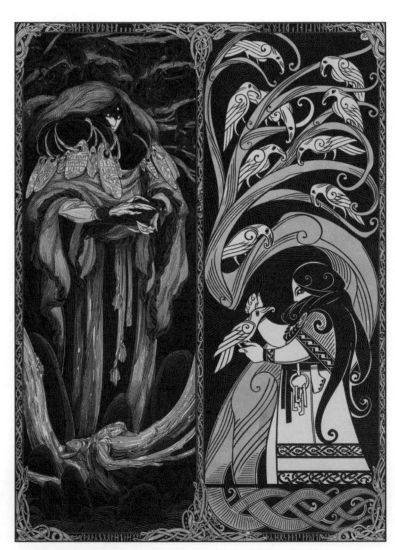

INSPIRATION AND IDEAS
◇◇◇◇

My narrative inspiration usually comes from mythology and song lyrics. The mythology sparks the ideas in my head and the music helps me add depth and layers to the story. For my visual inspiration, I look to history and other artists. History helps me make designs more believable and functional, while looking at other artists' work often gives me ideas on how to solve technical and stylistic problems. Lately, I prefer to look centuries back to find new and exciting things that I have never seen before.

MATERIALS
◇◇◇◇

When it comes to tools, I tend to stick to what I know. For many years I have been working in Adobe Photoshop, using a single pencil-like brush. This wasn't a conscious choice – more of a consequence of habit.

Some artists find learning new tools exciting and helpful, but I am not one of them. I often find it frustrating and prefer to focus on learning and improving in other areas, while keeping my tools the same for everything, so I don't draw traditionally or use any other software for my work.

TECHNIQUES
◇◇◇◇

My technical process is about breaking down the drawing into many little steps, where each step has a single goal or a problem to solve. I like to keep it simple so I can focus on one thing at a time and do my best.

The first step is doing a rough design or compositional sketch. The second is finding a good flow of lines and shapes. The third is adding and clarifying details. The fourth is doing light, clean line art, and the fifth is adding weight and crosshatching to it.

THIS PAGE, LEFT:
The Wolf's Bite, a masterfully crafted blade that looks as ancient as its master, the Kingslayer.

THIS PAGE, BELOW:
Too stubborn to die, some warriors still wander seeking another battle.

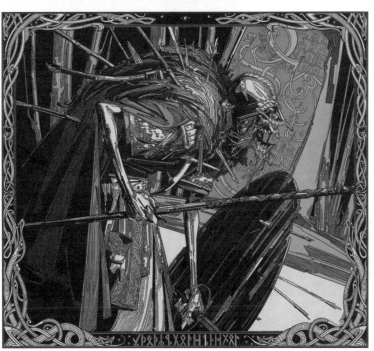

"Using my skills to visualize other people's ideas gives me a sense of purpose"

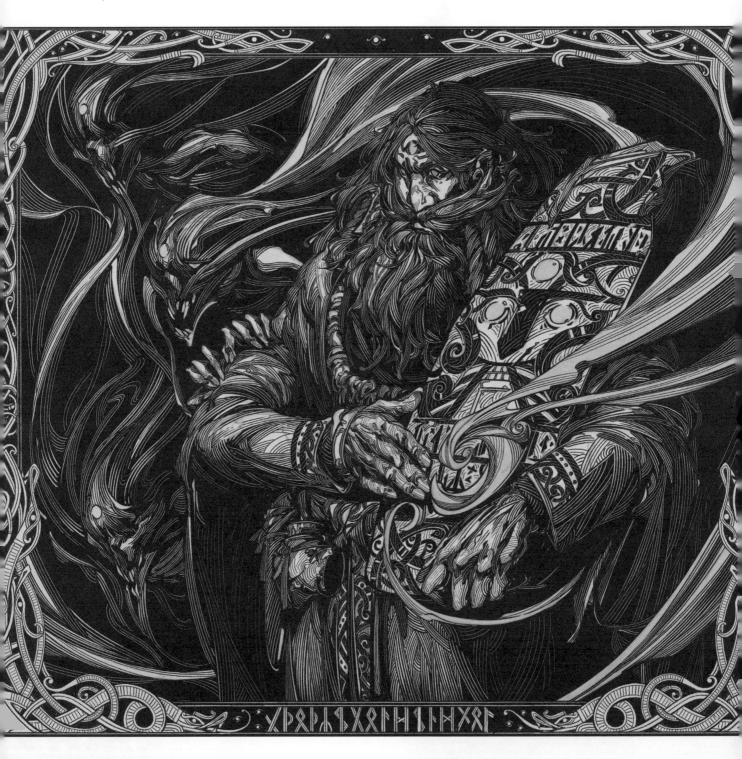

OPPOSITE PAGE: The survivors of Ragnarok
found power in ancient runestones, the broken
pieces of the shattered Stone Giants.

THIS PAGE: On his journeys, a lone mercenary discovered the
ancient Wolf Stone and a long-forgotten language of the wolves.

THIS PAGE: Scavenging old battlefields, a rare few learned the language of the dead and uncovered the mysteries of the past.

MIDDLE TOP: A mysterious lone hag lives far in the cold mountains. Only the desperate will seek her help.

OPPOSITE PAGE, TOP: A young Ravenseer in the making, carefully listening to the stories her black-feathered friends have brought from faraway lands.

MIDDLE BOTTOM: In his yearning for what was lost, an old raven often visits the ancient shrines to soothe his mind with memories of days past.

OPPOSITE PAGE, BOTTOM: Some still followed the traditions of the old world, seeking glory and writing history with their blades.

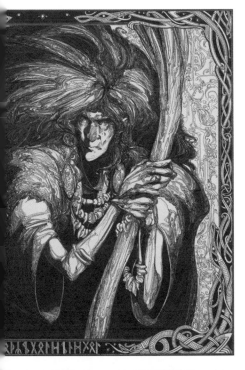

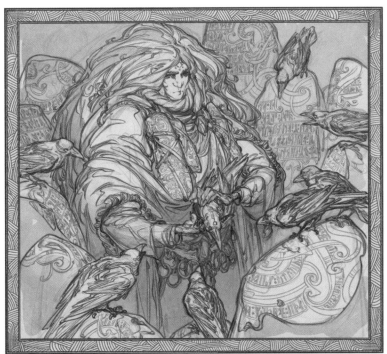

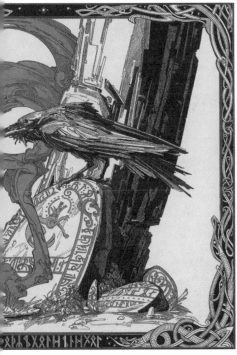

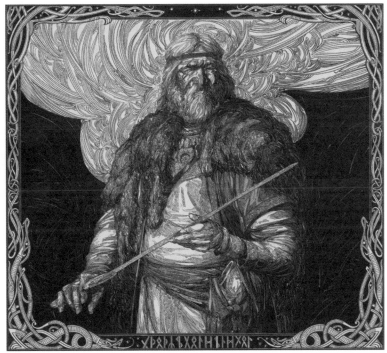

Tikhomirov, Dmitri

artstation.com/dreamrayfactory

All images © Dmitri Tikhomirov

I was trained as a linguist from a young age, and have always been fascinated by symbols, ancient languages, and the people and cultures that used them. I have studied a lot of history, and noticed how reality has always gone hand in hand with myth; how the two give strength and purpose to one another. Most of human history is shaped by the ancient seeds of symbolic stories. But with so much competition among modern mythologies, the really old ones often end up forgotten. So, I have to go digging. When I find one, I remove the dust, and attempt to give it new life.

INSPIRATION AND IDEAS
◇◇◇◇

Most of my inspiration comes from stories and legends, as well as from other artists' work. Everything beautiful and intriguing can be a source of inspiration: from the Paleolithic art of the Lascaux caves, to the Gnostic texts from the Nag Hammadi Library, to the enigmatic visions of H.P. Lovecraft. From pre-Christian myths and the imagery of Europe, to Shinto beliefs and the symbology of Japan, to the petroglyphs of Native Americans, which are in abundance in the area where I live. All of these amazing artifacts of our past inspire me to learn and share the stories of days gone by through my art.

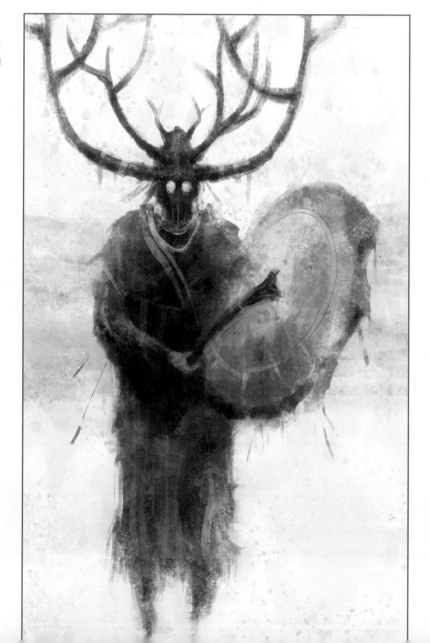

MATERIALS

Although most of my work can be done with ink or acrylic, I prefer to work digitally. I often start with an abstract underpainting. It takes a lot of effort to translate the free flow of traditional materials into digital media, but the flexibility and speed with which I can change anything, once I'm past the initial steps, make all that hard work worthwhile.

TECHNIQUES

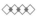

I usually start with a story or an idea. I focus on it and create an abstract painting of what I feel and see in my mind's eye. After making a series of abstract paintings with the same intent, I examine them in the same way that we used to look at clouds when we were children. I am looking for shapes that resemble some aspect of the story. On rare occasions, I go with a figurative sketch and build from there, using abstraction for texture and atmosphere. Regardless of approach, my focus is always on shapes and the emotions they evoke. I believe that a good illustration is like a magic door where the story whisks you away from everyday reality. It is up to me to open it for you, but you have to walk through that door and create a beautiful universe with your own imagination.

OPPOSITE PAGE: A shaman and his supernatural vision. I attempted to describe a shamanic trance with basic shapes.

THIS PAGE: Sketching the main shape for *The Fisherman and His Wife*, a Brothers Grimm fairy tale.

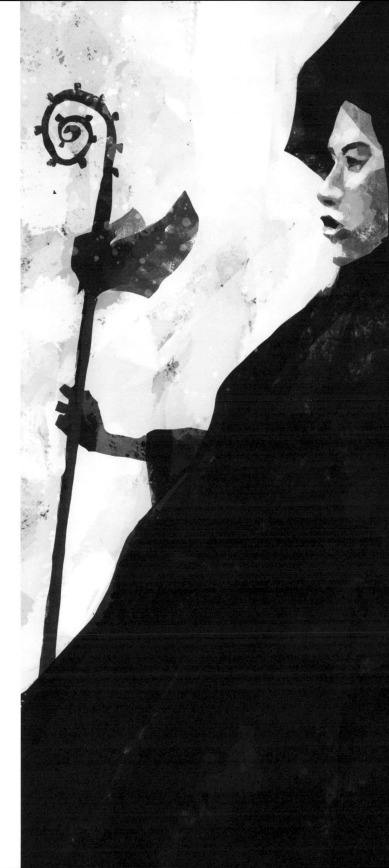

THIS PAGE, LEFT: Working out the composition for *The Valiant Little Tailor*, another Brothers Grimm fairy tale.

OPPOSITE PAGE: A composition for *A Gentleman at Heart*, part of a series of Gothic horror images.

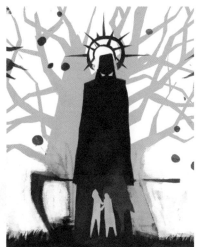

THIS PAGE, BELOW: Based on a Gnostic text, the *Secret Book of John*, this illustration shows a more figurative approach to storytelling. Adjusting and prioritizing shapes, while letting others fall away, is the best way to give maximum impact to the visual representation of the story (as you can see in the revised version).

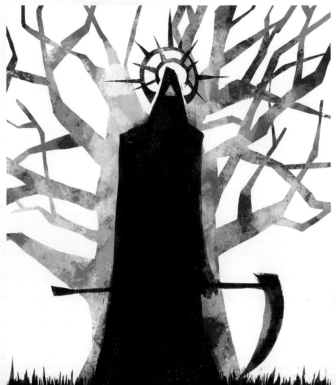

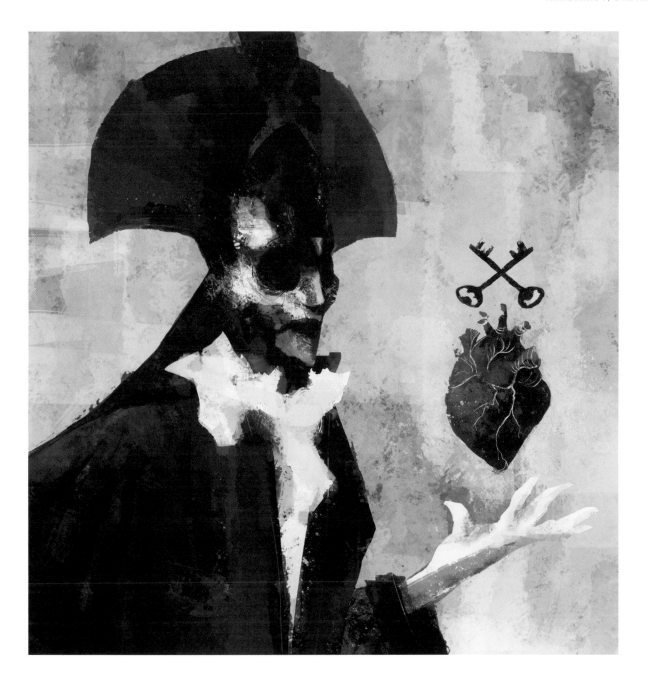

"Artifacts of our past inspire me to learn and share
the stories of days gone by through my art"

"I believe that a good illustration is like a magic door where the story whisks you away from everyday reality"

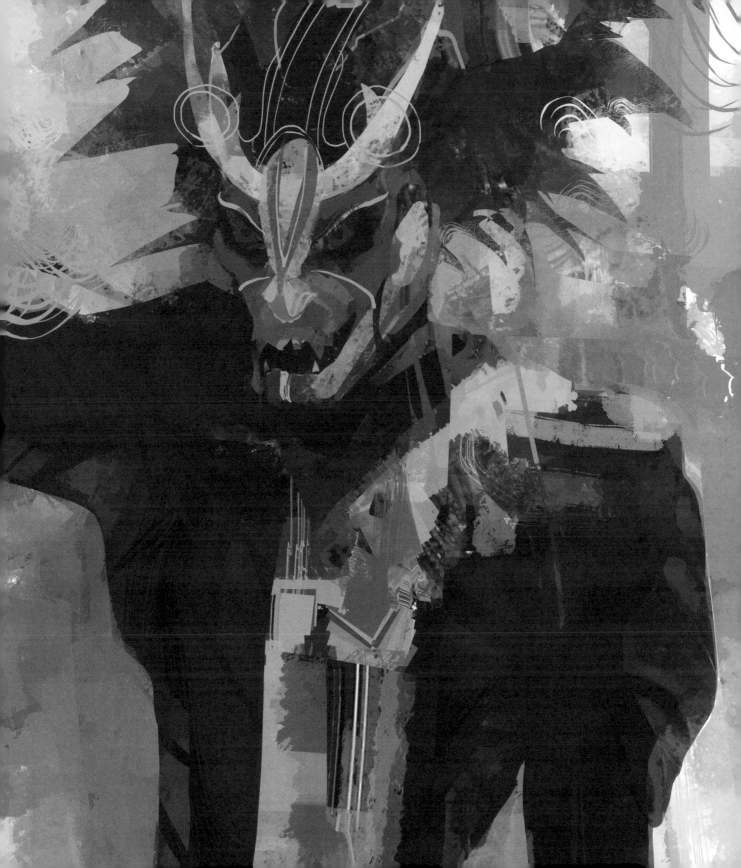

Tran, Leslie

lesdraws.com
All images © Leslie Tran

I grew up and spent almost all my life in sunny Southern California, but for the last few years I've found myself living in not-so-sunny Malmö, Sweden. I have been working as a freelance artist for over six years, mainly focusing on character design, visual development, and illustration.

I spent most of my childhood fishing, catching insects, and being obsessed with dinosaurs. I have always been into doodling silly things, like Neopets and *Dragon Ball Z* characters all over my calculus notes, but I didn't take drawing seriously until I started at California State University, Fullerton. I did not major or have a degree in anything art-related, but I just happened to have friends who drew religiously. It must have rubbed off on me, because eventually I found myself drawing, and I've drawn nearly every day since!

Art has always been a creative outlet for me, because since I was a kid, I've had an overactive imagination. Sketching has always been my way to tell a story because I'm a lousy creative writer. For me, there is no better feeling than being able to share your vision or story through an illustration you have poured your love into.

THIS PAGE: Exploration sketches for a cat character based on a Japanese samurai.

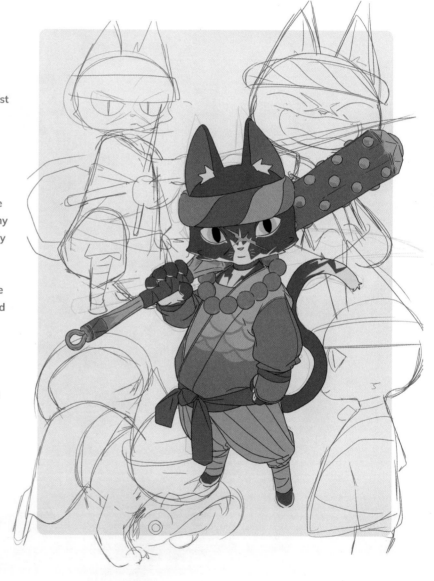

INSPIRATION AND IDEAS

I grew up in a working-class family, so I only had access
to an IBM computer I had to share with my brother. Much
of my inspiration came from thrift-store bookshelves
and the bargain bins at computer stores. I missed out
on the console craze, so I feel like my art draws from
different inspirations than other artists of my generation.

I have always been obsessed with "dungeon-crawling"
fantasy games. I loved games like *Wizardry*,
Elminage, *Baldur's Gate*, and *Might and Magic*
as a kid. Expansive fantasy worlds, unthinkable
creatures, and dark, Gothic settings have always
been the main reference points for my art.

MATERIALS

My favorite tool right now has to be my Wacom Cintiq
27QHD, used in combination with Adobe Photoshop.
Since my art is detail-oriented and line-focused, the Cintiq
has been one of the best investments I have made in the
last few years. For traditional tools I love to use watercolor
in combination with graphite. I enjoy the transparency
and the slight uncertainty that watercolor provides,
as well as its texture when combined with graphite.

TECHNIQUES

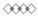

I like to start all my drawings with a rough, light brush
that simulates something like non-photo blue. It doesn't
have to be blue, but any light, noncommittal value works.
I like to work really roughly, feeling around for large
volumes and silhouettes that will work with my
design. Next I take a finer red brush and start to
chisel out the details. The main goal is to bring an
idea out of a fog and into reality. Then I do two or
three iterations of linework with a fine, round, black
brush before I move onto the final color render.

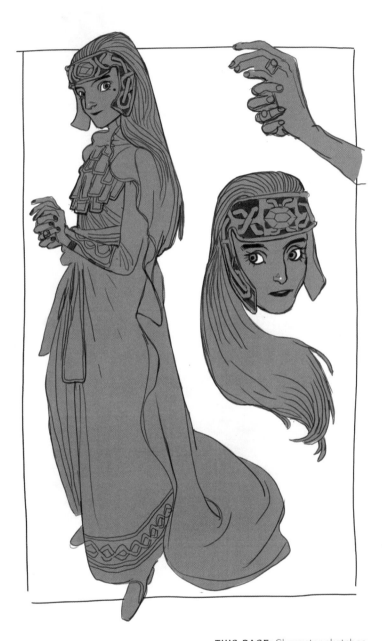

THIS PAGE: Character sketches
exploring costume and pose details.

THIS PAGE: Sketches for a girl with a turquoise earring.

OPPOSITE PAGE, TOP: Sketches of several cat characters and their props.

OPPOSITE PAGE, LEFT: Sketches for a desert sorcerer character.

OPPOSITE PAGE, RIGHT: Rendering style exploration for a demon-hunter character.

FOCUS YOUR STUDY EFFORTS!

Too often I see neophyte and journeyman artists alike make the same mistake when they're doing art studies. They will simply copy a drawing pixel for pixel, color for color. All this does is train you how to copy, rather than really teaching you anything. Imagine if you wanted to improve your creative writing skills, but just copied a story, word for word! I recommend going into a study having one or two goals in mind instead. A goal could be to learn how the reference artist uses color harmony, how they draw their linework, or how they make use of shape language.

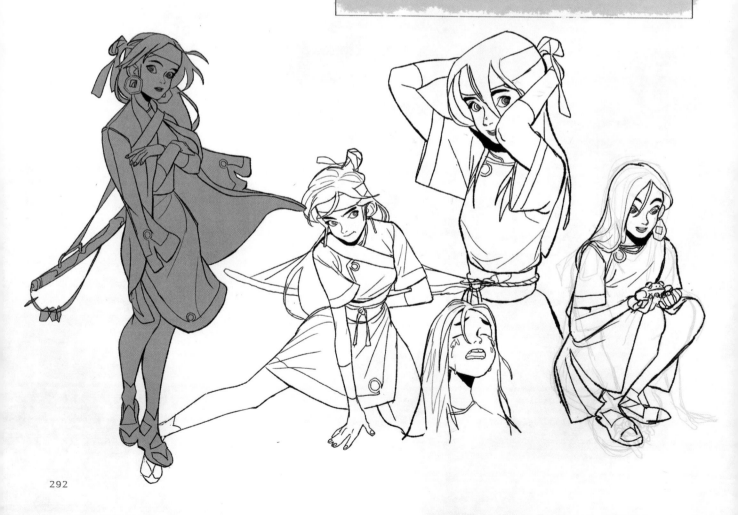

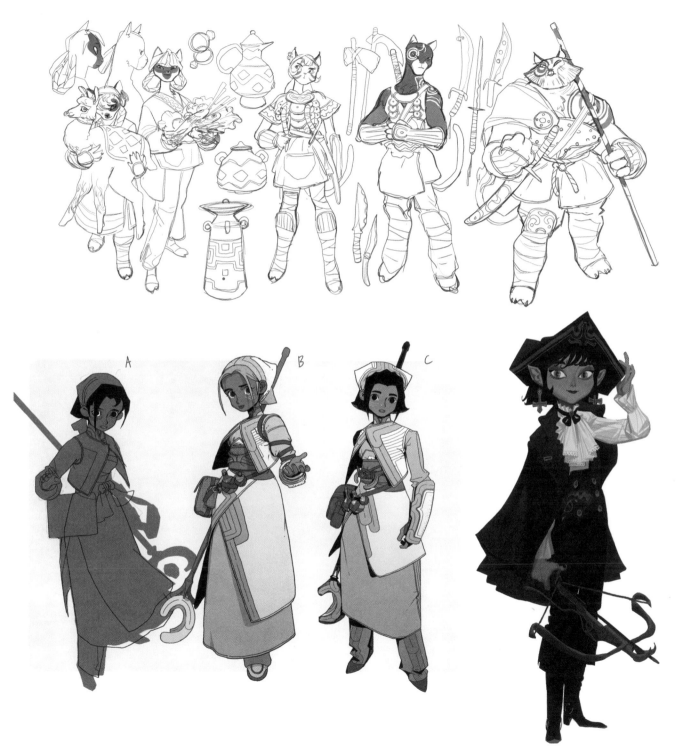

A B C

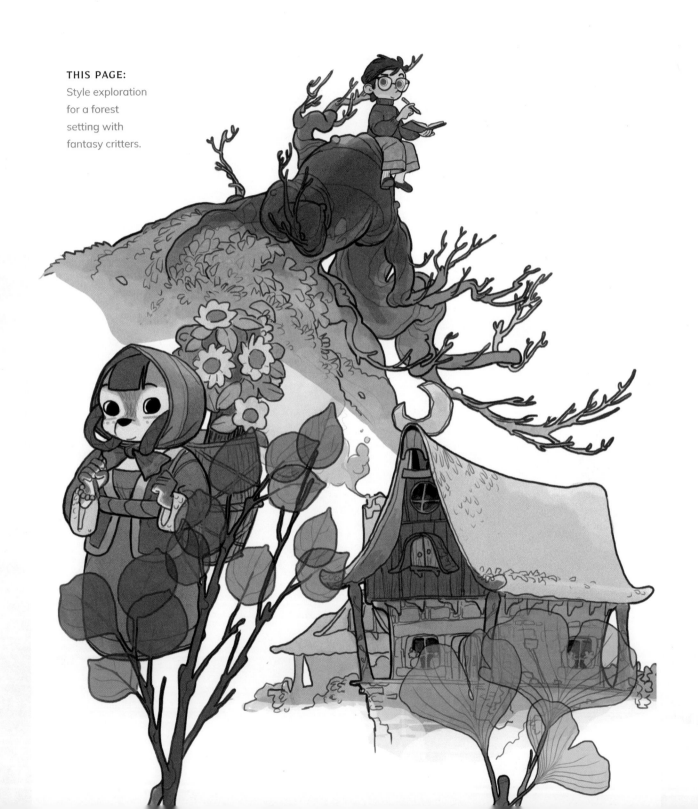

THIS PAGE:
Style exploration
for a forest
setting with
fantasy critters.

SLOW AND STEADY WINS THE RACE

The advice I always give my mentees is not to rush into a final character drawing. A successful character design should show much more than it tells. My tip is to spend a whole day or two *only* gathering references and inspiration that you think suits the character. Slowly remove references from your moodboard as you progress to the final design, until you have only a handful of "essential" images that represent your character.

THIS PAGE, ABOVE:
Sketches for a fantasy character based on a serval cat.

THIS PAGE, LEFT:
Exploration sketches of frog characters.

Tverdohleb, Mariia

artstation.com/drava_man
All images © Mariia Tverdohleb

From a young age I've been obsessed with various products of the imagination. All the imaginary worlds in the books, music, and movies around me got me thinking about creating my own. I spent years concentrated on finding the ways of getting there, looking for something that would channel my passion for worldbuilding and give me power to create. I challenged myself with different types of art, such as books, movies, music, role-playing, and even dance. It took me a few years to realize that only one of these persisted through time: the process of drawing.

One pencil is the most powerful tool to visualize the most whimsical things you can imagine. It always does its job, at any time, at any skill level. This thought drove me forward. A small pack of pencils has lived in my bag from the beginning until the present day, and hasn't left me, no matter where I go and what I do.

My path as an artist wasn't the smoothest one. There were ups and downs, but I'm stubborn! Those challenges have brought me to the point where I can call myself a "self-taught artist." This winding path is inspired by the imaginary worlds of the greatest artists and motivated by the help of the wisest.

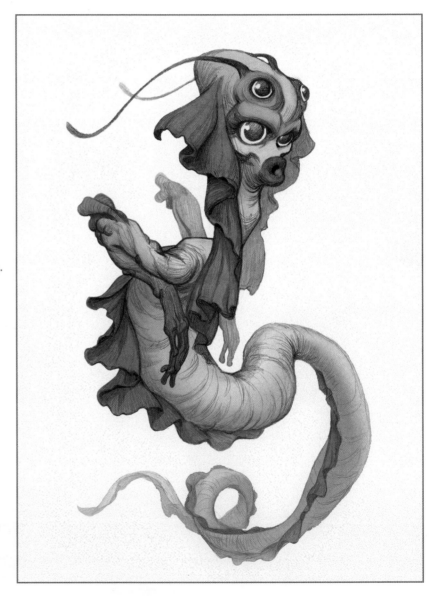

INSPIRATION AND IDEAS
◇◇◇◇

The incredible variety of things – their forms, shapes, and colors, or combinations of these – can inspire me at any moment. A source of inspiration can be almost anywhere: any emotion, sound, or movement can start a line in my sketchbook. Life itself is such a big thing to learn from and inspiration can be found literally anywhere.

MATERIALS
◇◇◇◇

Usually I'm not too picky about my tools, but my preferences are for fine-tipped pens, pencils, and brushes. I like simple mechanical pencils and different kinds of fineliners. Back in the day, I used to enjoy watercolor-painting a lot, but eventually it became too time-consuming. I still miss it and looking forward to making it my personal favorite again.

TECHNIQUES
◇◇◇◇

I like to experiment with techniques, but all of my experiments start from making a line drawing. It gives me a clear understanding of what I'm going to draw, and from there I can make other technique decisions and ask other questions. If there are no limitations ahead of me, I just go with the flow, but this usually depends on a variety of factors, such as my final goals and specific client requests.

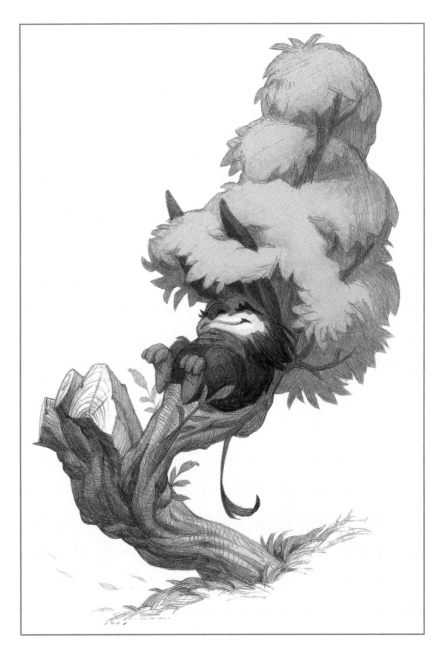

OPPOSITE PAGE: For the MerMay challenge, I thought about something twisted.

THIS PAGE: One summer I got really tired, so I decided to spend one whole month just pencil sketching. It was a precious time for me and I would like to repeat it one day.

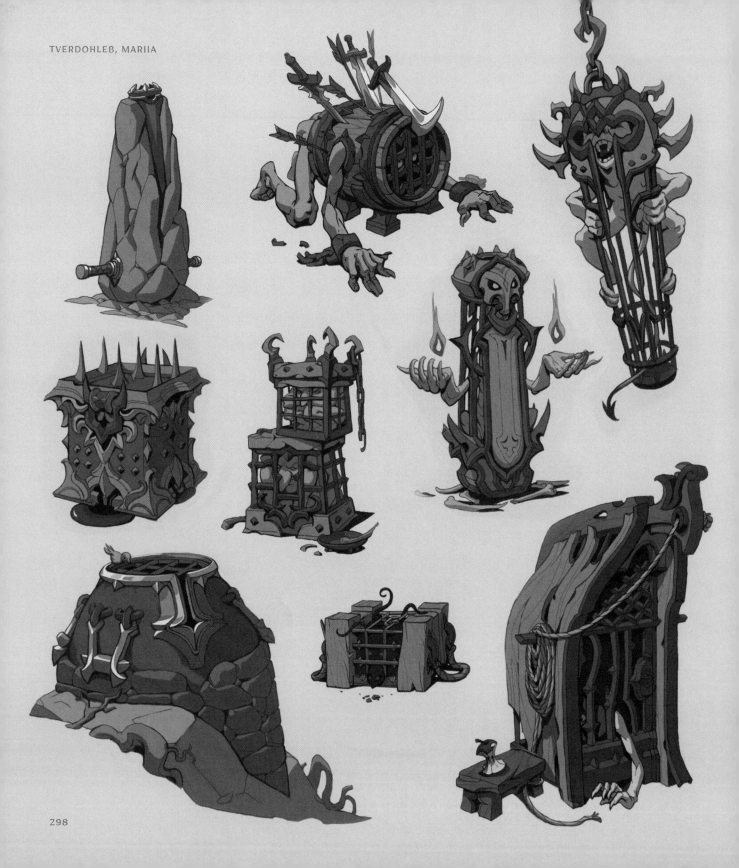

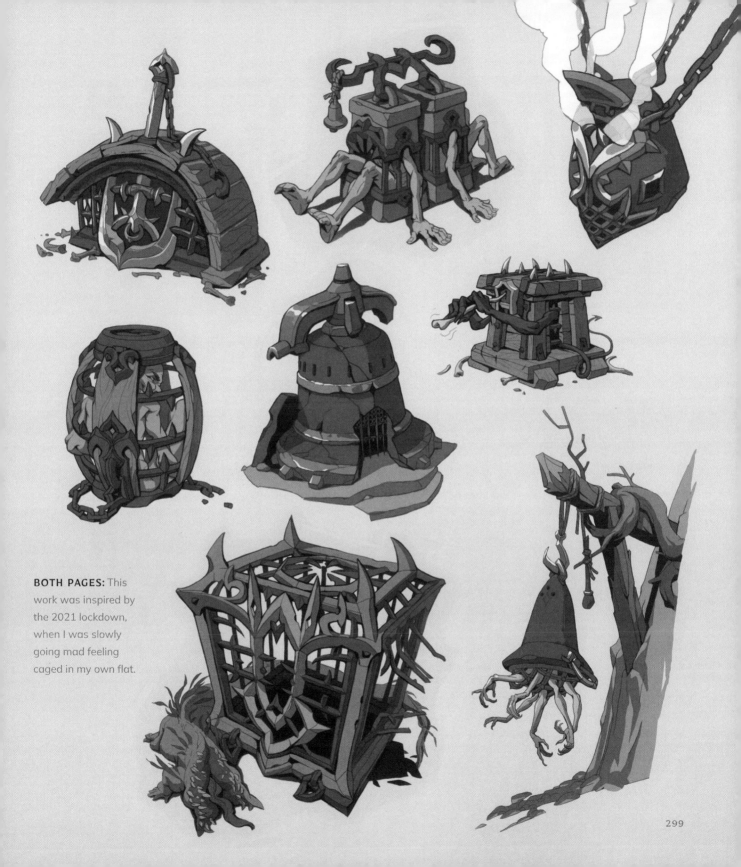

BOTH PAGES: This work was inspired by the 2021 lockdown, when I was slowly going mad feeling caged in my own flat.

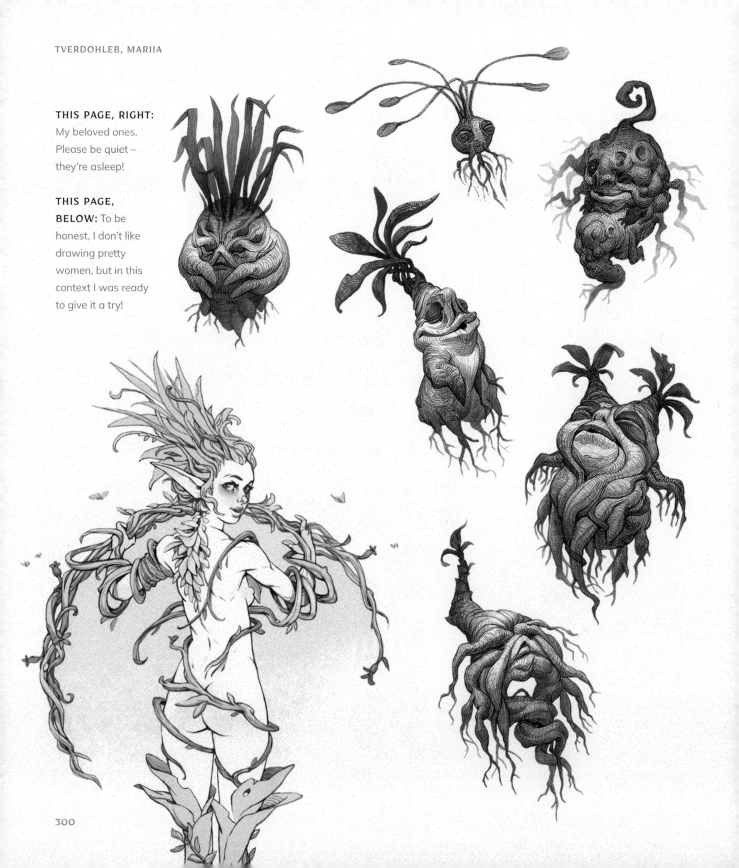

THIS PAGE, RIGHT:
My beloved ones.
Please be quiet –
they're asleep!

**THIS PAGE,
BELOW:** To be
honest, I don't like
drawing pretty
women, but in this
context I was ready
to give it a try!

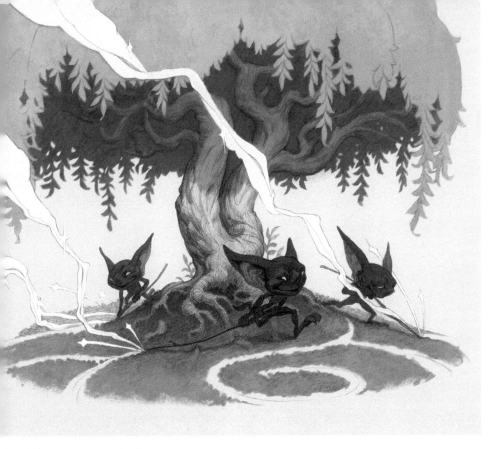

TVERDOHLEB, MARIIA

"A source of inspiration can be almost anywhere: any emotion, sound, or movement can start a line in my sketchbook"

THIS PAGE, ABOVE:
Once, I saw strange lines of dirt on the grass, most probably left by a bicycle. I thought they would be much more interesting if they were made by fairies' tricks!

THIS PAGE, RIGHT:
A long-fingered tree.

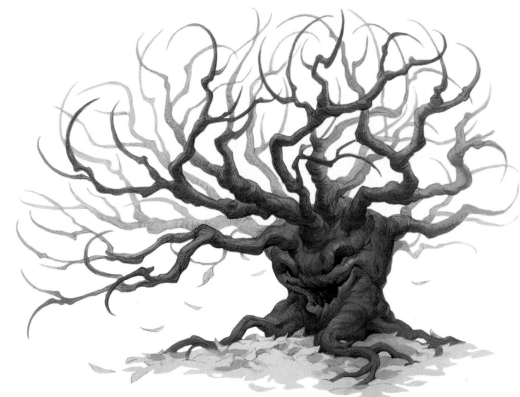

Walpole, Rachel

storyartistrachelwalpole.com

All images © NesoKaiyoH (Rachel Walpole)

Drawing for me can sometimes be hard to describe, but it's so deeply rooted into who I am that I absolutely can't live without it. What got me into drawing originally was that sense of freedom and imagination: you can essentially be whoever or wherever you want. I love drawing birds and angels, for that very reason of just being able to fly away, with no limit in the world.

High fantasy is my favorite genre. Everything from floating islands and dragons to typical medieval-style warfare are my go-to, though I'll draw anything and enjoy it! While concept art and illustration are my career and hobby, I would love to bring my own long-running story to life one day through the medium of a webcomic. Writing stories has also become a passion of mine and challenging myself to build an entire world and its inhabitants has become something of a habit. If my fourteen-year-old self looked into the future and saw how far I got through perseverance and hard work, she would probably be surprised.

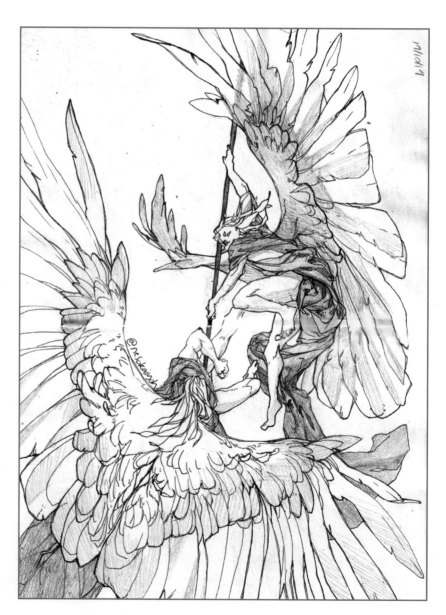

THIS PAGE: An image inspired by Renaissance art; these two angels are fighting among themselves.

INSPIRATION AND IDEAS

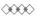

My biggest inspiration is nature. The boundless beauty, expanse, and just sheer awe it can invoke in any one person never get old! It can also be used in countless different ways to create art. Whenever I make something new, I look to the sway of nature for inspiration.

My second inspiration is Renaissance art, in particular marble statues and High Renaissance paintings. I have always been captivated by how the stoneworkers created so much life, emotion, and gesture through what is undoubtedly one of the most steadfast elements in the world.

MATERIALS

I used to experiment with everything – paintbrushes, quills, fountain pens – but these days I go with either a mechanical HB pencil or a ballpoint pen. Drawing in pen means I don't need to dwell on mistakes and can have a gesturally beautiful piece. I will use pencil for the basis of more complex pieces. Of course, most of my time these days is spent on digital sketches and artwork, which generally cancels out any limitations of traditional media, but I still keep the habits.

TECHNIQUES

When I want to draw something, I can usually see it quite vividly in my head, and use muscle memory from years of drawing practice to bring it to life. If I struggle with a drawing, I will often try different ways of imaging it, or use self-made guides such as hints of perspective lines or form building. Whenever I draw, I try to make it gestural, unless it needs to be otherwise!

THIS PAGE: A little bit of perspective gives an entirely different feel to an image. Give it a try!

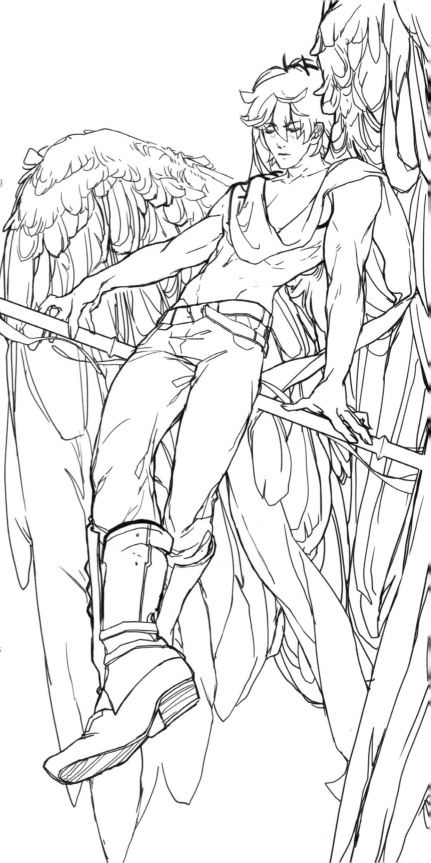

WALPOLE, RACHEL

THIS PAGE, BELOW: A proud celestial beast, adorned with trophies of its worshippers.

MIDDLE, TOP: An ancient God, transformed into a six-winged beast.

MIDDLE, BOTTOM: A masked seraphim gets ready for the day with his draped robes

OPPOSITE PAGE, TOP: Admiring the view, or getting ready to fight?

OPPOSITE PAGE, BOTTOM: A seraphim rises into the sky.

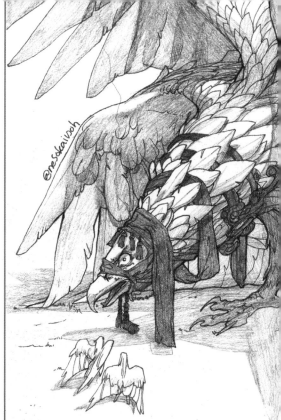

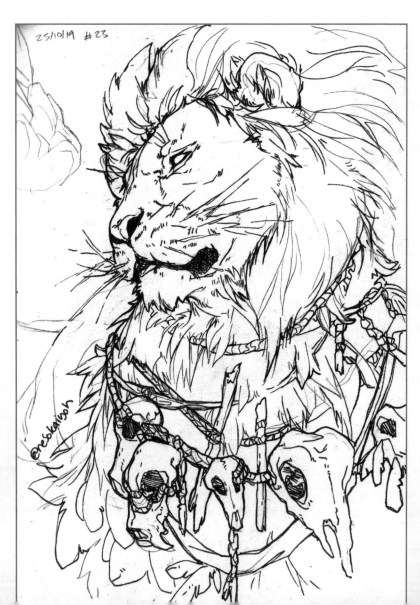

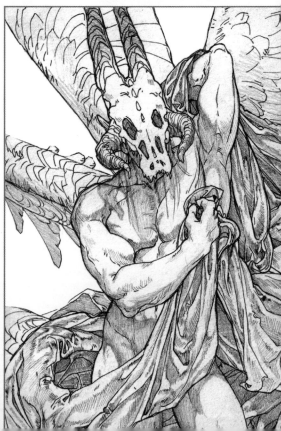

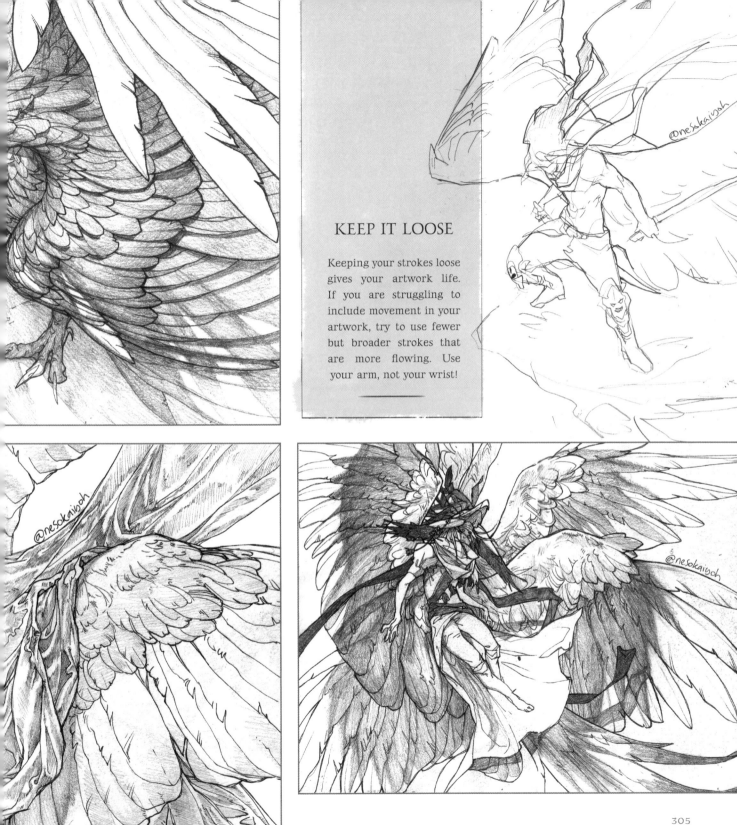

KEEP IT LOOSE

Keeping your strokes loose gives your artwork life. If you are struggling to include movement in your artwork, try to use fewer but broader strokes that are more flowing. Use your arm, not your wrist!

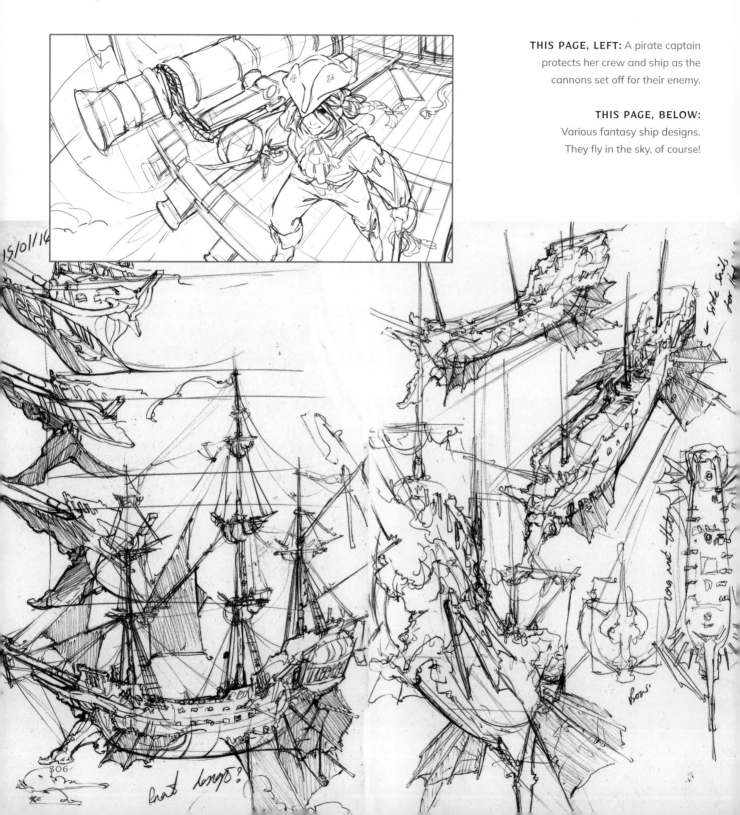

THIS PAGE, LEFT: A pirate captain protects her crew and ship as the cannons set off for their enemy.

THIS PAGE, BELOW: Various fantasy ship designs. They fly in the sky, of course!

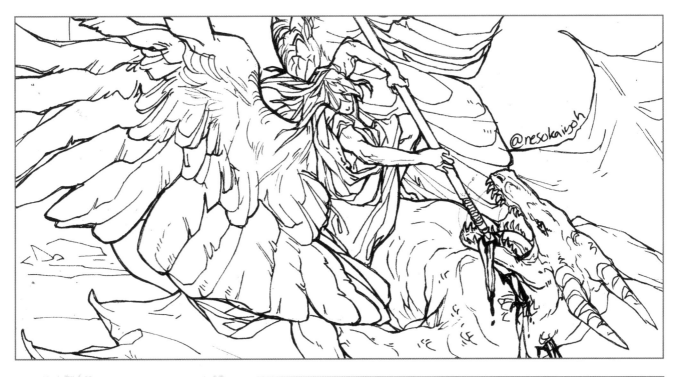

A LITTLE PERSPECTIVE

Sometimes a good way to bring your artwork to life is to include a bit of perspective. Whether it is subtle or extreme, it will definitely draw the eye. If you are drawing a figure, draw it from a slightly lower angle to create a very different look. If you are drawing an environment, have some of the elements pull back to a horizon point.

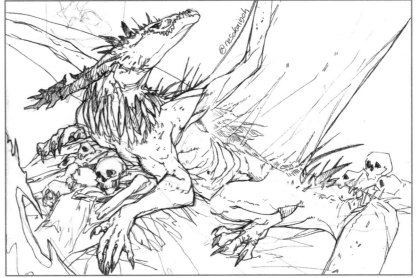

THIS PAGE, TOP: Avians and dragons have long been at each other's throats... literally!

THIS PAGE, BOTTOM: A very special type of dragon rests in his abode atop all his kills.

Zaleckė, Brigita

zaleckeart.eu

All images © Brigita Zaleckė

For as long as I can remember, I have been a dreamer. I enjoyed stories and fairy tales as a kid, and as a teen I started to create my own narratives. Those short novels needed illustrations, as any good story does, so I began drawing too.

I enjoy the fantasy genre for its ability to take something we are familiar with and twist it in a completely new way. The artistic freedom it gives, the joy of exploration and discovery, and the escape into a new world – all of that has got me through some very harsh and dark times. I think fantasy has been designed to provide shelter to those who can't find shelter anywhere else.

As an artist who finds solace and encouragement in the made-up world, I try to do the same for others. I write and create comics and stories because I want to read them. However, I also harbor hope that there might be people who will enjoy my works or find beauty in them. Creating a world takes a lot of time and knowledge, but at the same time, it allows complete freedom to do whatever you feel. I believe that this ease of creation is what draws a lot of people toward fantasy.

THIS PAGE:
The sigil for a guild of assassins.

INSPIRATION AND IDEAS

Most of my inspiration comes from the exploration of the unknown. I dare myself to experience things and travel to unknown places that are far beyond my comfort zone. When you are somewhere you have never been before, physically or emotionally, you stop for a moment, look around, and ask questions. It is in those moments that my imagination fires up. I also find inspiration in architecture and botany: they can be great visual references that demonstrate how various smaller shapes connect together to create form.

MATERIALS

For drawing, I mostly use Clip Studio Paint EX and an XP-Pen screen tablet. I used to draw exclusively with Adobe Photoshop, but I have found that it's healthy to change drawing programs from time to time. I also used to carry art supplies and several sketchbooks with me wherever I went, but I soon learned that having one book and pen is enough to document ideas.

TECHNIQUES

When I draw, I focus mainly on composition and shape. Getting them right is not always an easy task, but it is always worth it to create a base from which you can work further. I also tend to keep all of my sketch layers in the project file. While refining, it is easy to lose the flow of lines from the initial sketch, so it is always handy to keep it nearby. When the picture starts to stagnate, bring the sketch layer back to recover some lost liveliness.

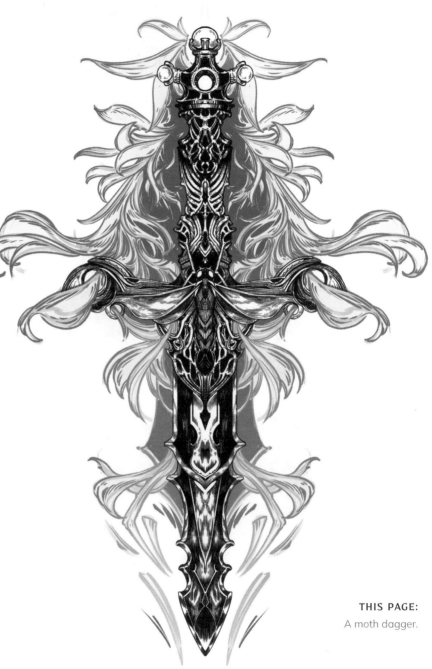

THIS PAGE:

A moth dagger.

309

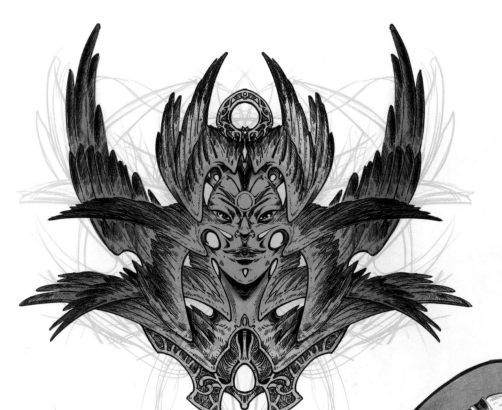

THIS PAGE, LEFT:
Neboras, god of the skies.

THIS PAGE, BELOW:
A dragon herder. She belongs
to the race of people of
the stone steppes, who
carry dragon hatchlings
on their earrings.

OPPOSITE PAGE: A duality
sigil, somewhere between
sketch and color. This drawing
marked a detailed, elaborate
new direction for my work.

PUT YOUR HEADPHONES ON

When you have an urge to draw but don't know
where to start, put your headphones on and play
some music. In times like this, I tend to go for
something epic, but genre doesn't really matter.
Just close your eyes and let the sound take you. Start
drawing what you see in your mind. This method
will always help you come up with something new.

"I dare myself to experience things
and travel to unknown places that
are far beyond my comfort zone"

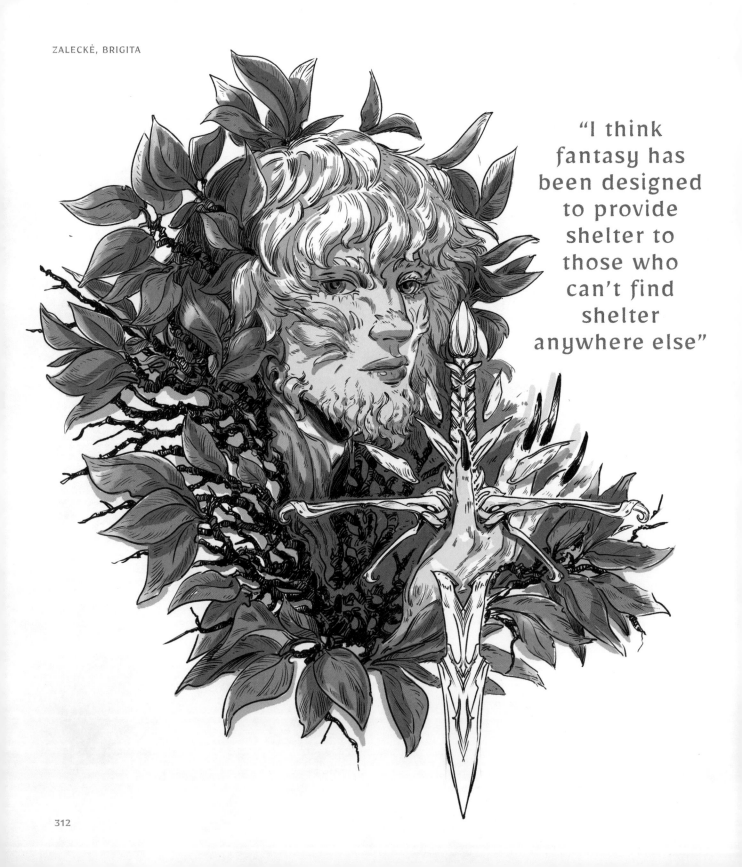

"I think fantasy has been designed to provide shelter to those who can't find shelter anywhere else"

OPPOSITE PAGE: A leafy guardian spirit that lives in the bushes and trees.

THIS PAGE: Urdens, god of water and rivers. Exploring symmetrical drawing and patterns.

Special thanks to all the artists who contributed to this volume.

ADAMS, SHAFI
◇◇◇◇

shafiadams.com
Shafi Adams is a freelance illustrator and concept artist from Singapore. He likes drawing monsters, characters, and scenes thick with atmosphere.

AFSHAR, REZA
◇◇◇◇

artstation.com/rezaafshar
Reza Afshar is an Iranian concept artist and illustrator who has been working professionally since 2012.

AMARAL, CARLOS
◇◇◇◇

artofamra.com
Carlos Amaral, aka Amra, is a freelance concept artist and illustrator from Portugal, focused mainly on the fantasy board-games and tabletop miniatures industries.

AVELINO, CINDY
◇◇◇◇

cindyworks.com
Cindy Avelino is a fantasy artist who freelanced from 2014 to 2020 creating card-game and book illustrations. Now she works on her own store and helps people create their characters.

AZEVEDO, CAROL
◇◇◇◇

carolazevedo.myportfolio.com
Carol Azevedo is a character concept artist based in Brazil. Highly interested in all things mythological and historical, she uses this knowledge to guide and expand her work.

BEAUREGARD, FRANCOIS
◇◇◇◇

deviantart.com/built4ever
Francois Beauregard is a residential designer of custom homes, an architectural illustrator, a concept artist, a craftsman/builder, and a designer of traditional and fantasy architecture.

BENAVIDES, CHRISTIAN
◇◇◇◇

voyagerillustration.com
Christian Benavides (a.k.a. Voyager) is an artist based in Medellin, Colombia, with seven years' experience in the illustration world. His travels and life experiences inspire his style.

BLIGHT, DAVI
◇◇◇◇

artstation.com/daviblight
Davi Blight is an advanced concept artist with over fifteen years' experience of working in the games industry. He currently works at Hi-Rez Studios remotely from beautiful Austin, Texas.

CORSI, CANDIDA
◇◇◇◇

candidacorsi.com
Candida Corsi is an illustrator and character designer based in Forlì, Italy. With ten years' industry experience, her many clients include Dragone, Book On A Tree, and Salani Editore.

CRUZ, RAÚL
◇◇◇◇

artstation.com/raulcruz
Raúl Cruz, better known as RACRUFI, is a freelance science fiction and fantasy illustrator and fine artist.

DE DOMINICIS, ANDREA
◇◇◇◇

artstation.com/huidao

Andrea De Dominicis is an Italian concept artist working for clients such as Wizards of the Coast, Netflix, Mountaintop Studios, VOLTA, Lucasfilm, Vogue, and many more.

EIDENSCHINK, LUKE
◇◇◇◇

instagram.com/luke.ink
youtube.com/c/LukeInk

Luke Eidenschink is a freelance illustrator based in Tucson, Arizona.

EIDINTAITE, MONIKA
◇◇◇◇

artstation.com/monikaeidintaite

Monika Eidintaite is an illustrator and concept artist currently based in the UK, with experience of working for the games industry and a passion for character design.

FAN, CINDY
◇◇◇◇

cind.ca

Cindy Fan is a freelance illustrator based in Toronto and Texas. Her work has been seen in *This Magazine*, *Strange Horizons*, *SmokeLong Quarterly*, *Split Lip Magazine*, and more.

FDEZ, FRAN
◇◇◇◇

franfdez.art

Fran Fdez is a freelance artist based in Spain. He specializes in concept art for miniatures and fantasy illustration.

FREDERICK, GRADY
◇◇◇◇

artstation.com/gradyart

Grady Frederick has freelanced as a video-game concept artist for the past five years. He has also worked in animation and on tabletop and card games like *Magic: The Gathering*.

GATTO, ROBERTO
◇◇◇◇

robertogattoart.com

Roberto Gatto is a freelance illustrator and background artist based in Italy. He has worked for Sun Creature Studio, Axis Studios, Spiderling Games, and Wizards of the Coast.

GJORGIEVSKI, DAMJAN
◇◇◇◇

damjangjorgievski.com

Damjan Gjorgievski is a digital and traditional artist from Macedonia, currently based in Finland as an art director and concept artist. His main interest is worldbuilding.

GRINTSOVA, ANASTASIA
◇◇◇◇

instagram.com/ana_griin_art
artstation.com/anastasiagrintsova

Anastasia Grintsova is a freelance artist, often creating concepts for video-game studios, board games, and miniatures.

HOKAMA
◇◇◇◇

instagram.com/noiaillustration

Hokama is a visual artist and freelance illustrator who is based in Minas Gerais, Brazil.

KAZALOV, BOYAN
◇◇◇◇

artstation.com/bbobyxp
Boyan Kazalov is a freelance character designer and illustrator working for games and comics. He also drinks a lot of coffee.

LEE, CHRIS LEWIS
◇◇◇◇

chrislewislee.com
Chris Lewis Lee is a freelance illustrator and 2D game artist based in the Midlands, UK. He works primarily on video-game projects, 2D concept art, production, and promo art.

KONIOTIS, COS
◇◇◇◇

deviantart.com/coskoniotis
Cos Koniotis is an illustrator and concept artist creating fantasy, sci-fi, horror, and superhero art. He received a gold award in *Spectrum 13: The Best in Contempary Fantastic Art.*

LI, SYRENA
◇◇◇◇

artstation.com/syrenali
Xinyue Li, a.k.a. Syrena Li, is a character concept artist from China, based in Shanghai. She is currently working on Riot Games' new, unannounced project in Kudos Shanghai Studio.

KORNEV, DENIS
◇◇◇◇

artstation.com/decor88
Denis Kornev is an illustrator and designer from Moscow. He mainly works on covers and illustrations for fantasy e-books, in addition to commercial advertising art.

LITRICO, FEDERICA
◇◇◇◇

fedelitrico.com
Federica Litrico is a concept artist and designer from Italy. Inspired by various concept artists, she taught herself to draw digitally, with a focus on character design.

KWONG, MARBY
◇◇◇◇

artstation.com/marby
Marby Kwong is an artist from the UK, currently based in California as a senior concept artist at Blizzard Entertainment.

LLORENS, DIEGO GISBERT
◇◇◇◇

artstation.com/diegogisbert
Diego Gisbert is a Spanish artist based in Berlin, working mostly for the entertainment industry but with a strong background in traditional art and a passion for storytelling.

LA CERVA, FRANCESCO
◇◇◇◇

lacerva_art.artstation.com
Francesco La Cerva was born in Palermo, Sicily, where he lives to this day. His work is inspired by a childhood immersed in fantasy and sci-fi films, cartoons, books, and comics.

LY, ERIK
◇◇◇◇

eriklyart.com
Erik Ly is a contemporary illustrator from Los Angeles, California. He specializes in surreal illustrations with a focus on characters, animals, and fantasy elements.

MESSINGER, ERIC
◇◇◇◇

instagram.com/ericmessingerart

Eric Messinger's creatures are the monsters, trolls, dwarves, and fairies of dark art, best expressed in charcoal powder. Galleries are his most prominent clients.

MORAIS, MARIA ("SUNI")
◇◇◇◇

instagram.com/__suni_art__

Maria Morais, a.k.a. Suni, is a vis-dev artist based in Portugal. She is currently working on a cute animation project with a Portuguese studio, as well as on her *Aurora & Sol* project.

MURZYN, KAMIL
◇◇◇◇

kamilmurzynarts.pl

Kamil Murzyn is a concept artist, illustrator, and art director living in Warsaw, Poland.

OCCULTMONK
◇◇◇◇

artstation.com/occultart

OccultMonk is a 3D and 2D artist from the Netherlands. Originally educated in computer science and programming, he now specializes in character design and hard-surface modeling.

OH, JINHWAN
◇◇◇◇

artstation.com/jinhwanoh
instagram.com/ozi_art

Jinhwan Oh is a web comic and concept artist who is based in Korea.

OWEN, MATT
◇◇◇◇

instagram.com/mrmattzan

Matt Owen is a freelance illustrator from the UK, best known for his work on Instagram under the name "mrmattzan."

PAUL, RÉMY
◇◇◇◇

artstation.com/alpyro

Rémy Paul is a French concept artist who has worked for Tokkun Studio and Playwing Bordeaux.

PAWLIKOWSKA, ELWIRA
◇◇◇◇

behance.net/ElwiraPawlikowska

Elwira Pawlikowska is an architect by education and a freelance illustrator and concept designer by profession, specializing in historical fantasy and architectural themes.

PHAM, NGAN ("ZEVANIA")
◇◇◇◇

zevania.artstation.com

Ngan Pham, a.k.a. Zevania, is a freelance artist from Vietnam. His many work projects include concept art, illustration, color-key painting for video games, book art, and animation art.

REMES, ALEKSI
◇◇◇◇

aleksiremes.com

Aleksi Remes is a freelance illustrator and artist from Finland with a career in illustration for indie games and comics. He is currently working to finish his graphic novel.

RIEKKINEN, RIIKKA SOFIA
◇◇◇◇

artstation.com/midorisa
Riikka Sofia Riekkinen is a freelance illustrator based in Finland. They are passionate about fantasy art and characters, and often find inspiration in nature, music, myths, and stories.

RYU, ENTEI
◇◇◇◇

artstation.com/badzr
Entei Ryu is a concept artist and digital sculptor based in Tokyo, currently working in the entertainment industry.

SPORIN, OGNJEN
◇◇◇◇

artstation.com/ognyendyolic
Ognjen Sporin is a fantasy illustrator and concept artist from Serbia. He's been in the art industry for over two years, with clients including Netflix, Wizards of the Coast, and Marvel.

STEINMANN, LEROY
◇◇◇◇

leroysteinmann.com
Leroy Steinmann is a freelance artist and designer based in Zürich, Switzerland.

STEPANOV, TIMOFEY
◇◇◇◇

artstation.com/timofeystepanov
Timofey Stepanov is a freelance artist from Nizhny Novgorod, Russia. He makes line art concepts and illustrations, working mainly with indie developers.

TIKHOMIROV, DMITRI
◇◇◇◇

artstation.com/dreamrayfactory
Dmitri Tikhomirov is a freelance illustrator based in California, who made art his full-time occupation in 2012. His passion is giving shape to ancient stories, legends, and symbols.

TRAN, LESLIE
◇◇◇◇

lesdraws.com
Leslie Tran is a character designer and illustrator with over six years' experience in games and animation. He lives in Malmö, Sweden, but calls his hometown Anaheim, California.

TVERDOHLEB, MARIIA
◇◇◇◇

artstation.com/drava_man
Mariia Tverdohleb is a concept artist who is currently located in Europe, and is particularly interested in storytelling, nature, and calm.

WALPOLE, RACHEL
◇◇◇◇

storyartistrachelwalpole.com
Rachel Walpole is a freelance concept artist and illustrator based in Nottingham, UK. An oppressive childhood led to a passion for fantasy that has become her life's driving force.

ZALECKĖ, BRIGITA
◇◇◇◇

zaleckeart.eu
Brigita Zaleckė is an artist based in Lithuania. She has worked as a graphic designer and 2D artist, and is now a game UI/UX designer who creates comics and illustrations as a hobby.

Sketching from the Imagination

In each book of the *Sketching from the Imagination* series, fifty talented traditional and digital artists have been chosen to share their sketchbooks and discuss the reasons behind their design decisions. Visually stunning collections packed full of useful tips, these books offer inspiration for everyone.

3dtotalPublishing

3dtotal Publishing is a trailblazing, creative publisher specializing in inspirational and educational resources for artists.

Our titles feature top industry professionals from around the globe who share their experience in skillfully written step-by-step tutorials and fascinating, detailed guides. Illustrated throughout with stunning artwork, these best-selling publications offer creative insight, expert advice, and essential motivation. Fans of digital art will enjoy our comprehensive volumes covering Adobe Photoshop, Procreate, and Blender, as well as our superb titles based around character design, including *Fundamentals of Character Design* and *Creating Characters for the Entertainment Industry*. The dedicated, high-quality blend of instruction and inspiration also extends to traditional art. Titles covering a range of techniques, genres, and abilities allow your creativity to flourish while building essential skills.

Well-established within the industry, we now offer over 100 titles and counting, many of which have been translated into multiple languages around the world. With something for every artist, we are proud to say that our books offer the 3dtotal package:

LEARN · CREATE · SHARE

Visit us at 3dtotalpublishing.com

3dtotal Publishing is part of 3dtotal.com, a leading website for CG artists founded by Tom Greenway in 1999.